Hartley Library

STUDIES IN IMPERIALISM

general editor John M. MacKenzie

When the 'Studies in Imperialism' series was founded more than twenty-five years ago, emphasis was laid upon the conviction that 'imperialism as a cultural phenomenon had as significant an effect on the dominant as on the subordinate societies'. With more than seventy books published, this remains the prime concern of the series. Cross-disciplinary work has indeed appeared covering the full spectrum of cultural phenomena, as well as examining aspects of gender and sex, frontiers and law, science and the environment, language and literature, migration and patriotic societies, and much else. Moreover, the series has always wished to present comparative work on European and American imperialism, and particularly welcomes the submission of books in these areas. The fascination with imperialism, in all its aspects, shows no sign of abating, and this series will continue to lead the way in encouraging the widest possible range of studies in the field. 'Studies in Imperialism' is fully organic in its development, always seeking to be at the cutting edge, responding to the latest interests of scholars and the needs of this ever-expanding area of scholarship.

Museums and empire

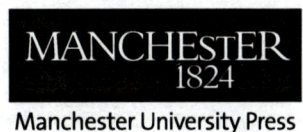

AVAILABLE IN THE SERIES

CULTURAL IDENTITIES AND THE AESTHETICS OF BRITISHNESS ed. Dana Arnold

BRITAIN IN CHINA
Community, culture and colonialism, 1900–1949 Robert Bickers

RACE AND EMPIRE
Eugenics in colonial Kenya Chloe Campbell

RETHINKING SETTLER COLONIALISM
History and memory in Australia, Canada, Aotearoa New Zealand and South Africa
ed. Annie E. Coombes

IMPERIAL CITIES
Landscape, display and identity
eds Felix Driver and David Gilbert

IMPERIAL CITIZENSHIP
Empire and the question of belonging Daniel Gorman

THE EMPIRE IN ONE CITY?
Liverpool's inconvenient imperial past eds Sheryllynne Haggerty, Anthony Webster
and Nicholas J. White

SCOTLAND, THE CARIBBEAN AND THE ATLANTIC WORLD, 1750–1820
Douglas J. Hamilton

FLAGSHIPS OF IMPERIALISM
The P&O company and the politics of empire from its origins to 1867 Freda Harcourt

MISSIONARIES AND THEIR MEDICINES
A Christian modernity for tribal India David Hardiman

EMIGRANT HOMECOMINGS
The return movement of emigrants, 1600–2000 Marjory Harper

ENGENDERING WHITENESS
White women and colonialism in Barbados and North Carolina, 1625–1865
Cecily Jones

REPORTING THE RAJ
The British press and India, c. 1880–1922 Chandrika Kaul

SILK AND EMPIRE Brenda M. King

COLONIAL CONNECTIONS, 1815–45
Patronage, the information revolution and colonial government Zoë Laidlaw

PROPAGANDA AND EMPIRE
The manipulation of British public opinion, 1880–1960 John M. MacKenzie

THE SCOTS IN SOUTH AFRICA
Ethnicity, identity, gender and race, 1772–1914 John M. MacKenzie with Nigel R. Dalziel

THE OTHER EMPIRE
Metropolis, India and progress in the colonial imagination John Marriott

IRELAND, INDIA AND EMPIRE
Indo-Irish radical connections, 1916–64 Kate O'Malley

SEX, POLITICS AND EMPIRE
A postcolonial geography Richard Phillips

IMPERIAL PERSUADERS
Images of Africa and Asia in British advertising Anandi Ramamurthy

GENDER, CRIME AND EMPIRE Kirsty Reid

THE HAREM, SLAVERY AND BRITISH IMPERIAL CULTURE
Anglo-Muslim relations, 1870–1900 Diane Robinson-Dunn

WEST INDIAN INTELLECTUALS IN BRITAIN ed. Bill Schwarz

MIGRANT RACES
Empire, identity and K. S. Ranjitsinhji Satadru Sen

AT THE END OF THE LINE
Colonial policing and the imperial endgame 1945–80 Georgina Sinclair

THE VICTORIAN SOLDIER IN AFRICA Edward M. Spiers
MARTIAL RACES AND MASCULINITY IN THE BRITISH ARMY, 1857–1914
Heather Streets
THE FRENCH EMPIRE BETWEEN THE WARS
Imperialism, politics and society Martin Thomas
ORDERING AFRICA eds Helen Tilley with Robert J. Gordon
'THE BETTER CLASS' OF INDIANS
Social rank, imperial identity, and South Asians in Britain 1858–1914 A. *Martin Wainwright*
BRITISH CULTURE AND THE END OF EMPIRE ed. Stuart Ward

Museums and empire

NATURAL HISTORY, HUMAN CULTURES
AND COLONIAL IDENTITIES

John M. MacKenzie

MANCHESTER
UNIVERSITY PRESS
Manchester and New York

distributed exclusively in the USA by
PALGRAVE MACMILLAN

Copyright © John M. MacKenzie 2009

The right of John M. MacKenzie to be identified as the author of this work has been asserted by him in accordance with the Copyright, Designs and Patents Act 1988.

Published by Manchester University Press
Oxford Road, Manchester M13 9NR, UK
and Room 400, 175 Fifth Avenue, New York, NY 10010, USA
www.manchesteruniversitypress.co.uk

Distributed in the United States exclusively by
Palgrave Macmillan, 175 Fifth Avenue,
New York, NY 10010, USA

Distributed in Canada exclusively by
UBC Press, University of British Columbia, 2029 West Mall,
Vancouver, BC, Canada V6T 1Z2

British Library Cataloguing-in-Publication Data is available

Library of Congress Cataloging-in-Publication Data is available

ISBN 978 0 7190 8367 9 paperback

First published by Manchester University Press in hardback 2009

This paperback edition first published 2010

Printed by Lightning Source

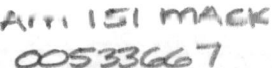

To all those who over the years have 'switched me on' to museums: the late Anne S. Robertson, Lawrence Keppie, Paul Greenhalgh, Charles Saumarez Smith, Philip Taverner, Linda Lloyd Jones, Paul Atterbury, Suzanne Fagence-Cooper, Jenni Calder, David Forsyth, Gareth Griffiths, Alan Borg, Julian Spalding, Nigel Rigby, Brian Durrans, Peter Funnell, my co-researcher Nigel Dalziel, and many others.

CONTENTS

List of illustrations — x
Acknowledgments — xi
List of abbreviations — xv

1	Introduction	*page* 1
2	Canada: the origins of colonial museums	21
3	Canada: the Royal Ontario Museum, Toronto and the Royal British Columbia Museum, Victoria	44
4	South Africa: the South African Museum, Cape Town	78
5	South Africa: the Albany Museum, Grahamstown	105
6	Australia: Museums in Sydney and Melbourne	120
7	Australia: the South Australian Museum, Adelaide	156
8	New Zealand/Aotearoa: the War Memorial Museum, Auckland	184
9	New Zealand/Aotearoa: the Canterbury Museum, Christchurch	210
10	Museums in Asia	234
11	Conclusion	265

Index — 279

LIST OF ILLUSTRATIONS

1 Royal Ontario Museum, Toronto (postcard, author's collection) *page* 51
2 South African Museum, Cape Town (postcard, author's collection) 89
3 Albany Museum, Grahamstown, Eastern Cape (postcard, author's collection) 112
4 Australian Museum, Sydney, New South Wales (postcard of 1903, author's collection) 126
5 The National Museum, Melbourne, Victoria located at the University, interior (by permission of Museum Victoria) 140
6 The National Museum, Melbourne, Victoria in the city centre, exterior (by permission of Museum Victoria) 146
7 North Terrace, Adelaide, South Australia (postcard, author's collection) 158
8 South Australian Museum, extension of 1914 (by permission of SA Museum) 172
9 War Memorial Museum, Auckland, New Zealand (author's photograph) 202
10 Canterbury Museum, Christchurch, New Zealand (author's photograph) 215
11 Indian Museum, Calcutta (Kolkata) (postcard, author's collection) 238
12 The restored V&A Museum (now Bhau Daji Lad), Bombay (Mumbai) (author's photograph) 241
13 Prince of Wales Museum, Bombay (now the Chhatrapati Shivaji Maharaj Vastu) (postcard, author's collection) 242
14 Colombo Museum, Ceylon (Sri Lanka) (postcard, author's collection) 245
15 Raffles Museum (and Library), Singapore (postcard, author's collection) 252

ACKNOWLEDGEMENTS

The research and writing of this book constituted a major journey of discovery, geographic and intellectual, around the museums (and other institutions) of the former British Empire. This involved travels for two of us in four continents and visits for comparative purposes in a fifth. A friend suggested that 'it's dirty work, but someone has to do it'. This led me to reflect that, although his was a light-hearted remark, it was indeed 'dirty work' in terms of the modern concern about carbon footprints. Hopefully, the results of the research will justify this, and an acre garden in Perthshire offers some environmental compensation. The intellectual part of the exploration continued in that garden and in the study which looks out upon it.

The first expression of thanks must go to the Leverhulme Trust, which provided an emeritus fellowship to help fund these extensive travels. The first Viscount Leverhulme left three major bequests of which the one to support academic research has particularly flourished. Many academics have reason to be grateful to him.

The staffs of museums covered in this survey, as well as related libraries and archives, have all been unstinting in offering help and support for the research. Most visits went wonderfully smoothly, thanks to the cooperation and support of the following individuals (these are organised in the chronological sequence of the research visits):

In Canada, Arthur Smith, Antoine Tedesco and Champa Ramjass at the Royal Ontario Museum, Toronto; Frederika Verspoor, Lorne Hammond and Bob Griffin at the Royal British Columbia Museum in Victoria.

In New Zealand, Bruce Ralston, Diane Gordon, Oliver Stead, Brian Gill, Paul Tapsell and Peter Millward at the War Memorial Museum in Auckland; Natalie Cadenhead, Kerry McCarthy, Eva Sullivan, Anthony Wright, Roger Fyfe and Sally Burrage at the Canterbury Museum. The latter, in particular, was a walking encyclopaedia. We are also grateful to the staff of the Christchurch City Library.

In the western and eastern Cape, Gerald Klinghart, Lindsay Hooper, Patricia Davison, Rina Krynau, Vicki Maccrae and Cindy Ludidi at the South African Museum; Mr McKechnie of Special Collections at the South African Library; Lita Webley, Fleur Way-Jones, Ayanda Pantsi, Mpho Jeffrey Molapisi at the Albany Museum; and Shirley Kabwato at the Cory Library.

ACKNOWLEDGEMENTS

In Australia, Fran Smith and Rose Docker at the Australian Museum in Sydney; Lea Gardam, Jill Evans, Fran Zilio and Philip Jones at the South Australian Museum in Adelaide, and Ross Harrison Snow, Sandra Winchester and Val Hogan at the Museum Victoria in Melbourne. We had a valuable conversation with Jude Philp of the Macleay Museum, the University of Sydney. Stephen Foster provided us with an expert guided tour of the National Museum of Australia.

In Singapore, the Director Lee Chor Lin, Senior Curator Cheryl-Ann Low, Library Services Officer Tan Chor Koon and intern Mohammed Azizi bin Mohammed. Ms Lee and Ms Low entertained us to a delightful lunch. Madam Tan helpfully sent for books and other materials from the Singapore Archives and National Library, enabling us to do all our work in the museum. Su-Lyn Seah helped to make initial contacts.

Our stay in Kolkata was rendered pleasant by Pramode Bhandari, Rodney Mendes, Sumona Ganguli and our driver Asif Ali, while the librarians of the Asiatic Society were very helpful. In Mumbai, we had fascinating conversations and much help from Mrs Tasneem Zakaria Mehta and Poulomi Das at the Bhau Daji Lad Museum (formerly the V&A, now magnificently restored under the inspired direction of Mrs Mehta). Pattem Jagannath Narasimhulu, librarian at the Chhatrapati Shivaji Maharaj Vastu (formerly the Prince of Wales Museum) facilitated our research, as did our driver Ashish Tiwari. We are grateful to Anne Buddle of the National Galleries of Scotland for advice regarding our Indian trip.

At the Royal Ontario Museum in Toronto, the South African Museum in Cape Town, the Albany Museum in Grahamstown, the Canterbury Museum in Christchurch, the South Australian Museum in Adelaide, and the Singapore National Museum we were invited to use the libraries and archives out of normal public opening hours.

Arthur Smith, Lorne Hammond, Gerald Klinghart, Paul Tapsell and Eva Sullivan helpfully answered email queries during the writing-up process, while Philip Jones read the two Australian chapters, made helpful comments, and also fielded questions.

Friends and relatives were welcoming and hospitable wherever we went. These included Rose Marie Spearpoint in Toronto, Bob and Mila Kubicek in Vancouver, Pat Roy in Victoria, John and Pam Cookson in Christchurch, Nigel Worden, James Patrick, Vivian Bickford-Smith, Elizabeth Heyningen and Julian Cobbing in South Africa; Libby Robin, Tom Griffiths, Stephen and Valsa Foster, Eric and Ngaire Richards, and Jim Hammerton in Australia; and Nicola and James Locke in Singapore. A visit to the Royal Museum of the Congo in Tervuren, Belgium, was facilitated by Karen and Mike Brzezicki.

ACKNOWLEDGEMENTS

Thanks are also due to the staffs of the National Library of Scotland, Edinburgh, the British Library, London, and the Museum of Empire and Commonwealth in Bristol, as well as to colleagues and friends Stephen Constantine, Jeffrey Richards and Irene Robertson.

Acknowledgements are usually a positive list of plaudits, but the accuracy of the historical record demands the inclusion of some scary moments. One was when we were informed at the Royal British Columbia Museum that a director had earlier abandoned the museum library and archive (the only one in our entire experience to do this). The library had been dispersed and the archives deposited in the nearby BC Archives. Apparently this director had never understood the contention of Roger Summers (the historian of the South African Museum) that a great museum, particularly a scientific one, is nothing without its library to support its scholarly research. But we do sympathise with the financial imperative that probably made this necessary and it does not detract from the fact that it is a great museum. However, the problem with the transfer to the provincial archives is that this places a private archive in the public domain, subject to the regulations of such a body. The BC Archives is not easy to use. The Canadian Freedom of Information Act is in fact an Imprisonment of Information Act. Any records which a researcher wishes to use have to be vetted by an archivist (to check whether material dealing with individuals is present), a process that takes three weeks. All photocopying, even from books, also takes three weeks. Neither provision is helpful to international researchers there for a period under two weeks. As if that were not enough, the archive is the noisiest and least helpful imaginable. This situation was saved by the wonderful support of Frederika Verspoor, the former librarian and archivist of the museum now working in the Archives, and by Lorne Hammond. Frederika and Lorne were unstinting in their support. Writing the history of their museum was only possible through their considerable cooperation.

It was also impossible to secure an illustration of the British Columbia Museum because the relevant person was abroad when permissions were required.

The next scary moment was in Auckland and was similarly out of the control of the staff. When we were there, major building works were taking place (as in so many museums around the world). We had arranged to be in the library and archive in one week and part of the next, but on arrival we were told that the builder needed to close the library in the second week. As we raced to complete our work in the first few days, the books were being shifted around us. Inevitably, we quaked at the thought of what would have happened if the contractor had closed the library before we arrived: a journey to the other side of

ACKNOWLEDGEMENTS

the world would have been rendered useless. As it is, the situation was once again saved by staff who are acknowledged above.

Nigel Dalziel accompanied me and shared the research in all the locations. He also read and commented on all the chapters.

LIST OF ABBREVIATIONS

AAAS	Australasian Association for the Advancement of Science
ADB	Australian Dictionary of Biography
AM	Australian Museum
BAAS	British Association for the Advancement of Science
BC	British Columbia
BM	British Museum
CPR	Canadian Pacific Railway
DCB	Dictionary of Canadian Biography
DSAB	Dictionary of South African Biography
DNZB	Dictionary of New Zealand Biography
EIC	East India Company
FMS	Federated Malay States
ITM	Industrial and Technology Museum (Melbourne)
NMV	National Museum of Victoria
NS	Nova Scotia
NSW	New South Wales
NZ	New Zealand
RCS	Royal College of Surgeons
ROM	Royal Ontario Museum
RSSA	Royal Society of South Africa
RSV	Royal Society of Victoria
SA	South Australia
SAAAS	South African Association for the Advancement of Science
SAM	South African Museum
SAuM	South Australian Museum
V&A	Victoria and Albert Museum (London and Bombay)
VOC	Vereenigde Ostindische Compagnie (Dutch East India Company)
WMM	War Memorial Museum (Auckland)

CHAPTER ONE

Introduction

Museums were an expression of the western conviction in the onward march of the rational. Cabinets of curiosities had contained the weird and the wonderful, exotica that seemed initially to be unknowable and unfathomable. Yet the act of placing such materials in the cabinet brought them into the realm of the potentially known and understood by being viewed and organised. The ancient and enduring Aristotelian system of classification of the natural world was constantly in the process of revision, at least from the late seventeenth century onwards. But as visions of nature moved from the era of the sublime, with its touch of fear as well as beauty, into the era of romanticism, a rapidly expanding natural world (not least as a result of expeditions and associated collecting) became ever more subject to forms of taxonomic systematisation. Contemporaries were increasingly confident that global nature could and would be comprehended. These processes embraced the era of natural theology, thought to offer an increasing understanding of God's design and, therefore, knowledge of the deity. Debates centred upon various forms of the great chain of being, the hierarchy of organisms from the 'lowest' to the 'highest', as well as upon the incidence of divine creativity linked to notions of biblical flood-like catastrophes of the past. But the role of divine providence was threatened, or at least became a source of greater controversy, with the inauguration of the era of scientific grand theory, best represented by the two Charles, Lyell and Darwin, each building extensively on work that had gone before.

The nineteenth-century museum lay at the heart of this. It constituted the public face of scientific endeavour, the point of contact between scientists and public exhibition, between empirical collecting and theorisation, and between such scientific discourse and popular understanding. Reverence in the face of grand mysteries gave way to a sense of the possibilities of knowing and therefore the opportunity for power, protection and control. While museums in the English-speaking

world dated from the seventeenth and eighteenth centuries (like the Ashmolean, the British Museum, and the two Hunterians in London and Glasgow), their great expansion took place in the nineteenth. The Museums Act (sometimes known as the 'Beetle Act', reflecting the early emphasis on natural history) was passed in 1845, although relatively few towns initially responded to its provision to permit the levy of a halfpenny rate to fund a museum where there were more than 10,000 inhabitants.[1] But there was to be a much greater expansion later in the century, partly related to the great success of exhibitions in the period.[2]

The opportunity to sweep the world up into one place, as in the great Crystal Palace Exhibition of 1851, seemed to offer an extraordinary insight into the possibilities of scientific globalisation. It also stimulated the growth of museums, directly in the form of the South Kensington Museum (later the V&A), indirectly in museums elsewhere in Britain and the British Empire. Indeed, the South Kensington Museum helped to develop provincial museums by sending travelling exhibits around them. Reacting to the 1851 Exhibition, the great natural philosopher William Whewell wrote that 'by annihilating the space which separates different nations, we produce a spectacle in which is also annihilated the time which separates one stage of a nation's progress from another'.[3] Exhibitions, from 1851 to the 1930s, offered what were in effect museums of global explanation, visual encyclopaedias of knowledge about empire.[4] Such exhibitions – on a variety of scales – spread to almost every imperial territory, influencing the foundation and development of museums as they did so.[5] These museums were also intended to offer spectacle, which would serve to obliterate the supposed gaps in the progress of nations and colonies. Indeed, the striking thing about this empire-wide movement is the manner in which developments in Britain spread to the colonies with astonishing speed. Some museums (like that in Calcutta of 1814) can be seen as emblematic of the earlier period of museum foundation, but the majority of colonial examples were part of the great multiplication of museums after the Crystal Palace extravaganza.

The grand exploits of the modern industrial complex, particularly the provision of worldwide infrastructures, contributed to this in notable ways. The laying of railway lines, for example, at one and the same time heightened the notion of conquest over nature while 'annihilating the time which separates one stage of a nation's progress from another'. The ocean-to-ocean survey of the engineer and surveyor Sandford Fleming for the Canadian transcontinental railway, starting in 1872, symbolised this industrial and intellectual complex, the increasing 'conquest' and therefore 'understanding' of nature and

INTRODUCTION

the elimination of the gaps in progress, or the perception of progress, matching the advancing lines of rail. Fleming's party included a historian and a naturalist, though his own interests embraced all aspects of study of the natural world.[6]

The Australian equivalent, completed in the year the Canadian exploit began, was linked to that other distance-conquering medium, the telegraph. This was the spanning of the continent from south to north, from Adelaide to Palmerston (Darwin) by telegraphic cable. Unlike the Canadian railway, this was in the same time zone, but it opened up vast tracts of difficult, dry territory and led to something of a natural historical and anthropological (and, therefore, museological) revolution. Everywhere, surveyors and geologists, explorers and botanists turned into collectors and suppliers of specimens to museums. In some places such figures faced a natural profusion influenced by abundant water supplies; in others, aridity was the key conditioner. In Australia settler pastoralists and others were constantly searching for sources of water, sinking wells and exploring creeks. They made surprising discoveries during such enterprises: once more economic activity caused nature to offer up 'secrets' which were duly exposed in museum collections.

Thus, wherever in the British Empire railways and roads, telegraphs and modes of exploitation of the environment advanced, surveyors and engineers, miners and farmers were inevitably sucked into the fascinations of geology, palaeontology and archaeology. Scarring the landscape for these new and improved modes of communication, as well as for economic activities, caused the environment to bleed out its hitherto hidden treasures, both natural and human. This was a characteristic of informal as well as formal empire. The building of railway lines in China breached many tombs and other archaeological sites from which treasure hunting and looting could feed the museums of the advanced imperial world. Another close conjunction between the conquest of nature and public display occurred with the fascination with hunting and zoology in the period. Those who travelled as explorers, surveyors, engineers, missionaries and naturalists hunted for knowledge and sport, for subsistence and collecting.[7] This latter linked a great chain of specimen acquisition from the tiniest insects to the skins and heads of the grandest mammals.[8] Most museums of the time had displays of such 'trophies' adorning their walls. Hunters tried for the largest specimens of horns or antlers and an urban public divorced from such rural pursuits were able to see the products displayed in the local, provincial or national museum. Even more spectacular were the assemblages of preserved and fossilised bones or antlers, which revealed the grandeur of extinct creatures of 'deep time'. The smaller-scale collecting of birds'

eggs, bird skins, butterflies, moths and so on was pursued by a wider public. Activities now viewed as wholly lacking in conservation correctness were encouraged by educators and clergymen as a means of 'rational recreation', the pursuit of higher moral attainment through greater understanding of nature. Museums reflected all of this, their displays – invariably donated by enthusiasts – in turn stimulating visitors to attempt their own collecting. As Gillespie has pointed out, such 'hunting' (both shooting and smaller-scale collecting) 'paradoxically promoted both the rational and the irrational, the civilised and the primitive, the modern and the pre-modern, the scientific and the romantic'.[9] All of these were encapsulated, intentionally or not, in the museum.

The colonial museum, in some respects, heightened the theme of the raiding of nature. It often symbolised the dispossession of land and culture by whites through the rapid acquisition of specimens and artefacts. Such colonial acquisitiveness occurred on a global scale, representing a worldwide movement brokered by imperial power. The museum's intellectual framework, its collecting habits, and so many of its methods were closely bound up with the nature and practices of imperialism. Thus the late nineteenth-century museum became, paradoxically, the emblem of modernism. The paradox lay in the fact that it was principally concerned with the past, the deep time of the natural sciences and archaeology, the more recent era of human endeavour, and even the 'contemporary past' of ethnographic artefacts, so often collected in order to reflect social and technological atavisms. Indeed, the act of collecting such emblematic artefacts demonstrated the alleged distance of the societies that produced them from the progress symbolised by the imperial modernism of the museum in which they were displayed. Thus, the museum revealed its modernity through its organisation of the pre-modern.

It reflected the ideas, the power, the technology, the urbanisation, the social relations, and even the architecture of a modern global system. It was spawned by, and fed off, the opportunities afforded by new power relations and technologies. It symbolised the networks, the support systems, and the skewing of administrative and legal provisions in the direction of the enthusiasms of the dominant people. In this respect, it was somewhat akin to the Crystal Palace Exhibition itself. The iron and glass architectural envelope of that exhibition represented a striking emblem of industrial modernism. But the jumble within, the diversity of the displays, the search for renewed craft values reflected the desire at the heart of modernism to invoke the values of a pre-modern age. Yet the museum, like the exhibitions, offered more than an arrogant cultural othering of nature and peoples: it also,

INTRODUCTION

ultimately if not immediately, stimulated fresh forms of respect. The artefacts of past and present cultures came to be revalued in new ways, representing parallel approaches to spirituality, aesthetics and peoples' efforts in time and space to grapple with the mysteries of the natural and human worlds. There were glimmerings of these revaluations in the nineteenth century and they greatly increased in the twentieth. Both the themes of rapacity and of respect, of authoritarian dictation and of cultural dialogue, are worked out in this book. These processes were themselves symbolic of the interaction of the modernist and pre-modernist modes.

Museums in imperial territories were inevitably differently focused from those in Europe. In all the territories of white settlement (and for a period in South and South-East Asia, though the focus here rapidly changed), they represented a western view of the world. As these colonies joined the modernising project, indigenous peoples might be viewed and assessed as part of the surrounding natural world. The museum was created by an essentially European vision and was intended to feed the white gaze. It offered a route into a global memory, the perquisite of western cultures. Memory is itself a source of power, a means of supposedly understanding the present and divining the future. Thus, the museum's visitor constituency was expected to be an immigrant one. 'Native peoples' were part of the objectivity of the museum, who were not expected to participate in the subjectivity of its users. Indigenous people everywhere were recognised as part of the landscape of the state, but they were not incorporated into the nation which it represented. Such incorporation did eventually come, but at differential rates. This timescale may be debateable, but the Maoris of New Zealand, the First Nations of Canada, the Aborigines of Australia and finally the Khoesan and Africans of South Africa were progressively adopted into nation (and therefore museum), although some might doubt that the proper degree of such incorporation has yet been reached. Thus potential museum visitors inhabited colonial states where degrees of subjecthood were slowly translated into equal rights.[10] There is some evidence to suggest that indigenous peoples made efforts to control the ways in which they were represented, but this was done in a situation of highly unequal power. Only in South Africa, as shown in chapters Four and Five, have the indigenous people arrived at political power, necessitating (though not always achieving) major reorganisation and refocusing of the country's museums.[11] African subjectivity must now be, or ought to be, central to all their concerns.

National identities have come to be enshrined in museums to an even greater extent than before. Throughout the British Empire, with the exception of India and other parts of Asia, the museum had

to cope with the fact that its traditional juxtaposition of antiquities and of nature was somewhat skewed. Nature often constituted the earliest means of inspiring a national geographical identity, although these identities were initially complex and pluralistic. At first imperial and proto-national, later they were colonial-national within an imperial frame, representing viewpoints from both above and below. Some museums compensated for the alleged lack of antiquities by introducing their visitors to artefacts from the cultures of the Middle East and of Europe. An example would be the Royal Ontario Museum in Toronto. In India, there was never any doubt that Indians would be the 'consumers' of museums and that India possessed artefacts of major civilisations, though some princes also wished to unveil the cultures of Europe to Indians. India generally occupied the centre stage, a major difference from settler societies. Local civilisations were also the prime focus in other Asian imperial museums.

Thus the geographical and ethnic perspectives of imperial museums were often complex, but the messages of their natural contexts and incipient nationalism were highly fluid. In the words of Elizabeth Edwards, in relation to photographs, museums were ambiguously dynamic.[12] They contained within them an inevitable dialogue between surface and depth, between the readily apparent display and the deeper background which it represented. And if they constituted performance spaces for the acting out of dramas of identity, power and intellectual grappling with the world, this was a theatrical event that was constantly in the process of renewal and reinterpretation. As the character of their visitor constituency was transformed, that dynamic induced changing meanings and shifting messages in the visible accounting of what was to be seen, ultimately producing the refocusing of the displays themselves. But we know all this with hindsight. Part of the point is that the original curators, collectors, trustees and audiences failed to recognise that this would happen. Self-interrogation and self-reflection took some time to arrive.[13] To a large extent, the original museums were (at least ideologically) uncritical and unproblematic. Arrangements were much debated, particularly in terms of the various disciplines represented or in respect of geographic or functional modes, soon often incorporating Darwinian principles. Yet the displays constituted the facts; the facts the displays. Empiricism was enthroned there. In this era, criticism was not about slanted or loaded presentations, but about balance or aesthetics.

When self-analysis did arrive, the central museological truism became more apparent. The museum, as it had done since the days of the cabinets of curiosities, reflected travel in time and space. As its interests developed and its scale increased, it served to collapse

both chronological and spatial considerations, opening up a number of dimensions within its portals. Geology, palaeontology and early archaeology offered time travel in the deep past. Once specimens came to be collected from across the world this vertical effect was matched by the horizontal: any museum worth its natural and human salt carried its vision of the past upwards in time and sideways in space, inexorably towards a modern world of progress and integration. These reflections on time and space were of course value laden and required to be invigilated in more recent years. But whatever interpretative net was eventually thrown over the museum, it was apparent that it offered, in effect, a 'Tardis', a machine for time travel in which the inside could seem to be a great deal larger and more expansive than the outside.[14] Exhibits reflected a vast range, almost a jumble of time/space reflections, which belied the carefully ordered architectural exterior.

This 'outside', no less than the interior displays, invariably made a whole sequence of political, intellectual and propagandist points. The architecture of museums is a large and separate study, but as we think about their interiors we should never forget the architectural composition containing their displays.[15] In common with other key building types – government houses and legislative buildings, mints and treasuries, churches and cathedrals, colleges, hospitals and asylums, town halls and libraries, hotels and railway stations – museums (at least the grander sort) came to evoke civic, colonial, national and imperial power. While these considerations were often inhibited by financial restraints, still the architecture of colonial museums made statements about the 'progress' exhibited in the colony in relation to the rest of the world. Moreover, it often reflected the manner in which we should think in terms of urban and regional identities.[16] Pride in place and forms of identity can also be attached to cities and to national subdivisions, which often had their roots in separate colonies (provinces in Canada and South Africa, states and presidencies in Australia and India, regional administrative areas and Islands, North and South, in New Zealand). The intentions of the founders of museums in architectural commissioning often reflected these sub-national divisions as much as the emergent nation itself.

There is a sense in which the museum, as much as weaponry, the steam engine, the telegraph, and medical and pharmaceutical developments, represented a tool of empire.[17] All of the conventional tools were inherently active in the collecting practices and intellectual relationships of the museum. If they entwined the means and motives of imperial rule, the museum offered a public justification for expansion and the accommodation of nature and peoples to its purposes. The museum was itself a machine for measuring the alleged achievements,

or lack of them, of mankind.[18] It was also a key 'imperial archive', both three-dimensional and conventional, through specimens, objects and records. As such, it provided a constant updating of the natural and anthropological markers of colonial rule.[19] In all these ways, it was intended to be a prime contributor to knowledge.[20] It was a central part of the process of ordering the world, familiarising and naturalising the unknown as the known, bringing the remote and unfamiliar into concordance with the zone of prior knowledge, both geographically and intellectually. These processes were often bound up with establishing and developing totalising precepts, supposedly reducing chaos to order, raw nature to developing systems. This at least was the ideal.

Benedict Anderson described the 'warp' of the 'colonial state's style of thinking about its domain' as being the creation of a 'totalizing classificatory grid to anything under the state's real or contemplated control: peoples, regions, religions, languages, products, monuments and so forth'. All this was 'countable' and contributed to the 'weft' which was 'serialization, the assumption that the world was made up of replicable plurals'. Thus, according to Anderson, 'the colonial state did not merely aspire to create, under its control, a human landscape of perfect visibility: the condition of this "visibility" was that everyone, everything, had (as it were) a serial number'.[21] Anderson's work is eminently quotable and has been much quoted. But the sceptical historian hesitates. If his notion of 'imagined communities' does not always fit the facts,[22] his statement about the museum represents the pure vision of the social scientist, which is only partly grounded in reality. Museums lived in the real world. We must be careful not to claim too much for them, as the so-called 'new museology' has too often done. It is stretching a point to say that they functioned as 'a metonym of the state itself'.[23] Reluctance to fund museums adequately was a common imperial experience. Colonial politicians were not always as 'sold' on them as their advocates were. All forms of public expenditure meet with almost inevitable opposition. This was particularly true because so many of the museums discussed here owed their origins to private societies, but were only able to develop adequately with official funding. Such funding was always contested and the museum often failed to establish the intensive 'visibility', which Anderson imagined. Moreover, ideal organisation and the application of the 'serial numbers' were inhibited by many factors: not just the financial, but also the pressure on often minimal staff and their lack of expertise, the absence of understanding of or refusal to accept some global scientific theories, the predilections of trustees, even the demands of the 'audience'. These various tensions, and the extent to which museums fell short of the ideal, are charted in the chapters that follow.

INTRODUCTION

We should not be carried away by the notion that museums were immediately seen as vital to the economic or cultural health of colonies, as their early protagonists often argued. Some museums struggled in their early years (and again later). They were never well funded; their budgets were always seen as vulnerable to attack, an easy and uncontroversial way of making savings. Colonies strapped for funds did not see museums as the vital resource claimed by their advocates. Museums were invariably collections-rich and cash-poor, always a dangerous and damaging combination. Lip-service to the museum ideal often failed to translate into budget provision. Perhaps it was for this reason that some museum curators disparaged the notion of small local or civic museums, attempting to keep the whole museum thrust at the centre, at the capital or larger city representing a form of centralised and nationalist (or provincial) assertiveness. They were anxious about the possibility of energy being dissipated, of smaller museums detracting from the opportunities and expansiveness of the larger. In any case, the notion that finds of any significance should almost automatically go to the central museum died hard. But smaller local museums were still founded.

Museums were dependent on 'forms of imagining' derived from infrastructures like shipping, railways, the telegraph, surveying and new scientific and technical advances in astronomy, horology, palaeontology, natural history, and their support systems in photography and print, many of them promoted by the 'deep driving power of capitalism'.[24] Among these, nineteenth-century shipping services, both regional and international, were vital in the physical accumulation of collections, as well as in the exchange of ideas and people. European, American and colonial museums set up a quite extraordinary international traffic in natural historical, archaeological and anthropological 'specimens'.[25] Geological, mineralogical, zoological and entomological collections were exchanged between Europe and the colonies, among European museums, and from colony to colony. Private collectors were also involved in this trade. But these exchanges moved on into a network of anthropological commerce. Nothing reflected the imbalance in power relations among the peoples of the world more noticeably than this commercialisation and commodification of the art, artefacts and human remains of indigenous peoples.[26] A great scramble for ethnographic artefacts took place in North and South America, Africa, Asia, Australasia and the Pacific Islands.[27] The scramblers were often museum agents, as well as administrators, soldiers and missionaries. Museums developed a voracious hunger for worldwide collections, which would establish their international status and offer evidence for the cultural relativities that justified their existence. This scramble

embraced both archaeological materials from the deep pasts of ancient 'civilisations' and the 'cultures' of contemporary peoples across the globe. They were, in other words, emblems of 'othering' in both past and present contexts. Whether this was purely hegemonic or enabled aspects of tired European design to be refreshed on the vital springs of more 'primitive' cultures may be open to debate.[28]

But material culture was not enough. A strikingly extensive 'trade' was also conducted in human remains. University departments of anatomy (and therefore university museums) together with European and colonial museums almost all began to collect skeletons and skulls of human beings, supposedly in the interests of science. The early manifestations of this reflected exotic physiques and physical features, largely in the business of the frisson of the different. But later it became part of the 'sciences' of anthropometry and craniology, the endless measuring of 'types' designed to illustrate evolutionary or other theoretical positions to be divined from morphologies of the human form.[29] These cranial and anthropometric studies necessitated the collecting of multiple 'specimens' since usable conclusions could supposedly only be reached through statistical sequences. But these sales and exchanges of human remains went beyond archaeological material. There was also a vigorous trade in the remains of the recently dead. A form of body snatching was stimulated by sciences that were deeply implicated in the racial theory of the day, facilitated by such gruesome practices as the boiling down of the remains to secure the skeleton. These activities, despite their alleged rejection by some anthropologists, continued until at least the inter-war years and have been seen as feeding into Nazi race theory.

Modern scholars recoil from these practices not only on the grounds of humanity and respect, but also because they represent inadmissible racial attitudes. The continuing presence of such remains has become a serious embarrassment to many museums: protocols and codes of good practice have been drawn up and the difficult process of returns has sometimes been embarked on. But scholarly rejection has also taken place because, in reality, the trade was unscientific. Contexts and provenance were seldom appropriately recorded, providing a sense of morbid and insensitive 'treasure hunt'. Many archaeological sites, as well as recent graveyards, were raided and destroyed, representing a form of historical genocide for some peoples. Body snatching was pursued as relentlessly as the looting of artefacts from tombs and other cultural contexts. The demand stimulated the activities of those who were out to make a 'fast buck', and those who participated in such mercenary pursuits were (and are) seldom squeamish about the destruction and loss of detailed study that goes along with them. And as we shall

see, curators as well as their highly dubious agents were themselves active as body and artefact looters. Curators usually had access to official channels to secure permissions, always in the name of 'science'. They were also able to seek out bodies resulting from deaths through murder, executions, or of prisoners or people in psychiatric asylums. It should, however, be said that modern osteological studies do offer many insights into the past, as do remains found in bogs or in contexts where freezing at high altitudes has permitted some preservation. Sometimes, more recent burials have been used to provide information about diseases (for example, the remains of those who died in the influenza epidemic of 1919), which could provide support for current health objectives. But the key point is that the earlier anthropological and anatomical passion was entirely racial. This involved the dominant race storing and objectifying the bodies of 'others' in order to explain and justify that very dominance.

Whether natural specimens, artefacts or human remains, the museum was in the business of presenting 'things' – things that carried varying meanings to different people, messages that change over time. The characterisation of things as 'emissaries' can be extended into viewing them as symbols of historic moments, ideas, ideologies, religions, socio-economic modes of organisation, and much else.[30] Such things have been ascribed a social life, acquired through their change of status from everyday items into representatives of culture, which offers the possibility of the writing of their biographies.[31] Nevertheless, the presentation of specimens and artefacts in museums has always been problematic. They are necessarily ripped from their contexts, natural or social, functional or spiritual, and can only achieve an imaginary replacement in such contexts if captions or forms of display allow. Generally, the early offerings of things in museum cases failed to do this. Perhaps modern associated visual media (for example, film of the natural regions where specimens originate or of people actually using the 'things') provide a greater opportunity to establish appropriate settings. Indeed, photography, later moving films and sound recordings, added a further dimension to the museum archive.[32] These techniques were particularly applicable to anthropology,[33] which had a parallel history with photography, but were used in other fields too. Originally conceived as contemporary aids to research, visual and sound materials have now acquired hallowed historic status and are sometimes reused in modern museum displays.

It has sometimes been suggested that collections of materials can only be appreciated if the viewer has the necessary and 'appropriate socially-coded ways of seeing', but this has to be rendered class- and expertise- specific.[34] All things and their assemblages certainly carry a

range of highly specific messages, but the despatches carried by these inanimate emissaries can be interpreted in many different ways. As the history of the colonial museum reveals, interpretations are likely to differ on the part of curatorial staff, elite members of associated societies, a range of white viewers, and, in modern times, visitors from indigenous communities. The latter in particular may have a completely different 'take' on things seen in the museum. They may, for example, imbue them with spiritual ancestral forces entirely lost on earlier viewers, just as modern settler descendants may read embarrassing, perhaps guilt-laden, intimations of dispossession, oppression and violence into them – sensations largely lacking from the reactions of their predecessors who were confident in the spread of 'civilisation' and aspects of modernity. But all 'natives', indigenous and white colonial born, may inject into ethnographic materials a sense of the potential for cultural revival and the assertion of identity for the modern state. Interpretations of the reading of museum displays must necessarily be fluid, across social and racial groups and through time. Supposedly 'dead' objects speak back and speak often.

Until the early to mid-twentieth century colonial museums were viewed as extensions of those of the metropole. This is apparent, for example, in the extraordinary survey of museums of the British Empire conducted by Sir Henry Miers and Sydney Markham for the Carnegie Corporation (and in association with Britain's Museums Association) in the 1930s.[35] They and their research associates travelled all over the British Empire preparing comprehensive surveys of the museums and art galleries of the British Isles and overseas dominions and colonies.[36] Their texts indicated that they were quite clear about what museums were for: they were for research, education and inspiration. Museums were indeed seen as treasuries, storehouses, laboratories and colleges.[37] The essence of the museum lay in its didactic purpose, conducted at every level from mature scholarship to schools. They noted some diversity in museum foundations, but viewed them uniformly as a source of national pride. If you took the total population of a territory and divided it by the number of museums, you came up with an index of progress. This procedure offered clues to the degree of civilisation, educational attainment, national pride and even the capacity to survive in a dangerous world. Comparative indices indicated that the USA and Germany were by far the most advanced countries. Some towns and counties in Britain, they noted with alarm, were wholly innocent of museums, as were some islands in the West Indies and other poorer colonial territories. In Rangoon, Burma, the museum had been shut for more than twenty years. Generally, they were obsessed with statistics. They counted collections, staffs, expenditures, visitor numbers and much

else. They listed copious recommendations at the end of each entry. Among imperial surveys, common in this period, this was one of the grandest.[38] Yet its effects were probably minimal. The Second World War intervened. By the 1940s and 1950s the world had moved on and their recommendations seemed old-fashioned and out of touch. Their multiple volumes now offer little more than a few juicy quotations.

Indeed, although the Miers and Markham project lumped metropole and empire together, they spotted little qualitative or ideological differences among them. Yet it has been a curious fact that the British were never particularly interested in the representation of the historical, cultural and social aspects of empire in their own museums, not at least in a formal and explicit way (natural history collections were a different matter). Empire was, in a sense, nowhere in the museums of the dominant power; yet imperial artefacts were everywhere. Metropole was saturated by the periphery. But the actual mechanics of empire, its conquest, its exploitation, its administration, were never formally laid out.[39] Still, the results of conquest, the loot of colonial campaigns and the 'tribute', even the presents to the royal family, were very widely dispersed in Britain. They could be found in the great institutions like the British Museum and the South Kensington or V&A Museum. They also appeared in regional, civic, university and regimental museums, as well as in the collections of learned societies, great country houses or private homes. Some of these were not necessarily open to the public (though they often became so later). Clothing, armour, weapons, above all royal and chiefly regalia, as well as much else from battlefields and conquered societies were widely collected, brought back by officers, troops, explorers, missionaries, administrators and travellers. How these were handled depended on the history and purposes of the respective institutions that harboured them.

Perhaps regimental museums were (and are) the most unblushingly explicit here: colonial campaigns and the perceived record of military heroism (seldom that of indigenous adversaries) have been laid out with an unwavering ideological bent. Ethnographic material, including weaponry and military apparel, is proclaimed as the booty of war. Elsewhere, 'anthropological' artefacts were symbolically separated from the collections of western and ancient art and sculpture. At the V&A, where one of the main purposes was to display craftsmanship from a wide range of sources as a series of object lessons for the instruction of the British in craft values, they were much more likely to be integrated as didactic examples of metalwork, woodwork, ivory craft and much else. But until recent years, the Museum of Mankind in London was separate from the British Museum, exposing the gulf between 'civilisations' and 'cultures', 'art' and 'artefacts'.

There is another distinction associated with the museum: past studies, both in Britain and elsewhere, have tended to concentrate either on natural history or on ethnography. Susan Sheets-Pyenson's pioneering work, *Cathedrals of Science*, focused on the former, while such notable books as those by Annie Coombes and Amiria Henare (among many others) have been concerned with cultural displays.[40] But it is important to bring these two together. The shift from natural history to ethnography constitutes one of the most important aspects of the dynamics of colonial museums.[41] The manner in which the one shaded into the other needs to be understood in order fully to understand museum development. Moreover, both were viewed as joint aspects of nineteenth-century science, for the period was entirely lacking in the notion of the 'two cultures' of science and the arts. In this key era in museum development, science became a location of heroism, scientists constituting new types of intellectual hero. And 'science' applied equally to natural and human sciences. As shown in the following chapters, they were also invariably practised by the same people.

Obviously, an entire book could be written about each of the colonial museums featured here (and in some cases has been), but this is offered as a comparative study, particularly dealing with questions of identity and colonial intellectual development. Scientific and ethnographic studies originally fed metropolitan aspirations and acquisitiveness, but they soon became contributions to globalising studies, which were sometimes marshalled by metropolitan scholars, but in which the so-called periphery developed not only its own autonomy, but also its power to develop metropolitan centres in their own right. What started as colonial auxiliary scholarship associated with museum disciplines developed into significant independent studies often in league with local (and newly founded) universities. This process was well in train by the turn of the twentieth century and often reached its consummation during the years following the First World War. Much more work needs to be done here, and in this book these developments are followed only in relatively superficial ways. Moreover, in following the multiplicity of themes associated with the colonial museum, there is an inevitable tension between information and argument. This is offered as a new and comparative study, developed in the belief that the 'British World' can only be understood by ranging widely over its territories. Hence, the reader requires a good deal of basic empirical material about the history of museums in the territories covered. Much of this information exists in local histories, but it has never before been brought together into a single work.

The histories of colonial museums have often been of the centennial celebratory variety. Few attempts have been made to produce parallel

INTRODUCTION

histories across territories. This book is designed to be both comparative and critical. The individual case studies make it clear that, while the parallels are indeed startling, the imperial museum sector was not a site of rigidly monolithic experience. There was no controlling hand or mind. There were far too many individuals, operating at different levels of expertise, to promote such a centralised or uniform approach. Instead, colonial museums responded differently to their versions of the exotic, to their opportunities to domesticate the alien, and thereby engage in knowledge production and distribution. Still, it is worthwhile pursuing the intriguing comparative characteristics of these museums.

Museums were classically the product of the interests of middle-class males, ranging from professionals to a wealthy upper-middle class, although some women did become involved from an early period. This middle class initially saw itself as the prime users of museums and their opening hours and mode of operation – not to mention the social events which took place within them – were based on that assumption. Thus the early years of museums were not unlike the cabinets of curiosities of the past: they offered privileged and restricted access. The widening of the class base of the visitor profile was happening everywhere by the later nineteenth century, and as museums realised that visitor numbers were crucial to their continued funding, this process was encouraged by curators. Thus the original elite institutions became progressively democratised, ultimately confirmed by the appearance of larger numbers of indigenous people within their walls. As this expansion of the viewing constituency occurred, any attempted answers to the question of what the museum was for inevitably passed through a succession of phases. Was it for research, for the social and intellectual cohesion of its founders, for enlightenment, education, recreational entertainment, identity formation, cultural renewal? All of these will be found to be prominent in different eras.

Extensive as it is, it is important to establish the limits of the study. In particular, although the material here inevitably touches on scientific history, it does not presume to be a contribution to the history of science.[42] Nevertheless, the linking of museum histories to the modern study of the social and intellectual contexts of past science is urgently required. One important theme has to be the influence of Darwin's theory of evolution by natural selection on colonial museums. After the publication of *The Origin of Species* in 1859, this became a central debate, Darwin's ideas being received with varying degrees of enthusiasm in different colonies. As we shall see, the Australian bourgeois elite was highly resistant, although some museum directors in Canada and New Zealand were more receptive. Moreover, the construction of scientific ideas and related authority systems is closely connected

with the demarcation of social class. The relationship of such classes to museums is an important theme without which museum histories cannot be fully understood. If we put indigenous peoples on one side as a suppressed and racialised 'underclass', still we find the class systems of the metropole recreated in more fluid forms in the colony. While issues of class are woven into every chapter, a more nuanced and technical analysis may well be needed. Finally, despite the book's considerable geographical sweep, large areas are left out, including the Caribbean,[43] West[44] and East Africa, Indian Ocean islands and Hong Kong.[45]

Museological theory is largely avoided; the book instead pursues a form of critical narrative in order to build up these colonial histories. In any case, some museum theory does not fit the colonial context. An example would be Bennett's notion of surveillance within the 'exhibitionary' complex, with its roots in Foucault's concerns with the modern state's search for discipline and control through institutional design. For Bennett such surveillance occurs at two levels, both in the architecture of exhibition and museum buildings and also through the organised system of displays, which become a 'self-monitoring system', a means of incorporation into the 'controlling vision of power', a 'model lesson in civics'.[46] In the colonial setting, the need for surveillance and coercive authority arose from the whites' need to dominate indigenous populations. But museums, at least in their early decades, seldom welcomed 'native' peoples, so their contribution to a controlling system lay in collecting and displays, an indirect form of surveillance. Once such indigenous peoples actively 'used' museums in modern times, it was more likely to be as part of cultural liberation rather than suppression, an opportunity to reconnect with their own pasts. In any case, not all museums in colonial territories would comply with the architectural requirements of such a surveillance culture, even if the objective was to control whites rather than blacks and browns. If displays, both natural historical and ethnographic, offered visitors a vision of power, as they certainly did, still the viewers have a tendency to make of displays what they will. Stuffed animals, exotica as much as local fauna, often constituted popular displays and here any sense of participating in versions of power and authority was much more diffused.

Finally, the approach is geographic rather than thematic. Sheets-Pyenson adopted the thematic mode in her chapters on 'Founding and funding', 'leaders and followers' and 'collections' in *Cathedrals of Science*, but here it seemed more appropriate to survey the museums in their territorial contexts. Thus two chapters are devoted to each of Canada, South Africa, Australia, New Zealand, with a final one examining the developments in Asia – intended to draw out the contrasts with settler territories. The standard procedure is to consider two or

INTRODUCTION

three museums in greater detail in each country while alluding to the existence and development of others. In the case of the Asian chapter, the coverage is wider and less detailed with only the National Museum of Singapore examined in some depth. The principal criterion for inclusion is an early history in the nineteenth century, thus representing the arrival of the museum idea in each territory. Art galleries, which were also seen as emblematic of the progress of the colony, are not considered, although reference to them is inevitable, particularly as their foundation was often influenced by the same middle-class elite groups.[47] Through its range, this book is consequently intended to be a contribution to a reinvigorated imperial (as opposed to national) history, using museums as a means of studying the cultural characteristics of the 'British World'.

Notes

1. Lawrence Keppie, *William Hunter and the Hunterian Museum in Glasgow 1807–2007* (Edinburgh 2007) provides an account of the origins of the Hunterian Museum in London and its move to Glasgow.
2. For municipal and other museums, see Kate Hill, *Culture and Class in English Public Museums 1850–1914* (Aldershot 2005) and articles in John M.A. Thompson, *Manual of Curatorship: a Guide to Museum Practice* (London 1984). See also Kenneth Hudson, *Museums of Influence* (Cambridge 1987) and Edward P. Alexander, *Museums in Motion: an Introduction to the History and Functions of Museums* (Nashville, Tenn. 1979). These are European and American in focus.
3. William Whewell, 'The General Bearing of the Great Exhibition on the Progress of Art and Science', in W. Whewell et al., *Lectures on the Results of the Great Exhibition of 1851* (London 1852), p. 14, quoted in Kaori Nagai, *Empire of Analogies: Kipling, India and Ireland* (Cork 2006), p. 74.
4. Phrases from Paul Greenhalgh, *Ephemeral Vistas: the Expositions Universelles, Great Exhibitions and World Fairs, 1851–1939* (Manchester 1988), p. 20 and William Beinart and Lotte Hughes, *Environment and Empire* (Oxford 2007), p. 224.
5. The relationship between exhibitions and museums is examined in Paul Greenhalgh, 'Education, Entertainment and Politics: Lessons from the Great International Exhibitions' in Peter Vergo (ed.), *The New Museology* (London 1991), pp. 74–98.
6. Clark Blaise, *Time Lord: Sir Sandford Fleming and the Creation of Standard Time* (London 2000), p. 112.
7. John M. MacKenzie, *The Empire of Nature: Hunting, Conservation and British Imperialism* (Manchester 1988); Greg Gillespie, *Hunting for Empire: Narratives of Sport in Rupert's Land, 1840–70* (Vancouver 2007).
8. They also invariably collected ethnographic artefacts.
9. Gillespie, *Hunting for Empire*, p. 42.
10. Julie Evans, Patricia Grimshaw, David Philips and Shirlee Swain, *Equal Subjects, Unequal Rights: Indigenous Peoples in British Settler Colonies 1830s–1910* (Manchester 2003); Diane Kirkby and Catherine Coleborne (eds), *Law, History, Colonialism: the Reach of Empire* (Manchester 2001).
11. Steve C. Dubin, *Transforming Museums: Mounting Queen Victoria in a Democratic South Africa* (Basingstoke 2006).
12. Elizabeth Edwards, 'Negotiating Spaces: Some Photographic Incidents in the Western Pacific, 1883–84', in Joan M. Schwartz and James R. Ryan (eds), *Picturing Place: Photography and the Geographical Imagination* (London 2003), pp. 261–80, particularly p. 261.

13 David Murray, *Museums: their History and their Use* (Glasgow 1904), three volumes, is an early survey.
14 The 'Tardis' is the time-travelling machine, larger inside than outside, in the long-running British television science-fiction series 'Doctor Who'.
15 Michaela Giebelhausen (ed.), *The Architecture of the Museum: Symbolic Structures, Urban Contexts* (Manchester 2003); Carla Yanni, *Nature's Museums: Victorian Science and the Architecture of Display* (New York 2005).
16 Stuart Davies, *By the Gains of Industry: Birmingham Museums and Art Gallery 1885–1985* (Birmingham 1985) reveals a museum and gallery service in an industrial setting, including the acquisition of a major collection of Pacific ethnography.
17 Daniel R. Headrick, *The Tools of Empire: Technology and European Imperialism in the Nineteenth Century* (Oxford 1981); Headrick, *The Invisible Weapon: Telecommunications and International Politics* (Oxford 1991). Headrick concentrates on undersea cables as part of his international theme and devotes little attention to the cultural, social and political effects of cables in specific territories.
18 Michael Adas, *Machines as the Measure of Men: Science, Technology and Ideologies of Western Dominance* (Ithaca 1989).
19 Thomas Richards, *The Imperial Archive: Knowledge and the Fantasy of Empire* (London 1993).
20 Eilean Hooper-Greenhill, *Museums and the Shaping of Knowledge* (London and New York 1992) deals with Europe, but some of her analyses can be applied to colonial museums.
21 Benedict Anderson, 'Census, Map, Museum', in *Imagined Communities* (London and New York, revised edition 1991, first published 1983), pp. 184–5.
22 An imagined community can be identified in Scotland well ahead of the eighteenth century.
23 Tim Barringer, 'The South Kensington Museum and the colonial project', in Tim Barringer and Tom Flynn (eds), *Colonialism and the Object: Empire, Material Culture and the Museum* (London 1998), p. 17. This book undermines postcolonial scholarship respecting the museum by offering examples of hybridities and cultural dialogues undermining binary and hegemonic discourse.
24 Ibid., p. 185.
25 Marjorie Caygill and John Cherry (eds), *A.W. Franks: Nineteenth-Century Collecting and the British Museum* (London 1997) examines one individual's collecting in aesthetic and quantitative ways.
26 Some of this museum commerce, though never explicitly analysed in respect of its dimensions and 'terms' of trade, can be discerned in Barringer and Flynn (eds), *Colonialism and the Object*.
27 Enid Schildkraut and Curtis A. Keim (eds), *The Scramble for Art in Central Africa* (Cambridge 1998); Markus Schindlbeck, 'The Art of the Head-Hunters: Collecting Activity and Recruitment in New Guinea at the Beginning of the Twentieth Century', in Hermann J. Hiery and John M. MacKenzie (eds), *European Impact and Pacific Influence: British and German Colonial Policy in the Pacific Islands and the Indigenous Response* (London 1997), pp. 31–43; Zachary Kingdon and Dmitri van den Bersselaar, 'Collecting Empire? African Objects, West African Trade, and a Liverpool Museum', in Sheryllynne Haggerty, Anthony Webster and Nicholas J. White (eds), *The Empire in One City? Liverpool's Inconvenient Imperial Past* (Manchester 2008), pp. 100–22. Hill, *Culture and Class* touches on anthropological collecting.
28 Rachel Gotlieb, '"Vitality" in British Art Pottery and Studio Pottery', *Apollo* 127 (1988), pp. 163–7, quoted in Craig Clunas, 'China in Britain: the Imperial Collections', in Barringer and Flynn (eds), *Colonialism and the Object*, p. 47.
29 Frank Spencer, 'Some Notes on the Attempt to Apply Photography to Anthropometry during the Second Half of the Nineteenth Century', in Elizabeth Edwards (ed.), *Anthropology and Photography 1860–1920* (New Haven 1992), pp. 99–107.
30 Asa Briggs, *Victorian Things* (London 1988); Thomas Richards, *The Commodity*

Culture of Victorian England (Stanford 1990); Chris Gosden and Chantal Knowles, *Collecting Colonialism: Material Culture and Colonial Change* (Oxford 2001); Arjun Appadurai (ed.), *The Social Life of Things: Commodities in Cultural Perspective* (Cambridge 1986); Susan M. Pearce, *On Collecting: an Investigation into Collecting in the European Tradition* (London 1995); and George W. Stocking (ed.), *Objects and Others: Essays on Museums and Material Culture* (Madison, WI, 1985).

31 Barringer and Flynn (eds), *Colonialism and the Object*, p. 6.
32 Edwards (ed.), *Anthropology and Photography*; Paul S. Landau and Deborah D. Kaspin (eds), *Images and Empires: Visuality in Colonial and Postcolonial Africa* (Berkeley 2002); Eleanour M. Hight and Gary D. Sampson (eds), *Colonialist Photography: Imag(in)ing Race and Place* (London 2002); Joan M. Schwartz and James R. Ryan (eds), *Picturing Place: Photography and the Geographical Imagination* (London 2003).
33 Christopher Pinney, 'The Parallel Histories of Anthropology and Photography', in Edwards, *Anthropology and Photography*, pp. 74–95.
34 Tony Bennett, *The Birth of the Museum* (London, 1995), p. 35.
35 Miers (b. 1858), crystallographer and mineralogist at the British Museum (BM), 1882–95; after holding a chair at Oxford, he was principal of London University and vice-chancellor of Manchester. He was also president of the Museums Association and a trustee of the BM. Markham (1897–1975, knighted in 1953) was secretary of the Museums Association and a Member of Parliament in both Labour and Conservative parties; Chairman of the parliamentary science committee, 1938–41, he led many parliamentary delegations around the Commonwealth in the 1960s.
36 These volumes, divided into directories and reports, and bound in various formats, include: Sir Henry Miers and S.F. Markham, *A Report on the Museums and Galleries of British Africa* (Edinburgh 1932); Miers and Markham, *A Report on the Museums of Canada*; (London 1932); Miers and Markham, *Directory of the Museums and Art Galleries in Canada, Newfoundland, Bermuda, British West Indies, British Guiana and the Falkland Islands* (London 1932); Markham and H.C. Richards, *A Report on the Museums and Art Galleries of Australia* (London 1933); Markham and Richards, *Directory of Museums and Art Galleries in Australia and New Zealand* (London 1934); F.A. Bather and T. Sheppard, *Report on the Museums of the British West Indies* (London 1933); Charles Squire and D.W. Herdman, *A Report on the Museums of Malta, Cyprus and Gibraltar* (London 1934); also the Museums Association, *Directory of Museums in Ceylon, British Malaya, Hong Kong, Sarawak, British North Borneo, Fiji, the West Indies, British Guiana* (London 1934); Markham and H. Hargreaves, *Report on the Museums of India* (London 1936); S.F. Markham, *Report on the Museums and Art Galleries of the British Isles* (Edinburgh 1938); a directory of British museums and art galleries followed in 1948.
37 This paraphrases John Ruskin's characterisation of the objectives of the museum.
38 For example, Lord Hailey, *African Survey* (Oxford 1938, 1956); Hailey, *Native Administration of the British African Territories* (London 1950–53).
39 In the Netherlands empire is confronted in the Rijksmuseum and the Maritime Museum in Amsterdam, the Vereenigde Ostindische Companie- (VOC) related museums in Enkhuizen and Hoorn; in Belgium, see the Royal Museum of Central Africa at Tervuren.
40 Susan Sheets-Pyenson, *Cathedrals of Science: the Development of Colonial Natural History Museums during the late Nineteenth Century* (Kingston 1988); Annie E. Coombes, *Reinventing Africa: Museums, Material Culture and Popular Imagination* (New Haven 1994); Amiria J.M. Henare, *Museums, Anthropology and Imperial Exchange* (Cambridge 2005).
41 For a metropolitan perspective, see Lynn Barber, *The Heyday of Natural History* (London 1980), and for modern concerns, Mary Bouquet (ed.), *Academic Anthropology and the Museum* (New York 2001).
42 See George Basalla's 'diffusionist' concept of colonial science, 'The Spread of Western Science', *Science* 156 (1967), pp. 611–22 and Roy MacLeod's colonial-centred model,

'On Visiting the "Moving Metropolis": Reflections on the Architecture of Imperial Science', *Historical Records of Australian Science*, 5 (1982), pp. 1–16. Also contributions to Benedikt Stuchtey (ed.), *Science across the European Empires 1800–1950* (Oxford 2005) and Helen Tilley with Robert J. Gordon (eds), *Ordering Africa: Anthropology, European Imperialism and the politics of knowledge* (Manchester 2007).

43 Among notable museums in the Caribbean region, see the National Museum of Guyana, founded in 1868 and developed by such celebrated figures as Robert Schomburgk and Everard im Thurn.

44 Claude Daniel Ardouin and Emmanuel Arinze (eds), *Museums and History in West Africa* (London 2000). Other comparative material can be found in *Outremers*, 95 (356–7), Dossier thématique, sous la direction de Sophie Dulucq et Colette Zyenicki, 'La Colonisation Culturelle dans l'empire Français entre visées éducatives et projets muséographiques (XIXe–XXe Siècles)'.

45 Museums in Hong Kong were a relatively recent development.

46 Tony Bennett, *Birth of the Museum*, pp. 63–9. For critiques see Andrea Witcomb, *Re-Imagining the Museum: Beyond the Mausoleum* (London 2003), pp. 15–19, and Hill, *Culture and Class*, p. 93.

47 Timothy Barringer, Geoff Quilley and Douglas Fordham (eds), *Art and the British Empire* (Manchester 2007) contains nothing on colonial art galleries and art education in imperial territories. Such a study would be valuable.

CHAPTER TWO

Canada: the origins of colonial museums

Introduction

Museums in Canada have a longer, though somewhat chequered, history than elsewhere in the British Empire. It may have been something of a false start, but they initially emerged from Catholic religious and educational contexts in Quebec. By the nineteenth century, the centre of gravity had moved into the Maritime Provinces, into the realms of auto-didacticism, 'rational recreation' and learning by the 'object lesson' method. This was maintained through the progression from school to college and university education. When museums emerged in Ontario they were firmly connected with these educational developments, public admission being almost secondary to the prime demonstration purposes of such collections. By the end of the century, the principle of the provincial museum was established, but in the early twentieth something dramatically new occurred. A group of individuals in Toronto, many of them involved in the reorganisation of the university in that city, conceived immensely ambitious plans to found a museum, which would vie with the burgeoning institutions of New York, Chicago, Washington and elsewhere. The province of Ontario would be too small a canvas for such a project. While a separate provincial museum survived until 1933, the new one would aspire to something grander. Though not national in name (this status would be preserved for institutions in Ottawa), it would be international in scope. This was symbolised in the choice of 'Royal Ontario Museum' as its title: although this was a North American museum struggling to assert itself against its exemplars to the south, the 'Royal' implied imperial scale, transnational affiliations not enjoyed by the implications of the double meaning of 'provincial'.[1] Indeed, by the time of the Miers and Markham survey, it had become 'the largest and richest of all Canadian museums', if not in the Commonwealth.[2]

Apart from the collection of religious relics in Quebec, all the early museums were concerned with forms of natural history. These soon incorporated the new disciplines of the age. Almost everywhere in Canada, as elsewhere in the British Empire, the study and collection of natural phenomena led to an awareness of the artefacts of humans within nature, in other words to archaeology and then ethnography. This was not some kind of tectonic shift: it was a seamless process in which one discipline emerged from another. Thus geology opened up palaeontology and then the record of early humans within geological contexts.

Charles Lyell's studies had themselves passed through this very progression.[3] In colonies, evidence of early men and women led naturally into the ethnographic studies of the recent past and the present, not least because their artefacts, economies and belief systems were themselves seen as atavistic forms, many of them reflecting a much earlier stage of development in Europe itself. And this, in turn, led into concerns with 'world civilisation'. Given the organisational methods of the time, collecting weapons of warfare or the hunt, ceramics and metalwork, utensils and religious objects, as well as the artistic forms that infused and 'spiritualised' them could be indulged on a global scale, allegedly illustrating a mix of functional, aesthetic and later evolutionary ideas. These more local interests expanded into comparative studies of 'civilisations' in both deep and more recent time. And what is striking about all of this is the manner in which it produced collecting passions, an almost manic search for the unattainable consummation – the 'complete set' concept, which infuses all collecting pathologies. This was a psychological condition which gripped certain individuals in Toronto in the first few decades of the twentieth century.

Carl Berger once remarked that, 'Natural history was born of wonder and nurtured by greed'.[4] It is a memorable soundbite, but it has its problems. One person's greed is obviously another person's enterprise. While individual fortunes were indeed made through the processes of natural extraction and exploitation, these were also the motive forces behind the economic development of colonies, the pulling in of migrants, the expansion of urbanisation and the provision of infrastructure, and not least the spread of new scientific discourses around the world. 'Greed' is most evident in the industrial and social relations, and by extension in the interactions of incoming and indigenous peoples, promoted by developmental capitalist systems. If enterprise was the motor of modernism and at times scientific investigation, greed was the concomitant of contemporary forms of dispossession, of (generally immigrant) labour and (usually indigenous) land. Moreover, among the settler harbingers of a new world system it would be quite wrong

to see 'wonder' and 'greed' in opposition. Those who wondered at the diversity and potential productivity of nature were usually very happy to justify their interests in terms of the economic 'benefits' that could flow from their studies. Thus natural science, in feeding an inquisitive mental frontier served to open up the acquisitive geographical frontier of the continent. Intellectual speculation was the forerunner of the financial, often pursued by the same people.

Museums were very much part of this entwining of the wonderful and the fruitful, the remarkable and the profitable. The founding of museums was also emblematic of the colonial development of the largely white bourgeois public sphere, which was a worldwide phenomenon of the period. These activities were generally, but not exclusively, the pursuits of a moderately leisured class, a class now fascinated by newly emerging concepts of time and distance, by notions of standardisation and conquest. They were thinking in terms of the 'time travel' of geology, palaeontology and archaeology as well as of the 'space travel' of increasingly convenient continental and intercontinental travel. The museum helped to satisfy both urges. And as this bourgeois sphere grew, the differentials and hierarchies within it expanded. By 1900, financial institutions and the enterprises that they nurtured were producing a class which, in modern terminology, could be identified as seriously, if not yet superlatively, rich.

Just as wealth and power in the European past had led to yearnings for immortality through the creation of religious foundations and the comfort of perpetual prayers, so did the members of a new moneyed class seek to carve out for themselves a cultural or charitable space in the regard of posterity. Fortunes, sometimes secured in infamy, are often invested to satisfy hankerings for fame. Moreover, the possessors of such fortunes were notably successful in this period in co-opting state finance to these objectives. Of course it is hard to disentangle the complex of urges that feed into the joint ambitions of entrepreneurs and politicians (sometimes one and the same): passionate private collecting projected into the public sphere; patriotic urges concerned with the international profile of province or dominion; desire for the enhancement of public education and culture that may or may not feed into concerns with averting social discontents; philanthropic motives bound up with the notion of offering others the advantages secured by oneself; the pursuit of scientific objectives; even confirmation of religious or scientific beliefs, racial notions or proofs of the norms of civilisation. What we can say is that this very powerful set of motivations seems often to have led to a conviction that ends justified means, that the great collection aspired to such a moral status that shady modes of collecting could be subsumed within its ethical cosmos. Of

course, succeeding generations may well approach such collections in wholly different ways, grateful for their existence if uneasy about their provenance.

There were also architectural and communications dimensions to this. The wealthy invariably combined grand town houses with major country residences, which had to be filled with something more than just decorative schemes, furniture and carpets. Books, works of art, antiquities and ethnographic items (less so the latter) became crucial emblems of status. They were, of course, partly the product of genuine interests, but they were also space fillers, markers of taste and discrimination to be shown off to distinguished and influential guests. Continuous processes of transfer fed this filling of private and later public space. And these 'fillers' often reflected specific tastes, sometimes embedded in the fashion of the period, and sometimes illustrating a certain amount of conservatism. Moreover, such transfers between town and country, between city and city, between Canada and the USA, and between Ontario and Europe, the Middle East and China were greatly facilitated by the rapid spread of railway lines (often revealing abundant palaeontological or archaeological remains), telegraphs, cables and shipping services. By 1900, such terrestrial movement by trains and vessels was not much slower than it is today. This had a dramatic effect on the ease and international character of the collecting process.

The emergence of the Royal Ontario Museum (ROM) reflects all these social, economic and normative phenomena. In analysing them (Chapter Three), we should, however, remember that it was brought into being in a highly competitive environment, one in which objectives could only be achieved against the backdrop of aggressive collecting by American institutions and individuals, as well as private collectors and museums elsewhere in the world. The collecting passion can take both spectatorial and secret forms, fuelled by both exhibitionary and hoarding ambitions. The origins of the ROM can only be understood in terms of the worldwide acquisitive lusts of the age, and also in the different legislative and moral codes of the time. These were sometimes, if rarely, questioned by contemporaries. The modern museum faces a real dilemma, often reflected in its publications, between celebrating the fact that a magnificent assemblage exists for the edification of a national and international public while noting the sometimes dubious means whereby it was brought together, between seeing the founding figures of its past as heroic characters or flawed personalities.

On the other side of the continent, in British Columbia, competitive struggle was also a key part of the picture by the end of the nineteenth century. However, there the shift from the natural environment to ethnography was much more pronounced and concerns with world

cultures were less significant. This was partly because the bourgeois sphere remained a predominantly intellectual one, inhabited by educationalists, doctors, ethnographers and essentially amateur figures. The business community had not developed to anything like the extent that it had in the East. Two other factors influenced the museological morphology of the province. The first was the fact that it was so much more cut off from Europe. Museum curators, collectors and donors in Toronto were able to reach Europe, and consequently its dealers and auction houses, relatively quickly. On the other hand, despite the existence of the transcontinental railway, their equivalents in the West would find it more difficult to respond to an auction catalogue or a dealer's cabled summons, even if they had the money. Secondly, the culture of North-West Coast Indians or First Nations peoples was strikingly visual, often grand in scale, and infused with artistic values, craft expertise and spiritual tales (themselves firmly rooted in the environment), which inspired considerable admiration. Subject to material and demographic changes that were deeply embedded in colonial social and economic change, these peoples discovered that their artefacts were in great demand in American museums. Collectors in British Columbia (BC) eventually responded to a wake-up call that if they did not react to the scramble for West Coast art and artefact initiated by avaricious Americans (and museums in Europe and elsewhere) there would be nothing left to collect. The provincial museum in BC was stimulated by such defensive reactions and propelled by a provincial patriotism that sought to preserve the cultures of its indigenous peoples. This was, however, a thrust that was very much of its age, rooted in Darwinian and racial assumptions. This chapter examines the early and often tentative beginnings of Canadian museums while the next surveys the emergence of the modern, and rather different, museums in Toronto and Victoria.

Origins

There may well have been cabinets of curiosities, and sometimes collections of relics, in the religious houses and seminaries of Quebec from the seventeenth century, bringing medieval and Renaissance practice together. Quebec City had a Musée de Seminaire from as early as the 1690s. By the eighteenth century priest educators were probably putting together rudimentary natural history collections for use in teaching, which would have been more theological than scientific. Later, the Presbyterian Rev. Thomas McCulloch (1776–1843) created just such a collection (entomology and ornithology seem to have been his principal interests) when founding his grammar school in Pictou, Nova Scotia

(NS), in 1811 in what was predominantly a Scottish community.[5] This practice spread to other schools in the province. McCulloch's ornithological collection seems to have been sufficiently notable that he was able to sell it in London, using the celebrated J.J. Audubon as his agent. He also sent a collection of Nova Scotian insects to Glasgow University (where he had graduated in 1792) and secured an honorary doctorate for himself. He later sent a similar collection to Edinburgh.

But the idea of the museum received its greatest fillip from the spread of mechanics' institutes. Dr George Birkbeck had founded the first of these in Glasgow in 1823 and similar institutions sprang up in NS a few years later. Newspapers argued for the founding of mechanics' institutes in the late 1820s and the scheme came to fruition in Halifax in 1831. They then rapidly appeared elsewhere in NS, as well as in New Brunswick and Newfoundland. Libraries and museums were integral to such notions of self-improvement, and were generally mentioned in their published objectives, although lists of acquisitions give them the air of being modern cabinets of curiosities. Their practical purpose was also illustrated by the fact that they often contained electrical apparatus as well as chemical and other 'machinery'. In Halifax, the museum was soon accommodated on the Dalhousie college campus and it even enjoyed, for a period, a modest government grant. The mechanics' institutes (which had in reality seldom appealed to the working classes) kept the museum flame alive until they went into decline – with the expansion of more formal education – in the 1870s.[6] One way in which they did this was to hold annual exhibitions on their premises – small local versions of the great expositions of the nineteenth century.

There were several other motors for museum creation in this period. The first represented the interests of the private individual, creating either semi-formal collections or the showman spectacle (though the dividing line is indistinct). The second was intellectual societies symbolising the development of a professional bourgeois class in the principal centres, the third, the emergent geological surveys, and the fourth, the educational concerns of incipient colleges and universities. An example of the first was the museum of Dr Abraham Gesner, a physician from NS with a considerable interest in geology.[7] In 1838 he was appointed provincial geologist in New Brunswick and sought to open his collection of geological specimens, together with some fossils, natural history materials (birds, reptiles and fish) and some ethnographic artefacts, as a museum. The province refused to have anything to do with this, so he turned to the mechanics' institute in Saint John, where Gesner's Museum duly opened in 1842. Receiving no financial encouragement from the province, as museum owner or geologist, he returned to NS in 1843, selling the collection to the mechanics'

institute (with the help of loans from two local judges). In the same year, he offered complete sets of the minerals of NS, containing sixty specimens, for sale at £6 each.

An early example of a showman's museum was founded by an Italian in Montreal in 1824, swiftly followed by one opened in Quebec City by a 'sculptor and gilder', Pierre Chasseur, in 1826. In 1836, his collection was bought by the provincial administration of Quebec, thus becoming the first in public ownership. It was, however, comprehensively destroyed by fire in 1854. Given the fact that so many Canadian buildings were wooden, fire was a major hazard for many of the early museums. Even more substantial buildings were not immune.[8] William Wood established the 'York Museum' (York, from 1834 Toronto) between 1826 and 1832. But perhaps the most notable of these proprietorial museums was that of Thomas Barnett, founded in Kingston before 1827 but moved to Niagara Falls to capitalise on the tourist trade in the same year. Although Barnett died in 1877, his reputedly popular museum survived until 1899. It apparently contained specimens of natural history, cultural and archaeological materials, and even Egyptian mummies.

Official encouragement was, however, given to early scientific endeavour. Lieutenant Governor Simcoe, who was a correspondent of Sir Joseph Banks and had an interest in systematic agriculture, was the patron of an early scientific society in Newark (Niagara) as early as 1791. Little is known of this shadowy body and it probably did not survive long. In 1824, the Governor, Lord Dalhousie, encouraged the establishment of a Literary and Historical Society of Quebec, initially with the objective of preserving historical records, but soon concerning itself with geological and botanical subjects. This was followed by a Natural History Society founded in Montreal in 1827. Both of these created cabinets of specimens, the latter surviving into the twentieth century. Berger has specifically linked these societies to the powerful Anglo-Scottish elite in Lower Canada, infused with evangelical Protestant convictions, which emphasised constructive recreation filling every hour with rational pursuits. The observation of the natural world seemed particularly well adapted to such worthy objects.[9]

Thus the phenomenon of the proliferation of natural history societies in Britain was disseminated throughout the Empire.[10] Such societies advanced their purposes by collecting and such collections often formed the basis of the local museum.[11] Throughout Britain and the Empire, natural history became the accepted pastime of the gentleman.[12] In Quebec, the commercial class together with medical doctors, clergymen, college lecturers and teachers formed a social alliance in honouring the respectability of these pursuits. But these

developments of the 1820s were fragile. By the 1840s the initial energy was already being dissipated, although a revival soon took place. In 1851 the Canadian Institute was incorporated in Toronto, and it was to be important in the founding of the Ontario Provincial Museum. The Montreal Society was revived and similar societies were formed in NS (1862), Hamilton, Ontario (1857), New Brunswick and Ottawa (both 1863). By 1890 these concerns had spread to British Columbia with the founding of the Natural History Society there. All became bound up with early museums.

The point about these societies was that they saw their functions in terms of an expanding set of concentric circles of interests. At the start, as in the British counties, their members were concerned with the natural history of their own localities. Here was an opportunity for original research on the botany, geology, mineralogy, ornithology, entomology and zoology of each locale. This was a notable objective for men (and later some women) who combined colonial practicality, with its attendant economic motivations, with a sense of slotting into a worldwide tradition of gentlemanly science. The members of this bourgeois sphere consolidated their influence and sense of self-respect through widening networks of articles, exchanges and correspondence. Hence localities were connected to wider regions, to provincial and ultimately national or even continental contexts, all to be set into descriptive and taxonomic listings on a global scale. Such research was originally fitted into ideas of natural theology, even as notions of the great antiquity of the world, and what we would now call its biodiversity, were being dimly perceived before being overtaken by the much more comprehensive theories of Lyell and Darwin.

Gone were the days when the Yorkshire Quaker, Charles Fothergill (1782–1840), could optimistically arrive in Upper Canada with the ambition of creating descriptive listings of the natural phenomena of the British Empire.[13] Fothergill seemed doomed to pursue hopeless objectives. Having published his first work of ornithology at the age of seventeen, he went on to attempt to embrace the natural history of Britain in one vast multi-volume study (which was never published). He arrived in Canada in 1816 determined to pursue the study of North American natural history. He was government printer for a period and published a column of nature notes in an official publication, attempting to bring a new and more popular print culture to the service of the natural sciences. Fothergill had other impossible dreams. He was instrumental in the founding of the Literary and Philosophical Society of Upper Canada in Toronto in 1831 (neither the York Literary Society of 1820 nor the Natural History Society of 1830 survived), which included a potential museum in its draft regulations. Typically, Fothergill's ambitions for

this society were far-reaching, no less than a 'lyceum of natural history', a museum, a picture gallery, all with a botanical and zoological gardens attached. None of this happened. His efforts to persuade the city and colonial administration to establish a museum also failed.[14]

His fertile mind proposed a geological survey. But his conviction that nature could be rendered empirically finite was doomed to be overtaken by the realisation of the almost limitless plenitude facing students of nature. The inventory was potentially almost limitless. The amateur dabbling in all areas of natural history had to be superseded by specialists in specific fields. The ill-starred nature of Fothergill's ambitions was somehow symbolised by the fact that all his specimens were lost in a fire soon after his death; and his notes were lost, only to come to light again in the following century. Yet from these tentative beginnings, including the survival of some early collections, local and provincial museums would eventually be created. Fothergill was ahead of the full development of the necessary bourgeois class, the interests of educational and administrative authorities, institutional foundations, and the sophistication of print culture. All of these expanded in the succeeding decades.

Just as Gesner's attempt at creating a geological survey of New Brunswick failed, such surveys were established in Upper and Lower Canada in 1842.[15] The joint Parliament of the two colonies established in 1841 (meeting in turn in Kingston, Toronto and Ottawa) was pressed by the Natural History Society of Montreal (among others) to vote funds for a geological survey (that of Britain had only been founded in 1835). The survey was initially located in Montreal, as a temporary gesture, and a long fight ensued against the fiscal parsimony of the politicians to have it made permanent. It moved to Ottawa (the capital from 1866) in 1888. William Logan (1798–1875 – making him an almost exact contemporary of Lyell) was appointed government geologist, taking a considerable cut in salary from his previous post as manager of a Welsh coal mine.[16] Born in Montreal (of Scottish parents), he was partly educated in Edinburgh, had experience of business in London, coal mines in South Wales, and travel on the European continent. A figure of striking physical energy and noted for his careful compilation of data, he had already impressed geologists with meticulous geological maps of South Wales.

Logan was determined to secure permanent funding for the survey and to this end he adopted two strategies: first, to attract public interest, and second, to pursue practical results in the search for coal and other exploitable minerals. A museum would help with the first, and he resolved to help with the funding from his own pocket.[17] Logan's museum occupied various sites in Montreal, and as early as 1853

he began to advocate the founding of a national museum, originally primarily with an economic purpose, though his own interests soon expanded in the direction of palaeontology, botany and biology. In 1881, and after Logan's death, the Canadian government bought his library and instruments. By then the collections had become 'national', at least informally, and ultimately constituted the basis of the geological, mineralogical and palaeontological sections of the museum established in a dedicated building in Ottawa in 1911. After some vicissitudes associated with the fire in the parliament building in 1916 (when Commons and Senate moved into the museum's accommodation and its departments were scattered), it finally received parliamentary recognition as late as 1927. Archie F. Key wrote that the closing of the national museum complex for five years after 1916 was damaging because it 'occurred at a critical period for Canada's cultural growth'.[18] Meanwhile, Newfoundland (a separate colony and Dominion until 1949) also had a geological survey with its attendant museum, already a significant collection when listed in 1903.

Higher education was a major promoter of museums.[19] Laval University had a geology and mineralogy collection as early as the last decade of the eighteenth century, though a fully fledged university museum only emerged in 1852. A number of seminary and college museums were founded in Quebec. The Peter Redpath Museum building, accommodating long-standing collections, was opened at McGill University in 1882. Among much else, it contained the palaeontology collection of Sir William Dawson, a close friend of Logan. Dawson (1820–99) was an important figure in the development of scientific studies and associated institutions in Canada.[20] Born in Pictou, NS, and educated at Edinburgh University, he was an associate of Charles Lyell in the study of the geology and mineralogy of the Maritime Provinces, creating extensive collections of his own.[21] He was later superintendent of education in NS, principal of McGill and the first president of the Royal Society of Canada (founded in 1882).[22] He published many scientific papers and books, one of them entitled *The Meeting Place of Geology and History* (1894) and *Science, the Ally of Religion* (1896). In the early twentieth century, the Redpath Museum became the recipient of the collections of the Literary and Natural History Society of Montreal. By 1910, the range of this collection was illustrated by the fact that it exhibited archaeological and ethnographic material from the Queen Charlotte Islands (off the coast of British Columbia) as well as material from Egypt and Equatorial West Africa. It thus saw continental and world civilisations as part of its cultural imperative. McGill also founded a medical museum, destroyed by fire in 1907, one of several departmental museums.

CANADA: ORIGINS OF COLONIAL MUSEUMS

Similar developments took place in the Maritimes and Ontario. There was a campus museum at Fredericton, New Brunswick, by 1860. A sequence of colleges was founded in Ontario from which a plurality of museums emerged. This included Queen's College (later University) in Kingston, a Presbyterian foundation of 1841, swiftly followed by Bishop John Strachan's scheme for an Anglican college in Toronto (King's). Strachan (1778–1867) was from Aberdeen, was educated there and arrived in Upper Canada in 1799 to be a headmaster in Ontario schools.[23] He was related by marriage to the wealthy Scots merchant of Montreal, James McGill, and acted as his executor for the bequest founding McGill University.[24] Well versed in higher educational developments, he designed King's to combine, slightly bizarrely, Anglicanism with the educational qualities of St Andrews and Aberdeen universities. After an intense struggle, it became non-denominational in 1849, symbolically renamed University College. This was later followed by other Toronto colleges, such as Victoria (initially at Cobourg, moving to Toronto in 1892), Trinity, Wycliffe and Knox, some constituting the federal University of Toronto, which was reorganised along the lines of the University of London in 1853. Victoria remained independent until the late 1880s.

Appointments to a number of scientific chairs in the 1850s resulted in each college developing demonstrating museums. The models were the Scottish University museums and the King's College Museum in London, founded in 1841. The federal University of Toronto created its museum in a space specifically designed for the purpose in 1860. This contained three departments: Natural History (Biology), Mineralogy and Ethnology – each, in effect, separate museums for the related teaching disciplines. A School of Practical Science (1873, later incorporated into the University) also started a museum. Following the models in Scotland, England and Germany, museums were seen as vital teaching aids, as well as offering prestige and evidence of scientific innovation and status. The specimens in the college museums were, however, damaged or lost by repeated moves. In 1890, a major fire destroyed the museum at the university and only a few items were saved. These museums tended to be dependent on the energies of specific individuals. This led to a lack of continuity and often there was little time or expertise for classification, accessioning and display. The fire stimulated fresh energies: the mineralogy and geology section was restored through the purchase of a large collection of W.F. Ferrier of Ottawa who had worked for the Geological Survey, while Professor Robert Ramsay Wright travelled to Europe to acquire replacements for other losses. The various collections survived to be incorporated into the University Museum and then the ROM. Nor were they always scientific. Knox

and Wycliffe colleges collected cultural materials sent to Canada by missionaries, and from 1892 Victoria College (which opened a geology museum in 1873) began to acquire materials from the Egypt Exploration Fund.

Yet another educational museum was developed in the Normal School. This was the brainchild of the notable Methodist educationalist and superintendent of education,[25] Rev. Egerton Ryerson (1803–82) and it was first opened in a former residence of the governor of Upper Canada (Ontario) in 1847. Based partly on the model of the Glasgow Normal School of 1836, it placed a good deal of emphasis on science in its curriculum (Ryerson had long argued for the importance of scientific and agricultural studies for the future of the colony). It moved to new accommodation, housing both the training college and the administrative offices of the education department, during 1850–51. This building contained an educational depository to display books and apparatus available for schools, expanding into a museum by 1857. In addition to exhibiting materials valuable in teaching arts and sciences, it was also a centre for informal adult education.

Ryerson had started collecting for the museum in 1853 and used a European tour of educational institutions in 1855–56 to develop his ideas. He persuaded the provincial administration to pay for his purchases and the museum enjoyed expenditures far in excess of those paid out for the university collections. Ryerson imbibed the notion that museums and art galleries inspired 'moral refinement', 'order and propriety of conduct' and 'cheerfulness of manners' in labouring classes.[26] His collecting activity was partly designed to have the same effect in Toronto. He became particularly interested in paintings and sculpture (most of them reproductions) as well as armour, specimens and 'apparatus', though his ambition to found a college of art and design was not realised while he held office. He made another collecting trip to Europe in 1867 and the museum came to reflect the contemporary fascination with Assyria when it opened a room containing reproductions of Assyrian frescoes and of the celebrated winged bull, a feature which greatly impressed the Governor General Lord Dufferin and Lady Dufferin when they visited in 1872. This somewhat eccentric collection at the Normal School became the proto-provincial museum, said to be visited by hundreds of people on summer days. Yet it lacked a full-time professional staff and any of the other characteristics of the modern museum. The Normal School Museum also exhibited at local and international exhibitions. Its display at the Philadelphia Centennial Exhibition of 1876 was described as the best educational exhibit there (some of it was purchased by Japan to stimulate Meiji educational reforms). But the cheese-paring Liberal administration, reacting partly

to an economic recession of the 1870s, closed the museum in 1880 (Ryerson had retired in 1876), and many of the scientific and technological collections were dispersed or sold.

International exhibitions were often showcases for early museum collections, the objective being to display the economic resources of new colonies. The Geological Survey sent a collection of minerals, organised by Logan, to the Crystal Palace Exhibition of 1851, where it was highly commended. This encouraged administrations to continue to use exhibitions for promotional purposes. Mechanics' institutes' collections were shown at the New York Exhibition in 1853, where the St John's Museum Society won three prizes (this was another casualty to fire in 1892), the Paris Exposition of 1855 and the London Kensington Exhibition of 1862. The Geological Survey also exhibited at the latter two. Yet all the collections featured in this section were supported by a relatively small population spread over a vast area. In the 1901 census, Canada's population amounted to five and a half million. But Canadian governments were beginning to recognise that such collections could be harnessed to the agricultural and mineralogical potential of both the older colonies and the developing western lands. They might indirectly encourage greater migration.

David Boyle: Elora, the Canadian Institute and the Provincial Museum

If the origins of museums throughout eastern Canada represent a number of different streams, those in Ontario clearly illustrate the educational, didactic, and multi-disciplinary forces which fed into the major development of the ROM. Among these, the emergence of a local museum in Elora some sixty miles (over ninety km) due west of Toronto is highly significant. This museum is inseparably connected with the extraordinary auto-didact David Boyle. Boyle (1842–1911) was a blacksmith and son of a smith who was born in Greenock, Scotland, and emigrated to Canada West (Ontario) in 1856. He was apprenticed to his uncle, a blacksmith in Eden Mills, Wellington County (which had a high proportion of Scots in its population) between 1857 and 1860. His father, John, had been a member of the 'aristocracy of labour' in Britain, having worked in engineering shops in Greenock and a locomotive works in Birkenhead before he emigrated. A Presbyterian with a strong sense of self-improvement, he had been a frequenter of the James Watt Library and the Mechanics' Institute in Greenock. Boyle junior inherited these ambitions for improvement, viewing knowledge, according to his biographer, not only as a source of power but also as a 'key to respectability'.[27] That respectability came at a price: it may

well be that his income in education and museums was lower than his potential earnings as a skilled artisan. At a highly impressionable age, between 1860 and 1864, Boyle came under the influence of the Rev. John MacGregor, a Glasgow graduate and headmaster of Elora grammar school. His reaction was to educate himself sufficiently to secure a teaching certificate. Having worked as a teacher in a small rural school for more than six years, pursuing the child-centred theories of the Swiss educationalist Pestalozzi, he really blossomed once he became principal of the school in Elora in 1871.

Elora was a town on the move, connected by railway to Toronto and generating the classic self-improving institutions of the civic bourgeois sphere. Boyle's ambitions were wider yet: he saw education and learning as catalysts of nation building and creators of a new patriotism. Since his own interests lay in natural science, he was assiduous in developing a scientific as well as a classical curriculum. His field studies of geology and palaeontology soon led to concerns with the archaeology of indigenous peoples (having discovered sites on an uncle's farm as early as the 1860s).[28] He was inevitably involved with the Elora Mechanics' Institute (founded 1857) and its extensive offerings of evening classes in 'mechanics, manufactures, agriculture, horticulture, science, fine and decorative arts, history and travels'.[29] By 1884, this institute had one of the largest libraries of any such body.[30]

The town also boasted a newspaper, the *Elora Observer* (founded 1859) and Boyle contributed many articles. The Elora Natural History Society, of which he was a leading member, perfectly illustrated the Victorian pursuit of 'civic science',[31] with its frequent educational field trips. He consumed the works of Lyell, Darwin and other notable scientists of the day to inform his studies of the geology and palaeontology of Wellington County. A fervent convert to evolutionary theory, he became embroiled in controversies with local clergy who saw his educational activities as undermining religion. Boyle largely won this battle of the 1870s (still being fought in many parts of the USA today),[32] and he later pilloried the clergy in a wildly satirical novel. What is indeed striking is the comparative speed with which Darwinism came to be accepted even in a region where fundamentalist religious views were strong and likely to fight powerful rearguard actions. He next illustrated his convictions in his most remarkable achievement, the founding in 1873 of a museum.

Originally an educational support for his school, this soon became the Elora local museum. It received large numbers of donations from residents as well as gifts and exchanges with others further afield. These included notable scientists such as the palaeontologist Professor Henry A. Nicholson of Toronto, Principal Dawson of McGill and

A.R.C. Murray, the director of the Newfoundland Geological Survey. In 1875, the future National Museum, still in Montreal, was already distributing natural history collections to schools throughout Canada, including one, comprising some 277 specimens of rocks, minerals and fossils, sent to Elora. Boyle was to build on this, adding collections of zoology, palaeontology, archaeology and ethnography. There can be no doubt that Boyle would have subscribed to the assertion of Thomas Greenwood (in 1888) that, 'A Museum and Free Library are as necessary for the moral and mental health of the citizens as good sanitary arrangements, water supply and street lighting. . .'[33] Boyle would have approved of Ryerson's encouragement to school museums, and his insistence that the natural curiosity of boys and young men should be developed to save them 'from many a snare and temptation' and direct their 'tastes and instincts' into 'simple scientific channels'.[34] For Boyle, such bodies had provided him with social advancement, intellectual stimulation, self-reliance and an awareness of a network of international science aided by the imperial webs of the post, the railways, and the mutual support of educational and cultural institutions. But Boyle was far from 'stuffy'. He not only involved himself in Scottish activities such as Burns Night celebrations (he was a great admirer of the egalitarian and humanitarian ethic of Robert Burns), but also in writing humorous stories in Scots under the pseudonym Andrew McSpurtle. Starting in local papers, he moved on to find an outlet in the *Scottish American Journal*.[35] He believed passionately in equal educational opportunity for both sexes, advocated franchise extension, and considered that the election of women to the committees of these self-improving organisations would improve their popularity, a radical position for the time.

Boyle resigned in 1881 and moved to the larger centre of Toronto to enter the world of educational publishing. He was discontented that the textbooks used in schools were taking very little account of their Canadian context. But his efforts to produce a rival set failed when the education department declined to countenance them. He moved on to found a Toronto bookshop, which became, in effect, a centre for the discussion and study of scientific and cultural matters. This was not a good recipe for retail success and it closed in 1888. Throughout this period, he had maintained his interests in fieldwork and local archaeology in Ontario and this became the key to the next stage of his career. Boyle had earlier developed his archaeological interests through reading Daniel Wilson's books on Scottish archaeology and on the antiquity of humankind,[36] linking this to the Danish concept of the triple ages of stone, bronze and iron.[37] Wilson (1816–92, later Sir Daniel), born and educated in Edinburgh, arrived in Toronto in 1853 as professor of history and English literature at University College.[38]

He was later President of the College and, after its reorganisation in 1887, of the University of Toronto. He was a charter member and President (1885) of the Royal Society of Canada. A frequenter of Boyle's bookshop, he encountered there the growing group of *savants* congregating in Toronto. Thus, Boyle was beginning to exchange ideas with far more significant figures than he would have met in Elora. In 1884, he joined the Canadian Institute (later the Royal Canadian Institute), which perfectly illustrated the expansion of the empire of science into Toronto.[39]

A number of architects, engineers and surveyors, including the great railway builder Sandford Fleming (1827–1915)[40] first met to propose the Institute in 1849 and organised meetings during 1850–51. William Logan was its first President. Its original objects had been the 'general advancement of the Physical Sciences, arts and manufactures' and 'particularly those branches of knowledge relating to Surveying, Engineering and Architecture'.[41] The practical character of this was well represented in the manner in which these were described as 'the Arts of opening up the Wilderness and preparing the country for the pursuits of the Agriculturalist' as well as adjusting necessary boundaries, improving and adorning cities and habitations, 'and otherwise smoothing the path of Civilization'.[42] It has been suggested that it was originally dominated by high Tories looking for interests after political reform in the province had ended the supremacy of the 'Family Compact'.[43] By Boyle's day, the Institute had become a much more generalised scientific body, proclaiming itself as open to members representing all shades of religion or politics. Although – like many such societies – its membership fluctuated considerably, it remained vigorous, devoted to the study of most natural sciences, anthropology and archaeology. This was not necessarily a departure from its earlier strictly practical objectives since such studies were similarly seen as offering keys to various forms of development.

The Institute set about the creation of a library and museum (even securing a small government grant for the purpose) and, from 1852, published the *Canadian Journal,* one of a handful of periodicals promoting scientific discourse within the colony.[44] Daniel Wilson became editor of this *Journal* and frequently published articles in it, including some powerful advocacy of archaeological endeavour. The archaeology of indigenous peoples had hardly developed at this time, retarded by deeply ingrained racial ideas that North American 'Indians' lacked any civilisation in the past. Yet, as early as 1871 a paper in the Institute's journal had proposed that its museum should become 'a repository of Canadian archaeological and historical objects'.[45] Daniel Wilson, during his second presidency of the Institute (1878–80) noted that the

Manitoba Historical and Scientific Society had initiated field archaeological expeditions and was amassing a collection of artefacts. Wilson urged that the Toronto body should do the same. A clear convergence was occurring since Boyle, while still in Elora, had been arguing for the founding of a provincial museum from at least 1879. Now the Institute's membership was growing after a period in the doldrums and its finances were in a better state. Soon after he had joined, Boyle donated his large private archaeological collection and duly became the curator of the Institute's museum, determined to specialise in Ontario archaeology. In 1884, the government of Ontario began an annual grant of $1,000 to support it. Still, Boyle did not abandon his geological interests. He planned an Ontario mineral exhibition at the Cincinnati Exposition (1888), as well as a more permanent display at the Imperial Institute in London,[46] and later at the Chicago World's Columbian Exposition (1893).

Boyle continued with his field archaeology and started a project for recording the indigenous rock art of the province. In 1896 a dramatic change took place in the fortunes of the Institute's museum. It had been in overcrowded, poorly housed accommodation while Boyle had received only a minimal salary. The Ontario administration had established a provincial museum in 1895 (on the third floor of the Normal School building) and it was resolved that the Institute's archaeological collections should be added to it. Boyle was appointed curator of the archaeological section and in 1901 became superintendent of the museum. But Ontario had been late on the scene. NS had a provincial museum from 1868; Quebec's Musée de l'Instruction Publique dated from 1881–82; while the BC Provincial Museum had been founded in 1887. Nevertheless, Boyle now had greater financial and professional security. He set about educating himself into the position, visiting museums in Europe in 1900 (mainly in London, Liverpool, Edinburgh, Glasgow and Paris) and in the USA in 1902. He was so impressed by the ethnographic collections in these cities that on his return he sent letters to a variety of institutions and missions soliciting donations.[47] By 1903 he had received enough to open a separate ethnological room, and he established personal connections with missionaries who collected for him. A notable example was the Rev. Joseph Annand, a Protestant missionary in the New Hebrides (now Vanuatu) whom Boyle commissioned to collect specific materials for him.[48] In early 1897, for example, he asked Annand to make an assembly of artefacts illustrating the 'life of the female from infancy to old age', a request which the missionary found difficult to fulfil.[49] Such collecting has been interpreted in various ways, as 'salvaged artefacts' that might disappear (and Vanuatu seems itself to have very little of its ethnographic past left),[50] as spoils

of imperial conquest, intended to illustrate the backwardness of non-Western peoples, and sometimes as objects useful in the propaganda of mission societies, illustrating and authenticating the activities of missionaries in foreign lands.[51] Moreover, missionary collecting could be closely connected with the conversion process, for 'fetishes' were often handed over as symbolic rejects of indigenous religion.

Boyle had thus expanded his interests from Canadian archaeology and ethnography into a global reach. Indeed, he made no bones about the fact that Canada should be viewed as part of a wider imperial network, proposing to an inspector at the Toronto School Board that the word 'we' should always be used when dealing with events in British history.[52] He had constructed his science as an imperial project, so his ethnographic agenda fitted this world view. Moreover, given his scientific predilections, it is hardly surprising that Boyle adopted a social Darwinist approach to these ethnographic displays. Concerned to illustrate cultural evolution across the world he adopted the Pitt-Rivers method in his organisation of the provincial museum, using typological classification rather than a geographical arrangement. But he did not neglect his local vocation: he continued to conduct extensive field research in Ontario and issued annual archaeological reports. He also produced remarkable wax cylinder recordings of speeches, songs and music among First Nations peoples.[53] But despite all his activities, the museum remained ill-funded and ill-staffed, seriously lacking in space until the last years of Boyle's life. By 1908, it was receiving $11,000 per annum, more than double the budget of the last year of Liberal rule in the province in 1905. His own salary had also become much more generous. Boyle died in 1911.

His biographer has described him as the 'most prominent and influential figure in the development of the Ontario archaeological tradition'.[54] He was also a major propagandist for the museum, fighting to prevent the 'wholesale and indiscriminate exportation of antiquities' to foreign and private museums.[55] To survive, he thought a museum must change and grow. He was assiduous in maintaining connections with First Nation peoples, acquiring artefacts for the collection. He was in touch with the chiefs of the Iroquois people and was assisted in his 1898 Archaeological Report on their culture by John Ojijatekha Brant-Sero, a celebrated performer at Indian shows, who was married to an English woman.[56] The flavour of the period is conveyed by the events of Boyle's excavations. He conducted extensive fieldwork down to 1908, when he examined a First Nation graveyard at Queenston Heights, St Catherine's Ontario, which had been raided by curio hunters from both the Canadian and American sides of the border.[57] This was a frequent hazard in such work. His archaeology was inevitably largely descriptive

and unproblematic, remaining somewhat primitive and elementary until an anthropology division was added to the Geological Survey of Canada in 1910. Boyle was succeeded by Rowland Beatty Orr and by 1933 the museum embraced some 50,000 ethnographic artefacts. But, by then, the ROM had become so large and powerful that it was difficult for a provincial museum to survive beside it. Moreover, the museum movers and shakers of Toronto had become much more interested in world rather than indigenous cultures.

The number of Scots and graduates of Scottish universities involved in these early intellectual and museum developments, many linked in Canadian and British networks, tends to confirm the contention that ideas from the Scottish Enlightenment were flowing through these processes of educational, disciplinary and institutional dissemination.[58] The museums of the Scottish universities were significant, as were the Glasgow Normal Schools, civic and mechanics' institutions. As well as the key Scots mentioned above, Henry Alleyne Nicholson (educated at Edinburgh and Göttingen and later professor at St Andrews and Aberdeen) brought much more advanced scientific ideas to Toronto in 1871, as did his successor in 1874, Robert Ramsay Wright, educated in zoology at Edinburgh. Influences were not all one way. Societies, journals, publications and government initiatives like the Geological Survey, fed ideas and information back to Britain. Dawson was important in supplying data on the Maritime Provinces to Charles Lyell. Thus the early emergence of museums in Canada illustrated the interactive character of collecting for the 'inventory disciplines', as well as the rapid extension of scientific discourse throughout the North Atlantic world.

Yet these early museum projects were often precariously tentative. Many more plans were laid than were executed. Even an apparently successful scheme like that of the Normal School failed to outlive the enthusiasm of its founder. What had happened was that museums, certainly in Ontario, had largely failed to make the leap out of the educational domain. Was this because the country suffered from a cultural and scientific anaemia? Was it because Canadians, largely in the business of survival, were doing rather than thinking or reflecting? Or was it just that revenues were so slight that the severely practical with immediate cost benefits won against seemingly idealistic proposals in which the dividends from investment were speculative and long term? Was the bourgeois sphere insufficiently developed? Had the necessary group of scholars and supporters not yet reached critical mass? Or again was it the lack of museum experience and professionalism that tended to stunt growth? Perhaps elements of all of these offer some explanation.

Nevertheless, as we have seen, the flow of scientific red corpuscles was rich and identifiable. Even an amateur and apparent outsider like David Boyle could achieve real success in a provincial town before moving towards a grander stage. Those who were 'doers' often attempted to take their practical studies into a sphere of public exposure where their work could be made available for wider application. Sandford Fleming, for example, not only pursued his interests as naturalist, meteorologist, geologist and engineer on his railway surveys,[59] but was also instrumental in founding the Canadian Institute. Revenues *were* stretched and the scientific and cultural group interested in museums was indeed small, though fruitfully in touch with each other in a tight network. But what is clear is that the groundwork had been laid. The take-off point occurred when facilitated by economic growth, the emergence of a wealthy and interested class, the growth of professionalism, and the opportunities afforded the public by increasing income and leisure time. The catalyst was, perhaps, the development of a patriotic fear of being stunted by a form of archaeological, ethnographic and scientific scramble, a competitive acquisitiveness that would leave its losers culturally and educationally bereft. These were certainly the significant factors in the emergence of the Royal Ontario and Royal British Columbia museums as significant institutions for the twentieth century.

Notes

1 'Royal' was used in some documents at the beginning, not backed by Royal charter, but disappeared from the annual reports in the 1920s. It reappeared in 1930, interestingly when the ROM was about to undergo further dramatic expansion. Annual Reports, ROM Library and Archive.
2 Sir Henry A. Miers and S.F. Markham, *A Report on the Museums of Canada* (Edinburgh 1932), p. 4.
3 Charles Lyell, *The Geological Evidences for the Antiquity of Man* (London 1863). Lyell (1797–1875), born near Kirriemuir, was brought up and educated in England. He later studied the geology of Scotland, particularly the county of Forfar or Angus, and lived on the Lyell estate at Kinnordy.
4 Carl Berger, *Science, God and Nature in Victorian Canada: the 1982 Joanne Goodman Lectures, University of Western Ontario* (Toronto 1983), p. 3.
5 McCulloch was a major religious and educational controversialist. Ordained in the Scottish Secession Church, he arrived in Pictou in 1803. His entry in the *Dictionary of Canadian Biography* (*DCB*) suggests that he was a product of the Scottish Enlightenment's scientific and philosophic innovation, strongly committed to Calvinism and philosophical liberalism with an intellectual appetite for new forms of study, all in the service of religion. In Canada he encountered a Tory and Anglican autocratic grip. His cause was education outside the established church and he fought many battles on its behalf. He founded a tertiary Pictou Academy in 1818, devoted to both classics and sciences, but he failed to secure degree-awarding powers. He intended this academy to train potential ministers, sending them on to Glasgow University. Nevertheless, his public lectures on chemistry (also delivered in Halifax) were popular and his interest in natural history led to his collecting the insects and birds of the region.

6 Dr S.P. May, the superintendent of the educational museum and library in Toronto, conducted a survey in 1880 and discovered that most institutes no longer offered evening courses and that their libraries were increasingly devoted to works of fiction. Gerald Killan, *David Boyle: from Artisan to Archaeologist* (Toronto 1983), p. 47. The institutes were combined with the free library system in 1883 and it was said that no one particularly noticed their passing.
7 Abraham Gesner, *DCB*, vol. IX, 1861–70, online version revised 2 May 2005. Information from the *DCB* was used to supplement material from other sources.
8 This early history of museums is based upon Archie F. Key, *Beyond Four Walls: the Origins and Development of Canadian Museums* (Toronto 1973); J. Lynne Teather, *The Royal Ontario Museum: a Prehistory, 1830–1914* (Toronto 2005); Harold G. Needham, 'The Origins of the Royal Ontario Museum', MA thesis, University of Toronto, 1970; James Roger Hunter, 'The Ontario Provincial Museum, 1896–1933', research paper for the degree of Master of Museum Studies, University of Toronto, 1987; Carl E. Guthe and Grace M. Guthe, *The Canadian Museum Movement* (Canadian Museums Association, 1958); and some chapters in Alvyn Austin and Jamie S. Scott (eds), *Canadian Missionaries, Indigenous Peoples: Representing Religion at Home and Abroad* (Toronto 2005).
9 Berger, *Science, God and Nature*, p. 48.
10 David Elliston Allen, *The Naturalist in Britain, a Social History* (London 1976).
11 An excellent example is the Perthshire Society of Natural Science (founded 1867 – though many were earlier), which formed its own museum (1881), eventually the basis of the Perth Museum and Art Gallery. This institution was praised by the influential sociologist and town planner Patrick Geddes (who came from Perth). Helen Meller, *Patrick Geddes: Social Evolutionist and City Planner* (London 1990), p. 25. See Diarmid A. Finnegan, 'Natural History Societies in Late Victorian Scotland and the Pursuit of Local Civic Science', in *The British Journal for the History of Science*, 38 (2005), pp. 53–72. Interestingly, the Perth Antiquarian Society was founded as early as 1784.
12 A typical instance is the Scot, Sir William Jardine (1800–74): Christine E. Jackson and Peter Davis, *Sir William Jardine: a Life in Natural History* (Leicester 2001). Jardine established a network of worldwide contacts in the pursuit of his collecting.
13 Charles Fothergill, *DCB*, vol. VII, 1836–50.
14 Charles Fothergill, 'Proposed Lyceum of Natural History and the Fine Arts in the City of Toronto, Upper Canada' (Toronto 1836).
15 At this time there were about 450,000 people in Upper Canada (later Ontario) and 700,000 in Lower (Quebec).
16 William Logan, *DCB*, vol. X, 1871–80.
17 Logan donated in turn £800 and later $10,000 for the work of the museum, for the survey and its publications. Before his death, he provided $20,000 as an endowment for a chair in geology at McGill. He became the first Canadian-born FRS (London) in 1851, was knighted in 1856, and received many other honours. His surveys and meticulous maps formed the foundation of Canadian geology. *DCB*.
18 Key, *Beyond Four Walls*, p. 9.
19 A survey of museums for the British Association for the Advancement of Science in 1897 discovered that a quarter of all museums in Canada were attached to educational institutions. Teather, *ROM, a Prehistory*, p. 13.
20 Sir John William Dawson, *DCB*, vol. XII, 1891–1900.
21 Charles Lyell, *Travels in North America, Canada and Nova Scotia with Geological Observations* (two volumes, London, second edition 1855). His tour was undertaken in 1841–42.
22 He was also President of the British Association in 1886 and of the American Association for the Advancement of Science in 1892. Thus he represented an 'Atlantic Triangle' of scientific endeavour.
23 Initially a Presbyterian, Strachan converted to Episcopalianism, crucial in his ascent to power as Bishop and member of the notorious 'Family Compact' which ruled Ontario. *DCB*, vol. IX, 1861–70.

24 James McGill, *DCB*, vol. V, 1801–20.
25 He held this appointment from 1844 to 1876 and is viewed as the architect of the educational system of Ontario, credited with creating high standards of literacy by the 1870s. *DCB*, vol. XI, 1881–90.
26 Quoted in Teather, *ROM: a Prehistory*, p. 82.
27 Killan, *David Boyle*, p. 23. See also *DCB*, vol. XIV, 1911–20.
28 It was also said that he had been captivated by the excavations of Botha and Layard at Khorsabad and Nimrud, which had been received with much enthusiasm throughout Europe. See the obituary of Boyle contained in the Appendix to the 'Annual Archaeological Report of 1911, including 1908-9-10' (Toronto 1911), pp. 7–9.
29 Ibid., p. 43.
30 Ontario had 24 mechanics' institutes in 1851 and 311 later in the century.
31 Finnegan, 'Natural History Societies'.
32 By 2007, no fewer than twenty-four states had legislation banning the teaching of evolution. According to Gallup Polls, the number of Americans believing the truth of Genesis far exceeds those who accept evolution. *The Guardian*, 15 February 2007.
33 Quoted in Teather, *The ROM, a Prehistory*, p. 6.
34 Quoted in Needham, 'Origins of the ROM', p. 77.
35 This had no fewer than 15,000 subscribers across America. Some of this material can be found in the Boyle papers in the ROM archive. Boyle even wrote his own version of Burns's 'Holy Willie's Prayer', the text of which is in the Boyle papers, SC1, box 4.
36 Daniel Wilson, *The Archaeology and Prehistoric Annals of Scotland* (2 volumes, Edinburgh 1851) and *Prehistoric Man: Researches into the Origin of Civilisation in the Old and New Worlds* (Cambridge 1862).
37 Proposed by Christian Jurgensen Thomsen as far back as 1819.
38 Wilson's way of combining these subjects was remembered by one student who wrote that Wilson 'told us much of the Elizabethan Age, and of the Lake School of Poets, with the tendency to slide into Scottish Archaeology'! Quoted in Needham, 'Origins of the ROM', p. 101.
39 The Institut Canadien of Montreal, founded 1844, was both literary and scientific in its interests. Quebec City had a similar society by 1847.
40 Born Kirkcaldy in Fife, educated there, and emigrated to Canada 1845.
41 Fleming's first papers to the Institute in 1850 dealt with the beaches of Lake Ontario and the prospects for harbour development at Toronto. He later used the Institute as a venue for laying out his proposals for the creation of standard time.
42 W. Stewart Wallace (ed.), *The Royal Canadian Institute Centennial Volume 1849–1949* (Toronto 1949), particularly pp. 123–35. See also Clark Blaise, *Time Lord: Sir Sandford Fleming and the Creation of Standard Time* (London 2000), *passim*.
43 Wallace, *RCI Centennial Volume*, p. 123.
44 Another was the *Canadian Naturalist and Geologist*, which was taken over by the Montreal Natural History Society in 1857.
45 Henry Scadding, 'On Museums and Other Classified Collections Temporary or Permanent as Instruments of Education in Natural Science', *Canadian Institute Journal*, 13, 73 (1871), quoted in Needham, 'Origins of the ROM', p. 59.
46 John M. MacKenzie, *Propaganda and Empire* (Manchester 1984), chapter 5.
47 ROM archive, Boyle papers, SC1-5, contain remarkable collections of Boyle's extensive correspondence with individuals and institutions throughout Canada and elsewhere in the world, including letters to and from Australian scholars on Aboriginal societies there. These papers also contain copies of his reports, lectures, articles, as well as photographs, cuttings and other sources. Boyle attempted to secure West Coast ethnographic objects as early as 1897, when he had been rebuffed by the Director of the Ottawa Museum on the grounds that the museum never exchanged or gave away anything. However, he went on to say that he had seen a good collection of 500 items in Victoria priced at $5,000, which he thought too much. George M. Dawson to Boyle, 30 September, 1897. Boyle papers, SC1, Box 1.

48 Arthur Smith, '"Curios" from a Strange Land: the Oceania Collections of the Reverend Joseph Annand', in Austin and Scott (eds), *Canadian Missionaries, Indigenous Peoples*, pp. 262–78.
49 Annand to Boyle, 8 June 1897 in Arthur M. Smith (ed.), *The Collected Letters of the Rev. Dr Joseph and Alice Annand* (Toronto 2005). See also Arthur M. Smith, transcriptions from the Daily Journals of Joseph Annand, Missionary to the New Hebrides 1873–1912 from the originals in the NS Archives, ROM archives and library.
50 Barbara Lawson, 'Collecting Cultures: Canadian Missionaries, Pacific Islanders, and Museums', in Austin and Scott (eds), *Canadian Missionaries*, pp. 235–61, particularly p. 247. Other missionary-collected artefacts went to the Redpath Museum in Montreal and the NS Museum.
51 In addition to the articles in footnotes 39 and 40, see also France Lord, 'The Silent Eloquence of Things: The Missionary Collections of the Society of Jesus in Quebec, 1843–1946', in Austin and Scott (eds), *Canadian Missionaries, Indigenous Peoples*, pp. 205–34.
52 James Hughes, School Inspector, to Boyle, 22 April 1898, Boyle papers, SC1, Box 1.
53 These have been remastered and returned to First Nation cultural centres. Extracts can be heard in the modern ROM First Nations Gallery.
54 Killan, *David Boyle*, pp. 228–9.
55 Nevertheless, a significant collection of artefacts from Alberta, collected by Mr Frances Kirby was turned down by him when offered for sale on the grounds that it was too expensive. The collection passed into the hands of a Chicago dealer, thence to an American collector, who left much of it to the American Museum of Natural History in New York. Arni Brownstone, 'Treasures of the Bloods', *Rotunda*, 38, 2 (winter 2005–6), pp. 22–31.
56 Ibid., pp. 26–7.
57 Appendix to the Annual Archaeological Report 1911, p. 9.
58 Teather, *The ROM: a Prehistory*, p. 42.
59 Blaise, *Time Lord*, p. 82.

CHAPTER THREE

Canada: the Royal Ontario Museum, Toronto and the Royal British Columbia Museum, Victoria

The Royal Ontario Museum

In 1834 the population of Toronto had been no more than about 10,000. By the 1880s, it stood at around 86,000. But by 1911 it had reached 375,000 and the city was on its way to being the largest in Canada, overtaking Montreal as the principal commercial and industrial centre, and with international ambitions to go with it. The strikingly rapid growth in population in the thirty years before the First World War reflected the manner in which the city and its province had become a power house of economic development. Toronto now inevitably developed civic pretensions: large public buildings were erected; parks were laid out; department stores and impressive hotels opened; while the street system was rendered more appropriate to a city of its size and sense of self-importance. What it clearly needed was a museum (and an art gallery) to confirm its status. Yet all it had was the provincial museum, of recent foundation, still occupying the top floor of the main building of the Normal School and starved of funds and staff.

The principal question was what sort of museum would this be? The main influences so far had been educational and intellectual. Toronto museums were the handmaidens of scientific enterprise and public instruction. Boyle had introduced a major interest in archaeology and the Ontarian indigenous past. It might well have been expected that a museum for Ontario and for Toronto's civic pride would have brought together these main streams. After all, early museum professionals would wish to distance any such development from the Barnett Museum at Niagara Falls, which had been looked down upon as nothing but a 'tourist trap'. The question arises how far such a new respectable museum would reflect local history.

A Canadian historical exhibition took place at Victoria College in 1899 and it included displays of First Nations' culture.[1] Dioramas and

'habitat groups' were also shown at the Toronto National Exhibition grounds. However, concerns with the settler past had hardly developed at all. There were some historical societies, including one founded by women, and a few buildings were being treated as 'heritage' structures, all of this partly stimulated by what has been described as 'vehement anti-Americanism'.[2] But the history of whites in Canada, except perhaps the empire loyalists who were perceived as contributing much to the character of the colonies after the American Revolution, apparently evoked little nostalgia of a specifically museological kind. Instead, something very different emerged. That the future Royal Ontario Museum became more interested in world cultures and 'civilisations' was largely the product of one museum maverick, a man who succeeded in charming the new plutocracy and, more significantly, unlocking their wallets and purses.

If David Boyle had been a pioneer, Charles Trick Currelly was a buccaneer. Currelly (1876–1957) was born in Exeter, Huron County, Ontario of an Italian father (whose name may have been 'Anglicised' by an immigration clerk) and an English mother. He has been described as 'the Right Man in the Right Place at the Right Time', though it has to be said that his professionalism was insecure, his credentials doubtful, and his methods highly dubious.[3] Northrop Frye, the distinguished literary critic and Toronto professor, wrote an introduction to Currelly's hugely self-regarding and, at times, disturbing autobiography (its title sets the tone: *I Brought the Ages Home*), suggesting that he was a 'cultural missionary'. 'His converts were Canadians and his gospel was preached by all the world.'[4] Frye went on to say that a huge collection was made by one man, fighting 'myopic politicians and apathetic committees'. Currelly had rendered the civilisations of the Mediterranean world, the Middle East, the Americas, and the Far East 'ours', 'not in the sense of possession, but in the sense of shared experience'.[5] Some might doubt the denial of 'possession'.

Currelly shared with Boyle a fascination for the work of artisans in his home town (which he linked to historic equivalents). While still a boy he visited the museum in the University of Toronto and was particularly enthralled by cases of butterflies and moths as well as two Maori tattooed heads. Later, he was equally fascinated by the Egyptian and other collections at Victoria College. As a student at Toronto, he developed his interests in geology, palaeontology and all forms of natural history. Like so many of his time, he loved shooting and its attendant practice of taxidermy. After a false move as a lay Methodist missionary in Manitoba (he was thrown out of the church as a critic of its theology, though later reinstated), he completed a master's degree at Victoria College (where his exhibitionism was reflected in the fact

that he was said to have wandered about in full Blackfoot First Nation regalia). He then worked his passage to Britain in 1902. In London he visited the BM to have coins identified, using a letter of introduction from James Mavor (1854–1925), the influential Scottish professor of political economy at Toronto.[6] He started buying antiquities in a small way in London and this led to an introduction to the celebrated archaeologist Flinders Petrie. Impressed by Currelly's drafting skills, Petrie invited him to stay at his home and join him in an excavation at the great site of Abydos in Egypt.

By these extraordinary twists his future was decided. He excavated in Egypt for a number of seasons from 1902 and developed a correspondence with Sir Edmund Walker, the father of a university friend. He began collecting for Walker and urged the formation of the Toronto collection. In one such letter, pleading for money, he captured the atmosphere of the time by writing: 'things are simply tumbling out of the mounds – sculpture, paintings on linen, enamels and tools mostly, but other stuff as well'.[7] While we have to make allowance for the different standards and mores of the period, it is, nevertheless, clear that his excavating techniques amounted to little more than treasure-hunting and, judging by the detritus lying around his hut when it in turn was excavated, he was neither particularly tidy in his digging nor careful in his methods.[8] When he was not excavating, he travelled extensively in Crete, mainland Greece, Palestine, Syria, Sinai and elsewhere. He became an assiduous frequenter of dealers in London and other European cities, responding to sale catalogues and chance sightings of objects by buying almost everything he could lay his hands on. He was frequently heavily in debt, but persuaded dealers to part with objects 'on tick'. He was not particularly scrupulous in record-keeping or in the disposal of what he bought. Some he passed on to private collectors (occasionally at a worthwhile profit, which he often turned to further buying); some he kept himself; others went to the museum collection. It is not surprising that after his death, there were problems about alleged loans from his own collection to the ROM.[9]

It is perhaps to be expected that his autobiography is full of strange coincidences, exciting tales and amazing events. At times, the reader is tempted to think that never did a man have a more appropriate middle name. But whatever else one may think, he clearly had striking energy, great charm and a capacity for friendship. At university, his friends included Walker's son and the son of Principal Burwash of Victoria College. As well as Flinders Petrie, he also became friendly with the collector G.A. Farini, the celebrated artist William Holman Hunt, and encountered scholarly luminaries such as Sir William Ridgeway, Sir Arthur Evans and Ernest Gardiner (who worked on Crete). He was an

associate of G.D. Hornblower, a British archaeologist and inspector of antiquities in Egypt: he often stayed at Hornblower's house in Cairo and they travelled together, as far west as Spain. In Toronto he put together a coalition of wealthy and influential individuals who would press for the creation of the kind of museum he envisaged for the city.

The key figure in this group was Sir Edmund Walker. Walker (1848–1924), extravagantly described as a Canadian Medici, supposedly fulfilled the classic myth of the rise from log cabin to riches. Born in Caledonia, Upper Canada, he never received any formal education beyond the age of twelve. Starting work in an uncle's currency house, he joined the Canadian Bank of Commerce in 1868, and was transferred to its New York City office in the early 1880s before rising rapidly up the managerial ranks as general manager (1886), director (1906) and president (1907). Credited with creating a stable Canadian banking system, he came to be known as the pope of the colonial financial system. Long a political Liberal, he changed sides when opposing Wilfrid Laurier's espousal of free trade believing that protectionism had favoured Canadian industry and commerce since the days of Sir John A. Macdonald. This was partly because he did not approve of the fundamental characteristics of the American system. He was a fervent British imperialist and a member (with the political economist James Mavor) of the Round Table movement, believing the Empire to be the 'greatest political and social enterprise in the history of the world'. Although he was seen by many contemporaries as arrogant, domineering and pretentious, running the bank and all his other cultural and economic enterprises as an unsmiling autocrat, he was convinced that society could be civilised through higher education and the fine arts. After the great fire at the University of Toronto in 1890, he set about reorganising its finances for the restoration. This led to influential membership of a Royal Commission to look into the University's reform (1905–6), the chairmanship of its board of governors and later the Chancellorship.[10]

While in New York, Walker had developed an interest in the city's museums and galleries. He had also dabbled in collecting fine art, graduating from etchings to original oils as his income increased. In this his tastes were old-fashioned (he did not approve of more avant garde movements like the French-influenced 'Group of Seven' landscape painters, for example) but he soon filled up his Toronto town mansion and also his country home at Lake Simcoe. He was involved in proposals to found an Art Gallery in Toronto, but under the influence of Currelly turned to collecting antiquities from the Middle East as well as Far Eastern material, particularly Japanese prints. (After his death his impressive collection of such prints went to the ROM.) He

had long been interested in geology and palaeontology, in keeping with the fashion of the age, and would eventually donate a vast collection of fossils to the ROM. While involved in the Royal Commission on the university he became convinced that it needed an impressive museum to establish its full cultural authority (considering it to be the most important institution in Canada after the government itself). It was certainly through his good offices that funds began to be forthcoming for Currelly's collecting activities. There can be no doubt that a key part of his imperialism was Canadian patriotism. He was immensely ambitious for Canada, eager to establish the country as a counterweight to the USA. Creating a great museum, as well as a significant art gallery and a world-class university, were very much part of these ambitions.

Among Currelly's other contacts were Sir Joseph Flavelle (1858–1939), industrialist, railway director and banker. He was chairman of the university's Royal Commission, trustee of the ROM, and also heavily involved with the Toronto General Hospital and, during the First World War, the Imperial Munitions Board. The museum coalition also included Sir Edmund Osler (1845–1924), yet another banker and railway director, who was a federal MP in the Conservative interest from 1896 to 1917;[11] and Sir Robert Mond (1867–1938), the celebrated British chemist and industrialist, who was influential in funding archaeological expeditions to Egypt and Palestine and who, with his father Ludwig, had interests in nickel mines and other works in Canada. Robert Mond's relationship with Currelly is neatly represented by a volume in the ROM archives and library. It is a vast dictionary of Egyptian hieroglyphs (1,356 pages) inscribed in Mond's hand 'a monumental book for a monumental work and a monumental labour'.[12] Whether this refers to Currelly's Egyptian archaeology or to the development of the ROM is not clear, though the date of the present, September 1920, implies that it could indeed be the latter.

One of the most significant members of this group was Sarah Trumbull Warren (1862–1952), the strikingly wealthy widow of Henry Dorman Warren, the president of the Gutta-Percha and Rubber Company. Sarah Warren, an American of Dutch extraction who had arrived in Canada on her marriage in 1887, chaired this company's board after her husband's death in 1909. Given the burgeoning demand for rubber in the period, it was hugely successful. She became one of the most influential people in Ontario, combining membership of the Board of Governors of the ROM with executive positions with the Toronto Art Association, the Royal Canadian Institute, the Patriotic League, the Girl Guides, the National Council for Immigration of Women for Dominion Service, and others. She and her husband were among the party that visited Currelly at Abydos in the winter of 1906–7. It also included Osler and

Charles Cockshutt, the son of a wealthy general merchant, railway promoter, and owner of real estate. Afterwards, Warren's chequebook was almost unfailingly available to fund Currelly's exploits. Inevitably, she had a very grand Toronto mansion and a large staff to support her in her philanthropic and public activities.

This group had wealth, power and influence. Those who had the leisure that allowed them to travel to Egypt demonstrated the convenient modern connection of Canada to the 'old world' by comfortable and fast train and ship.[13] They were all, regardless of origins, imperially minded and ambitious for Canada and its institutions, and they were all imbued with a sense of competitiveness in respect of American equivalents. This was true even of the American Mrs Warren who identified fully with her new country. Currelly had the drive and the charm to be able to manipulate them towards his own ends. He had first visited Walker in 1903 and passed on his infectious collecting fever. In 1906, Walker persuaded the university to appoint Currelly as its official collector, providing him with a salary of $500 and an acquisition fund of a further $500. But he was still playing the field. The visiting Toronto party encountered him in Egypt colouring casts of reliefs of sculptures of Queen Hatshepsut on the expedition to Punt, fulfilling a commission from the Metropolitan Museum in New York (for which his fee was $1,000). They promptly paid for him to prepare another copy for Toronto. They could convert their tourism into patriotic collecting, capitalising on the presence of a Canadian working for the Egypt Exploration Fund. They decided to advance the cause of an Egyptian collection for Toronto.

Currelly was not yet fully committed. He was offered further employment by the Metropolitan Museum, by the hugely wealthy collector John Pierpoint Morgan, and also began to collect for the Royal Scottish Museum (which became very dubious about his activities)[14] and the Fitzwilliam in Cambridge. Toronto responded by doubling his salary and increasing his acquisition fund to $1,500. Moreover, grants now seemed to be forthcoming for the building of a new museum in Toronto and Currelly's ambitions were both explicit and fully formed: he wished to secure an academic appointment in the university and to head the new museum.

The political times were also propitious. The Liberals had dominated the administration of Ontario for some thirty years. In early 1905 the Conservatives under (Sir) James Whitney came to power in the province, dedicated to overturning much of what the Liberals had stood for, including extreme fiscal parsimony. Whitney immediately set about trying to enhance the fortunes of the university (and appointed the Royal Commission for the purpose). He was also more amenable

to supplying cash for the provincial museum at the Normal School and for the ambitious plans for a new museum associated with the university. Walker, Flavelle and Osler all worked on him to achieve the kind of grand civic statement through a museum that had marked out the ambitions and status of British cities such as Birmingham and Glasgow. Toronto should assert itself not only as the capital of Ontario, but also as a world-class city to compare with equivalents in Europe and the USA.

Moreover, Currelly was adept at public propaganda. In 1909 he organised a Toronto exhibition of Egyptian and other antiquities, which achieved celebrity status. People awoke to the fact that he was putting together materials on the scale of collections in London or New York. Premier Whitney and members of his Cabinet had paid a visit. The university professors in the natural and earth sciences realised that they could perhaps swing the building of a grand museum for their collections on Currelly's archaeological coat-tails, as it were.[15] A Bill was put to the Ontario legislature and a promise exacted that the administration would fund half of the costs of the new building, estimated at $400,000. With this came an increase in Currelly's collecting budget. Currelly and the Walker family met in London, frequenting dealers together. Currelly, newly married, spent his honeymoon on a tour of European museums! He and his new wife also travelled up the Nile, joining yet another party from Toronto, and around the Middle East, still collecting and running up considerable debts. Meanwhile, back in Toronto, the site for the museum and the architects had been chosen. Currelly claimed to have met Sir Aston Webb, the architect who was redesigning part of the Victoria and Albert Museum, on a train when Webb drew a design of the ideal museum literally on the back of an envelope. This was in the shape of an H. There is no other evidence for such a story except Currelly's own reminiscences, but it was another convenient myth for the glorification of the ROM.[16]

The building, half of the Webb H, was erected between 1910 and 1912 and once the collections had been installed, it was opened by the Governor General, the Duke of Connaught in 1914, in the kind of civic durbar so beloved of the period. Currelly had secured the lion's share of the new building. The archaeological collections occupied the first and second floors; mineralogy, zoology and palaeontology occupied the top, while geology was consigned to the basement. But he had not, initially, secured the directorship. The museum was, in effect, five museums with each of the four concerned with the natural and earth sciences curated by the relevant professor in the university. Currelly was given academic rank to ensure that the niceties of status were satisfied, but the others were at the very least suspicious of him. The

ROYAL ONTARIO AND ROYAL BRITISH COLUMBIA MUSEUMS

1 Royal Ontario Museum, University of Toronto, built between 1910 and 1912, opened in 1914. This building was subsequently engulfed by many extensions.

marriage of university and public museum created an initial tension between the excitements of spectacular archaeological materials and the more restrained scholarly tradition. Moreover, although Currelly had become active in this field too, ethnography (still in the provincial museum) remained marginal to the university's interests until a new academic appointment was made in 1925. But something of the grandiloquent ambition of the museum was conveyed by two inscriptions on stone slabs facing each other at the entrance, reading: 'The record of nature through countless ages' and 'The arts of man through all the years'. These (still there today) encapsulated the objectives of the museum in displaying natural and earth sciences with archaeological and cultural material, and also suggested the contrast between deep and more recent time.

Currelly's interests were still expanding from his original Egyptian and Mediterranean specialisms. In 1913 he went on a lecture tour in the USA and returned via British Columbia (BC) where he became enamoured of the splendours of the West Coast First Nations peoples in basketry, pottery and wood carving. He set about securing the immense totem poles that grace the building to this day (with staircases entwined

around them). He also set about a collection of arms and armour, of swords, bows and arrows, and helmets.[17] In this he was helped by Sir Henry Pellatt, who, he wrote, had 'such big ideas for Toronto and its future'.[18] Pellatt was a wealthy businessman who had been a partner of Edmund Osler. He was later involved in insurance, in electrical power generation, brewing and other interests. Regarded by many as a highly dubious figure, he also had military and musical connections.

The development of the ROM soon illustrated the adage that nothing succeeds like success. Despite the onset of the First World War, the growing fame of the collection ensured that more donations were made to it. But the war did introduce a period of financial austerity, which the museum survived through a combination of economy and the support of its wealthy benefactors. Although additions continued to be made to the mineralogical and other scientific collections, it had become quite clear that it was the cultural material that grabbed the headlines and drew in the visitors. Only the excavation of a magnificently rich dinosaur graveyard, long known in the valley of the Red Deer River, could possibly compete. These excavations continued throughout the inter-war years and eventually constituted a spectacular display in the museum. Meanwhile, the cultural collections of the ROM continued to find new fields.

While still working in Egypt, Currelly had developed an interest in Chinese ceramics, bronzes, and other antiquities that turned up at the dealers there. Cairo was the pivot between Asia, Africa and Europe, a leading tourist city of the world. Given these strategic and market advantages, dealers dealt in more than Egyptian materials. Once Currelly had established this new taste he also began to exploit his dealer sources in Europe. Soon the museum possessed a respectable collection. These interests were developed by Currelly's encounter in 1918 with George Crofts, a wealthy fur merchant with a large factory in Tientsin. He had built up a very considerable collection of Chinese antiquities using the importer S.M. Franck as his agent. Crofts was intrigued by the fact that a fine Luohan figure which he had sold to Franck was now in the ROM collection (having been bought by the ever-generous Mrs Warren). Currelly later claimed that his friendship with Crofts brought some $10 million dollars' worth of Chinese works to the museum, which Crofts took on as a personal project. He was duly rewarded with an honorary degree from the university, although the collapse of the fur trade had caused the loss of his fortune by his death in 1925.

Crofts was swiftly replaced by another buccaneering collector for the ROM, in the unlikely guise of the missionary and Anglican bishop William Charles White, who first met Currelly in 1924. White (1873–1960) had emigrated from Devon to Canada with his parents while still

a child. He was educated at Wycliffe College, ordained priest, and left for China as a missionary in 1897 (his first choice having been Africa).[19] There he encountered distinguished sinologists such as John Ferguson, the president of the missionary university of Nanjing, and James Mellon Menzies (1885–1957), a civil engineer turned Presbyterian missionary and later scholar of some distinction, both of them Canadians.[20] From them, White was to learn a great deal: Menzies, for example, helped White authenticate many of the items he acquired, though he disapproved of the bishop's methods.[21] In 1909, partly on his own recommendation, White was consecrated Bishop of Honan (Henan) and was energetically active in building up the Anglican church.[22] But as well as 'saving souls' and building churches, he became a fervent collector of Chinese antiquities.

On a visit to the Normal School Museum as a young man, he had been hugely impressed by the busts of great men exhibited there, conceiving an ambition to emulate them in some field, in Chinese studies and in collecting, if not in the church. In China, initially in Fujian province, he dressed in the garb of a mandarin, learned the language, and worked hard to make himself acceptable to the Chinese population. He greatly respected Chinese mores, but not enough to restrain himself from the aggressive collecting that today looks close to looting. Interestingly, this may have started within the very processes of Christian conversion. He instructed one of his first converts to destroy his household idols to abjure publicly Chinese religious forms. But with his second conversion he chose a different course. He simply confiscated an 'idolatrous' scroll and gilt image.[23] This was to constitute the start of his collecting passion.[24]

Railway lines were being constructed across northern China after the fall of the Manchu Qing dynasty and engineering works often broke through tombs. White used scouts to inform him of likely sites. In an echo of Egyptian practice, peasants were bribed (certainly by dealers) to loot graves and place the contents on the antiquities market. As in Egypt, this was treasure-hunting without any attempt at serious contextual archaeology. White also used intelligence networks to inform him of wealthy families falling on hard times who might want to dispose of libraries or collections.[25] By 1924, his methods were well honed, and he became a prolific collector for the ROM. After that, shipments regularly reached Toronto (some of the early ones broken beyond repair). In September 1925, for example, three Chinese consignments arrived at the ROM, one containing some 170 items. Of these, White wrote 'the enclosed will take your breath away, for I have gone more than the limit, and have overdrawn my bank account to do it . . . too good to let pass'.[26]

White's biographer estimated that his shipments to ROM numbered several thousand pieces.[27] Among them were three astonishing late thirteenth-century wall paintings of the Yuan Dynasty, one Buddhist and two Daoist, which were sent out in pieces and restored at the ROM. These are regarded as among its greatest treasures.[28] The justification for their removal was that they were in a derelict monastery, which might be destroyed by campaigning war lords.

Soon his activities were causing real alarm (financially if not morally) to the ROM board. At one stage his insatiable purchasing ran up an overdraft of $90,000 and he claimed that he spent a good deal of his own money (out of an episcopal salary that cannot have been all that great). A real sense of excitement emerges from his correspondence with Currelly, chiming with Currelly's letters to Walker. White wrote that 'he had practically cleaned out the collections in the city's [Kaifeng?] shops', that the 'present nationalistic feeling in China is really anti-foreign and it is going to hinder the exportation of Chinese antiquities'. Currelly responded: 'There is no doubt that a settled China would try to make it difficult to export the antiquities. I feel therefore that there is all the more need to make hay while the sun shines.'[29] These read as damning confessions: an unsettled and violent China caused the sun to shine on the ROM. But they have to be placed in the context of what was happening at the time, an apparently unending stream of antiquities flooding out into the museums and private collections of the West. ROM was unashamedly involved in a scramble, a process of looting that implicates museums and collectors in the general political and economic rape of China of the period.

The fact that the ROM contains one of the richest Chinese collections of any museum is largely down to White and the encouragement he received from Currelly.[30] White believed that his justification was that Canada should have the opportunity to appreciate the glories of Chinese civilisation, as well as understand a great country and potential trading partner, which shared a Pacific Rim location. Through this rationalisation he could also claim to be doing something of considerable practical significance for China.[31] Establishing a notable Chinese collection at the ROM was a matter of creating mutual understanding. Thus, aided by Crofts, White, Walker, Currelly and others, ROM developed one of the great Far Eastern collections. Currelly, as always, enthused about the relative cheapness of the items acquired, attempting to put prices on them. White for his part clearly decided that his ambition for fame could be better satisfied as a collector than as an ecclesiastic. By his agency, a vast Chinese collection was transferred to Toronto and he duly received his reward in 1934, being appointed Professor of Chinese Studies at the university and curator of the

Chinese collections. But in reality, White's scholarship was suspect. His teaching abilities were untested and he was known to be thoroughly difficult and autocratic in his dealings with others. It is indeed testimony to Currelly's easy charm, and to their joint passion for grab, that these two personalities got on with each other for so long.

Not everyone approved of White's and Currelly's exploitation of instability and war-lordism in China and the difficulty of applying export regulations. Although they thought they had a 'once-in-lifetime opportunity' to remove antiquities and relocate them in the ROM collection, James Menzies considered that the looting of Chinese material was unacceptable. When he found a great dump of Bronze Age artefacts (mainly oracle bones inscribed with one of the earliest of Chinese scripts) on the banks of the Huan River north of Zhangde in 1914, he was determined that the material should be kept in China. He refused all approaches from Currelly to collect for the ROM and it is a reflection of the jealousies and infighting among this group that, although he was a good deal more distinguished as a scholar and authority on Chinese calligraphy than White, they made him effectively *persona non grata* at the ROM and the university.[32] In the 1930s the Zhangde site was excavated by the Academia Sinica, perhaps saved by the fact that its artefacts were a good deal less visibly spectacular, in a public and aesthetic sense, than the kind of material White had been removing.[33]

By then, the Chinese authorities (in 1930) had attempted to stem the flow of cultural treasures from the country, which caused White to splutter about 'the present selfish and narrow anti-foreign attitude'. From now on his activities began to slow down. All of this reflects the often fruitless efforts of the territories with the richest material civilisations to protect their inheritance. The Chinese situation paralleled that of Egypt almost a century earlier. As early as 1835, Mehemet Ali, pasha of Egypt, had passed an ordinance forbidding the wholesale removal of antiquities. He also attempted to establish a museum.[34] But he seems to have been ambivalent and gave his approval for expeditions and for the further removal of materials. Realpolitik could be more important than patriotic protection. In 1858, the French archaeologist Auguste Mariette set up the Egyptian Museum and the Egyptian Antiquities Service, once again attempting to restrict exports. But Islamic Egypt did not have a profound reverence for its ancient and 'idolatrous' past at this time and archaeology was so heavily politicised that the scramble in effect continued. Egypt's financial fall into the hands of Anglo-French debt commissioners and British informal rule ensured that European collectors enjoyed a privileged position. The seepage of antiquities out of the country continued until at least the First World War.

ROM had managed to capitalise upon the free-wheeling conditions

in Egypt, China and elsewhere during its ebullient foundational period. Bequests and donations, both artefacts and money, flowed in, including the Reuben Wells Leonard bequest of 1930. Leonard had been a military officer who had made a considerable fortune in mining. One-sixth of his very considerable estate was to be applied to the development of the museum, 50 per cent of this going to the Museum of Archaeology. Another benefactor was the wealthy Dr Sigmund Samuel who frequently opened his chequebook for the ROM (starting with responding to Currelly's pleas by paying for some Greek statuettes in 1914). Born in 1867 he had entered his father's business, importers and dealers in iron, steel and metals, as a youth. He became the sole proprietor of this company in 1935. On his death in 1962 he left a considerable bequest for a new wing to the Canadiana Museum to house his collection of historical paintings, drawings, prints, books, maps, documents and ship models.[35]

By the late 1920s it was apparent that the ROM was seriously short of space. In 1929, the ROM board decided that the time was right to complete the H-plan of the original architectural concept.[36] Interestingly, whereas back in the Edwardian period the timing was propitious because of positive economic indicators, this time the plans were promoted by highly negative ones. As the Great Depression deepened, the ROM project became a significant work creation scheme for the Toronto unemployed. Private and public funding was put together and the provincial administration insisted on job-sharing schemes (for example week-on, week-off work, doubling the labour force) and the use of only Canadian building materials. The new building was completed in 1933, greatly increasing the space available for the magnificent worldwide collections. The five museums were also rationalised, reorganised as five departments under a single director. A corollary of this expansion was that the original provincial museum now seemed redundant. It was closed and much of its archaeological and ethnographic collection was handed over to the ROM. The result of this museum imperialism was that Toronto's civic coming of age had taken the form of a desire to slot itself into the world civilisations of the past, into international empires rather than British. To this day, Toronto lacks a separate museum dedicated to Ontario's past, both indigenous and immigrant. Apart from some large houses open to the public, which offer insights mainly into the history of its elite, it also lacks a civic museum to celebrate its own history.

The history of the ROM reflects the shift from an inquisitive age to an acquisitive one, from an age of innocence in a belief in education through the natural sciences and ethnography into cultural collecting at all costs. The publications of Currelly and White transformed this

'smash and grab' imperialism into shameless 'grab and brag', making for some alarming reading today. The notion that many of the characteristics of the imperial era reach something of a climax in the early twentieth century is more than confirmed by these collecting practices. But if the political, military and economic record exists only in slightly nebulous documents and statistics, the evidence for museum imperialism is tangible, the material presence of objects acquired through these inequalities in power relations. Yet there is a case for the defence. Much may have been damaged or lost in the turbulence of the time. Indeed, the monastery from which the Yuan dynasty murals were removed was destroyed in the 1940s.[37] It is also fair to say that the ROM collections are made up from many different sources. The important Korean collection, for example, came from a variety of different private collections in the twentieth century.[38] Though it is always a poor moral justification, it is true that all westerners were at it (if some were expressing real doubts) and those who held back lost out. A museum like the ROM created a great 'contact zone' of world cultures, which perhaps ultimately helped to overturn the more simplistic racial values of the time. It may be that some mutual understanding did arise from the splendours of the cultures of the past, though contrasting these with the alleged decadence of the same people in the present constituted a common approach to the analysis of cultural relativism. Moreover, unlike the other territories examined in subsequent chapters, Canada occupied a very particular situation in North America.

The country and its population suffered not only from a genuine anxiety about absorption by the USA, but also a fear of competitive acquisition. If great railway projects, like the eastern Intercolonial and the Transcontinental, were designed to unite the confederation against the American threat, museum development came to signify a means of keeping representative artefacts of both Canadian and world cultures in Canada. Frustrating the voracious maw of American collectors and museums was another means of establishing Canadian nationalism and identity. Currelly was an indefatigable lecturer and writer of articles, often pursuing these themes. In 1935 he claimed that Canada 'has lagged far behind practically every other civilised nation' in respect of the development of museums.[39] He was also insistent upon the 'relation of museums to industrial development', insisting on the practical value of museums in ways that are reminiscent of the founding values of the South Kensington Museum (V&A) in London.[40] Currelly blended a mix of Canadian and Ontario nationalism, for it may be argued that it was in the federated era after 1867 that provincial pride became particularly powerful. This was also a function of economic growth, of increasing immigration, and of urban expansion, but the self-respecting

province now required the institutions that would confirm its individual significance within the nation state. The Royal Ontario and the Royal British Columbia museums were two notable, yet very different, expressions of this phenomenon.

The Royal British Columbia Museum

Many museums emerged out of natural history societies, but the BC provincial museum in Victoria did it the other way round: the museum came first and the associated society followed. Unlike the ROM, this museum made no attempt to present world cultures, to display international civilisations to its public, residents and visitors. From the start it was, and remained, a museum of BC. Interestingly, it inverted various characteristics of museums elsewhere. In many respects, it sought to maintain the image of its province as a frontier society, as an inspiring wilderness full of landscape glories, geological marvels, zoological and marine wonders as well as ethnographic treasures. Even in its anthropological function, it was less concerned with projecting primitive pasts into a more developed future than with illustrating a contemporary and, supposedly, dying indigenous culture. Moreover, whereas hunters often contributed to museum collections and justified their 'sport' through alleged scientific credentials, this museum became, at least for a period, an aid to their activities. It also, in curious ways, failed to move on into the twentieth century. Until the later 1930s it experienced comparatively little growth and was staffed by the old-fashioned 'amateur' figures of early colonial museum foundations. Only from 1935 were university-qualified scientists added to its staff.[41] Thus, its arrival in the modern era, with the opening of a brand new building and innovative displays in 1968, was compressed into a brief and hectic thirty-year period.

The BC Museum was closely related to its 'field', that is the northwest of the North American continent, particularly in its coastal manifestations. Its staff and society members worked intensively there, giving the museum its distinctive character and spreading scientific discourses to this relatively remote area. There has indeed been a good deal of debate among geographers and historians of science about the character of 'field work'.[42] It is no longer possible to see such a field as an objective phenomenon, 'out there' from which specimens can be brought 'in here' to the confines of the museum. The field is formed and framed by those who work within it, the fieldworkers who delineate it and define it. Thus, both field and museum are social and intellectual constructs, which take specific landscape and display forms. In establishing these connections, society members and museum affiliates

indulge in the formation of scientific pluralities, which are in a constant organic process of formation and re-formation. Moreover, this is a museum that moves swiftly from natural history to anthropology, from specimen collecting in the earth and biological sciences to the acquisition of human artefacts. Nevertheless, mainly because of the personalities involved, ethnographic material did not receive the full attention it deserved until at least the 1930s.

Victoria was ideally situated to exploit the biological and ethnographic riches of the region, not least because it remained something of a frontier town. It was, after all, recently known as Fort Victoria, founded in 1843. James Douglas (1803-77), the powerful Hudson's Bay Company factor, moved his headquarters there in 1849 and in 1851 he was appointed Governor of Vancouver Island. In 1858 he duly became governor of the whole colony of BC, though Victoria had to wait until 1866 to be designated the capital. Half of Victoria's frontier was the sea, opening up considerable scope for marine biological study, as well as offering fishing opportunities and the capacity to access the entire coast with its multiplicity of islands. The other half of that frontier was the sizeable Island itself, almost 500 kilometres in length. It was home to one of the several indigenous peoples of the region, the Salish, while other important communities such as the Haida and the Kwakiutl, were within reach.

The late 1880s were a crucial period in the history of BC. First brought to the attention of a wider world by the marine landfalls of Spanish vessels and the celebrated captains, Cook and Vancouver[43] (among others), it had become a notable location for the Hudson's Bay Company fur trade, and was then given a considerable boost from the discovery of gold in the Fraser River from 1859. Declared a separate colony in 1858, BC had entered the 1867 Confederation in 1871 only on condition that it would be connected to the rest of Canada by a transcontinental railway. The last spike in this massive undertaking was driven in 1885 and the west coast was now directly connected to the great cities of eastern Canada by rail and telegraph. From the Canadian Pacific Railway terminus at Port Moody and, from 1887, the newly named Vancouver (initially an insignificant settlement called Granville) steam shipping would carry the communications systems to Vancouver Island, Victoria and many coastal communities. Without such a system BC would have felt itself to be ground between the western American states to the south and Alaska to the North. Nevertheless, Victoria's economy benefited from the fact that it was well connected by sea to the state of Washington and the west coast of the USA. In the later 1890s, Victoria also received a notable fillip when it became a significant staging post for the Klondike gold rush, a useful

entrepôt and supply point for the long voyage to Alaska and the Yukon. Moreover, mineral discoveries on Vancouver Island (particularly coal) propelled economic growth and the first island railway line, from Nanaimo (facing east and the mainland) to Esquimalt, the Royal Naval base (facing west and south) was completed in 1886. It was extended into Victoria in 1888. This line was designed to carry coal from the mines at Nanaimo (which, with the railway, made a vast fortune for the Scot Robert Dunsmuir) to fuel the ships of the Pacific fleet.[44] The Island also had tremendous potential in the development of logging.

This was the context in which a number of professionals, businessmen and politicians in Victoria decided that it was time the province had a museum.[45] In January 1886, this group of thirty men met in the provincial capital and drew up an 'address' for presentation to the lieutenant governor and his council.[46] The economic intentions and the competitive fears of American collecting imperialism were explicit from the start:

> It has long been felt desirable that a Provincial Museum should be established in order to preserve specimens of the natural products and Indian Antiquities and Manufactures of the Province and to classify and exhibit the same for the information of the public.
>
> It is a source of general regret that objects connected with the ethnology of the country are being yearly taken away in great numbers to the enrichment of other museums and private collections while no adequate means are provided for their retention in the province.

It went on to suggest that the losses were irreparable in terms of scientific value and utility to the country. Moreover, the recent opening up of BC by the railway would 'stimulate the development of her mineral and other natural resources' such that a museum to classify ores, and so on, would produce great practical benefit. This would also have the effect of creating much more knowledge of the natural history of the province 'by no means as yet perfectly understood' and would advance the 'interests of science' and draw 'the attention and cooperation of naturalists of other countries . . .' Thus, in a nutshell, the economic future of the province was linked to the facilitating existence of a museum, one which would also preserve the striking ethnological artefacts of the region, placing it more readily on the scientific map, as well as rendering it more visible to the constituency of scientists in North America and elsewhere. Hence the museum would be a mediator of the frontier to the capital and the wider world.

The Lieutenant Governor, Clement Cornwall, duly endorsed this for the consideration of his council. Many of the thirty signatories can be identified:[47] there were two clergymen (P. Jenns and Archdeacon Scriven), one senior judge (M.B. Begbie) and two other lawyers (G. Walkem, also

a high-ranking civil servant, and H.P. Crease, the attorney general), the surveyor general (W.S. Gore), several members of the provincial legislature and town councillors (at least one of whom had been mayor), one Hudson's Bay man who was also a noted linguist of indigenous languages (W.F. Tolmie, whose son later became the premier of the colony), two men closely connected with the Victoria Mechanics' Institute[48] (the businessman J. Fell, and N. Shakespeare, described as a champion of the working class). A number of other importers, commission merchants, insurance agents, and a grocer who imported tea and coffee made up the list. Some are harder to identify, though they almost certainly represented a coalition of similar occupations. They all, in one way or another, had an interest in the development of the colony and of Victoria as its capital, in the economic growth that would pull in more migrants to augment what was then a tiny white population. While all of them could have been classified as solidly middle class, none represented the kind of wealthy plutocracy soon active in Ontario. Many of them had a direct line into the administration, still very small scale, and indeed the signatories of the 'memorial' were clearly pushing at an open door. The council endorsed the proposal: the museum had a curator and a collection by October of that year and was duly opened to the public in December, symbolically located (in a room measuring only 15 × 20 feet) next door to the Provincial Secretary's Office. There was never any doubt that this was an official initiative and the museum was to continue to be located adjacent to the legislative buildings until 1968. The new building is still nearby. Now it has adopted the functions of museums worldwide, but there can be little doubt that its initial role was to inform legislators and colonists of the economic and scientific potential of the province.

The initial collections of the museum had been largely donated by the public. Indeed, the original memorial made no mention of collecting: the founders seem to have envisaged a repository rather than an active outgoing institution. It is perhaps not surprising then that the first curator had 'frontier' metaphorically written all over him. This set the museum's tone and it was to survive for nearly fifty years. John or Jack Fannin (born in Ontario in 1837) was a frontiersman and 'overlander' who had travelled to BC in 1862 to join the gold rush.[49] He endured a number of life-threatening adventures, but also enjoyed thoroughly initiating himself into his new environment. As well as prospector, he became in turn rancher, shoemaker and surveyor, whose surveys, despite his lack of training, seem to have been competent enough. Through this experience, he developed an interest in geology and mineralogy, inevitably became a capable hunter, and from there graduated to taxidermy and collecting. Through acting as a hunting guide, he made

contacts with many influential people and this may have helped him into his new post, which involved a move from the mainland to the Island. Like David Boyle in Ontario, he donated his own collection to the museum. Soon the tiny first room was filled up and already in 1889 it was moved, in the same building, to the old courthouse, a new one having been built in Bastion Square.[50] Throughout this time, Fannin continued to act as a hunters' guide, contributing his expertise to those pursuing the game of the region for 'sport' and for natural history collecting. He also continued to be a formidable collector himself.

The fortunes of this museum were to be influenced by other characteristics of BC. Although Victoria was the provincial capital and a significant commercial port, it would rapidly be overtaken in economic significance by Vancouver. And it was in Vancouver that the first university of the province was founded during the First World War. Since the University of Victoria was not created until nearly half a century later, the museum was to be cut off from the intellectual stimulation of the scientific and anthropological staff of an academic community. Moreover, the museum was forced into specialisation. Within four years of its founding, its mineralogical collection was removed to the Department of Mines and one of its principal economic justifications was removed.[51] Unusually, it ceased to have any major interest in geology. However, it increased its commitment to botany. A botanical office was founded in Vancouver in 1911 charged with preparing a provincial herbarium. This was transferred to the museum in 1915, grew rapidly and was located in its own room on the main floor.[52] Nevertheless, the foundation of a botany department in the new university in Vancouver shifted the botanical centre of gravity again and it seems that a herbarium was also developed there. The museum never aspired to major prestige as a scientific institution, although it was visited by representatives of the British Association for the Advancement of Science in 1924 and by delegates to the Fifth Pacific Science Congress in 1933.

Nevertheless, it initially received the full support of the Natural History Society of BC, which was founded in 1890, the first meeting taking place within the museum.[53] Its constitution explicitly described it as 'an independent auxiliary to the Provincial Museum', its prime purpose being to 'acquire and promote a more extended knowledge of the Natural History of the Province'. It was almost as though the collecting function was to lie in the hands of this associated society. The first field trip (which was archaeological rather than natural historical), took place in the spring of 1890, and a photograph seems to indicate that its first members were all male. In its first year, no fewer than twenty-two papers were read, almost all of them devoted to the

natural history of BC. But there were also lectures on ethnography and anatomical anthropology, one of them by the celebrated anthropologist Franz Boas, an active 'anthropological' collector in BC who frequently passed through Victoria. There were ten field trips in the inaugural year and photographs indicate that women were soon involved. The society rapidly developed an interest in marine biology and early 'field' trips were often 'water trips' using a dredge. These activities were carefully recorded and their products were systematically catalogued as they entered the museum collection. By 1893 the society was publishing a bulletin. It is apparent that the distinction between amateur and professional is hard to define in the extension of 'provincial science' in the period. The so-called amateurs, in which putative category Fannin himself must be placed, were laying the foundations of the taxonomy of the region. He produced its first publication, a *Check List of British Columbia Birds*, in 1891.[54] But he has also been described as 'erratic and negligent', sometimes throwing material out.[55]

The most notable of the early naturalists was Charles Frederick Newcombe (1851–1924). Born in Newcastle and a graduate in medicine at the University of Aberdeen he arrived in Victoria in 1889 after extensive travels.[56] He was a founder member of the society and its President in 1900. His route to his work as a naturalist and ethnographer was a tortuous one: he abandoned his original calling as a psychiatric doctor working in asylums and entered general practice, but his efforts never seemed to prosper and he devoted himself to his various collecting interests. After the death of his wife in 1891 he went to England to take a course in geology at the University of London. Hence he had more formal training than many of his associates on the coast. He also travelled to Ottawa to consult George Dawson of the geological survey and to Washington and New York to see the museums there. From the mid-1890s he was active in botany and marine biology, developing ocean dredging interests. He studied the mollusca and crustacea of the Strait of Juan de Fuca and made the conventional move through geology to palaeontology. Between 1895 and 1897 he sailed around the Queen Charlotte Islands on several expeditions collecting botanical specimens and, increasingly, First Nations artefacts from the Haida and Kwakiutl peoples with the support of indigenous helpers Henry Moody and Charlie Nowell of Alert Bay.

Indeed, this activity represented the darker underside to the amassing of 'specimens' from the coast. As mentioned, anxiety about predatory exporting was one of the motives for the foundation of the museum, and almost all the naturalists turned to ethnological collecting. It took over the lives of Newcombe and others. To understand this shift from the natural and earth sciences to the so-called sciences

of man requires an overview of the ways in which the cultures of the North West Coast stimulated an extreme form of museological cupidity. By the 1890s this amounted to a scramble for 'captured heritage' as Douglas Cole put it.[57] These collecting activities can be divided into two major periods. The first occurred during the fifty years after 1774 when some 450 ships visited the region, the crews invariably collecting materials for European museums and collectors. The second was a century later when the scramble became a great deal more hectic, aided by the numbers of collectors on the coast, by steam, by the presence of dealers, and the burning desire of museums in the USA and across the world to seize a slice of this great carving tradition. This acquisitiveness was a key aspect of histories of contact, museums, anthropology, trade and much else.

The availability of such artefacts was deeply implicated in the social and medical history of the period. In the days of early Hudson's Bay Company contact, there were perhaps 80,000 First Nations people on the coast. The fur and other trades brought temporary wealth to them, bringing quantities of iron for tool manufacture, facilitating the competitive, status-induced, production of totems, residences and other luxuries. By the end of the century, the population – ravaged by violence, smallpox (there was a serious epidemic in 1862), measles, chickenpox and other scourges induced by contact with whites – had been reduced to about 28,000. By 1929 the population may have declined further to just over 22,000. The outlawing of the great potlatch feasts in 1884 had ensured that many ceremonial objects became available. Thus the early period stimulated carving and artefact creation; the latter ensured that many settlements were crumbling and their wooden structures and objects were in danger of returning to nature. Even more alarmingly, the collectors, including Boas, turned their avid attention to grave sites and anatomical specimens.[58]

In this situation, American museums were particularly aggressive: the Smithsonian Institution (which Cole condemned for its 'casual and unsystematic' methods and its 'ineptness')[59] built up a vast collection, as did the Harvard Peabody Museum, the Field Museum in Chicago, and museums throughout Europe.[60] The activities of Currelly and White in Egypt and China were mirrored here on the North American continent: it was said that 'the time is short and the opportunity fleeting', that a museum 'which does not utilize the current moment dooms its further development'.[61] The collecting imperative seems to have had an almost addictive power over many people. James Swan, a teacher at an Indian school on the BC coast who had some sensitivity to Indian culture, abandoned teaching in order to collect full time. He sent a magnificent collection to the National Museum in Ottawa. Franz Boas (1858–1942),

born in Germany and educated in physics and geography at Heidelberg, Bonn and Kiel, arrived in BC in 1886 to collect for profit in order to pay off debts. He emerged as one of the first professional anthropologists, the founder of the discipline in America and the trainer of its early practitioners.[62] It is ironic that his radical and admirably non-racist anthropology should be rooted in his role as a leading 'scrambler', for collecting became a passion, feeding his concept of cultural study in all its material aspects. He worked for the Field Museum in Chicago,[63] further inspired by a Northwest display at the Chicago Columbian Exposition of 1893.

Such activity inevitably produced its own infrastructure: guides,[64] dealers and First Nation associates. The dealers, such as Andrew A. Aaronson, H. Stadthagen,[65] and Frederick Lansberg, developed major businesses with large warehouses of artefacts.[66] Boas used a mixed-race agent called George Hunt, who had formerly worked for the Hudson's Bay Company.[67] Individuals vied with each other in cloak and dagger fashion, indulging in 'raids' using every trick and subterfuge. Boas, for example, was in fierce competition with George Dorsey, who mounted what Cole described as 'rip and run' expeditions, riding roughshod over the susceptibilities of indigenous people.[68] Questions of price also became a major issue as the competition increased. Even the crews of American revenue and naval cutters became 'great rifflers' of graves and one captain built up an enormous collection. The sea was indeed vital: often totem poles were simply felled at their sites and hauled down to anchored vessels like so much lumber. Christian missionary activity helped the process and there are records of converted shamans, important figures in Coast society, selling out. Cole wrote that by 1925 the plunder was almost complete and there was little left to collect. By this time, individual American museums had more Kwakiutl or Salish material than survived in their own territory while Washington and New York City were richer in such artefacts than BC itself.[69]

Newcombe became involved in these exploits at what he himself described as the 'eleventh hour'. From this time, he increasingly supported himself by collecting botanical, natural historical and ethnographic specimens for institutions outside Canada: including Kew Gardens, the American Museum of Natural History (New York), the Smithsonian (Washington), the Field Museum (Chicago), where he helped to organise the display on the Northwest coast, and the Berlin ethnological museum.[70] His obituary in *Nature* declared that he felt that 'the decay of the culture and handicrafts of the gifted peoples of the coast could not be arrested'. He felt that their skills should be commemorated by the presence of their totem poles, boats and carvings in museums throughout the world. Although he did contribute some such

materials to the museum in Victoria and to the national institutions in Ottawa, he supposedly felt that the Canadian and BC governments were not sufficiently alert to the need for such collecting, 'for he would have vastly preferred to enrich the museums of his own country'. Indeed, it was said that he had an ambition to place a totem pole in all the major museums of the Empire.[71] There can be little doubt that his activities in exporting such artefacts are now highly controversial. He was also involved in the showman side of this passion. In 1904, he took several Kwakiutl and Nootka individuals to the St Louis World's Fair. On the way back he called at the Field Museum with Nowell to plan collecting strategies and discuss displays he would design.[72] Nevertheless, in his other guise, Newcombe is a classic case of the early semi-professional naturalist, operating in circumstances where, as the writer in *Nature* put it, he had 'scarcely any scientific companionship'. He made the classic leap from zoological, biological, marine and botanical studies into ethnographical collecting, supported himself by spreading, as he would have seen it, knowledge of the peoples of the Northwest coast. He was driven in this by the social Darwinian imperative that such peoples were doomed to extinction, an assumption that seemed to be confirmed by the extraordinary decline in population during the century.

If the people were not condemned to extinction, as mercifully we now know, the survival of their artefacts in their proper contexts, as well as many other aspects of their culture, was indeed doomed. Newcombe was but one in a long line of collectors involved in this wholesale destruction. Settlements were certainly abandoned, as disease and violence had their baleful effects, and some of the collecting did seem like salvage and rescue, but this led to something more widespread and destructive. As the BC museum's collection grew, Fannin organised the materials into the Pitt-Rivers mode – that is, by typology – categories of use divorced from either social or environmental context. He was more interested in representing the habitats of zoological and ornithological specimens where he was an early exponent of the diorama. In 1898, a grand Victorian building was opened for the BC legislature and the museum was located in its east wing, where it was to remain for the next seventy years. In this period its sole extension was into a temporary annexe,[73] which was replaced in 1920 by a newly excavated basement.

Fannin had successfully expanded the collection and moved it twice into new quarters. He died in 1904 and the Natural History Society urged that Newcombe should succeed him. However, the administration passed him over in favour of an employee of the museum, Francis Kermode. Kermode was born in Liverpool in 1874 and arrived in BC

with his parents in 1881, working as a clerk, once his schooling was finished, in a mercantile firm in Victoria. In 1890 he joined the museum as an office boy and apprentice taxidermist. Whether Newcombe wanted the job is not known. What is clear is that he was perfectly happy to continue collecting for the museum.

Kermode's museum philosophy was laid out in a Visitors' Guide published in 1909. He pointed out that the museum was crucial to a province where 'the great bulk of our wealth is drawn directly from the hands of Nature'. A museum 'supplies a need which is felt in every intelligent community, and which cannot be supplied by any other agency'. It also acted a racial marker: 'it does not exist except among highly enlightened peoples, and obtains its highest development only in great centres of civilisation, and is a necessity in every civilised community'. In introducing what he called anthropological 'works of art and industry' – 1,500 specimens, which illustrated the skill of the natives – he asserted that they constituted the 'fast disappearing original occupants of the land'. The museum was located in the midst of a collection area 'unrivalled in the world' and the 'golden opportunity of the present' needed to be seized more quickly and thoroughly.[74]

Kermode remained Curator, then Director, until 1940. Some have seen him as a self-effacing amateur who lacked the confidence of his peers in the developing museum profession, who did very little to lobby for growth in the museum's funding, the expansion of its staff or other development. He indulged in some major biological errors, for example, over the alleged existence of a rare white bear (which was briefly given his name) and in effect promoted the speeding up of the extinction of a rare mutant caribou on Graham Island. He was touchy and ever ready to fall out with associates more knowledgeable than himself. His annual reports do give an impression of torpor, of lack of energy and innovation. He has been described as an 'embattled dinosaur' by the later 1930s, 'doing little or no collecting, even less writing, barren of new ideas, constantly on the defensive...'[75] But he has also been defended. He continued to share projects with Newcombe (though he later fell out dramatically with Newcombe's biologist son). He secured some expansion in space for the museum and he kept it alive in a climate of provincial parsimony. In 1912, he made an extensive tour of museums in the USA and Britain in order to plan a new building for the BC Museum. This was never built. Much later, in 1933, Kermode served on the Carnegie Corporation's Advisory Board of the Canadian Committee on Museums, travelling across Canada to visit many examples.

Before the First World War, Victoria had other leading figures who were beginning to be influential in collecting in all its forms. One of these was E.O.S. Scholefield, the Provincial Librarian and later

Archivist, who himself pressed for action in his annual reports.[76] Indeed, it was the archives that began to collect 'pioneer' materials, which would later contribute to the significant displays of the modern BC Museum. There was some relaxation on the purse strings in the years before the First World War and Newcombe came into his own. In 1909 he set about reorganising the ethnographic displays by culture rather than use and wrote an illustrated catalogue of the collection.[77] In 1911, as a result of the urgings of Scholefield, the administration gave Newcombe $3,000 (and more in the following year) to gather a representative collection of so-called Indian relics. Newcombe had soon doubled the collection, from 1,390 to 2,837 items, but it was a brief bonanza. In 1914 the days of stringency were back. Kermode abandoned an anthropological budget of $2,000. He never showed much interest in the field again and the museum employed no anthropologist during this period.[78] In 1914, the museum boasted only four staff – the curator, two assistants and a janitor/attendant. It was about to be hit by the economies of the war.

Despite its lack of dynamism, it received a good press. In 1911, William Holland of the Carnegie Institute viewed it as 'growing in importance'.[79] In his annual report of 1913, Kermode, no doubt seeking to enhance its status, described it as 'one of the foremost of its kind' and it was visited in 1915 by Teddy Roosevelt and later by members of the British royal family, including the Prince of Wales. Moreover, in 1913, it was at last given legislative recognition.[80] Named the Provincial Museum of Natural History and Anthropology, its curator was redesignated as director and its three objectives were listed as the securing and preservation of specimens illustrating natural history; the collection of 'anthropological material relating to the aboriginal races of the Province'; and the acquisition of information respecting the natural sciences and the diffusion of knowledge of the same. Kermode was given the power to permit the export of natural history specimens. In 1918, he also became director of the Game Department until the police took it over, but remained as secretary of the BC Game Conservation Board, which he lamented took up a great deal of his time.[81]

In 1913, the annual report detailed various research trips and espoused the myth of completeness, suggesting that fieldwork would continue until 'all areas of the Province have been covered'. After the setbacks of 1914–18, the annual reports of the inter-war years reflect a relatively static time. Biological and botanical fieldwork continued, but conducted by a tiny staff. Because 'anthropology' had really meant collecting rather than social study, it effectively came to an end. In 1918 Kermode declared that collections had been offered, but there was no money to buy them. In 1920, anthropology was not even mentioned

(and was often cut in other years too), though it sometimes made a come-back and lectures were given in the field.[82] Visitor numbers are hard to interpret in this period. Kermode pointed out that 500 had been mentioned in 1888 and that in his period only a minority signed the visitors' book, which did not include spouses, school parties or 'Orientals'.[83] Once staff attempted to check the numbers, he claimed a figure just short of 60,000.

As Kermode left office, the museum did embark on a new and popular enterprise. Totem poles, house poles and boards, mortuary poles and other carvings had been stored in the Old Drill Hall for a number of years, where they had sometimes been open to the public. These included materials from the Haida, the Kwakiutl, the Salish and the Nootka people. These were moved to 'Thunderbird Park', leased by the City Council and arranged through a grant from the provincial administration.[84] A newer and much improved version of this feature, incorporating modern carving representative of the extraordinarily renaissance in the art in more recent years, is still there. In some respects this represented the fresh burst of energy that broke out with Kermode's departure and it would ultimately lead to the striking museum of today.

A museum for Vancouver

The fortunes of the BC Museum at the beginning of the twentieth century can only be understood, however, in terms of parallel developments in Vancouver. The latter settlement (by 1926 it had a population of 250,000, far more than Victoria) was also in the business of creating scientific and cultural institutions. Mrs S.G. Mellon was one of the original movers arguing for the preservation of historical materials from as early as 1887. This was a brand new city already concerned with the past. The first art exhibition was held in 1890 and two years later a meeting chaired by the mayor proposed a new cultural and historical society. Intriguingly, the Japanese consul, Mr Kitto, described how public museums were conducted in Japan. These first efforts went nowhere, but in 1894, the Vancouver Art, Historical and Scientific Association was founded. Its initial honorary office holders included two bishops, the mayor, two ex-mayors and six women, while the general committee comprised ten women and five men. The involvement of so many women is striking and may be explained by the combination of natural historical interests with art, the latter often placed in the women's sphere. (In 1903, its president was Mrs McLagan, wife of the founder of the *Vancouver Daily World*.) The society immediately declared that the collection of 'native Indian relics' was of the 'utmost

importance'. Early on it appointed a curator, Will Ferris, and also A.F. Corbin to take charge of Indian materials. Initially, it occupied a variety of locations, including the basement of the city hall. An effort by Captain and Mrs Mellon to persuade Lord Strathcona to provide a building failed.[85] Nevertheless, it enjoyed a $100 grant from the city from 1898, an amount which progressively increased. In 1904 it moved to the top floor of the Carnegie Library.

It has an air of greater vigour about it than its Victoria equivalent. It held art and other exhibitions from the start, in an effort to make, as its president the Rev. Norman Tucker put it, 'the hard and unlovely lot of our toiling and struggling fellow citizens a little less hard and unlovely'. Whether the toiling ones appreciated this concern is not recorded. Donations flowed in from a variety of donors,[86] including Siamese[87] and Japanese material,[88] as well as a mummy from Luxor. Vancouver seems to have been interested in world cultures, though the museum was also concerned with natural history. The Vancouver Naturalists' Field Club was founded in 1906 and initiated field trips, setting out to stimulate interests in botany, entomology and geology as well as advocating nature study in schools. It survived for only a few years and was soon surpassed by the Vancouver Mountaineering Club, which formed a natural history section, which in turn broke away to form the Vancouver Natural History Society in 1918. This club attracted an outstanding figure who was a notable pioneer botanist, founder of a botanical garden, and was influential in museums and national parks. John Davidson (1878–1971) became a 'boy-attendant' in the botany department of Aberdeen University where he later took charge of the botany museum. He was active in the Aberdeen Working Men's Natural History and Scientific Society, but a breakdown in health led to his decision to emigrate. He was fascinated by BC because he had been totally unable to secure botanical specimens from the colony when working in his museum. Arriving in 1911, he swiftly made a mark. He was the first appointee to the University of British Columbia, became provincial botanist, developing a herbarium and a botanical garden, and he started botany classes for the BC Mountaineering Club (as it had become).[89] He was convinced that the great cities of the world were defined by museums, galleries and libraries.[90]

Indeed, the Vancouver Museum continued to prosper involving itself in the 1920s in affairs that seemed to pass the BC Museum in Victoria by. In 1925 there was a pioneers' reunion with an exhibition of pictures and photographs; historic sites were identified; and it urged the preservation of Fort Langley, among other historic locations. Lectures included one on Egypt illustrated by antiquities from the collection and a project for the erection of an Indian village was proposed.[91] This was

suggested by Mrs Campbell-Johnstone in 1915 and was executed after the First World War. A site in Stanley Park was selected and poles from Alert Bay were introduced to simulate a Kwakiutl Village.[92] By 1924, the society had spent $1,000 on the scheme. It was, however, fraught with diplomatic difficulties. The local Squamish people protested at this Kwakiutl invasion and they were supported by the Native Sons of BC, which, contrary to expectations, was a white settler body.[93] These sensitivities survive to this day. Hence the society seems to have been eager to illustrate both indigenous and pioneer life in the colony and its records seem to indicate that its members' motives were mainly connected with the preservation of what might disappear, though commentators and visitors may have seen a contrast between the primitive and the progressive. The museum claimed attendances of 5,000 a month by this time and was eager to propagandise its existence even further afield. In the British *Museums Journal*, Henry Pybus announced that the museum, while specialising in ethnography, natural history, history and geology, possessed objects illustrating the arts and crafts of Ancient Egypt, Siam, India, Japan, Africa, Oceania, as well as North and South America (all from private donors).[94] 'History' (presumably meaning a mix of indigenous and immigrant) was a new departure. Whether by accident or design, the Vancouver Museum was setting itself up as a complementary or contrasting institution to that in Victoria.

Conclusion

The implication of museums in the imperial expansiveness of the late nineteenth century is a familiar phenomenon. In Britain, for example, they became the repositories of loot from military operations in East and West Africa (Ethiopia and the Sudan; Benin and Asante, among others), as well as elsewhere in the world. But museums were something much more than passive recipients. They were themselves imperial in their grab for art, archaeology and artefacts.[95] Museums were as much implicated in scrambling as European states were in Africa, Asia and the Pacific or settlers in North and South America, southern Africa and Australasia. Moreover, this was a universal phenomenon. American museums, in the era of the Spanish-American War, were notably aggressive. Museums had their explorers and 'agents' as much as imperial states. George Dorsey, who turns up on more than one continent, was to the Field Museum what Karl Peters was to German imperialism in Africa.[96] And this cultural grab bounced Canadian institutions into an effort to compete or to act defensively. ROM can only be compared with major American and European museums in this respect, while the

museums in BC were stimulated by outside predators, forced, in this case, into a scramble in its own hinterland. Ironically enough, the ROM disregarded the Northwest Coast until Currelly 'discovered' the region and secured his totem poles. But, not unnaturally, it was the national institution in Ottawa that was most concerned to form representative collections of indigenous material.

In contrast with ROM, the BC Provincial Museum, at least during its first fifty years, was neither in the business of presenting the world to BC nor projecting BC to the world. It really presented BC to itself, much handicapped by its loss of its mineralogical collection and its educational and intellectual rivalry with Vancouver. Its growth and development were also restrained by the parsimony with which it was treated by the provincial government. In all of these respects it contrasts strikingly with the energy and support that transformed the ROM, offering a revealing illustration of the differences between Ontario and the remote and 'backward' BC in the period. Nevertheless, it made significant contributions to the initial incorporation of BC into the language and taxonomies of nineteenth-century science. Before the foundation of the University of BC, the museums in Victoria and Vancouver were the main portals for the illustration and practice of a modernist technology and natural science. It was not until the complete reorganisation of the Royal BC Museum in 1968, when West Coast ethnographic materials were given a magnificent setting accompanied by displays on the economic and social history of white and other settlers, that it became – as modern guidebooks indicate – one of the 'must see' attractions of the province.[97] At this point, it did indeed become a major means of displaying BC and its natural and human histories to the world.

Notes

1. Arni Brownstone, 'Treasures of the Bloods', *Rotunda*, 38, 2 (Winter 2005–6), pp. 22–31.
2. Such societies included the Hamilton Historical, Scientific and Art Association (founded 1857), the Upper Canada Historical Society (1861), the York Pioneer and Historical Society (1869), and similar bodies in other towns. These were brought together in 1872 to form the United Canadian Association. The Women's Canadian Historical Society appeared c.1894. In 1901 the National Trust in England stimulated the founding of the Committee for the Preservation of Scenic and Historic Places in Canada, later transformed into the Historic Landmarks Association and the National Battlefields Commission. J. Lynne Teather, *The ROM, a Prehistory* (Toronto 2005), pp. 209–12.
3. Julia Matthews, 'The Right Man in the Right Place at the Right Time, A Look at the Visionary who was instrumental in founding the ROM', *Rotunda*, 38, 3 (Spring 2006), pp. 15–18.
4. C.T. Currelly, *I Brought the Ages Home* (Toronto 1956), pp. vii–viii.
5. Homer A. Thompson also contributed a eulogistic foreword. He became head of

the University of Toronto's department of archaeology in the 1920s and had been associate director of ROM.
6 Appointed to that post in 1892. *Dictionary of Canadian Biography (DCB)*, XV, 1921–30.
7 Matthews, 'The Right Man', p. 17.
8 Kei Yamamoto, 'The Excavator's Digs – a Glimpse into the Past: Excavating the hut of ROM founder Charles Trick Currelly in Abydos, Egypt', *Rotunda*, 38, 3 (Spring 2006), pp. 19–21.
9 ROM archive, Currelly papers, SC3.
10 G.P. de T Glazebrook, *Sir Edmund Walker* (Oxford 1933); Heather Robertson, 'The vanishing patron', *The Beaver*, 82, 2 (April/May 2006), pp. 24–9; and the entry by David Kimmel in the *DCB*, XV, 1921–30 (Toronto 2005), pp. 1046–51.
11 Sir Edmund Byrd Osler, *DCB*, XV, 1921–30.
12 Sir E.A. Wallis Budge, *The Egyptian Hieroglyphic Dictionary* (London 1920).
13 Sandford Fleming was far from being typical but, having emigrated to Canada at the age of eighteen, he returned to Britain for the first time when he was thirty-six in 1863. After that he made no fewer than 43 more transatlantic journeys. Clark Blaise, *Time Lord: Sir Sandford Fleming and the Creation of Standard Time* (London 2001), pp. 52–3. Such frequency of travel – apart from by seamen – would have been unthinkable in the eighteenth century and most of the nineteenth.
14 Lovat Dickson, *The Museum Makers: the Story of the Royal Ontario Museum* (Toronto 1986), p. 21.
15 Henry Montgomery, a geologist and biologist, took charge of the University of Toronto Museum in 1903, having been curator of Trinity's museum since 1894 where he developed a much more professional approach, transforming the collections. He was quickly upstaged by Currelly in discussions for the new museum. ROM Archive, SC7, Montgomery papers.
16 For ROM buildings and collections see Dickson, *Museum Makers*; Currelly, *I Brought the Ages Home*; Matthews, 'The Right Man'; Arthur Smith, 'From Dream to Reality: a ROM Retrospective', *Rotunda*, 38, 3 (Spring 2006), pp. 23–9.
17 Currelly, *I Brought the Ages Home*, pp. 232–9. On one occasion he discovered that a Viking sword was coming up in a sale in London. He established that Sigmund Samuel was in the city and he had him 'steered to the sale, and he bought it', p. 235.
18 Ibid., p. 233.
19 Lewis C. Walmsley, *Bishop in Honan: Mission and Museum in the Life of William C. White* (Toronto 1974); Lee-Anne Jack, 'Man on a Mission', *Rotunda*, 38, 3 (Spring 2006), pp. 31–41; *DCB*.
20 Menzies was the grandson of a Scots migrant who had been involved in William Lyon Mackenzie's anti-'Family Compact' Ontario 'rebellion' of 1837.
21 Linfu Dong, 'Finding God in Ancient China: James Mellon Menzies, Sinology and Mission Policies', in Alwyn Austin and Jamie S. Scott (eds), *Canadian Missionaries, Indigenous Peoples* (Toronto 2005), pp. 278–307, particularly p. 296.
22 He also built himself a grand palace in Keifeng, became Masonic Grand Chaplain, and collected several Chinese orders. White was never inclined to be shy or modest. ROM archives, SC12, Bishop White papers; SC11, Lewis C. Walmsley, papers relating to the biography of White.
23 Though this may have served to preserve these items, the action was freighted with ideological content, not least to avoid recidivism by their owners.
24 Jesuit missionaries also collected in China and set up the Musée d'art Chinois in Quebec City to publicise their work. They even sold Chinese 'knick-knacks', small items of little value sent home by missionaries for the purpose. France Lord, 'The Silent Eloquence of Things: The Missionary Collections and Exhibitions of the Society of Jesus in Quebec, 1843–1946', in Austin and Scott (eds), *Canadian Missionaries, Indigenous Peoples*, pp. 219–23.
25 An excellent example was the vast library of Professor H.H. Mu, numbering over 40,000 volumes, acquired after the death of Mu Xuexun in 1929. White said he had

contributed $10,000 of his own money to the purchase. *Rotunda*, 38, 3 (Spring 2006), p. 32. For this and other rare collections in the ROM library see Pearce J. Carefoote, Marie Korey and Barry Walfish (eds), *Extra Muros/Intra Muros: a Collaborative Exhibition of Rare Books and Special Collections at the University of Toronto* (Toronto 2006), pp. 13–14. I am grateful to Arthur Smith for kindly sending me a copy of this.
26 Quoted in Walmsley, *Bishop in Honan*, p. 144.
27 Ibid. Currelly began to commission White to find multiple examples of everyday items, such as hinges or stirrups.
28 Ka Bo Tsang, 'The Paradise of Maitreya: a Yuan Dynasty Mural from Shanxi Province', *Orientations*, 37, 3 (April 2006), pp. 60–5.
29 Dickson, *Museum Makers*, p. 77.
30 In 1936, Currelly, ever fascinated by values, claimed that the ROM collection of Chinese ceramics was worth $10 million. *Oshawa Daily Times*, 13 January 1936, reporting a speech by Currelly.
31 White was very active in famine relief in his region, saving many Chinese lives through the distribution of food.
32 Menzies was White's PhD student, explaining some of the tension in the relationship.
33 Linfoo Dong, 'Finding God in Ancient China', pp. 280–3 and 300. This author has described Menzies as 'breaking the yoke of ethnocentrism' and as being so sympathetic to China that he believed that Christianity had to be 'sinicised', deeply rooted in Chinese cultural and social tradition. See pp. 283 and 302. Menzies bequeathed some of his personal collection, notably some fine Shang bronzes, to the ROM.
34 Maya Jasanoff, *Edge of Empire: Conquest and Collecting in the East, 1750–1850* (London 2005), pp. 299–301.
35 Samuel served on the Board of Governors of the ROM. The building to house his collection was acquired by the University of Toronto in the 1990s.
36 For this period see Dickson, *Museum Makers*, Smith, 'From Dream to Reality'; 'Sinaiticus', 'Royal Ontario Museum, Toronto', *Construction* (November 1932), pp. 247–55; and Loren A. Oxley, 'Retrospect – The First 75 Years: Expansion is nothing new to the ROM', *Rotunda*, 15, 2 (Summer 1982), pp. 6–13.
37 Ka Bo Tsang, 'The Paradise of Maitreya', p. 60.
38 Christina Hee-Yeon Han, 'The Korean Collection of the Royal Ontario Museum', *Orientations*, 37, 3 (April 2006), pp. 70–6.
39 This is from a typescript dated 14 December 1935, ROM archives, SC3, Charles Currelly, box 2. These Currelly papers (also box 1) include the typescripts of many lectures, speeches and articles.
40 C.T. Currelly, 'The Relation of Museums to Industrial Development', *Social Welfare*, August 1928, pp. 251–3. SC3, box 2. In this piece he also suggested that museum collections led visitors to distinguish between cultures in which progress had occurred and those in which it had been arrested.
41 Dr Ian McTaggart Cowan was appointed Assistant Biologist. He became Assistant Director in 1938 and might have succeeded to the directorship had he not moved to an academic post at UBC.
42 Charles W.J. Withers and Diarmid Finnegan, 'Natural History Societies, fieldwork and local knowledge in nineteenth-century Scotland: towards a historical geography of civic science' in *Cultural Geographies*, 10 (2003), pp. 334–53 contains a useful survey of this debate.
43 Cook's collections from the Coast went to Sir Joseph Banks and eventually to the BM. Twelve other members of Cook's crew donated to the BM, as did Archibald Menzies, naturalist on Vancouver's expedition.
44 To get the railway built, the government made massive grants of land to Dunsmuir's company. A deeply unpopular man, he was notorious for screwing down his workers.
45 There had been a 'menagerie, museum and saloon' operating in Victoria between

46 1876 and 1882, operated by an American showman called Bristol, but its sensational displays resemble a museum only in the use of the name. *The Daily Colonist*, 2/3 November, 1872, BC Archives Add. MSS 2082.
46 Printed in full, appendix to Peter Corley-Smith, *White Bears and other Curiosities: the first 100 years of the Royal British Columbia Museum* (Victoria 1989), pp. 142–3.
47 This survey of the signatories is compiled from a number of sources, including the *Biographical Dictionary of Well-Known British Columbians with a Historical Sketch* by J.B. Kerr (Vancouver 1890); *British Columbia Pictorial Biographical Dictionary from the Earliest Times to the Present*, 4 volumes (Vancouver 1914); *Williams' British Columbia Directory* (1887); and online *DCB*.
48 Only in 1891 did BC promulgate An Act to Provide for the Establishment of Free Libraries. *Statutes of the Province of British Columbia* (Victoria 1891), chapter 20, p. 73.
49 John Fannin, *DCB*, XIII, 1901–10.
50 This courthouse was offered to the museum when it was in turn vacated. This was rejected and the building now houses the maritime museum of BC.
51 Fannin recommended this himself, annual report 1897. He was probably already obsessed with space when in the same report he announced 16,577 items in the collection. Yet the museum was about to move to larger accommodation.
52 Corley-Smith, *White Bears*, p. 33, suggests that the herbarium moved to Vancouver. But there seem to have been two, one in Victoria and another in Vancouver.
53 Societies included the Philharmonic, St Andrew's and Caledonian, St George's, Victoria Amateur Orchestral, but nothing scientific. See the *Williams' BC Directories* of the 1880s. Print culture was represented by two newspapers, *The Daily Colonist*, dating from 1858, and the *Victoria Times*.
54 The Society commenced publication of *Papers and Communications read before the Natural History Society of BC*, vol. 1 in 1891, BC Archives. Fannin's bird book was followed in 1893 by a *Preliminary Check List of Marine Shells of British Columbia*. See also 'One Hundred Years in Print: a Checklist of Publications of the BC Provincial Museum/Royal BC Museum, 1891–1991', compiled by Cathy Ronay, edited and revised by Frederika Verspoor.
55 Douglas Cole, *Captured Heritage: the Scramble for North West Coast Artifacts* (Vancouver 1985), p. 226.
56 Keir B. Sterling, Richard P. Hammond, George A. Cavasco and Lorne F. Hammond, *Biographical Dictionary of American and Canadian Naturalists and Environmentalists* (Westport, Conn. 1997), pp. 575–7; see also obituary of Newcombe in *Nature* (December 1924), reprint in BC Archives. Newcombe published a number of articles on totem poles. See also *DCB*, XV, 1921–30.
57 Cole, *Captured Heritage* relates the sorry tale in lurid detail.
58 It has been suggested that, from 1894, Boas believed that the collecting of human remains had little value. But he was involved before that date and helped to stimulate competitive collecting. R.E. Beider, 'The Collecting of Bones for Anthropological Narratives', *American Indian Cultural and Research Journal*, 16, 2 (1992), pp. 21–35.
59 Ibid., p. 17.
60 Ethnological museums were founded in St Petersburg (late 1830s), Copenhagen (1841), Leipzig (1873), Rome (1875), Bremen (1876), Hamburg (1878) and Dresden (1879). In addition the more general museums in Paris, Stockholm, Oslo, and Vienna (among others) were eagerly purchasing, as were major university museums.
61 Cole, *Captured Heritage*, p. 51.
62 Boas has been seen as anti-racist and opposed to the notion of a deterministic social evolution. He developed concepts of 'particularism' (that is the idea that diffusion could operate in random and unpredictable ways to form distinctive cultures), of cultural totality (to be explained through artefacts as well as other aspects of culture), and of cultural relativism, the latter leading him to the idea that Europeans were wrong to see their religion and other cultural forms as inherently superior.

63 The Field Museum owed its name to a major donation by the wealthy department store magnate, Marshall Field. It was one of the most predatory museums, perhaps helping to explain the urgency felt by Currelly in Toronto. In modern times, the activities of Boas have been celebrated as essentially unproblematic. See the article in the *Field Museum of Natural History Bulletin*, 53, 4 (April 1982) by Peter McNair with the immensely ironic title 'The Northwest Coast collections – Legacy of a Living Culture'.
64 One guide was a Scot called James Deans. Another, James A. Teit, worked as a collector for Boas.
65 A photograph of Stadthagen's curio shop can be seen in Cole, *Captured Heritage*, p. 234.
66 See *Henderson's British Columbia Gazetteer and Directory*, 1890, 1891 and 1893 editions, for entries on these dealers.
67 Hunt later worked for the BC Museum, sorting the Kwakiutl collection and providing reliable labels. He also offered advice on plants used by First Nations people as food and medicines. For a brief survey of his activities as a photographer, see Ira Jacknis, 'George Hunt, Kwakiutl Photographer', in Elizabeth Edwards, *Anthropology and Photography* (New Haven 1992), pp. 143–51.
68 Dorsey also went on artefact hunting expeditions for the Field Museum in other parts of the world including New Guinea. See Markus Schindlbeck, 'The Art of the Head-Hunters: Collecting Activity and Recruitment in New Guinea at the Beginning of the Twentieth Century', in Hermann J. Hiery and John M. MacKenzie (eds), *European Impact and Pacific Influence* (London 1997), pp. 33–5.
69 Douglas Cole, 'Tricks of the Trade: Some factors in North West Coast Artifact Collecting, 1875–1925', paper for BC Studies Conference 1981, BC Archives.
70 The Berlin Museum made a significant collection of Northwest coast material. Newcombe also sent totem poles to Kew and helped with the collecting exploits of the Pennsylvania Museum of Science and Art, later the University Museum.
71 Cole, *Captured Heritage*, p. 196.
72 McNair, 'Northwest Coast collections', pp. 4–5.
73 A temporary wooden building formerly occupied by the Public Works Department.
74 *Visitors' Guide to the Provincial Museum of Natural History* (Victoria 1909), pp. 3–5.
75 Corley-Smith, *White Bears*, p. 87.
76 Terry Eastwood, 'R.E. Gosnell, E.O.S. Scholefield and the Founding of the Provincial Archives of BC 1894–1919' paper for BC Studies Conference, 1981, BC Archives. Gosnell, a former journalist, was the first provincial librarian, doubling up as the premier's secretary. Scholefield started out as a page in the Legislative Assembly, became assistant to Gosnell and chief librarian in 1900.
77 *Guide to the Anthropological Collection in the Provincial Museum* prepared by Charles F. Newcombe (Victoria 1909). This was soon followed by the Visitors' Guide mentioned above (note 74). The earliest *Preliminary Catalogue of the Collections of Natural History and Ethnology in the Provincial Museum, Victoria, British Columbia* was published in 1898. A *Preliminary Catalogue of the Flora of Vancouver and the Queen Charlotte Islands* appeared in 1921.
78 W.A. Newcombe, the son of Charles, was assistant biologist with some interest in anthropology, between 1928 and 1932. The first anthropological appointment was A.E. Pickford in 1944.
79 Quoted in Archie F. Key, *Beyond Four Walls: the Origins and Development of Canadian Museums* (Toronto 1973), p. 120.
80 *Statutes of the Province of British Columbia*, chapter 50 (Victoria 1913), 'An Act respecting the Provincial Museum of Natural History and Anthropology', pp. 323–4. *The Daily Colonist*, 29 January 1913, published a report on the minister's speech in support of the bill. Dr Young, Minister of Education, suggested that the legislation was necessary because of the plan to build a new museum (never done). He announced that the museum had won a gold medal at the International Sportsmen's

Exhibition in Vienna. It is interesting that in this speech he mentioned the successes of Dr Newcombe, but made no mention of Kermode.
81 *Report of the Provincial Museum of Natural History for the Year 1918* (Victoria 1919), p. 5. Kermode appeared to drop the word 'Anthropology' from the title.
82 Dr Lorne Hammond supplied copies of the annual reports.
83 The Chinese population of Victoria, already a considerable group, suffered many acts of racial discrimination.
84 See Report of the Provincial Museum for 1940, compiled by Dr Clifford Carl, Kermode's successor.
85 Captain Mellon was a Royal Navy officer, born in 1840, who had served in the Indian 'Mutiny'. He was employed as a captain by the Allan and Dominion lines and emigrated to Canada with his wife in 1880.
86 These are listed in 'The Vancouver Museum', a news-sheet published by the museum, c.1981.
87 From a medical missionary, Dr W.A. Briggs.
88 From a CPR ship's captain, Henry Pybus, who commanded a vessel sailing between Vancouver and Japan.
89 Davidson published Annual Reports of the Botanical Office of the Province of BC for the years 1913/14/15 (Victoria 1914/15/16, illustrated). He did experimental work on eucalyptus and conducted correspondence with a botanist at the Botanical Garden in Sydney NSW.
90 Jim Peacock, *The Vancouver Natural History Society 1918–1993* (Vancouver 1993). See also 'A Scottish Emigrant's Contribution to Canada: A Record of Publications and Public Lectures, 1911–61, by John Davidson, Emeritus Professor of Botany, UBC', published on the 50th anniversary of his arrival in the Province. Copy in BC Archives.
91 *Museum Notes*, 1, 1 (February 1926), p. 4. Subsequent issues of these *Notes* offer many insights into the activities of the museum and the volunteers associated with it.
92 The scheme was too ambitious and only the poles went up. 'Cabinets of Curiosities: An Exhibition of the Collections of the Vancouver Museum 1894–1981' (Vancouver 1982), Legislative Library, Victoria.
93 Daniel Francis (ed.), *Encyclopaedia of BC* (Madeira Park 2000). When a genuine indigenous society was set up it was called the Native Brotherhood of BC, founded 1931.
94 Commander Pybus, RNR, 'The Museum of Vancouver British Columbia', paper read at the Wembley Conference of the Empire Exhibition, July 1924, published in the *Museums Journal*, 25, 1 (July 1925).
95 For literature on artefact scrambling, see Chapter One, footnote 26.
96 One Field Museum agent, Frederick Starr, turns up both in Mexico and Oceania. There were others.
97 The *Rough Guide to Canada*, p. 683 describes it as an 'inspirational museum', 'perhaps the best in Canada', pp. 690–1.

CHAPTER FOUR

South Africa: the South African Museum, Cape Town

Few museums have passed through as many political changes and cultural transformations as those in South Africa. For 170 years, between the 1820s and the 1990s, they represented white dominance in a black-majority country. Between the 1950s and the 1990s some of them were partly forced into a new ideological mould by the apartheid Nationalist government, which infiltrated boards of trustees.[1] Sometimes Africans were not welcome to enter the halls of these museums: what should have been portals to their own nationhood became closed doors behind which whites could inflict their spectatorial and objectifying gaze upon displays which, in some cases, represented the culture of those who should have been their fellow citizens.[2] But since the mid-1990s, all this has changed. Not only have museums become open to all, they have also begun the process of reordering their collections and exhibits to illustrate a multicultural nation with a violent, repressive and discriminatory past. All the territories of white settlement surveyed here have indigenous societies, peoples who were formerly represented within their museums as part of the respective countries' 'natural world'. All have developed more sensitive approaches to such displays in modern times. But only in South Africa have the 'native peoples' remained a majority and come to political power. This shift from repression to re-empowerment has inevitably led to extensive re-thinking and reordering of the museums of the Republic. This is yet another, and all important, phase in the history of the response of museums to their social and political context in the subcontinent.

Museums interacted with a white populace both through the presentation of colonial identity (natural and economic) and with modes of presentation of black culture. They promoted local and civic pride as well as the wider provincial/colonial sense of nationalism within imperial/international webs of both competition and cooperation. They were learned institutions with a public face, reflecting the ideas

of their time. They maintained both intellectual and practical contacts, exchanging scientific and social practice among British imperial, intercolonial and also international networks. All of these phenomena have been manifested in the two representative museums treated here, the South African Museum in Cape Town and the Albany Museum in Grahamstown. These are the two oldest museums in southern Africa. Although many other museums would have made interesting case studies, these two most closely follow the development of scholarly activity at the Cape from the earlier colonial period. Nevertheless, the spread of natural history societies and of related museums was remarkable. We should note in passing that the Port Elizabeth Museum was founded in 1857; the Bloemfontein in 1877; while the remarkable Kaffrarian Museum in King William's Town owes its origins to the founding of a naturalist society there in 1884.[3] The Durban Natural History Museum appeared in 1887;[4] the Transvaal Museum in 1892;[5] and museums were created in Southern Rhodesia (Zimbabwe) as early as 1900 in Bulawayo and 1901 in Salisbury (Harare), only a few years after Rhodes's British South Africa Company seized the territory. The McGregor Museum, Kimberley followed in 1907.[6]

Origins of the South African Museum (SAM)

Although forerunners have been identified during the era of Dutch rule at the Cape, the idea of the museum was largely a British import. Perhaps this is not surprising since the earliest public museum in the Netherlands is the Teylers Museum of Haarlem, dating from 1778, which largely retains its original form to this day. Nevertheless, the beginnings of a Cape museum collection date from the Dutch period. The display of 'trophies' of the hunt was of long standing and skins and mounted specimens were installed in what became Cape Town Castle as early as the seventeenth century. Fascination with the animals of the region was universal and this explains why Governor Willem Adriaan van der Stel created a menagerie and associated trophy collection in the Company Gardens. This was a gubernatorial interest in many colonial settings and may be seen as symbolic of governorship of the natural as well as of the human world. Dealers and taxidermists also established themselves at the Cape, exporting both live and mounted animals to zoos and museums overseas.

The origins of non-zoological collections are normally traced to a German, Joachim Nickolaus von Dessin (1704–61) from Mecklenburg who arrived at the Cape as a mercenary soldier in 1727, rose through the ranks, dabbled in trade, and made a small fortune. He collected books, pictures, coins, medals and 'curiosities', which he bequeathed

to the church. A small building was constructed adjacent to the Groote Kerk to accommodate them. When Captain Cook called in at the Cape in the 1770s he handed over some South Pacific ethnographic material to this Dessinian collection (as it became known) and after his death his brother-in-law Captain James King added some items from the Pacific Coast of Northwest America. The assemblage created by Dessin was eventually handed over to the Cape Town Library and the Art Gallery. The Library was proclaimed in 1818, and the Dessinian collection was handed over in 1822, mainly because of the significance of its books. In 1861, the somewhat decayed remnants of the 'curiosities' and other materials were acquired by the SAM.

This museum now traces its origins to 1825 (that is, fewer than twenty years after the British permanently took the Cape in 1806) and describes itself as the oldest western-style museum in the southern hemisphere. But the reality is that the original museum was tentative and fragile. It lacked full-time staff and received little official encouragement. For these reasons, its foundation date for a long time was declared to be its second incarnation in 1855, second to the South Australian Museum, with which it developed quite a close relationship.[7] The foundation of the museum, by Dr Andrew Smith, illustrates the bringing together of military, medical and metropolitan interests. Smith was born in the Borders of Scotland, the son of a shepherd who became a market gardener.[8] He was apprenticed to a local doctor, entered Edinburgh University to study medicine, and applied to become an army medical assistant in 1815. He was interviewed by Sir James McGrigor, the Director-General of the Army Medical Department whose influence on Smith included an interest in museums. McGrigor had created a museum of anatomy and natural history 'bearing upon military surgery' at Fort Pitt in Chatham and it is possible that Smith sent specimens to it from his early postings in Quebec, Nova Scotia and Malta. He arrived at the Cape in 1821 and was immediately sent to Grahamstown, where most military doctors were stationed for service in the frontier wars.

Smith's collecting habits were already well established and he gathered natural history and ethnographic material during his years at the Eastern Cape. He met Lord Charles Somerset, the Governor, and may have raised the question of a museum with him. By the time Smith returned to Cape Town, Somerset was prepared to issue a notice (in English and Dutch) in the *Cape Town Gazette and African Advertiser* on the need for a museum. His intentions were primarily economic combined with a desire to stress the uniqueness of the Cape. He noted the 'endless diversity and novelty of the natural products' of the colony and considered that this should be reflected in the founding of an

'establishment' to be known as the South African Museum, designed for the 'reception and classification of the various objects of the Animal, Vegetable and Mineral Kingdoms', so that the colonists might become 'acquainted with the general and local resources of the Colony'. The emphasis is clear: humans are not mentioned, despite Smith's developing interest in ethnography. Smith was duly designated superintendent and citizens were urged to collect for him. Somerset granted a budget of 2,000 Rix dollars, about £154 (and a good deal less than the 16,000 thousand – £1230 – bestowed on the library). Smith's position was to be purely honorary, sustained by his military salary,[9] and the museum was to be established in the old Supreme Court building in the complex of the former Slave Lodge. Given Smith's experience and predilections, it would involve bringing the frontier to the town.

Smith threw himself into the task with great energy. He advertised for donations, pledging to publish the names of donors, and was soon receiving large numbers of specimens. Some notable names turn up in these lists of donors, including the Rev. Fearon Fallows, the Astronomer Royal at the Cape, Andrew Geddes Bain, the surveyor often dubbed the 'founder of South African geological studies', the Governor himself, C.F.H. Ludwig (later Baron von Ludwig), a German apothecary and doctor with a considerable interest in botany, various other doctors and several clergymen. This listing of donors helped to create a sense of a scientific community at the Cape, as well as serving to enhance the status and self-regard of both individuals and museum. Smith lent his own collection and continued adding to it from the region around Cape Town, aided by a soldier-servant, John Minton, who received some training as a taxidermist. He also attempted to secure the services of a taxidermist and a painter/illustrator (natural history artists were in considerable demand in the period), issued a questionnaire, and offered advice on collection and preservation.[10] He sent out letters soliciting donations, one of which, to the missionary Robert Moffat at his mission at Kuruman beyond the northern frontier of the colony, survives. He asked Moffat to forward interesting specimens and enclosed some arsenical soap to help in the preservation of animal skins. The museum, he wrote, 'is intended to receive everything that can be found in the Colony or in Southern Africa, and will no doubt eventually be extended to the productions of other parts of the globe'.[11]

His ambitions, which were to be unrealised in his life time, are clear. A further measure of this initial burst of energy was that he issued a descriptive catalogue of the contents of the SAM in 1826. Smith's work for the government and his museum activities were complementary. He now emerged as a major explorer and intelligence gatherer in the colony and beyond, travelling extensively, hunting, and collecting both

information about indigenous peoples for the administration and material for the museum. In 1828–29 he visited Namaqualand in the north of the colony to investigate the 'Hottentot' or Khoe peoples there.[12] Much of his collecting at this time seems to have been ornithological.

During his absence from Cape Town, the museum was probably closed, though the collection was nominally under the care of Jules Verraux, a member of a celebrated family of taxidermists from Paris.[13] While the museum was (probably infrequently) open, Verraux was able to keep the admission fees collected at the door. In 1828 the museum moved to the new Commercial Exchange. At this stage it was not really a public museum: it was a resource for scholars which could be visited, with permission, by members of the elite. A member of a parliamentary commission investigating the museum in 1859 did suggest that it had been something of a tourist attraction when he arrived in Cape Town in 1834, but it does not seem to have made much of an impression. When a young officer, Thomas Duthie, mentioned it in his 1832 diary, it was in laconic terms: 'To a Museum with Mr and Mrs Cunningham.'[14] He was clearly not moved to expand further, though all his diary entries are terse.

On his return from Namaqualand, Smith was clearly restless to accomplish further exploratory feats. In 1829 he was involved in the founding of the 'South African Institution for the purpose of investigating the geography, natural history and resources of South Africa' and became its joint secretary. (An earlier attempt in 1824–25 to create a literary and scientific society had been frustrated by Somerset's anxieties about organisations that might become subversive.)[15] Later in the same year the institution extended the opportunity for scientific discourse at the Cape by founding the *South African Quarterly Journal*, in which Smith was to publish many of his papers.[16] The museum became attached to the institution and moved to its rooms. It was mentioned in the official *Cape of Good Hope Almanac*, in 1826 and 1827, subsequently disappeared, and was advertised again in the almanacs in the 1830s. Smith, however, was repeatedly absent from Cape Town and between 1834 and 1836 conducted a major expedition into the interior, funded by the issue of shares by the institution.[17] On this journey he visited the Moffats at Kuruman and found them ill from fevers. Moffat offered testimony to Smith's medical skills in curing both of them.[18] Smith also treated some of the Africans at the mission station and took an interest in a disease prevalent among their oxen. He was thus detained at the mission longer than expected, but as a result he was able to add 'materially to the objects of the expedition, by enriching his collections of specimens'.[19] Moffat rewarded him by accompanying him north to the territory of King Mzilikazi of the Ndebele people.

When Smith returned, his collections were enthusiastically received by his white audience. The museum was also visited by a passing naturalist who became a regular correspondent of Smith and was later to become the titanic scientific figure of the nineteenth century. Charles Darwin called at the Cape on the way home from his celebrated voyage on the *Beagle*.[20] But this was to be the swansong of the first phase of the history of the SAM. Smith left the Cape in 1837 taking with him his own collections as well as the materials gathered on the 1834-36 expedition. The colonial periphery now came to the metropole, with unashamedly mercenary objectives. The collections were displayed at the Egyptian Halls in London's Piccadilly advertised as 'The South African Museum', a title which had also been used by Andrew Steedman, a Cape merchant and naturalist who had displayed Cape objects at the London Colosseum in 1833.[21] 'Museum' covered the entrepreneurial show as well as the public institution. Once interest had been aroused, it was hoped that the sale of the collections would recoup the costs of Smith's exhibition, an ambition that was frustrated, though the British Museum was a considerable buyer. Some also went to the Muséum d'Histoire Naturelle in Paris. Smith published his *Illustrations of the Zoology of South Africa* in four volumes between 1838 and 1849 and was elected to the Fellowship of the Royal Society and of the Zoological Society. His subsequent career took him to the top of the army medical service and to considerable controversy at the time of the Crimean War, but he had undoubtedly helped to make the Cape better known in Europe.

Between the late 1830s and 1855 the museum in Cape Town was effectively defunct. Smith's energy was removed from the scene; Verraux returned to Paris; and the institution also lost its initial impulse. Indicative of this is the fact that Baron von Ludwig sent his collections away from the Cape to Württemberg. In 1838, what was left of the museum was handed over to the South African College as a teaching aid and effectively lost its public function. Nevertheless, some visitors managed to see it and generally regarded it as the depressing remnants of a formerly promising assemblage of natural history, with some ethnography.

Sir George Grey and the civil service museum 'amateurs'

Grey was one of the most forceful and dominant colonial governors of the nineteenth century, not least in his promotion of scientific and intellectual objectives. He administered South Australia, was twice Governor of New Zealand as well as of the Cape and later became premier of New Zealand after he had left official service. He had a

considerable interest in natural history and anthropology, was himself a major collector and put together a library of note.[22] He set out to create his own environmental laboratory on an island he owned in New Zealand.[23] As Governor of the Cape from 1854 to 1861 he instituted the building of a new library and museum building. Grey's initiative reveals the extent to which the museum was not in fact the product of the liberal-mercantile group at the Cape who sometimes have been seen as the fount of literary and scientific endeavour. Although the museum was never adequately funded, its original founders were Smith (in imperial government service) and Somerset, the supposedly philistine governor. When placed in the hands of private bodies, the South African Institution and the College, it languished and nearly died. Again, it was a governor who revived it. Nevertheless, when an appeal for donations was issued after the refounding, the document announced that the purpose of the SAM was to provide 'practical information' to 'the mercantile community', as well as 'the instruction of youth'. The list of articles required was once again largely economic, though 'specimens of Native art and manufacture' were also mentioned.[24]

Yet Grey's ambitions were not matched by budgetary support and the museum was to remain insubstantial until the last quarter of the century.[25] Before the Governor's ambition was realised, the refounded museum yet again put together a coalition of British, colonial and German interests. Grey had consulted Richard Owen, the director of the BM (Natural History) in London about the possibility of securing a competent biologist for the Cape. But professionalisation had not yet advanced sufficiently to free such a figure from other duties. Owen recommended Edgar Layard (1824–1900), the son of a high-ranking officer of the East India Company who had followed his father into that service in Ceylon (Sri Lanka). Sir Austen Henry Layard, who had caused such a major cultural storm with his Assyriological excavations at Nineveh in Mesopotamia and with his exhibits in London, was his elder brother. Edgar Layard had developed a considerable interest in natural history in Ceylon, notably in ornithology and conchology. Grey duly recruited him for the Colonial Secretary's office at the Cape,[26] but he also had other plans for him. Grey appointed a commission to look into the possibility of creating a properly constituted museum. This was chaired by the Colonial Secretary, Rawson A. Rawson and its most influential member was Charles Aken Fairbridge (1824–93), a local attorney.[27]

It duly recommended favourably, as the Governor intended, but proposed that the museum should be funded by a (niggardly) grant of £300. The intention was that the museum should also receive private funding, by way of subscriptions from its colonial supporters. The South African Literary and Scientific Association (which had only

loaned the collection to the South African College) obediently proposed that the original materials should be handed over, and the reconstituted museum was proclaimed by a Government Notice of 1855. The trustees were to be Rawson, Dr Ludwig Pappe, an apothecary and notable botanist (from 1858 the colonial botanist), and Sir Thomas Maclear, the Astronomer Royal, the latter representing the subscribers. No fewer than 125 paid up their guinea subscription to add to the museum's funds, probably to curry favour with the Governor.[28] Yet, as well as the collection, the museum did represent some continuity from the older foundation. Maclear, Pappe and Charles Bell (the surveyor general), influential in the affairs of the Association, were former associates of Andrew Smith.

Layard was expected to look after the museum in his spare time (with a £100 stipend) and no full-time curatorial salary was paid until 1876. Indeed, funding was long going to be a problem. Rendering the museum's financial well-being dependent on public subscriptions to supplement official funding was a dangerous policy. Such subscriptions readily slip away. Transforming intention (and the kudos of appearing on a list of supporters) into payment is always insecure. Moreover, the public awareness of the government subvention leads to a sense that this should be enough. This is certainly what happened. In 1856 there were supposedly as many as 311 subscribers, though the subscriptions collected seem to have amounted to only £246.[29] This went into steep decline until in 1895 only £6 was collected. The other problem was that the museum collection continued to be highly mobile. The first move was from the South African College to rooms above a bookseller in St George's Street.[30] Soon the trustees of the museum had to take over the bookseller's lease in order to keep the museum there. Layard wrote a description of the museum in this location: it seems to have been a 'fantastic jumble' with one case 'containing a mixed assortment of birds' eggs, Egyptian and Greek relics, casts of celebrated men, and lastly an embroidered Greek jacket worn by the Poet Byron, an interesting relic. . .'[31] But the museum had at least been given legislative backing by an Act of 1857,[32] interestingly, largely based upon the Act of 1853 setting up the Australian Museum in Sydney, though the latter was given more adequate funding.[33]

But Grey and others had grander ambitions. It was resolved that there should be a new library building with the museum located in the same structure, and the Governor organised the transfer of some land from the Botanic Gardens for the purpose. An architect, W.H. Köhler, was appointed and prepared an ambitious neoclassical design supposedly based on the Fitzwilliam Museum in Cambridge. A Library and Museum Building Committee was formed and received evidence from

Layard, who proposed that the museum had great value for the colony's international reputation; that the role of the museum in education should never be underestimated; and suggested that visitors from the frontier and other parts of the interior always made a point of visiting it while in the capital. In effect, he was arguing that it already played a role in a sense of local colonial nationalism. He also advocated the need for a proper building in order to enhance conservation arrangements, visitor comfort and adequate display space.

The fierce opposition of some elected members of the legislature seems to have been turned aside, although jealousies remained since the new building was going to be somewhat grander than that used by the legislative council itself. Moreover, as always happens, costs escalated dramatically and eventually stood at £13,000. Yet the building seems to have gone up with extraordinary speed, partly built by convict black labour.[34] It was handed over in November 1859, with the portico looking out over the Government Gardens, the library in one wing and the museum in the other, neatly representing the twin arms of intellectual endeavour.[35] The official opening took place in September 1860, performed by Queen Victoria's son Prince Alfred. In 1864, a statue of Grey was erected in front of it, neatly symbolising his personal and official support for the two institutions. Today the building is occupied by the South African Library and the museum stands facing it at the other end of the Government Gardens.

But this did not solve Layard's financial difficulties. He had to raise a loan to complete the curator's offices and it has even been suggested that he paid some money out of his own pocket.[36] The question of full-time, professional staff was also by no means resolved. If Layard was strapped for cash, time and staff, he also had a considerable curatorial task, for the old collections had suffered from neglect: some specimens had been lost and others damaged. Captioning and cataloguing must have left much to be desired. He worked at the museum early mornings and evenings and performed his civil service duties during the day. Only in 1859 was he permitted to devote one day a week to the museum, but even that was granted in a parsimonious manner: he was expected to catch up on his civil service work during the evenings. When Grey was reappointed Governor of New Zealand in 1861 he announced that Layard would accompany him as private secretary. Though it seemed like a setback, this ultimately helped the museum.[37] Layard was able to visit museums in Auckland, Sydney, Melbourne and Adelaide, made much use of these contacts in the future, and returned to the Cape in 1862. His situation was greatly improved since he was given a sinecure (Arbitrator to the Mixed Commission for the Suppression of the Slave Trade) and was able to devote much of his time to the museum.

A catalogue of the collection, which he had prepared in 1860, was published on his return. In this, Layard revealed a somewhat whimsical character. In his introduction he wrote that 'man is omnivorous, disputes for territory, and unites with his fellows for the express purpose of destroying his own species'.[38] He announced that the museum was organised according to the Cuvier system with nine orders of mammals and also told various droll stories about the hazards of collecting.[39] Later he revealed his continued adherence to his old specialism of ornithology by publishing, in 1867, *The Birds of South Africa*. But he was a polymath, collecting material relating to zoology, mineralogy, palaeontology, archaeology and ethnography. He also developed an interest in marine biology, particularly mollusca.[40] Like many early curators, he accepted 'curiosities' of all sorts. He preserved some significant, but much damaged, zoological specimens from the old collection (including extinct species), recognised the significance of the Captain Cook material and took over the Dessinian coins and medals languishing in the library.

Like the good civil servant he was, Layard instituted decent record-keeping. Among the museum records are letter books, which indicate just how extensive his correspondence was. He created a network of exchanges that covered a large part of the world, communicating with scholars and curators in Denmark, Britain, Germany, France, Switzerland, Canada, the USA, Brazil, and elsewhere in South Africa. He was also in touch with the Asiatic Society of Bengal and with his Australasian contacts. He claimed that his ambition was to turn the museum into a treasure house of specimens from around the globe. This probably impractical ambition was effectively abandoned by his successor and by the beginning of the twentieth century, the museum was consciously specialising in southern Africa, at least in the scientific field. But though Layard was assiduous in maintaining the museum and setting up some good practice, he was not a trained scientist, did little fieldwork,[41] and continued to collect whatever came his way. He left the Cape in 1870, resigned in 1872 and returned to England.[42]

Layard's successor, Roland Trimen (1840–1916), had a solid background in entomology but, again, was a civil service clerk who was given Friday off to run the museum. Layard had tried to block his appointment alleging that he had an insufficiently diverse knowledge of natural history, that he dealt commercially in specimens, and that he had done very little while acting curator during Layard's leave in 1866–67. But potential curators were not ten-a-penny in Cape Town and there was no thought yet of advertising overseas. Like Layard, he was initially given an extra £100 per annum as curator. In 1875–76, the museum budget was still a meagre £350, and not a high priority

for the colonial administration. When Anthony Trollope visited it in 1877, he thought the stuffed animals were very dilapidated and Trimen confessed to him that they were a 'poor lot'.[43] Trimen was indeed a more notable scientist than Layard, with an international reputation as a lepidopterist, distinguished enough to be elected FRS in 1882. While Layard was a taxonomist, Trimen did serious research on protective resemblance and 'mimicry' in animals. Like Layard he was not a graduate, but the University of Oxford gave him an honorary MA in 1899. He published a large number of papers in a variety of journals, was a correspondent of Charles Darwin, and attended international conferences on phylloxera at Bordeaux in 1881 and the zoological congress in Paris in 1887. He was also secretary to the Cape premier, J.C. Molteno, on a mission to Britain in 1876.

Like Smith he was able to combine official duties with fieldwork, accompanying the Governor (as his private secretary) on visits to Griqualand West and Namaqualand in 1872–73 and to King William's Town on the Eastern Cape in 1877. He had published a number of papers and a two-volume work on butterflies[44] at the time of his appointment and wrote many more papers while curator from 1872 to 1895.[45] During these years the staff remained minimal, little more than a taxidermist (later with an assistant), a clerical assistant from the 1880s, and an attendant. Both Trimen and more particularly his successor (but one) Louis Péringuey were able to exploit their entomological expertise for the benefit of Cape vineyards when they were attacked by phylloxera. Indeed, Péringuey (who became an assistant in the museum in 1884 and was acting curator on several occasions) was appointed inspector of vineyards and colonial viticulturalist in 1885.

The new building and tentative professionalisation

In the course of the 1880s it became increasingly apparent that both the museum and the library were hopelessly short of space. The museum consisted of only one room, to which balconies had been added in 1868 and 1876. The solution was that the library should take over the whole of the original building while the museum would move to the other end of the Government Gardens. Trimen wrote the brief for this before retiring to England and funds were placed in the estimates in a number of years. The new building, designed (after a competition) by J.E. Vixseboxse, the State Architect of the Orange Free State, was completed in late 1895 and opened in 1896. It was built 'in a style somewhat reminiscent of the transitional Gothic-Renaissance Antwerp Town Hall'[46] and clearly represented the growing ambitions of both colony and city. The total cost of construction and fitting out was £28,000 and

SOUTH AFRICAN MUSEUM, CAPE TOWN

2 South African Museum, Cape Town. The original building by J.E. Vixseboxse, completed in 1895.

the operating budget was considerably enhanced.[47] This transformation in the museum's fortunes as a marker of colonial identity was largely based on diamonds.[48] Cape budgets expanded with the economic impetus of the burgeoning mining at Kimberley in the previous twenty years.[49] Moreover, railways, roads, telegraphs and docks had pressed forward modernisation in the same period.

Meanwhile, the scientific credentials of the museum grew along with the development of educational and other institutions at the Cape. The South African College was expanding. The South African Philosophical Society was created in 1877 (transformed into the Royal Society of South Africa in 1908), and the South African Association for the Advancement of Science (SAAAS) was founded in 1902.[50] In 1896 the museum was to make a stride towards professionalisation. With the new building in prospect and expansion in scientific provision apparent, it is significant that the trustees of the museum decided to advertise abroad for a new curator (now upgraded to director), creating an appointing panel of distinguished figures in London.[51] This process turned up William Sclater, a science teacher at Eton College. He was educated at Winchester and Oxford, had field experience in British Guiana (Guyana) and had been deputy superintendent of the Indian Museum in Calcutta. Here was a highly educated figure who had imperial experience, including working in a museum. He was to have

a relatively handsome salary of £600 per annum. Sclater quickly made his mark by organising, for the first time, Dutch labels for the exhibits and also arranged for Sunday opening. Although he so obviously represented British imperial networks,[52] Sclater clearly understood the role that the museum was to play in both a fully rounded (white) colonial identity and in public accessibility. He founded *The Annals of the South African Museum*, a scientific journal published from 1898, and reorganised the museum into six departments.[53] There were now two other curatorial staff (including Péringuey as Assistant Director) and honorary appointments were made from among the professors of the South African College.[54] Thus, each department had either a full-time or honorary head.[55] The leap in scientific respectability, in research activity (the Cape Geological Survey was also located in the museum for a period) and in publications was apparent.

Despite the manner in which Sclater clearly revolutionised the workings of the museum, it seems that he did not get on with the trustees. The absence of a full-time curator had encouraged their dominance, and a power struggle ensued. There were disputes about the editorship of *The Annals* and also over the question of leave. Some trustees may also have found Sclater cavalier in his approach to the budget. He pre-empted dismissal by resigning in 1906, returned to England, and worked for over thirty years at the BM (Natural History). Together with Smith, Layard and Trimen, he was the fourth expatriate curator/director. Senior museum staff at the Cape seem to have been less committed to the colony than was the case in Canada, Australia or New Zealand. Like Smith, they were essentially imperial appointments and may well have wished to plug themselves back into metropolitan science.[56] It would seem that the trustees considered that their attempt to give the museum a higher scientific profile, to connect it further into imperial networks, and to appoint a figure with an international aura had failed. The Assistant Director, Péringuey, was now appointed without competition.

By the end of the nineteenth century, white identity was also to be expressed through observation of the 'Other'. The 1897 Annual Report contained the first contribution from the anthropology department by its head, Péringuey. Its room in the new museum was relatively small, but Péringuey laid out a prospectus for the future. He wrote that there was a considerable need for 'exact models' of the 'native races'. This new interest had some basis in the past. Trimen had exhibited very little interest in ethnography, although he did accept from Cecil Rhodes a gift of the soapstone birds and other items from Theodore Bent's excavations at Great Zimbabwe (there was no museum in Central Africa at the time). Earlier, Layard had begun the museum's fascination with

anthropological 'figures'. Steedman's 1833 display in London (see above) had included eight modelled figures of the 'four principal tribes' (Xhosa, Sotho, Khoe and San), prepared with the advice of Charles Bell. These were acquired by J. van Reenen and presented to the museum.[57] Although they subsequently disappeared and no photographs survive, they started a tradition which continued into the twentieth century. In 1905 the British Association for the Advancement of Science (BAAS) held its annual meetings in South Africa and the museum was closely involved with its deliberations when in Cape Town. The Director of the Museum für Völkerkunde, Berlin, Felix Luschan, a physical anthropologist, paid a visit and suggested to Sclater that casts should be made of the Bushmen (San).[58]

This idea seemed to find immediate favour. It was thought that the San were doomed to disappear and they had, indeed, been killed or marginalised by frontiersmen and settlers. They were also considered to be the original human inhabitants of the Cape, representing a throwback, a sort of living archaeology that would offer insights on the past as much as on the present.[59] Some whites, however, saw them as no more than advanced primates, a justification for the brutality to which they were subjected. Responding to Luschan, a taxidermist of Scottish origins, James Drury, started making such casts from living subjects (the process allegedly involved no pain) in 1907 under the directorship of Sclater's successor, Péringuey.[60] In 1911 Drury made casts of some thirteen people, continuing to do so until the 1920s, using peoples on the fringes of the Cape and later in South-West Africa, as well as prisoners and others held within the colony. In the end, he made casts of more than 65 people. These became part of human habitat groups at a later date, serving to re-emphasise the notion of indigenous humans, 'children of nature', as part of the natural history of the region. They were so lifelike that some visitors thought that, like the animals on display, they were 'stuffed' specimens – a thoroughly alarming response.

They were also used to promote the theory of racial difference between the Khoe and the San, part of the contemporary desire to create repeated subdivisions in the races of humans. Indeed, it is possible that African and coloured visitors to the museum saw them as representing people as alien to themselves as to the whites.[61] The casts became so celebrated that some are still shown in the museum, though now clothed more appropriately and with much more sympathetic captions than before.[62] Nonetheless, they continue to offer a static performance of the primitive, a classic instance of stereotyping and objectifying, which has survived efforts to reinterpret the lives and culture of the Khoesan since the 'great transformation' of the 1990s.[63] This fascination with the San was to lead to much more dubious developments (see below).

Louis Péringuey (director from 1906 until his death in 1924) had been involved with the museum since joining its staff in 1884, acting as curator in 1886, 1889–90, 1892 and 1895. He was born in Bordeaux in 1855, travelled widely, mainly in the French empire, in the 1870s, and arrived in Cape Town in 1879, initially teaching French at the Diocesan College at Rondebosch. In a sense, he was another 'amateur', neither a qualified scientist nor a professional with museum experience, but a practical entomologist. It has been alleged that, because of the Franco-Prussian War, he had a considerable dislike of Germans, which was ironical given their considerable influence upon the museum.[64] As an autocratic figure, his effect on its development was considerable. He initiated a major concern with prehistory, partly as a result of picking up handaxes and other Palaeolithic implements when exploring vineyards in the course of his viticultural duties.[65] From 1911 he organised excavations at cave sites on the south coast (actually excavated by Drury) as well as other sites nearer Cape Town. He also developed the museum's interest in rock art, including various collections of copies. He encouraged Drury over the casts, involved the museum in natural historical and anthropological surveys in South-West Africa after its capture from the Germans by South African forces,[66] and developed the museum's holdings of cultural exotica.

In 1906 the trustees declared an interest in the greater development of 'the ethnological and antiquarian side of the collection' by pursuing the 'rich field for making the institution in some degree representative of the whole continent' through acquiring materials from recent excavations in Egypt and material from 'a curious civilisation partly indigenous and partly exotic' in Nigeria.[67] This was of course a plea for more funds. The ethnographic collection had never been properly organised and it may be that its chaotic state served to dilute full-blown racial constructions.[68] Nevertheless, the annual reports distinguished between 'work of civilised races' and work of 'uncivilised races'.[69] But the desire for exotica was now prominent: from soon after the Anglo-Boer War until the 1930s, the SAM contributed to the Egypt Exploration Fund, a system used to finance excavations in exchange for antiquities sent to the donor museum. Under this scheme artefacts were received from Saqqarna, Tarkhan,[70] and Tel-el-Amarna, some of which remain on display at the Iziko Slave Lodge.

During 1912–13, the museum also received 'idols, ornaments, arms' and other objects from Northern Nigeria, Palaeolithic material from Swaziland, and also Peruvian items. The 1914 Annual Report again mentioned Egypt as well as rain-making artefacts from Southern Rhodesia (Zimbabwe), and items from the 'Basutos' (Sotho) and 'Barotse' (Lozi) peoples outside the borders of South Africa. Another

field developed in this period was the coin collection, originating in Dessin's collection. In 1902 Hadji Suleiman Shah Mohammed, who had made numismatic gifts, donated a sum of £100 to be invested in order to enhance the coin assemblage.[71]

Péringuey also promoted palaeontology, which became one of the prime scientific interests of the museum. Some fossil collections had been in the museum from an early date, but from the beginning of the twentieth century the palaeontological riches of the Karoo became increasingly apparent. Dr Robert Broom became honorary curator of palaeontology in 1905 and the museum's holdings began to grow into a collection of world renown. Péringuey initially supported Broom's efforts, but they fell out when Broom removed specimens (with permission) for lecturing purposes in Europe and America, later selling them.[72] Broom's plaintive letters about his banning from the museum can be found in the Cape press in the early 1920s.

The museum weathered some political storms in this period: after union in 1910 it became a provincial responsibility, but it was recognised by the trustees that this might damage its reputation and funding. In 1913, the Union Government was persuaded to restore its national status (shared only with the adjacent National Gallery and the Transvaal Museum in Pretoria).[73] This helped to protect its budgets and inaugurated a period of expansion into new additions to its building. However, supervision of the Cape herbarium (in the museum from 1905) was retained by the province and later went to the botanic garden at Kirstenbosch. Moreover, the close scientific relationship with tertiary education (the University of Cape Town was founded in 1916, replacing the examining University of the Cape of Good Hope of 1873) moved into a different phase when the honorary curatorships were abolished in 1923. After that date all the departments were in the charge of professionals within the museum. Meanwhile, as white power, racial separation and pseudo-scientific racist thought grew, the museum became involved in some very dubious practices. Péringuey was at the centre of this, linking the museum's concern with physical anthropology to the interests in the Philosophical Society and the SAAAS.[74]

The body snatchers

The 1860 Annual Report mentioned a display of the osteological collection 'for the use of the student of comparative anatomy'. Layard's *Catalogue* listed the skeletons and crania of humans, including 'Caucasian, Mongolian, Ethiopian or Negro' and recounted the racial ordering that these indicated. But in the twentieth century, this kind of collecting was taken much further and became more closely involved

with racist thinking. Early in the century, the museum was caught up in the trade of human remains, which became a feature of museums everywhere. This was all part of the project to establish biological distinctions among the races – an obsession of contemporary anthropology – that were largely illusory.

In December 1905, the curator W.L. Sclater wrote to an anatomical biologist in Britain, Dr Frank C. Shrubsall, that he had sent a case of skulls by the mail steamer.[75] Shrubsall intended presenting a study of these to the Anthropological Society, and Sclater hoped to put the museum on the scientific map.[76] The accompanying inventory listed no fewer than 34 skulls and in one or two cases 'imperfect skeletons' of a number of South African peoples, including 'Kaffir' (Xhosa?), 'Bechuana' (Tswana), Herero, Hottentot (Khoe) and Bushmen (San). This represented a significant stage in a disturbing process, which has been charted by Martin Legassick and Ciraj Rassool.[77] It is clear that this obsession emerged not only from the highly charged state of physical anthropology in the period, from the 'mystique and the presumed authority of science',[78] but also from the kind of competitive conditions that we have already encountered in North America. Grave looting and the body trade were propelled by considerable rivalries, by the notion that only large collections were of any value, and by a degree of chauvinism.[79] Modern histories of museums seldom mention this aspect of their collections, perhaps confirming the notion of a conspiracy of silence.[80]

However, there seems to have been little shyness in the period itself. The records of the Albany Museum (Chapter 5) are full of references to human remains, which were acquired over a number of years in the Edwardian period.[81] This museum was involved in two excavations in pursuit of skeletons, at Norval's Pont and at the Kowie sand hills near Port Alfred.[82] In the latter case, it seems to have failed to secure a permit; the magistrate intervened and confiscated some of the remains.[83] The meeting of the BAAS in 1905 brought the Director, Schonland, into contact with museum directors from Europe and America, and he realised the exchange possibilities of such remains.[84] A missionary in Namaqualand (Rev. Kling) started sending materials, but there were repeated disputes as to whether these were true 'Bushmen' or not. Even if we make a distinction between genuine archaeological remains and more modern burials, it is still clear that there was a scramble going on.

In the case of recent interments, the body snatching started out with a form of official sanction, since governments were eager to appease international scientists, later to support their own museums by enacting legislation banning exports. Although there had already been much activity in the field, the Cape scramble was partly driven by the arrival

in 1909 of Dr Rudolf Pöch from the Imperial Academy of Sciences in Vienna with considerable diplomatic support for his exploits. Interested also in photography and sound recordings, he later conducted an 'anthropological' survey in German prisoner of war camps during the First World War.[85] In South Africa, he used highly dubious agents to add to his collection – including a Hispanic American called Mehnarto who dug up and despatched at least thirty-one skeletons. Another agent who sought out clients for the purchase of skeletons was an adventurer called George St Leger Lennox, known as 'Scotty Smith'. What is alarming about these practices is that supposedly 'archaeological' concerns rapidly shaded into an insensitive interest in burials supposedly to establish racial anatomical 'types'. Both Mehnarto and Lennox dug up recently buried bodies and boiled them down. It is even suggested that Lennox was prepared to kill to create a quicker route to body acquisition.[86]

Mehnarto was also eager to acquire San cave paintings and incised rocks. These paintings could only be removed if their rock 'canvas' was hacked off and he acquired at least 400 paintings by such brutal destruction of San sites. Within South Africa, at least two museums were now in the same business, the SAM and the recently founded McGregor Museum in Kimberley (whose curator Miss Wilman had moved from the SAM in 1908), while museums elsewhere in southern Africa soon joined in with these practices of dig and grisly grab. The southern African curators were soon agitated about the losses and, together with pressure from the Medical Office of Health and the law officers, combined to promote the passing of the Bushmen Relics Act through the Union Parliament in 1911. But although the wholesale digging up of bodies inspired some sensitivities (not least when relatives naturally protested about what was happening to recently buried family members), the curators were not so much concerned with the morality and lack of respect of these ghoulish activities as with the fact that so much material was leaving the country.[87] In fact, skeletons continued to enter museum collections for several more decades after the passing of the Act. Human remains (though many may have been archaeological) continued to arrive in the McGregor museum and the SAM until the 1980s and 1990s. In Cape Town they were initially stored in an outside shed.

Visitors and staff

The question of the museum's visitor profile is an interesting one. Visitor numbers are always suspect because the means of counting were never very sophisticated, but the first report to mention a figure was 1875,

when it was claimed that over 23,000 people had been to the museum.[88] This fluctuated wildly over the next few years – down to 15,000 in 1881 and 11,000 in 1882 when it was claimed that a smallpox epidemic had reduced the numbers. The numbers remained low, however, before escalating again at the end of the decade. In 1895, it was suggested that a reduction in railway fares had increased the numbers to more than 38,000, while the new building pulled in well over 50,000 in its first year. After that there was a steady climb to almost 100,000 in 1906, followed by further fluctuations until a peak of 283,000 was reached in 1919, supposedly as a result of the many troopships calling at the Cape.

But much more interesting than these raw figures is the breakdown first offered in the annual report of 1910.[89] In that year it was suggested that over 43,000 white men and 26,000 white women visited the museum. It is probable that in the nineteenth century male visitors were preponderant and the latter figure represented a growth in the twentieth. But more intriguingly there was also a breakdown by colour. It was said that over 8,000 'coloured' men and 7,000 'coloured' women had also visited. It is interesting that the male/female balance was more even in this category, but what did 'coloured' mean? Did it refer only to the Cape Coloured community? Did it include Africans? At any rate this breakdown by whites and coloureds continued for a number of years, with males continuing to predominate in the white figures. Then in 1927 'native visitors' are listed separately for the first time: over 2,000 men and 864 women out of a total of over 141,000. This may have been under the influence of the Director Gill, a Quaker. In 1934 African visitors rose to 2,484 and 1,958 respectively (total down to 127,000).[90] The division into whites, coloureds and 'natives' continued until 1957; from 1958 the division was between European and non-European; and from 1964 visitors were not subdivided as to ethnicity or gender. It is difficult to interpret these changes: do they represent the onward march of apartheid? Is it inherently unlikely that they reflect a greater sensitivity to racial categories?

There is no evidence that Africans were ever formally excluded from the museum, but informal exclusion can happen in many forms (including a sense of alienation, a feeling that this is part of a whites-only domain, lack of opportunity or funds, absence of welcome, attendant refusal of admittance, or harassment once in). But we can be sure about the composition of the staff. This was almost entirely white, with only a few coloureds performing menial tasks. At the time of the new Act in 1925 a pension scheme was introduced for whites only. In 1968, new superannuation arrangements were again not extended to coloured staff.[91] Moreover, the museum remained a predominantly Anglophone institution until well into the twentieth century. The

annual reports were published only in English until 1938 when they started to appear additionally in Afrikaans. The names of members of curatorial staff remain heavily (though not exclusively) Anglophone up to modern times.

Expansion: science and race

During the inter-war years, the museum aspired to greater scientific respectability, expanded into new galleries, experimented with innovative forms of display, and developed greater educational outreach to schools. The original act of 1857 was amended in 1925 to include extra trustees from the Royal Society of South Africa (RSSA) and from the Cape Town municipality, representing both new scientific connections and a wider local constituency.[92] After Péringuey's death, the trustees again took the museum into the international field. An internal candidate (Barnard) was passed over and the post was advertised in Britain. The successful candidate, Leonard Gill, had university qualifications in geology, zoology and palaeontology and, having completed a PhD, had experience of museums in Leicester, Manchester and Edinburgh. Professionalisation had finally arrived, symbolised by the fact that from 1924 all the curatorial staff were graduates. Gill found the museum crowded and the displays faded. He and his staff quickly lobbied for more space (new buildings and extensions were built in the grounds), developed fresh display modes – particularly dioramas and habitat groups – expanded the library, appointed a full-time post in anthropology in 1933, and (with the help of a Carnegie grant) started a schools museum case service in 1936. Further imperial connections were made when the BAAS paid another visit to South Africa in 1929 (though the museum was less involved than on the previous occasion) and the Miers and Markham team visited South Africa in 1932. This helped to stimulate the foundation of the Museums Association of South Africa.[93]

Although there were considerable financial problems as a result of the depressed trading conditions of the early 1930s, the museum enjoyed its largest (and mainly scientific) staff numbers in this period. Marine biology became a significant area of research.[94] Palaeontology, entomology, geology and botany remained important while archaeology and ethnology became more prominent.[95] The number of women on the staff also grew at this period. Moreover, social history, generally the cultural history of whites, grew in importance at this time. An eighteenth-century residence, the Koopmans de Wet house, had been acquired by the museum just before the First World War. Various other collections, such as the de Pass, of antiquities from ancient Mediterranean and Asiatic cultures,[96] the Talbot of furniture, the Judge

Davis of Chinese porcelain, the Robinson of South-East Asian silver and the Holler of Cape silver were all acquired by the museum in the 1930s and 1940s. This was an era when wealthy businessmen and professionals, who had collected in earlier years, were dying and sought to commemorate themselves by placing their passions in the public domain. But it was clear that the range and specialities of the museum were changing. Ultimately, a Social History Museum was founded in the early 1960s, in the old Slave Lodge and Supreme Court building, and it became a separate institution. It dealt in exotic cultures and the artefacts of whites at the Cape, but more recently it has taken on the role of commemorating the institution of slavery and the lives of slaves; it has been reunited with the main museum through the Iziko organisation, which controls the various museums and houses in Cape Town.[97]

In 1954 new legislation brought the museum directly under government authority, administered by the Department of Education, Arts and Science. This was part of the Nationalist thrust to bring all aspects of the state under its control. From now on the trustees were political appointments under the control of a senator of the ruling party. It was clear that museums would not be permitted to act as liberalising or multi-racial institutions. From 1956 the directors[98] and most of the staff were South African born with a continuing emphasis on science. Though some international connections were maintained the museum became much more inward-looking. The SAM was in effect 'nationalised'. Moreover, as late as the 1970s, the museum was enlarging its ethnographic and cast displays of San and Nguni peoples: apartheid trustees sanctioned such exhibits as illustrative of the 'Others' who were supposedly ejected from the white state by 'separate development' policies and the creation of the so-called Bantustans.

But now Iziko has overturned such myths. The word means 'hearth' or 'centre of cultural activity' in Xhosa and neatly represents the re-Africanisation of the museum organisation since the 'transformation'. Before modern times, the museum projected the notion that the indigenous peoples of the Cape were the supposedly doomed Khoesan. Thus it illustrated the authority of white science both in its implicit justification for white rule and also in the historical myths of Cape settlement. Now the Nguni people of the Eastern Cape (who include the Xhosa) have come centre stage, although for Cape Town this represents, in a sense, another myth.

Notes

1 The Nationalists probably never regarded museums or art galleries as particularly important or potentially subversive.

2 Sometimes these policies were exercised in an informal way, by white attendants refusing to permit young blacks or coloureds to enter the museum. Some curators will deny that this ever happened, but those who were formerly debarred from entry are easy to find.
3 Brian M. Randles, *A History of the Kaffrarian Museum* (edited by Pierre Swanepoel and Manton Hirst (King William's Town 1984).
4 Clive Quickelberge, *Collections and Recollections: the Durban Natural History Museum, 1887–1987* (Durban 1987). The Natal Government Museum in Pietermaritzburg (1904) started publishing its *Annals* in 1908, as did the Transvaal Museum.
5 J.W.B. Gunning, 'A Short History of the Transvaal Museum', *Annals of the Transvaal Museum*, 1, 1 (1908), pp. 1–13. For the museum's survival during the Anglo-Boer War, see E. Grobler, 'Die Staatsmuseum van die Zuid-Afrikaansche Republiek, Die Anglo-Boereoorlog en Regstellende Aksie Oktober 1899–December 1904', *Research by the National Cultural History Museum*, 9 (2000), pp. 1–37. I am grateful to Jane Carruthers for a copy of this article.
6 'Provincial Museums of the Cape Province' (Cape Town, Department of Nature Conservation, 1971) offers a useful compendium.
7 For the early period, see R.F.H. Summers, *A History of the South African Museum, 1825–1975* (Cape Town 1975), chapters one and two. Although Summers was a professional archaeologist and museum curator, this 'official' history contains neither footnotes nor bibliography, and omits any reference to race, in respect of collections, staff or visitors. See also the pamphlet 'The SAM, Cape Town, 1855–1955' (Cape Town 1955), which treated the re-founding of the museum as its true origins in order to celebrate a centenary.
8 Percival Kirby, *Sir Andrew Smith MD, KCB, his Life, Letters and Works* (Cape Town 1965).
9 The Colonial Office in London declined Somerset's request to give Smith a curatorial salary of £200.
10 *Instructions for preparing and preserving the different objects of the animal, vegetable and mineral Kingdoms* (Cape Town 1826), South African Library (SAL).
11 The letter is quoted in full in Kirby, *Sir Andrew Smith*, pp. 56–7.
12 He developed an interest in their origins and published on the question of racial distinctions.
13 Another member of the family, Alexis Verraux, was employed by the museum later in the century.
14 Thomas Duthie Diaries, Monday 3rd September 1832, SAL MSS collection, MSC 9.9 (1), 359 (1832). Also catalogued as STOC/4793 Rex Family.
15 John M. MacKenzie, *The Scots in South Africa: Ethnicity, Identity, Gender and Race* (Manchester 2007), pp. 73–4. Saul Dubow, *A Commonwealth of Knowledge: Science, Sensibility and White South Africa 1820–2000* (Oxford 2006), chapter one.
16 Smith also published in the *Transactions of the Linnean Society* of London. The Institution's Journal survived until 1836, edited by Smith's co-secretary Rev. James Adamson.
17 Percival Kirby (ed.), *The Diary of Dr. Andrew Smith . . . 1834–46*, 2 volumes (Cape Town, Van Riebeeck Society, 1939 and 1940); William F. Lye (ed.), *Andrew Smith's Journal of his Expedition into the Interior of South Africa 1834–36* (Cape Town 1975).
18 Moffat wrote 'by the divine blessing on his medical skills, I was soon restored'. Smith treated Mrs Moffat after the birth of a son, when she seemed close to death, and 'we cannot but record how much we owe to this intelligent and enterprising traveller, for the untiring assiduity with which he exercised his professional skill'. Robert Moffat, *Missionary Labours and Scenes in Southern Africa* (London 1846), p. 151. There seems to be no evidence for Summers's assertion that Moffat did not like Smith (*History of the SAM*, p. 11).
19 Moffat, *Missionary Labours*, pp. 151–2.

20 Janet Browne, *Charles Darwin, Voyaging* (London 1995), pp. 328–30. Darwin was at the Cape in May and June of 1836. He made short excursions into the interior (and disliked what he saw), but particularly enjoyed meeting Andrew Smith, Sir John Hershel and Thomas Maclear.
21 Andrew Steedman, *Wanderings and Adventures in the Interior of Southern Africa*, 2 volumes (London 1835).
22 He handed over 5,000 volumes to the South African Library; then collected again and made a similar donation in New Zealand. Trollope described him as 'that eccentric, but most popular and munificent governor'. Anthony Trollope, *South Africa* (Stroud 2005, first published 1878), volume 1, p. 53.
23 Kawau, near Warkworth.
24 The list, published in Government Notice No. 153, 1855, included ores, minerals and fossils, soils and analyses relating to agriculture and wine production, dyes, hides, animals, plants, timbers, 'especially those of economic and medical importance'. Bizarrely, the SAM received six different donations of Inuit objects within the first six months, one from the splendidly named Miss Crapper.
25 Thus the museum benefited little from the wool boom of the 1840s or the entrepôt status secured by Cape Town during the Australian gold rush of the 1850s.
26 The Colonial Secretary was effectively the second to the governor.
27 Fairbridge was the son of a district surgeon at the Cape and, from 1846, built up a major legal practice, which included acting as legal adviser to the City Council, Union and Castle shipping Lines, Standard Bank and other major institutions. He entered the Cape Parliament in 1854, proposed the formation of the Select Committee to consider the establishment of a museum, and was subsequently a trustee. He became a friend of Edgar Layard and helped with the classification and arrangement of exhibits. He also presented items to the museum. His own library was bought by the mining magnate Sir Abe Bailey and presented to the SAL.
28 The Annual Report of 1856 included a list of subscribers. These included Langham Dale, the superintendent of education, John Fairbairn, MLA, the celebrated radical journalist and businessman, J. Rose Innes, Baron von Ludwig, and the governor himself.
29 Or should this be guineas?
30 This space was highly inappropriate since it tended to be very hot in summer.
31 Annual Report, 1856, misquoted by Summers, *South African Museum*, p. 33. The jacket had been kept by a manservant of Byron and was bought by C.A. Fairbridge. It was later sent to the Byron Museum at Newstead Abbey.
32 Cape of Good Hope, an Act to Incorporate the South African Museum, no. 17 of 1857. Its main purpose was to establish and regulate a board of three trustees to oversee 'the specimens of natural history and other public property deposited in the South African Museum [which] have now become of considerable value'. The collections should be arranged for 'public convenience' and for 'the promotion of literature and science'. One key provision was that the museum 'should be kept open, free of charge, to visitors, during at least four days in the week'.
33 This was ruefully noted in the centennial pamphlet of 1955, p. 2.
34 The convict labourers were given a celebratory dinner at the opening of the museum. Maclear presided and taught the Africans how to use knives and forks. Dubow, *Commonwealth*, p. 68.
35 Ibid., p. 3. This pamphlet suggested that this association of library and museum reflected that of the great library in Alexandria, a parallel used by Grey in his speech at the grand opening.
36 Summers, *History of the SAM*, p. 38.
37 The Rev. John Fry, Rector of St. Paul's Rondebosch 1836–61, who had been acting curator of the museum in 1856–57 now resumed this role.
38 *The Catalogue of the South African Museum, part I Mammalia, compiled by the Curator E.L. Layard*. This is a bibliographical curiosity since the date 1861 appears inside and 1862 on the outside cover. This is explained by Layard's absence and the delay in publishing until his return from Australasia. The quotation comes from p. 9.

39 The conchological collection was organised according to Lamarck; Lepidoptera to de Jean; minerals to Birzelius.
40 Summers (p. 29) suggests that Layard had no fewer than 38 species of mollusca named as layardii to honour his work in this field.
41 However, Layard was sent by the Governor on a survey voyage by HMS *Castor* between October 1856 and March 1857, visiting Mauritius, Mombasa, Zanzibar, Madagascar and the south-east coast of South Africa, pursuing marine biology. Annual Report,1860 and in the *Dictionary of South African Biography (DSAB)*, vol. 1, pp. 467–8.
42 He became British consul in Para, commissioner in Fiji, and British consul in New Caledonia before retiring to Budleigh Salterton. He added to his ornithological collections in all of those places.
43 Anthony Trollope, *South Africa*, volume one, pp. 52–3.
44 *Rhopalocera Africae Australis: a catalogues of South African butterflies* . . . (London 1862–66).
45 *South African Butterflies: a monograph of the extra-tropical species* (London 1887–89), 3 vols.
46 Hans Fransen, *Guide to the Old Buildings of the Cape* (revised edn, Johannesburg 2004), p. 365. I am grateful to Nigel Worden for this reference.
47 The budget from 1899 was in excess of £2,500. From 1904 it exceeded £3,600, rose to £4,600 in 1907, dropped back for a period and reached £5,400 in 1913.
48 A new era was reflected in the fact that in 1891 there was a break-in at the museum and burglars made off with the Stonehurst collection of rough diamonds collected in the early days of the diamond diggings. Some were subsequently recovered. Annual Report, 1891.
49 Though the museum did not play as much of a role in this as it might have done. Its acting curator in 1871, H.W. Piers, lamented the fact that its mineralogical collection was 'too cosmopolitan and general', not to mention ill-sorted, to be of much help in identifying the mineral potential of the region. This was in an article in the *Cape Monthly Magazine* which paid a good deal of attention to museum matters. Dubow, *Commonwealth of Knowledge*, p. 103.
50 For a contextualised history of the RSSA, see Jane Carruthers, 'Science in Society: the Royal Society of South Africa', *Transactions of the RSSA*, 63, 1 (April 2008), pp. 1–30.
51 This panel comprised Sir William Flower of the BM (Natural History), John Murray of Edinburgh, Professors Foster (Cambridge) and Sanderson (Oxford). The 1896 Annual Report announced that the trustees had decided to 'make a strenuous effort to secure' as Trimen's successor 'a man in every way qualified to develop the Museum on the lines approved by the best modern authorities'.
52 An additional qualification, as noted in the Annual Report for 1896, was that his father, P.L. Sclater, was the Secretary of the Zoological Society in London. Taxidermy continued to be an important service in the museum and there were still hunting expeditions on its behalf to secure specimens, continuing the tradition from Smith and the celebrated hunter F.C. Selous who had sent mammals and butterflies to the museum in 1890 and 1892.
53 These were: Vertebrates, Land Invertebrates, Marine Invertebrates, Entomology, Geology and Mineralogy, and Anthropology. Palaeontology was added later.
54 George Corstorphine, professor of Geology, appointed to the department of mineralogy and geology in 1894, had already compiled a report on the geological collections, Annual Report, 1895.
55 An unsuccessful candidate for the directorship, Dr W.F. Purcell, became full-time head of land invertebrates.
56 Trimen, as well as FRS, was fellow of the Linnean, Zoological, and Entomological Societies (president 1897–98) and could not have played a full role in these bodies had he stayed at the Cape.
57 Government Notice No. 24 of 1856.
58 Von Luschan himself attempted to make such casts, but without much success.

Luschan had been in charge of the African and Pacific department at the Berlin Museum. See Markus Schindlbeck, 'The Art of the Head-Hunters: Collecting Activity and Recruitment in New Guinea at the Beginning of the Twentieth Century', in Hermann J. Hiery and John M. MacKenzie (eds), *European Impact and Pacific Influence* (London 1997), p. 32.

59 They had acted out their sad role in both the Union Pageant of 1910, celebrating the coming together of the four colonies and republics, and again in the van Riebeeck tercentenary pageant in 1952.

60 Péringuey's letter instructed Drury to pay particular attention to the genital area of his models since both male and female genitalia of San were alleged to have differences from other 'races'. Patricia Davison, 'Material Culture, Context and Meaning: a Critical Investigation of Museum Practice with Particular reference to the SAM', PhD, University of Cape Town, 1991, pp. 144–53. The other object of western prurient observation was the 'steatopygia' or prominent buttocks of the Khoesan. For an account of Drury's activities, see Walter Rose, *Bushman, Whale and Dinosaur: James Drury's Forty Years at the South African Museum* (Cape Town 1961). The most recent work on the 'Hottentot Venus' (Saartje, Saartjie or Sarah Baartman), displayed in London in the early nineteenth century partly through fascination with her anatomy, is Rachel Holmes, *The Hottentot Venus: the Life and Death of Saartjie Baartman* (London 2007). After her death at the age of 26 in 1805, no respect was shown to her body either. Her remains went to the Musée de l'Homme in Paris and she was finally returned to South Africa and buried in 2002. An account of the strangely mixed messages of her burial can be found in Steven C. Dubin, *Transforming Museums: Mounting Queen Victoria in a Democratic South Africa* (New York 2006), pp. 101–11.

61 Dubin, *Transforming Museums*, pp. 55–6, quoting Nomvuyo Ngcelwane, *Sala kahle, District Six: an African Woman's Perspective* (Cape Town 1998).

62 See Patricia Davison, 'Human Subjects as Museum Objects: a Project to Make Life-Casts of "Bushmen" and "Hottentots", 1907–24', *Annals of the SAM*, 102, 5 (1993), pp. 165–83.

63 For modern representations of San, see Robert J. Gordon, '"Captured on Film": Bushmen and the Claptrap of Performative Primitives', and Pippa Skotnes, 'The Politics of Bushmen Representations', both in Paul S. Landau and Deborah D. Kaspin (eds), *Images and Empires: Visuality in Colonial and Postcolonial Africa* (Berkeley, CA, 2002), pp. 212–32 and pp. 253–74 respectively.

64 Summers, *South African Museum*, p. 96.

65 Péringuey made an initial stab at the periodisation of the Palaeolithic and published extensively in the field. See 'The Stone Ages of South Africa as represented in the Collection of the South African Museum', *The Annals of the SAM*, 8 (1911).

66 Péringuey was quick off the mark: he first made approaches to the Union Government in 1916 and later secured funding from the South West Africa Administration for these expeditions. Drury went there to make casts of so-called Bushmen and Hottentots in 1918–19, 1920 and 1921.

67 Annual Report, 1906.

68 There were visits from Henry Balfour of the Pitt-Rivers Museum in Oxford and Alfred Haddon from Cambridge at the turn of the twentieth century and they offered some advice on ethnographic materials. Dubow, *Commonwealth*, p. 58.

69 See annual reports of the 1880s. 'Uncivilised races' was changed to 'native races' in 1890.

70 The Annual Report, 1913 announced the receipt of the second share of finds from Flinders Petrie's excavation at Tarkhan.

71 Annual Report, 1902. Hadji Shah Mohammed was a prominent member of the Cape Malay community who in 1929 left a bequest to the University of Cape Town to found an Islamic College. I.D. du Plessis, *The Cape Malays* (Cape Town 1972), p. 33. Vivian Bickford-Smith supplied this reference.

72 Broom offered them to the BM, but considered their price too low. He subsequently sold them to the American Museum of Natural History. Ownership seems to have

been unclear and Broom was reinstated in the museum after Péringuey's death. The export of fossils was banned in 1934.
73 Shaun Kirchoff, 'Museum Policy of the Cape Provincial Administration, 1910–1994, a Study of Continuity and Change', BA dissertation, Rhodes University, 1994.
74 Saul Dubow, *Scientific Racism in Modern South Africa* (Cambridge 1995), particularly pp. 36–8.
75 Shrubsall was considered an expert on southern African anatomical anthropology because he had written a study of such materials held in British collections. F.C. Shrubsall, 'A Study of A-Bantu Skulls and Crania', *Journal of the Anthropological Institute*, 28 (1899).
76 Sclater to Shrubsall, 6 December 1905. SAM Letter Book, 1905–8.
77 Martin Legassick and Ciraj Rassool, *Skeletons in the Cupboard: South African Museums and the Trade in Human Remains, 1907–1917* (Cape Town 2000).
78 Ibid., p. 2.
79 Legassick and Rassool did a specimen count in South African museums and anatomy departments, finding that (at the time of writing) the SAM had 788 specimens, the National Museum in Bloemfontein 403, Anatomy, University of the Witwatersrand 365, Anatomy, University of Cape Town 239, Albany Museum Grahamstown 168 and the McGregor Museum, Kimberley 150. *Skeletons*, p. 1.
80 However, the Annual Report of the Albany Museum, 1895, p. 6, listed 'ethnological and anthropological collections', including '189 skulls and other osteological remains of South African aborigines', and of 'the animals on which they fed'. These were presumably archaeological rather than modern. A similar listing appeared in 'Catalogue of the Contents of the Albany Museum', 1881.
81 Monthly reports of the Director to the Trustees, October 1902, August 1904, September 1905, February 1906, January 1908, February 1909, May and June 1909, August, September and October 1909, October 1910, January, February, April, June, July and October 1911, January, April, May and June 1912, November 1913, among others. Library of the Albany Museum. A list of skulls was appended to the Director's report of July 1909.
82 The Norval's Pont excavation took place in 1904. Director's monthly report, August 1904.
83 The first Kowie excavation yielded twenty skeletons. Albany Director's report June 1909. The museum sent its African employee, William, to help with these excavations. The problem over permits occurred in 1910, under Schonland's successor Hewitt. Showcases to exhibit osteological remains were ordered in November 1909.
84 Among others, material was sent to the Smithsonian in Washington, the BM in London, the University of Cambridge and the Berlin Museum.
85 Andrew D. Evans, 'Capturing Race: Anthropology and Photography in German and Austrian Prisoner-of-war Camps during World War I', in Eleanor M. Hight and Gary D. Sampson (eds), *Colonialist Photography: Imag(in)ing Race and Place* (London 2002), pp. 226–56.
86 Legassick and Rassool, *Skeletons*, p. 31.
87 There were complaints from the palaeontologist Robert Broom and the anatomical anthropologist Roland B. Dixon that the SAM did not make its collection of skulls as available to scholars as it should do. SAM Library cuttings collection. Newspaper cutting of 1923.
88 Annual Report, 1875. All the figures that follow are derived from the relevant annual reports.
89 The annual reports for 1910, 1911 and 1912 were published together in 1913.
90 No figures were given for African children, though they appeared under whites and coloureds.
91 Summers, *South African Museum*, p. 209, the only reference in the book to people other than whites.
92 Since 1904 the Cape Town municipality had been paying for Sunday opening.
93 A cutting from the *Cape Times* in 1927 (n.d.) in the SAM Library cuttings collection

indicates that the directors of the major South African museums started meeting annually in 1926, mainly concerned with questions of funding. See also C.K. Brain and M.C. Erasmus, 'The Making of the Museum Professions in Southern Africa: the Southern African Museums Association, 1936–86', *SAMA*, April 1986, pp. 2–3.
94 This had started in 1896 when the government became interested in developing sea fisheries. A marine biologist, Dr J.D.F. Gilchrist was appointed and promptly became honorary curator of marine invertebrates at the museum.
95 An article in the *Cape Times*, 10 May 1930, 'Behind the Scenes at the SAM', described many of the treasures not on view. Apart from the large research collection of fossils, this article concentrated on ethnographic materials, perhaps as propaganda for the opening of a new ethnographic gallery.
96 *Cape Times*, 28 November 1929, describes the de Pass collection presented to the SAM.
97 Although Iziko administers some fifteen institutions in and around Cape Town, only two of these (the downstairs section of the Slave Lodge and parts of the Bo-Kaap Museum) are truly representative of indigenous peoples. The District Six Museum is a private foundation.
98 K.H. Barnard, acting director and director 1942–56, born in London and educated in Cambridge. A marine biologist, mountaineer and zoologist, he spent almost all of his career at the Cape, working in the museum for more than 45 years. A.W. Crompton, director 1956–64, born in Durban, specialised in Karoo palaeontology and moved on to appointments in museums at Yale and Harvard. T.H. Barry, born in Mossel Bay, was educated in zoology at Stellenbosch, and also studied Karoo palaeontology. He moved from the directorship of the Albany Museum to the SAM in 1964. F.H. Talbot, assistant director of the SAM, became the Director of the Australian Museum in Sydney in 1965.

CHAPTER FIVE

South Africa: the Albany Museum, Grahamstown

The influence of boredom upon history should never be underestimated. The Albany Museum was partly conceived in boredom but developed in personal enthusiasms. There was a concentration of military doctors in the Eastern Cape because of the prevalence of frontier wars and the garrisoning of troops there. The lives of these doctors (four or five at any one time) must have reflected those of the soldiers themselves: long periods of routine punctuated by bursts of intensive activity when either hostilities with the Xhosa or epidemics broke out. But these were nineteenth-century gentlemen and their minds turned to the possibility of founding a society that would forward their profession.

In July 1855, four doctors (not all military), Armstrong, Atherstone, Edmunds and Hutton (who later wrote of the monotony of his life at this time),[1] together with A.L. McDonald, an officer of the garrison Ordinance Department, met and agreed to found the 'Graham's Town Medico-Chirurgical Society', electing Dr A. Melvin, Principal Medical Officer, as its first president.[2] The society sought 'to facilitate intercourse on medical subjects' and to 'collect specimens in the various departments of Medical Science in all its branches, with the view of forming the nucleus of a Museum'. Although not mentioned, presumably the example of McGrigor at Chatham was in their minds. This was also the year when Grahamstown was beginning to establish itself as a major educational centre: St Andrew's College, still prominent today, was founded then. Several other schools followed – a development important to the future of the museum.[3] The frontier garrison town was establishing its civic character.

The leading figure of the group of doctors was unquestionably William Guybon Atherstone, who seems to have had little monotony in his life. Born in England in 1814, he had arrived in the Cape as a boy settler in 1820. He was a pupil of James Rose Innes at Uitenhage, studied medicine in London, became an assistant staff surgeon in the

sixth frontier war of 1834–35, returned to Europe for further studies in Dublin and Heidelberg and became district surgeon in Grahamstown after 1839. He conducted the first amputation under anaesthetic in the Eastern Cape[4] and became something of a Renaissance man. He was said to be a musician, artist, astronomer, botanist and zoologist, but his major interests were undoubtedly geology and palaeontology in which he developed a considerable 'amateur' reputation. He was credited as a founder of the Grahamstown Library and the Botanic Gardens as well as the museum. He was active in the Albany Hospital and the Grahamstown Lunatic Asylum from 1875. Said to have identified the diamondiferous deposits of Kimberley, he was instrumental in securing the Colonial Bacteriological Institute for Grahamstown in 1891. He became a member of the Legislative Assembly in 1881 and of the Council in 1884 and remained active in the society until his death in 1898, writing many of the museum's annual reports.[5]

Although the concentration of doctors in Grahamstown was higher than the town would normally warrant, this group soon realised that a society devoted solely to their professional interests was impractical. The second meeting of the society heard a paper on fossils by Andrew Geddes Bain, the surveyor and geologist, while at the third it was resolved that papers should be given on the 'physical characteristics, manners and customs of the native tribes of South Africa, as well as on the geology of the Grahamstown area and on natural history'. By September 1855, its name had been changed to the 'Literary, Scientific and Medical Society' (it survived until 1901) and the foundation of a 'General Museum' (perhaps to distinguish it from a purely medical-chirurgical one) was declared to be its ambition. By then, Bain was a member and soon other figures in Grahamstown society joined up. Donations of specimens quickly poured in and in 1856 the museum was already said to have six divisions: anatomy, physiology and pathology (reflecting medical origins), natural history, geology and mineralogy, palaeontology (still regarded as a realm of 'curiosities') and 'native manufactures'.[6] Atherstone had made the latter prominent by moving the second resolution at the September 1855 meeting:[7]

> Situated, as this place is, on the very border of numbers of native tribes, many of whom are now making some progress in the scale of civilisation, and consequently emerging from the condition they were in some years ago, it was therefore very desirable that some relics of their former customs and manners should be procured before being entirely lost.

In fact, the frontier remained disturbed and the final war would be fought over twenty years later, but the museum's founders were already thinking in terms of a 'rescue' operation for a 'refuge' culture.

Amazingly, the initial collection of specimens was open to the public in a room of Dr Edmunds' house.[8] It rapidly aroused the curiosity of the people of Grahamstown, for sixteen, then 34 people visited it on the first two days of opening in February 1856.[9] Some weeks later, an average of 150 people were attending each day, including 'a considerable number of young persons of both sexes'. In 1865, the population of whites in Grahamstown was a mere 5,265 with fewer than 2,000 non-white. In 1875 the whites numbered no more than 7,000.[10] It was soon apparent that a room in Dr Edmunds' house was not an appropriate place to keep a museum, and the collection was moved to accommodation above Temlett's store in Hill Street. The society grew rapidly, and soirées were held in both 1856 and 1857 (with the help of the bands of the 6th Royal Regiment and the 13th Light Infantry, respectively) to celebrate the museum's existence and help raise funds.[11]

But the museum clearly needed stronger financial foundations. The society petitioned the government for funds and it was visited by that museums godfather, Sir George Grey.[12] In 1858, the administration agreed to a grant of £150 per annum. The corollary, so useful to the historian, was that the museum had to be placed in the hands of responsible trustees and annual reports prepared. With the new government funding, it also became necessary to create a deed of settlement (dated December 1858) to ensure the trust status of the museum.[13] By this deed, it was to be dedicated to the 'diffusion of Useful Knowledge', aided by lectures and essays delivered in the society's rooms.[14] Society members were to pay an annual subscription of one guinea or a life membership of fifteen. The signatures of 48 members were appended, including those of the Mayor, the Civil Commissioner, R. Southey, later to be Colonial Secretary, and the Anglican bishop.[15] By 1861, the museum had outgrown the space above the store and it was provided with accommodation in three rooms in the Town Hall on Bathurst Street, facilitated by the town clerk, B. Glanville, former secretary of the society and effectively curator from 1858.[16] He continued to perform this role, formally designated from 1870, until 1882.

Thus the origins of the Albany Museum were embedded not only in the scientific interests and professionalism of a growing white middle class upon the frontier, but also the incipient civic pride of the town. Another group greatly interested in the museum (here as elsewhere) was the clergy. The first Anglican bishop of Grahamstown, Armstrong, arrived in 1854 and immediately supported it as representing a vital need for the town. His successor after 1856, Bishop Cotterill, concurred and was an active member and office bearer of the society, as was Archdeacon Merriman, father of the politician John X. Merriman (later an influential trustee of the SAM). Still, the museum combined

rudimentary conditions with heroic efforts by the museum subcommittee of the society to organise it properly. On Hill Street, it was housed in a space measuring 40 × 18 feet. Specimens were laid out on 'rough shelves and rougher tables'.[17] But the committee divided responsibilities among its members to organise the mammalian and ornithological specimens, the fossils, minerals and shells in an appropriate fashion. Glass was ordered from England (said to be unavailable in Cape Town or Port Elizabeth), but it was lost in the wreck of *The Shepherdess* in Algoa Bay. It was also said that the light in the museum was entirely inadequate. Despite these difficulties, the subcommittee declared itself 'deeply impressed . . . with the value and importance to a Society like this, to Grahamstown, and the frontier generally, to have a well-ordered museum'. But, as in Cape Town, private subventions, with a marginal official grant, were to be a shaky way of funding a museum. By 1892, the membership of the society was down to twenty-six and at a meeting in the council chambers the annual subscription was reduced to 10 shillings, clearly a desperate attempt to increase the numbers.

From the beginning, the 'Curators' Laws' operated. The museum repeatedly filled the space available to it; money was always tight; and staffing wholly inadequate. The emphasis remained clear: natural history and palaeontology preoccupied the early annual reports. H. Piers (perhaps the Piers who was later acting curator of the SAM) donated a collection of icthyolites and much else poured in. In 1861 the museum also received specimens of raw materials for manufacture (including flax, aloe fibre and cotton),[18] as well as 'arms, implements and other ethnographic materials from the Lieutenant Governor'.[19] It was clear that, from the point of view of donations and support, this was seen as a colony-wide project.

Ludwig Pappe gifted 1,000 botanical specimens in 1862, a collection augmented by the botanist Peter McOwan, including examples from Scotland and the English Lake District. There were exchanges with Layard of the SAM and Pappe and Layard helped with identifications. Sir George Grey gave stone adzes from Australia and New Zealand; the bishop handed over material relating to Jews and Christians in South India; and Major Orme gave a curious crossbow and bolts from China.[20] Messrs Bowker and Orpen gave shells, including specimens from Ireland, Ceylon and the Cape, while the museum even accepted 500 electrotype matrices of medieval seals, illustrative of English and Scottish history, together with thirty rubbings of monumental brasses and Roman coins.

It is clear that the museum was still indulging in relatively indiscriminate collecting, the colonial 'cabinet of curiosities' phase common everywhere. Glanville continued to struggle with his part-time

curatorship, writing many of the annual reports. The slightly haphazard arrangements were illustrated in 1864 when Bain took palaeontological and geological material to Britain for identification at the BM. He died on this trip and the BM simply acquired the specimens, subsequently sending out casts in compensation. In 1882, the museum moved into a new town hall, occupying rooms on the upper floor. Glanville died in the same year. Since 1880 he had been assisted by his daughter and she took over from him at a pittance of a salary of £50 per annum. It was suggested that the name should be changed to the Eastern Districts Museum, presumably to embrace the region more widely, but this never happened. Miss Glanville continued to cope with the accessioning of donations, fitting out the museum more professionally, and with keeping records.

In 1886 the annual report dedicated the museum to the 'comparative knowledge of the Cape and the rest of the world' and to the 'education of young colonists'. Visitor numbers were estimated only from the number of signatures in the visitors' book, where 2,000 names were recorded in 1883. In 1886, there were said to be almost 10,000 entering the museum, while in 1887 the Golden Jubilee Exhibition (celebrating Victoria's reign) caused the numbers to spring up again. When the exhibition finished the museum acquired its turnstile. But Miss Glanville died prematurely in April 1888 'in the midst of her labours', praised in the annual report for her 'untiring zeal, genial courtesy, and indefatigable exertions'.[21] The Glanvilles, father and daughter, had had to struggle against a tidal wave of donations with a tiny budget, inadequate accommodation and fittings, and a minimal staff. The museum owed its survival to their endeavours.

By 1867 Grahamstown boasted a natural history society, which became closely connected with the museum. Other societies included a reading society, founded in the 1840s and associated with the Albany Public Library of 1843, and a Debating Society of 1862.[22] Print culture was satisfied by the *Graham's Town Journal*, the *Grocott's Penny Mail* and, from Port Elizabeth, the *Eastern Province Herald* and the *Eastern Province Monthly Magazine*, all of which took an interest in the museum. The intellectual and organisational infrastructure of the town was developing rapidly.[23] The Natural History Society's members shot for the museum, which wanted stuffed examples of all the great African animals. It was said that young men who had formerly shot birds for fun now did so for the museum – a classic nineteenth-century legitimation of 'sport'.[24] By the 1880s and 1890s an extraordinary network of collectors, many of them women in rural areas, was sending in specimens (often entomological).[25] While this clearly represented a striking spreading out of bourgeois interests in the natural world, it

also reflected the fact that collecting alleviated the relative monotony of remote farming life. One collector, Mrs Becker, gifted a microscope to the museum. She was working from her farm on the insect pests of the eastern districts, work seized upon by the trustees as illustrative of the practical importance of the museum. The study of insect pests became a recurring refrain. The 1887 exhibition convinced the trustees that national expositions (with museum involvement) would be key to the development of natural resources and industries. By 1890, under the influence of its new curator, the annual report asserted that the 'museum [was] becoming the centre of scientific study in the eastern districts and was extensively used by farmers and others' for references on agricultural matters, including plant pests, minerals and industrial products. In 1892–93 it was involved in research into rust in wheat. The curator was also interested in poisons, attended a congress, and argued that too many wild animals were destroyed through being on the vermin lists. By 1895 this search for an instrumental role led the trustees to assert that the museum was developing its fish collection to further the emerging fishing industry from nearby Port Alfred.

All this no doubt helped the museum in its 'great leap forward'. In 1887 a deputation waited on the premier, Sir Gordon Sprigg, when he visited Grahamstown. Sprigg seems to have been convinced, for the budget promptly more than doubled, and continued to increase rapidly over the succeeding years. The earlier repeated cries for a properly qualified curator and a taxidermist were about to be met. The changes are well represented in the budgets. In 1861, expenditure reached the giddy heights of £321, but in 1866, it was a mere £159 and there was a deficit. Until 1888 it oscillated between this low and highs of £200–£300. Only in the post-Glanville era in 1889 did the budget climb to more than £500 and in the following year was over £600. By 1895 it had reached almost £1,000 and the salary bill was in excess of £500.[26] In 1902 the budget was just short of £1,500, reflecting the improving economic prospects of the colony. The Eastern Cape emerged from instability and warfare in the 1880s.

The museum matured under the influence of two Germans. Dr Selmar Schönland (1860–1940) arrived in the curatorship in July 1889 (becoming Director in 1895 'as a mark of appreciation'), and soon joined by Carel Wilde, 'a highly qualified taxidermist from the Berlin Museum'.[27] Schönland was educated at universities in Berlin and Kiel, obtaining his PhD in botany in 1883. Having taught for a period in Prussia, he became assistant in the herbarium and museum of botany at Oxford, publishing a number of papers during this period. His arrival in Grahamstown brought an early professionalism to the Albany (several years ahead of the SAM). His marriage in 1896 to the daughter of the

Cape botanist, Peter MacOwan, connected him to a powerful figure. He developed a large number of overseas contacts, founded *The Records of the Albany Museum* in 1902,[28] and published extensively both in this journal, in the *Transactions of the South African Philosophical Society* (later the *Transactions of the RSSA*), and in the *Agricultural Journal*. He created a genuinely scientific profile, greatly developed its connections with educational institutions and gave many lectures. When Rhodes University College was founded in 1904 he became its first professor of botany. He put Grahamstown on the museological map and contributed to the expansion of the city's educational role. He also involved himself in national environmental concerns, issuing warnings about uncontrolled grazing and the spread of exotic weeds such as the prickly pear and jointed cactus.[29]

Schonland (the umlaut was dropped) discovered that some of the districts of Lower Albany were unexplored botanically. This helps to explain why he would wish to leave a herbarium of world significance in Oxford and find a distant post attractive: it opened up opportunities for botanical exploration and scientific advances on a broad front. But the stimulation of this new work was balanced by the frustration of coping with an entirely inadequate museum. The town hall accommodation was cramped and the curator's office was in the town council room, which he had to vacate when it was in session. Pressure for a new building resulted in funds being placed in the estimates in 1896. Construction would begin soon after the similar development in Cape Town. The High Commissioner Milner laid the foundation stone in September 1897 and Vixseboxse was again the architect.[30] A Grahamstown exhibition of arts and industries in 1898–99 brought large numbers of visitors to town and helped to create the economic and social climate for the new museum.[31] Schonland meanwhile went on a tour of museums in England and Germany to prepare himself for his new role. Yet this was a difficult decade when there were severe droughts, problems with locusts and other pests, as well as a smallpox epidemic.

The museum was opened to the public in August 1900 (though it was only officially opened by the Governor, Sir Walter Hely-Hutchinson, in January 1902) in its new position along Somerset Road from the Drostdy Gate, fronting what would become the university campus. Like its equivalent in Cape Town, it soon had a collection of temporary buildings at the back, acting as storerooms and eventually as laboratories. Scientific connections were enhanced when an assistant Government Entomologist was stationed in Grahamstown in 1903. The museum's work stepped up a gear: a Leitz microscope was acquired; free transport of specimens was secured on the railways and shipping lines; the

3 Albany Museum, Grahamstown, Eastern Cape. The original building by J.E. Vixseboxse, completed in 1900.

library expanded and was catalogued; the quantity of correspondence and exchanges, as well as numbers of staff (including several women assistants) all increased.[32] The palaeontologist Broom arrived from Cape Town to identify and write up notes on the fossil collection. Schonland also went on shooting expeditions and used celebrated taxidermists overseas to mount specimens.[33] The numbers of visitors to the museum ran at about 2,000 a month during these years.

In the new building, ethnography was given its own gallery to the right of the main doorway. Its prominence reflected Schonland's fascination with the ethnographic collections and the potential for archaeological activity in the region. A museum which had sold itself on its practical value quickly adapted to these interests. In his 1889 report Schonland had produced two justifications for this ethnographic collecting: the first a matter of preservation, the second pulling in an economic justification. He wrote:

> I have endeavoured to increase the collections of native weapons, ornaments and implements. As the natives are taking more and more to articles of European manufacture, I am afraid that in a few years time it will be very difficult to procure articles of their own make, which are not only of interest from an ethnographic point of view, but also of importance as showing their natural skill which might perhaps be utilised in the manufacture of certain articles in the Colony.

From that time, the ethnographic and archaeological collections began to feature intermittently in the reports. The 'ethnological collections' were relabelled and redisplayed at the beginning of the 1890s.[34] In 1893 Schonland was busy photographing a large collection of stone implements, the first mention of photography in relation to the museum's work. He explored a large cave at Bleakhouse farm near Grahamstown as well as three caves at the King's Quarry and another at Alicedale, while in 1897 he visited Bushman paintings at Glen Rennie, Baviaans River.[35] Later he investigated what was described as a 'Hottentot encampment', which had been exposed by heavy winds near Port Alfred. The museum taxidermist Irniger (Wilde's successor) was sent out to excavate kitchen middens and also secured 'original Bushman paintings' and one rock engraving from Fernrocks near Tafelberg Station.[36] The museum was also casting its net further into exotic cultural materials. A set of Chinese carvings from the imperial palace at Peking was added to the collection in 1901, together with an ivory carving from Delhi. Roman and Greek antiquities were purchased, said to be of great interest to numerous school pupils in Grahamstown: thus the museum had to cater to its educational base in schools where a classical education was still at a premium. More Roman and Chinese materials were added later and the museum acquired an Egyptian mummy in 1908.[37]

However, the relationship between museum and university, which seemed to offer great promise, did not work. After the foundation of the University College, joint posts were established. As well as Schonland's chair, the professors of geology and zoology looked after the respective collections (paid £150 from the museum budget). But these arrangements were abandoned in 1910 when conflicts arose between educational and museum duties. Schonland was forced to choose and resigned the directorship,[38] though he continued to be curator of the herbarium.[39]

Schonland's successor as Director was John Hewitt, who represented the full professionalisation of the museum. Educated at Cambridge, he had spent four years as curator of the Kuching Museum in Sarawak and a year at the Transvaal Museum in Pretoria. A zoologist, he held the directorship until his retirement in 1958. One of his first acts was to produce a guidebook to the museum, which was published in 1912. But he faced a major problem immediately, for the creation of the Union ensured that the Albany Museum became a purely provincial responsibility. The fact that the SAM became national ensured that it pulled ahead in the funding stakes. Hewitt soon developed interests in archaeology, Bushman paintings and the historical collections. But the museum was forced to struggle on with very restricted funding through the inter-war years, though a grant from the Carnegie Corporation in 1936 permitted

it to offer a schools service of loan boxes. However, the museum suffered a major fire in 1941 when considerable damage was done to the building and much of the mammal and other zoological collections were lost. The library, ornithology and historical artefacts were saved. The building was reconstructed and the collection was restored with the help of other museums. The mummy case shows evidence of the fire to this day.

Schonland had begun the collection of artefacts relating to settler history, but this was given a major fillip by the centennial celebrations of the founding of Grahamstown and of the 1820 settlement. This developed into a major interest of the museum and a room was dedicated to settler history.[40] An ambition to create a separate settlers' museum was not fulfilled until 1965 when a new building, in a neoclassical style, was built on the other side of one of the access routes into the university. At first this building was dedicated solely to settler history, but in modern times the history of Africans on the frontier, together with the record of contest for land and resulting warfare has also received attention. Because of serious funding difficulties an exhibition entitled 'Contact and Conflict', intended to be temporary, has continued to be shown. Archaeology and ethnography are still on display in the natural history part of the museum, though the transfer of Xhosa materials has begun the process of integration.

Conclusion

The rhetoric of museum propaganda, in the Cape as elsewhere, involved their alleged effects upon economic development. Dr Atherstone produced a classic statement of this in 1888:

> National museums liberally supported by the State for national objects are absolute necessities in all civilised countries. In South Africa, especially, where mineral and metallic discoveries are rapidly assuming gigantic proportions, such a museum in a central position, equipped with all modern scientific aids to study, maps, plans, books of reference, typical specimens of rocks, ores, minerals, fossils etc. etc., and a skilled scientist to assist in exploration and development of our nature resources, are (sic) much needed.

Atherstone went on to suggest that Grahamstown was ideally situated to perform such a role. He went further, claiming that the museum would be useful in education, offering practical facilities for the study of science and art as well as 'fostering a love for intellectual pleasures and pursuits and rational development in the study of the beneficent works of creation' and elevating 'the social, moral, and religious condition of the people'. This would further 'diminish crime' and reduce the 'cost of detection and punishment'. The museum had become a

universal panacea, a sort of philosopher's stone, turning the base elements of society into consumers of cultural and educational gold.

The reality is that there is very little evidence that museums performed any of these functions. It is true that individuals combined museum and economic roles. Thus, entomologists worked both in museums and in research into agricultural insect pests.[41] But these were incidental rather than museum-driven. Moreover, there is no evidence that governments responded rapidly to overblown museum rhetoric. They knew perfectly well that economic growth was forwarded by practical people. This is well illustrated in countless complaints. As we have seen, an acting curator considered the SAM's mineral collection to be disorganised and too cosmopolitan.[42] At the Albany, the mineralogical collection was not displayed for a long period because of pressure on space.[43] Far from museums being economic drivers, it is much more likely that economic growth fuelled museums. Both those of Cape Town and Grahamstown began to flourish once the colonial revenues had been placed on a sounder footing through the 'mineral revolution' and resulting trade.

Curiously in Grahamstown, the museum flourished at a time of considerable ecological crisis, when the town's economy was not doing well and drought and recession were endemic.[44] Museums were more important in their social and intellectual effects. As Hely-Hutchinson put it at the opening of the Albany Museum, the museum's objective was 'the promotion of culture and knowledge'. It also helped to 'get Nature on our side'.[45] Museums certainly contributed to identities, imperial/international and colonial/civic, and in the conditions of the region this meant essentially white identities. Museums helped to offer reassurance and justification, polishing the notion that the global phenomenon of white rule illustrated the knowledge/power relationship. As their economic phase moved into the ethnographic, the presentation of the 'Other' became central to their role in the dominance/understanding connection. Yet the direct projection of white identities through settler history came comparatively late: in some respects it arrived only with the need to present the new 'nation' after Union in 1910.[46] And when it did, this western cultural projection, in both Cape Town and Grahamstown, was promoted through a separate museum. Natural history and ethnography went together as representative of the African environment – cultural history, whether of whites or of ancient cultures, was something quite distinct. They have only been brought together in modern times.[47]

Later, in 1929, the anthropologist A.J.H. Goodwin published an article with the resonant title 'The Universities of the Poor Man' with the subtitle 'How South Africa Neglects its Museums; Cinderella of Science

Awaits Her Prince'.[48] He considered that museums which should be performing scientific work of incalculable value and educating the people (presumably meaning mainly white people), were instead 'overcrowded, badly displayed and left to accumulate dust'. The SAM, in the 'Mother City', the 'Gateway of Africa', was 'ill-housed in an extraordinary structure of crumbling sandstone, a variety of iron sheds and a brick barn'. He surveyed most of the museums of the Union and found them all to be in a parlous state. Thus, they were failing in the prescription offered seventy years earlier, that museums should be 'places of instruction and amusement to colonists'.[49] Of course the 'curators' laws' always apply: they fill up to congest the space available (curators were complaining within a year or two of the opening of the new SAM building in 1897); they always require more money; they find the balance between public instruction and amusement, between science and display, problematic; and they have greater difficulties than other scientific and educational institutions in extracting money from government.

Making due allowance for Goodwin's propaganda, it is a fact that museums at the Cape were initially tentative; the early curators, at least of the SAM, were essentially expatriates with little desire to commit themselves to the colony; they remained strongly Anglophone and their role in the creation of colonial and Union identities, limited largely to whites, was more shaky than might be expected. Above all, they seldom received the financial support they believed they required and deserved. But they did contribute to serious scientific work; they displayed some cultural exotica for the education of visitors on 'world civilisations'; and they reflected the (sometimes alarming) anthropological trends of their period. The era of Afrikaner Nationalist authority was pronounced, on the eve of the revolution wrought by the political changes of the 1890s. Their true role in the establishment of multi-racial identities, in the display of the distinctive characteristics of the natural environment of the subcontinent, and in the exposition of the histories of peoples violently thrown together by the past, is only now being realised. But in this period of transition, there have been fresh crises. Museums have not been high in the new government's agenda and they went through considerable financial and policy crises (the Albany Museum was a temporary casualty in this period) in the years before and after the dawn of the twenty-first century.[50] Though it is still 'work in progress' their efforts to grapple with the new social, political and cultural dispensation have generally been impressive.

S. AFRICA: ALBANY MUSEUM, GRAHAMSTOWN

Notes

1 Surgeon-Major Hutton later published his reminiscences in the *Eastern Province Monthly Magazine* 1907 and recounted that he was ordered to Grahamstown to take medical charge of the general and his staff. It was, he wrote, 'a monotonous life' with slight and repetitive daily duties, quoted in John Hewitt, 'The Albany Museum, Grahamstown', a pamphlet reprinted from the *South African Museums Association Bulletin*, 4, 4 (December 1947), South African Pamphlets, 81, no. 12.
2 'Chirurgery' is an antique form of 'surgery' as in the medical qualification ChB.
3 St Andrew's College was founded by Bishop Armstrong to offer a 'sound Christian education for frontier farmers' and also train men for holy orders and missionary operations. It later sent an annual Rhodes scholar to Oxford and received a bequest to send a pupil to Cambridge. R.F. Currey, *St. Andrew's College, Grahamstown, 1855-1955* (Oxford 1955). The Roman Catholic equivalent was St Aidan's College, founded in 1873. See Francis L. Coleman, *St. Aidan's College, Grahamstown* (Grahamstown 1980). Other schools included Graeme College (1873); the Diocesan School for Girls of 1874; Kingswood, the oldest Methodist school in South Africa, in 1894; and the state-run Victoria Girls' High School (1897). There was also a teacher training college.
4 Edmund H. Burrows, 'The First Anaesthetic in South Africa', *South African Pamphlets* no. 81, reprinted from *Medical History*, 11, 1 (January 1958), pp. 47–52.
5 Sources for Atherstone's life include the *Standard Encyclopaedia of South Africa* and the *Dictionary of South African Biography (DSAB)*. See also Nerina Mathie, *Man of Many Facets: Dr. W.G. Atherstone 1814–1898, a Pseudo-Autobiography* (Grahamstown, three volumes, 1998). vol. 3, pp. 930–1 has interesting material on Atherstone's palaeontological activities and contacts with Bain and Grey. Atherstone's own reminiscences of his medical practice were published in the *South African Medical Journal*, IV, 11 and 12, April 1897. In this he indicated that the original intention was that the museum would concentrate on comparative anatomy – hence the osteological collections. He also wrote, interestingly, that because of the problems of securing drugs on the frontier, doctors often had recourse to traditional African and Boer remedies.
6 N. Fowler, 'A History of the Albany Museum, 1855–1955', bound typescript in two volumes without a date, probably a centennial project of 1955. A summary of the annual reports and newspaper accounts, this constitutes a useful source book. See also Hewitt, 'The Albany Museum, Grahamstown'; James M. Gore, 'A Short History of the Albany Museum 1855–2005, with a focus on its early years', *Annals of the Eastern Cape Museums*, 4 (2003), published November 2005, pp. 1–27; and James Gore, *A Short History of the Albany Museum: Celebrating 150 Years* (Grahamstown 2005). The annual reports start in 1858 and were examined up to the twentieth century as were the manuscript monthly reports of the director to the trustees for the period 1901 to 1914. See also a valuable volume of minutes and letters relating to the museum and its trustees in the museum library. Another large notebook contains the minutes of the Literary, Scientific and Medical Society of Grahamstown. Photographs of exhibitions and early museum displays can be found in the Bowker Africana Library in the Albany History Museum.
7 Quoted in 'The Albany Museum: the New Buildings', the *Journal*, Christmas Supplement, 16 December 1897.
8 Hewitt, 'Albany Museum', p. 4, suggests that collections were also kept in the homes of Bain and Atherstone (perhaps a confusion since Atherstone acquired Bain's house).
9 Miers and Markham, when they visited South Africa on their great museums survey in 1932, mistakenly thought that the Albany was the oldest museum in the Cape.
10 Melanie Gibbens, 'Two Decades in the Life of a City: Grahamstown 1862–82', MA thesis, Rhodes University, 1982. See also Eric W. Turpin, *Grahamstown: Hub of the Eastern Cape* (Grahamstown? n.d. c.1967?), 'The foundations of the Oxford of South Africa', pp. 40ff.

[117]

11 Fowler, 'History', pp. 14, 17.
12 Hewitt, 'Albany Museum', p. 2.
13 Unlike the SAM, this was not done by Act of Parliament, which would have cost the Society too much.
14 Lists of lectures given in the early days of the society can be found in the Bowker Africana Library at the Albany History Museum.
15 Deed of Settlement and Minutes of the Literary, Scientific and Medical Society of Grahamstown, 1858. The deed of settlement and the by-laws of the Albany Museum were later published as a pamphlet (Grahamstown 1902).
16 This arrangement was already being discussed in 1863 when Glanville wrote to the Secretary of the Society to enquire about requirements for space for the museum. Glanville to Hoffmeyer, 3 September 1863, MS letter, SMO 1127b, Albany Museum archives. The dimensions of these rooms and the mode of display were described in Atherstone's 1867 Annual Report. He insisted (p. 3) that the role of the museum must be to offer 'an exposition on the natural features in the part of the world in which it is placed' with 'colonial specimens entirely distinct from the foreign'.
17 Annual Report, 1858.
18 Later, in 1885, fifty specimens of wool and cotton in different stages of manufacture arrived from the Bradford Art Museum.
19 Annual Report, 1862.
20 Annual Report, 1861, p. 3. In the annual plea for space, it was said that there was no room to display either minerals or shells.
21 Annual Report, 1888. There was not to be another woman curator/director until Dr Webley was appointed in 1999.
22 The library opened in the jail at the top of the High Street. It was used by garrison soldiers; a 72nd Highland Regiment corporal proposed travelling subscription libraries 'for troops in the field'.
23 Eventually there were also the Grahamstown Athenaeum and a local branch of the British Medical Association. A new Literary and Scientific Society was founded before the old one disbanded in 1901.
24 Annual Report, 1867. Nevertheless, the annual report of 1895 decried the enormous slaughter of birds and robbing of eggs on the fringes of the town. The trustees called for legislation on the protection of birds and the control of firearms, which was passed in 1896.
25 Annual Reports of 1891 and 1892. Mrs G. White of Brake Kloof farm was particularly assiduous (she died in 1907 and was the sister of Dr Atherstone, whose brother Edwin was also a keen naturalist); the list included Miss Lilly Lepan of Teafontein, Miss Barrett of Middle Drift, Miss Goldswain of Grassflats, and the Misses Leppan of Kimberley, Mrs Francis of Mafeking, and others.
26 The staff in that year comprised the curator (£300), taxidermist (£150), juvenile assistant to the curator (£36) and a museum attendant (£30). In 1910, the attendant was described as an African.
27 Annual Report, 1889.
28 There were subsequent difficulties in funding this publication, but the directors Schonland and Hewitt both insisted that it was vital to the scientific reputation of the museum. It was valuable for exchanges of publication with other museums, building up library holdings.
29 Schonland's sons became significant figures – Sir Basil Schonland as a scientist; Felix in farming; and Richard in forestry.
30 See the article and illustration in the *Grahamstown Journal*, Christmas supplement, 16 December 1897.
31 *Exhibition of Arts, Science and Industries, Grahamstown, Cape Colony, 1898–99, Official Catalogue*. This exhibition was larger in scale than that commemorating the Queen's Jubilee in 1887. It included a machinery hall, three courts, a Rhodesian jungle, and a Fine Arts Section. The Catalogue even offered a history of expositions since that in Paris in 1798. Emphasis was also laid upon the history of Grahamstown and the role of its museum. A syllabus of varied lectures reveals interests of the

32 moment, including the 'opening' of Southern Rhodesia and the wars there, with one on the 'ruined cities' of Central Africa. There was a performance of something called a 'Mashonaland gold banshee wail'. The museum's times of opening on the upper floor of the Town Hall were publicised in this catalogue, which also included a description of the 'handsome new building'. Yet again, the museum secured a turnstile from the exhibition, a metal one where the previous had been wooden.
32 In the Edwardian years, they were the Misses Sole, Daly (two sisters), Gane, Cherry, Baines and Shaw, all paid so little that they represented a cheap option rather than an expansion of employment opportunities. It seems to have been deemed improper to use first names, as they never appear, evidence maybe of depersonalisation. They were often out in the field collecting. Not surprisingly, they appear in the Director's monthly reports asking for more money, usually granted. In 1909, Miss Daly received £9 per month; Miss Baines £5 10s; Miss Cherry £4 10s; the younger Miss Daly £2 10s.
33 Schonland, accompanied by Dr Greathead, visited the Kalahari, with the permission of King Khama of the Tswana, to shoot eland and acquire specimens of natural history and ethnography, in August 1903. Greathead seems to have done most of the shooting and accounts of the expedition appeared in *Grocott's Penny Mail*. The eland were also intended for the American Museum of Natural History. Schonland was now using Rowland Ward of London for taxidermy.
34 Annual Report, 1891, p. 7. Schonland was anxious such materials would become unavailable. This report also indicated that some Pondo snuff spoons had been stolen.
35 Annual Reports, 1896–97.
36 Annual Report, 1895. This report suggested that as soon as ethnographic material was placed in table cases, the public took a greater interest.
37 This, together with scarabs (some stolen in Egypt), was provided by Professor Garstang of Liverpool at a cost of £25. Instances of breakages in consignments of Egyptian and other pottery are alarming to modern eyes. See the Director's monthly reports, June 1902 and September 1905. Some Egyptian pottery was presented by the Beni Hasan Excavation Committee in 1904.
38 His retirement letter was appended to the Museum report of July 1910.
39 This had been expanded by the addition of the Gill College herbarium in 1904, established by the college's principal, Peter MacOwan, later Colonial Botanist and Professor in Cape Town. It contained South African, American and Asiatic plants. Director's report, September 1904.
40 The museum also acquired a number of memorabilia of the Anglo-Boer War.
41 This was stressed by Dr Becker, president of the society and chair of the museum committee, at the opening of the Albany Museum in January 1902. *Grocott's Penny Mail*, 23 January 1902, cuttings collection of Albany Museum.
42 Footnote 49, chapter 4.
43 There were no museums in Kimberley or Johannesburg at the time of the mineral discoveries.
44 Rose-Mary Sellick, 'A Study in Local History: Grahamstown 1883–1904', MA thesis, Rhodes University, 1983. A good example of the problem is the Victoria Woollen Company, founded with a government grant of £1,000 and using Scottish migrants brought out to produce tweed and other woollen cloth. It collapsed after a few years in 1891.
45 *Grocott's Penny Mail*, 23 January 1902.
46 J.M. Gore, 'A Lack of Nation? The Evolution of History in South African Museums, c.1825–1945', *South African Historical Journal*, 51 (2004), pp. 24–46.
47 As with the British Museum and the 'Museum of Mankind' in London.
48 *Cape Times*, 28 March 1929, cuttings collection, SAM library.
49 Annual Report, SAM, 1856.
50 Steven C. Dubin, *Transforming Museums: Mounting Queen Victoria in a Democratic South Africa* (New York 2006). On the crisis in the Albany Museum, see pp. 210–11.

CHAPTER SIX

Australia: museums in Sydney and Melbourne

Australian museums were characteristically founded in each colony by a group of bourgeois dilettante scientists, wealthy businessmen and influential professionals. Initially, the creation of such museums was designed to forward their own natural historical interests, to establish a club in which they could interact, and to connect them with both imperial and international networks of scientific endeavour. But the relationship between scientific society and museum could be different from that elsewhere. First, the members of the Australian elite group often remained more influential for a longer period. Second, the reception of Darwinism was generally more hostile than it was in Canada and, as we shall see, in New Zealand. Third, although 'curiosities' were collected at an early period (particularly from the Pacific Islands), the ethnological imperative in respect of Australian materials sometimes came later. This was partly because of the undervaluation of Aboriginal culture compared with other indigenous peoples. Moreover, the international market, compared with Western Canada and New Zealand, was initially sluggish. Whereas Canadian and New Zealand museums became genuinely alarmed at the exporting of indigenous artefacts, in Australia there was some concern that international collections had missed out on Aboriginal materials. Chapters Six and Seven consider the founding of the Australian Museum (AM) in Sydney and, in more detail, the origins and development of the National Museum of Victoria (NMV) in Melbourne and the South Australian Museum (SAuM) in Adelaide.

The Australian Museum and other museums in Sydney

The status of New South Wales (NSW) as a penal colony ensured that museum development would be delayed until the necessary elite group had formed. A critical mass of such figures was necessary for

the foundation of societies, libraries and related institutions. This was despite the fact that many of the transported convicts had capabilities as artists, natural history collectors, taxidermists and other relevant pastimes or skills: some would indeed play a significant role in the development of the museum. But the colony presented strikingly different fauna and flora from other territories, as Cook, Banks and their companions had observed. This meant that natural history specimens from the southern continent were in demand in Europe, notably Britain, where Kew Gardens, the BM, the Linnean Society, the Royal College of Surgeons (RCS), and the university museums were all eager to collect such striking exotica.[1]

This transfer of specimens for the edification of European science was partly based on the notion that species were doomed to disappear in the face of imported fauna and flora, sharing their fate with indigenous people who would be unable to withstand the biological supremacy of white immigrants. Indeed, the transfer of such materials to Europe rather than their study in the colony itself has been graphically dubbed an aspect of the 'biological cringe' of the time.[2] But the foundation of colonial museums soon responded, even if these origins were tentative and discontinuous.

The colonists showed signs of interests in scientific study and institutions at a fairly early stage. Land surveys, always a source of scientific discovery, were conducted from the earliest days of white settlement. The surveyor general's department was regularised under Governor Macquarie in 1812, with the naval officer J.J.W.M. Oxley as its first head. The first government mineralogist, Adolarius Humphrey, was employed between 1803 and 1812. The Botanic Gardens were established in 1816, the Parramatta Observatory in 1822. The need to study water supply further encouraged exploration. In 1821 seven leading colonial figures created a Philosophical Society at a meeting in the home of Judge Barron Field.[3] They dedicated themselves to 'collecting information with respect to the natural state, capabilities, productions and resources of Australasia and the adjacent regions, and for the purpose of publishing from time to time, such information as may be likely to benefit the world at large'.[4] The typically practical and economic objectives of such early societies, as well as a desire for international respectability (plus a degree of proto-sub-imperialism), are apparent in this statement. Moreover, its members were ambitious to found a museum of geology and fauna. They set up a subcommittee for the purpose and planned field trips – no doubt to feed the collection, which was to be deposited in the Colonial Secretary's office.[5] They planned to enter the international arena by sending letters to other societies for cooperation and exchanges, but this was probably never

done. Governor Brisbane agreed to become President of the Society as soon as he arrived in NSW.

But it is clear that the necessary official-bourgeois-intellectual complex necessary for the development of society and museum had not yet fully formed.[6] The society sought to restrict its membership to men qualified by wealth and education, with blackballing permitted. Such social exclusiveness had already proved fatal to an Agricultural Society of 1818, which had collapsed in disarray over whether emancipists should be allowed to join (Governor Macquarie had demanded their inclusion).[7] The Philosophical Society folded in 1822, though its collection was preserved.[8] Yet within a few years, the urge to establish a museum regenerated. In 1827 and 1828, Sydney newspapers urged such a foundation, arguing that museums were vital for colonial development and for international recognition. This colonial debate was forwarded by a conjunction of forces in London and a new appointment to NSW. Governor Sir Ralph Darling appointed a London civil servant, Alexander Macleay, a passionate collector, to the post of colonial secretary in Sydney in 1826. Macleay had been a Fellow of the Linnean Society (FLS) since 1794 and FRS since 1808. His role as honorary secretary of the Linnean Society (founded in London in 1788) between 1798 and 1825 had put him in contact with many scientists and collectors.[9] However, it has been pointed out that Macleay's collecting interests neither made him a scientist (he published little) nor necessarily gave him an interest in museums.[10] Still, British naturalists were complaining at the time that the flow of specimens from the colony had largely been cut off and made representations to the Colonial Office, where some officials shared these interests. A senior official wrote to Macleay requesting that specific items, such as eggs of the platypus, should be sent to London.[11] Macleay was sympathetic, but complained of pressure of business and lack of support for colonial science in London. He pointed to competition from French and German collectors and suggested that his son, William Sharp Macleay, who would have made an ideal collector, had been denied an appointment. Macleay senior proposed that a society should be re-formed with the principal objective of founding a museum.[12]

The Colonial Secretary in London, Lord Bathurst, responded positively. He issued a despatch in March 1827 authorising the colonial authorities to spend £200 per annum on a 'Publick Museum' for the display of 'rare and curious specimens of Natural History from the colony of New South Wales'.[13] The amount was to include the salary of a zoologist and collector, the model to be the Botanical Garden in Sydney. Bathurst indicated that a suitably qualified young man would be sent out, but he left office within a few days and no one was appointed.

Lacking direction from London, Governor Darling did nothing, despite his patronage of the supposedly scientifically-minded Macleay, and the idea of a museum in NSW lapsed. In 1828 there was another false start when the Rev. Charles Wilton resolved to promote science in the colony by founding a periodical (the *Australian Quarterly Journal of Theology, Literature and Science*). The first issue contained an anonymous article suggesting that if the colonists were to be seen as 'the progenitors of a great nation' it was essential to found a museum for educational purposes. The Attorney General, A.M. Baxter, was keen, but the Governor did not like him and paid no heed. The Australian Phrenological Society proposed a Museum of Comparative Anatomy, but that too came to nought.

The idea was resuscitated in 1829 when Governor Darling appointed William Holmes, a carpenter and joiner, as government zoologist and museum curator. There is no evidence that Holmes knew much about zoology, but it was yet another false start since Holmes died in a shooting accident in 1831. The original collection of the Philosophical Society and newly collected specimens were then placed under the authority of Edward Deas Thomson, the clerk to the executive and legislative councils. Intriguingly, a convict messenger who worked for the council, William Galvin, was put in charge of the collection while another convict, John Roach, was employed as taxidermist, both of them for tiny sums out of the £200 available. Galvin had a particular interest in ornithology while Roach also conducted field trips. The museum moved to an outbuilding behind the Judge Advocate's residence. Galvin, pardoned in 1832, was in charge of the museum until 1836, while Roach, who accompanied the surveyor general Thomas Mitchell on one of his expeditions, received his ticket of leave in 1836.[14] He remained with the museum until 1840 when he set himself up as a commercial taxidermist. The museum's course was still not smooth. A powerful faction opposed anything seen as unnecessary expenditure, its views trumpeted in the paper the *Sydney Monitor*. Calls for retrenchment endangered both museum and botanical gardens, but both survived. Indeed, Deas Thomson's authority was enhanced when Darling's successor, Sir Richard Bourke (whose daughter Thomson had married in 1833) dismissed Macleay as Colonial Secretary in 1837 and appointed Thomson in his place. This was helpful to the museum, since Macleay exhibited little interest in it, allowing its fortunes to languish in his final years in office.[15] Thomson remained influential in the affairs of the museum for more than four decades, although it was handicapped for much of the century by the lack of an energetic and avaricious figure of the sort who turns up in so many other colonial museums.

The tempo in the affairs of the museum began to quicken in the 1830s. Thomson proposed that it should be known as the Australian Museum in 1834, a pre-emptive strike against other museums yet to be founded. The post of secretary and curator to the museum was regularised in 1835 when Dr George Bennett secured the position. He was a medical man and naturalist who had a varied experience of collecting on voyages in the Indian and Pacific oceans, publishing papers on subjects as varied as New Zealand conifers and Polynesian dialects.[16] Bennett was a friend of Richard Owen (establishing a NSW tradition), and had received the gold medal of the Royal College of Surgeons. He visited the museum in 1832 when he found only 'natural productions' and an emphasis on ornithology. He later settled in Sydney, perhaps specifically to secure the curatorial position. Despite holding a variety of other positions (inspector of abattoirs, supervisor of hangings, dissector of the executed criminals, as well as his medical practice),[17] Bennett produced the first catalogue of the collection in 1837. In 1836, the museum and the botanical garden had been brought together under a Committee of Superintendence with ten members, including Alexander Macleay as chairman and his son George, a member. A subcommittee had oversight of the museum.[18] This showed an initial burst of energy by requesting commandants of penal colonies at Moreton Bay, Port Macquarie and Norfolk Island to instruct convicts to collect zoological specimens. The members also resolved to open the museum from Tuesdays to Fridays, ensuring a predominantly middle-class attendance. If convicts were doing some of the collecting, they, and emancipists, would be unlikely to gain admission. Although collections continued to grow, the museum still lacked a dominant figure. Bennett sent large numbers of specimens 'home' to the BM and the RCS, where he was much valued. Today the museum would dearly like to have some of these back. Discontented about the low level of remuneration, his intellectual isolation and his failure to secure the post of Colonial Botanist, he resigned in 1841.

His successor, for two years only, was the Rev. William Branwhite Clarke, a geologist of some note who had connections with Adam Sedgwick and was a correspondent of Sir Roderick Murchison (despite the antipathy between these two figures).[19] His effectiveness was, however, reduced by the fact that he ran the museum from Parramatta (at the head of the harbour and several miles from the town), where he was parish priest and head of the Anglican School. He regarded the colony as something of an intellectual wasteland, but thought Australians would develop a thirst for knowledge. He was later a trustee of the museum (1853–73); and he corresponded with Darwin, who duly sponsored him for the FRS in 1876. The day-to-day oversight of the museum was in

the hands of William Sheridan Wall, who had been appointed collector and preserver of specimens in 1840. The museum had by then moved to the courthouse in Woolloomooloo.

But the swift turnover of curators produced a somewhat anarchic situation, which persisted for at least two more decades. Part of the reason may be that the supervisory committee, later the trustees, were not as vigorous in their support as they might have been. Meetings were held infrequently and attendance was poor. Several of the members had their own private collections to consider, which inhibited the museum in key ways. Moreover, there was an economic recession in the early 1840s and visitors – such as the German expedition leader Ludwig Leichhardt in 1842 – were severely critical of both its lack of professionalism and the failure of public support. Indeed, colonial hostility continued. The newly founded Legislative Council voted in 1843 to abolish the post of curator to save money. The museum was little visited and large numbers of specimens were still sent to Britain.

Nevertheless, powerful figures argued passionately for the educational, cultural, and prestige advantages of the museum. Charles Nicholson, a member of the Council involved with the museum of the Sydney Mechanics' School of Arts, founded in the 1830s, strongly argued the case for the power of museums to educate and uplift the broad mass of the population. Thus, the museum was saved by the abandonment of the past elitist approach: the discourse of public instruction and moral elevation would offer its prime justification. Indeed, a surprising burst of generosity was at hand. In 1845, the Legislative Council voted £3,000 for a new building. This was commissioned from the colonial architect, Mortimer Lewis, to be built on a prime site overlooking Hyde Park not far from the legislative council building, the Mint, the convict barracks and relatively close to Government House, the Domain and the Botanic Gardens. Still, progress was painfully slow. Although Governor Fitzroy opened the north wing in 1849, the building was not completed until 1852 and it was still being fitted out in 1856. A Museums Act was passed in 1853, providing a grant of £1,000 per annum, and appointing a board of twenty-four trustees to oversee it.

The concerns of the museum were to be twofold – science and literature, the latter effectively meaning the arts of humans, books, manuscripts, coins, statues and pictures (no mention of anthropology). The distinguished artist, naturalist and traveller, George French Angas,[20] was secretary of the museum between 1853 and 1860, though he fell out with Wall (curator 1844–58), an obscure figure from Dublin. Angas was active in classifying and arranging the collection, particularly pursuing his interest in ethnography, numismatics, and conchology.[21] He combined this with pursuing his own collecting, artistic and

4 The Australian Museum, Sydney, facing Hyde Park. The first section was completed in 1852 and the west wing extension in 1867.

publishing interests. The collection became sufficiently notable that a further £30,000 was voted in 1861 (symbolising the new prosperity of the colony) for the building of a west wing, completed in 1867, and tripling the size of the museum.[22] This extension, together with the original structure, still forms its core.

In 1861, a curator was appointed who seemed likely to give the museum a higher profile and plug it into international scientific networks. This was Johann Ludwig Gerard Krefft (1830–81).[23] Born and educated in Germany, he emigrated to New York and moved on to Melbourne in 1852. For five years, he worked on the gold mines, but also went on a collecting expedition with William Blandowski (whom he did not like) and made contact with the almost piratical director of the Victoria Museum, Professor Frederick McCoy, whom he liked even less (see below for both these personalities). For a period he helped to catalogue the Melbourne collection. Krefft was a convinced Darwinian who pursued interests in palaeontology and zoology, with a specialisation in snakes. In 1869 he conducted a survey, funded by the NSW government, of the limestone caves at Wellington known to be rich in fossil remains since they had first been examined by Thomas Mitchell in 1831.[24] Accompanied by the geologist, Dr A.M. Thomson, Krefft made a considerable haul of fossils, many of which were sent on to Owen in London. Others were photographed for the latter to study and possibly publish. As a result of Owen's continuing work, the governments of NSW and South Australia decided to award him a grant for the illustration of his major book on the extinct mammals of Australia, somewhat to the irritation of Krefft.

Indeed, it was not long before Krefft clashed (in correspondence) with Richard Owen about the characteristics of a fossil marsupial, Thylacoleo carnifex (the so-called pouched lion). Krefft was right and was supported by significant figures such as William Flower. But this was dangerous, for Owen was held in high regard in NSW and many of the trustees were pro-Owen and anti-Darwin. Krefft, in turn, had little respect for the trustees. It is hard to avoid the impression that they were intent on laying a trap for him and their opportunity came in 1873. Gold specimens (always a major danger in museums) were stolen, when Krefft was at Botany Bay preparing the skeleton of a beached whale. The trustees immediately held Krefft responsible and moved to a state of open warfare. Interestingly, this dispute was bound up with fierce political rivalries since the Liberal Henry Parkes considered that the alleged maladministration of the museum was a further instance of conservative incompetence. A select committee was appointed, but two powerful trustees were among the members and Krefft was duly criticised for incompetence, drunkenness and insubordination. He

resisted dismissal on the grounds that the trustees had no such power, but in a bizarre scene his apartment in the museum was invaded and he was physically ejected. A number of court cases followed, but Krefft was ruined and died a few years later.[25] There is no more dramatic incident anywhere in the history of colonial museums. Krefft was certainly a difficult man, but it may be that had he survived, the AM might have developed more effectively.[26]

Most colonial museums turned to ethnological collecting quite early in their histories, but this was less true in NSW. In 1832, George Bennett had urged that the museum should be assembling a collection of 'native weapons, utensils, and other specimens of the arts' of Aborigines. Skeletons and skulls should also be collected, all of this to constitute 'lasting memorials of the former races inhabiting the land, when they have ceased to exist'.[27] Bennett's 1837 catalogue listed only nine Australian Aboriginal artefacts with sixteen from Melanesia; despite his advocacy, he was not himself an avid anthropological collector. It may, however, be the case that he encouraged the surveyor Mitchell to donate Aboriginal artefacts from his 1835 and 1836 expeditions (eleven and thirty, respectively), while items from the Torres Strait islands were donated in the same years. Although the museum started buying biological specimens in 1838, the first human artefacts to be purchased were twenty-seven plaster casts of Greek and Roman statuary, acquired for £320. Thus NSW mirrored the common imperial fascination with casts and the desire to plug itself into ancient European civilisations. The desultory approach to anthropological acquisitions continued until 1853 when the appointment of George French Angas as secretary led to a surge of collecting of both Aboriginal and Pacific artefacts. During this period the trustees expressed interest in exchanges and in creating a world collection. In 1858, anthropological materials (not specified) were sent to Denmark in exchange for 'a fine collection of Northern antiquities of the stone age' procured from 'ancient tombs and refuse heaps'. This seems a curious development given the relative lack of interest in Aboriginal materials, but perhaps the trustees had some kind of comparative study or display in mind.

Krefft developed an interest in Aboriginal cave painting and investigated a number of sites, but he never published on the subject, nor was he particularly energetic in ethnological collecting. Nevertheless, the museum mounted a major anthropological exhibit for the Sydney International Exhibition in 1879, and won an award.[28] Yet two facts are indicative. Many of the specimens collected in the earlier years were not in this exhibit and it has been suggested that they may have been lost, damaged or destroyed.[29] The second is that Dr James Cox (a trustee of the museum from 1865 to 1912) was the largest private exhibitor in

the ethnology hall: the museum's interests in the natural sciences had long been bedevilled by private collecting and this was also true of ethnology. The 1879 exhibit was almost entirely lost in the 1882 fire that destroyed the 'Garden Palace', one of the remaining exhibition buildings. This disastrous loss galvanised Krefft's successor into recreating an anthropological collection almost from scratch.

A further reason for the rather stunted development of the AM, despite its inflated name, was the influence of the Macleay family. As well as Alexander, the Colonial Secretary (1767–1848), this included his son William Sharp Macleay (1792–1865), another son, George (1809–91),[30] and his nephew William John Macleay (1820–91).[31] It was a family that used colonial opportunities to restore and extend its fortunes. Alexander had inflated ideas of his own social importance, but in 1818, his enforced retirement sent him into straitened circumstances. His move to NSW, with a salary of £2,000, plus his civil service pension of £750, had provided considerable wealth, but he was profligate in the pursuit of status. As well as his official residence he owned 54 acres at Elizabeth Bay (granted by the Governor) and he acquired a country estate. Building projects at both sites nearly ruined him, and he ended up in debt to his son William. As mentioned, Alexander arrived in Sydney with one of the most notable private collections of insects in the world, embracing both British and foreign specimens. This collecting had secured his position in the scientific networks of London, Edinburgh and elsewhere. Remarkable for its size and its range, the collection also contained many type specimens (original examples on which the initial description had been based). Once in Australia, he developed his global reach by working with collectors and dealers. Although he did not publish himself, he did make the collection available to others.

His well-educated son, William Sharp, arrived in Sydney in 1839 after a diplomatic and legal career in France and Cuba. He moved into his father's grand property on Elizabeth Bay, where there was a botanical garden (with Australian and exotic plants) and, later, a private museum for the collections.[32] William had a better scientific pedigree than his father. He had been president of the natural history section of the British Association for the Advancement of Science meeting in Liverpool in 1837; he had published *Annulosa Javanica* in 1825, a description of insects collected on Java by Thomas Horsfield; and he had examined the entomological collections made by Andrew Smith on his celebrated expedition at the Cape (see Chapter Four).[33] This would be published as *Illustrations of the Annulosa of South Africa*. William held natural history meetings at the Macleay house and was instrumental in the preparation of the Museum Act of 1853. He also gave encouragement to his younger cousin, William John, who accompanied

him to NSW and was to become a wealthy and influential 'squatter'. Together they were opposed to Darwin's evolutionary ideas after they reached the colony in 1860, since they adhered to the Circular or Quinary System.[34]

William John also began his own collection (insects seem to have been in their genes) and used the former museum curator Wall as a collector. He was a founder of the entomological and Linnean societies of NSW in 1862 and set about turning the Macleay collection into a major private museum employing George Masters, the assistant curator at the AM in Krefft's day, as a collector. From 1874, Masters became full-time curator of the Macleay collection and a separate building to house it was completed at Elizabeth Bay in 1875.[35] The museum spread its interests more widely in natural history and also in anthropological specimens from Australia and overseas.[36] But Macleay remained solidly anti-Darwin, considering evolutionary ideas 'barren theories', worthy of the Scottish verdict of 'not proven'.[37]

These competing interests ensured that the AM would be hamstrung. For forty years, a Macleay was always chairman or president of its trustees and there were invariably two members of the family (plus other relatives by marriage) on this governing body.[38] William John confessed to the 1874 Select Committee that he seldom attended the trustees' meetings, and he resigned in 1877. In the 1880s he resolved to give the Macleay collection to the University of Sydney, with a sum of £6,000 as an endowment to pay for a curator. An impressive building, funded by government (William John had been a member of the legislative council), was erected between 1886 and 1888. The collections were transferred by 1890 and George Masters moved with it. Macleay was duly knighted for his munificence. This museum, properly developed, could have become an important institution, but the university did not appreciate it. The Macleays died out; the collection ceased to be fashionable; and avaricious professors, in times of financial difficulty, cast covetous eyes upon its building. From the First World War, the Macleay museum was progressively relegated to totally unsuitable roof space, where it still languishes. The Macleays failed to impose legal restraints upon the university with more or less disastrous results.[39] Hence, the rivalry of the Macleays helped to inhibit the AM while failing to establish a notable one at the university.

Nevertheless, F.A. Bather, on a tour of museums in the southern hemisphere and the Far East in 1893, described the AM as 'probably the largest and most important museum in all our colonies'.[40] The investment of the colonial government had to some extent paid off. Moreover, the Krefft crisis, the associated turmoil among the trustees, and the losses in the fire of 1882 galvanised the museum staff into an unheard

of degree of energy. The new curator (1874–94) was Edward Pierson Ramsay, Australian-born, and the son of a prosperous Scots doctor. He was a self-trained naturalist, with particular interests in ornithology, but he rapidly restored the ethnological collection, assembling some 7,500 items.[41] He was interested in both Pacific and Australian material despite the contemporary view that Aborigines were 'incapable of improvement' as other 'native races' were.[42] Later, his personal collection of Aboriginal material was purchased from a descendant (again reflecting competitive private collecting).[43] The collection of human artefacts from this and other regions now became a central aspect of the museum's activity, although today the museum concentrates mainly on natural history and Aboriginal material.

A temporary brick ethnography hall was built in 1888 and photographs survive of its cluttered displays around the turn of the century (it was demolished in 1906). An anthropology gallery was remodelled in the south wing in 1907, but as usual, little attention was paid to the social, cultural and historic contexts of artefacts and many entered the collection with records of use and provenance missing. A great weakness was that the collection lacked much of significance from the Sydney area, where Cook and Banks had been intrigued by what they saw. Meanwhile, the Pacific collection also developed rapidly after the fire. Many private collectors, including missionaries, administrators and ship's officers contributed to this by donation or sale. Sydney was a key port for the Pacific Islands and this greatly facilitated the assemblage of such material. In 1890, the NSW government purchased 183 items collected during Cook's Pacific voyages.[44]

In Ramsay's era, the scientific staff increased in numbers from one in 1878 to eight at the end of the succeeding decade. More space was created in 1888 when the curator ceased to live in the building; the periodical *The Records of the Australian Museum* was founded in 1890; and a new floor was created by adding a storey on the William Street side of the building. The public and educational objectives of the museum were symbolised by the transfer of its control to the Department of Public Instruction (1889), but the character of the displays remains obscure. Poorly organised in Krefft's day, there must have been some improvement under Ramsay, but the museum maintained its nineteenth-century characteristics until at least the First World War and continued to drift until the 1950s.[45] A major financial crisis in 1893, when funds were halved, drove Ramsay into stress-related ill-health. Symptomatic was the fact that a new geology hall completed in 1893 had insufficient attendants to man it. Before these cuts, a staff of thirty-four enjoyed a budget of £11,000, but several were dismissed and the pre-1893 figure was restored only in 1909.

Robert Petheridge, Ramsay's successor, was a palaeontologist who also worked for the geological survey. Petheridge's interests classically shifted from fossils to ethnography and archaeology, publishing on cave painting and anthropological subjects. He introduced a higher degree of professionalism during his period as curator and later director,[46] including the institution in 1908 of a cadetship scheme to train 'young men' (the first woman appointed to the scientific staff arrived in 1920). In 1910, two of the museum staff, C. Anderson (later director for almost twenty years from 1921) and C. Hedley (acting director, 1920–21) applied for funds to visit museums overseas. Anderson went to Europe for six months; Hedley to the USA. This turned out to be of little value: their reports were not particularly penetrating and both had poor relations with Etheridge. Still, the museum was clearly interested in learning from international comparators, though it was left with a slightly uncomfortable blend of natural history specimens and ethnographic artefacts.

The AM always inhabited a competitive environment and failed to become the major museum of the colonial capital. One practical function was taken over by the Mining Museum, founded in 1875–76,[47] while a rival museum inhibited its assumption of broader interests in art and design, technology and social history. This owed its origins to the 1879 Exhibition, and was given the cumbrous name of the Technological, Industrial and Sanitary Museum. First mooted in 1878 it was planned as an equivalent of the Victoria and Albert Museum in London.[48] From 1883, it was housed in an unsanitary tin shed, which belied its name. Known as the Technological Museum from 1893, it collected Australian decorative arts, exotic materials and reproductions of European works, with a natural historical research function behind the scenes. By the 1950s, it was the Museum of Arts and Sciences, and in 1988 it moved to the former power station of the tram system.[49] Now known as the Powerhouse Museum, it has become one of the most impressive in Australia. It has upstaged the AM, presenting popular and modern displays where its predecessor seems partially locked into an earlier paradigm.[50]

The National Museum of Victoria, Melbourne

The territory that became the colony of Victoria was first settled in the mid-1830s when pastoralists arrived in the Port Phillip (later Melbourne) region from both NSW and Van Diemen's Land (Tasmania). These settlers soon became discontented with rule from distant Sydney and both the appointment in 1839 of an able administrator, Charles Joseph La Trobe, and representation in the NSW Legislature after 1843

failed to mollify them.[51] In 1851 the proclamation of Victoria as a separate colony was received with great jubilation.[52] As it happened, it was about to be utterly transformed economically and demographically by remarkable gold discoveries at Ballarat, later elsewhere in the territory. When La Trobe arrived, there were no more than 10,000 whites in the Port Phillip district. Between 1851 and 1861, the white population surged from 77,000 to 540,000. Meanwhile, the population of Melbourne, less than 20,000 in 1851, tripled in the space of three years in the early 1850s, reaching 150,000 by 1870. In this boiling pot of migration, there was something of a social revolution: rich pastoralists constituted the colonial gentry, but found their influence and power swiftly threatened by newly rich merchants and businessmen. The middle class expanded rapidly and soon exhibited the classic nineteenth-century anxiety about the growing numbers of the proletariat. Victoria quickly overtook NSW in wealth, urban growth and other indices of colonial 'arrival'.

When La Trobe arrived, a Mechanics' Institute was being formed at Port Phillip.[53] He promptly became its patron. His background as a teacher and his polymathic interests put him entirely in tune with the ambitions of the institutes. He had travelled extensively in the USA, Mexico and the West Indies before arriving in Australia. In America, he explored the prairies with the writer Washington Irving, who described La Trobe as 'a man of a thousand occupations; a botanist, a geologist, a hunter of beetles and butterflies, a musical amateur, a sketcher of no mean pretensions; in short, a complete virtuoso'.[54] He published books on natural history and geology discovered on his travels and seized the opportunities to pursue these interests on the south coast of Australia. Meanwhile, the Mechanics' Institute, perhaps catering for middle- rather than working-class interests, was bringing together men with scientific aspirations desiring to propel the territory into international networks. Indeed, it saw one of its main functions as revealing the characteristics of 'this remote region of the earth' to 'thousands and millions of the enlightened northern hemisphere'.[55]

Members of the Institute also collected assiduously for its museum, which by 1844 was ambitiously divided into departments, no less than Zoology and Comparative Anatomy, Ornithology, Conchology, Entomology, Botany, Geology, Aborigines and Miscellaneous. La Trobe himself sent shells, birds, plants and Aboriginal weapons abroad, to the museum of the Société des sciences naturelles de Neuchâtel, which had been founded by the celebrated Louis Agassiz; fossils were sent to Owen at the museum of the RCS; while plant specimens were despatched to the Linnean Society. But although the Mechanics' Institute did well financially (mainly through securing a valuable piece of land

in the city), it failed to become the leading light of scientific and museum endeavour. Moreover, La Trobe failed to persuade his superior, Governor Gipps in Sydney, to offer a government subsidy to the museum in 1846, but he did found the Botanic Gardens in the same year. In 1853 he appointed Ferdinand von Müller (or Mueller), later one of the most distinguished of all colonial botanists, as Government Botanist and Director of the Gardens. La Trobe also initiated surveys of forests and geology and created a small observatory.

Meanwhile, *The Argus* reported in September 1853 that Mark Nicholson had moved the founding of a museum in the Legislative Council, but that this had been met with scepticism: one member thought it was premature; another that a society needed to be created to take charge of it; while others proposed that it should be associated either with the Botanic Gardens or the Mechanics' Institute.[56] Nicholson had looked at the Institute, but had discovered that their museum was boxed up to make way for a fine arts exhibition. Still, Nicholson's motion passed. La Trobe seems to have been impressed by the idea and consulted Evan Hopkins, a mining engineer attached to the Port Phillip and Colonial Gold Mining Company, who suggested that such a museum should be associated with the Assay Office. He then turned to the Surveyor-General of the Colony, Captain Andrew Clarke RE. Trained at Woolwich, Clarke had had experience of Van Diemen's Land and New Zealand before his Victoria appointment and was involved with a new Philosophical Institute (see below) from the start.[57] It is clear that this 'parentage' would ensure that the museum should be strictly practical, designed to display the resources of the colony. Wilhelm (William) Blandowski, a mining engineer from Silesia, submitted a memorandum proposing a museum of practical geology in December 1853 and was appointed Government Zoologist in April 1854 as well as, in effect, the first curator of the museum. Blandowski was, like La Trobe himself, a maverick traveller and amateur scientist. He had abandoned a career in the Prussian army and arrived in Australia in 1849. A minor fortune secured at the goldfields at Castlemaine (near Bendigo) enabled him to indulge his interests in natural history, botany and geology. He was a founder of the Geological Society of Victoria in 1852, briefly joined a geological expedition and applied to La Trobe for government support in developing his illustrated natural history of the colony.

Funds were, however, forthcoming for museums of natural history and of economic geology, the government estimates of 1854 including generous sums of £2,000 each. However, by 1856, the budget combined the two and the sum had been reduced to £1,000, reflecting the financial stringency associated with a recession that year. As these

plans advanced, Blandowski was involved in expeditions (1855–57) to collect specimens of mammals and birds, compiling a checklist. He also claimed knowledge of physical geography and geology, botany, mineralogy, palaeontology, ichthyology and ethnology. Gerard Krefft, later curator in Sydney, accompanied him on the 1857 expedition to the Murray and Darling rivers, but relations were not good. Krefft's diaries indicate that the white members of the expedition did little collecting, but relied on Aborigines to bring in specimens.[58]

Blandowski published seven reports on his work in the *Transactions of the Philosophical Institute of Victoria* during these years. He had a good understanding of wildlife and landscape, and was a competent artist. He used Aboriginal informants and, unusually, named them, although he adopted the conventional view that the Aborigines were doomed to disappear. He also confirmed the sense of great natural abundance which had been noticed by some of the earliest visitors to the region, described in 1794 (by the Rev. T. Fyshe Palmer) a 'land of wonder and delight' that could not fail to stimulate the 'philosophic mind'.[59] But Blandowski's ambition was blighted by the fact that he was 'eccentric, stubborn, impulsive, quarrelsome'.[60] During 1856–57 he repeatedly clashed with the university professor and second curator, Frederick McCoy. He outraged the Philosophical Institute by naming a number of fish after its members and then rendered their descriptions all too anthropomorphic in character. The Ceruna Eadesii, for example, was described as a fish 'easily recognised by its low forehead, big belly and sharp spine'.[61] Another was described as a 'slimy, slippery fish. Lives in mud'.[62] The scandalised society (Richard Eades was the Mayor of Melbourne!) ordered him to withdraw, but he refused to do so and the *Melbourne Punch* inevitably had a field day. As the dispute escalated, he declined to hand over many of the specimens, memoranda, drawings and notes from his expeditions, and left Australia for Europe in 1859, hoping to make some money from his natural objects and illustrations from the still exotic southern land.[63] He never ceased to complain about the treatment he had received.

By the time of Blandowski's departure, the position of science in the colony had become regularised. The dramatic mushrooming of the incipient colony, unmatched anywhere else in the British Empire, ensured that a whole range of new institutions were brought into being in the course of the 1850s. In 1854, no fewer than two scientific associations appeared in Melbourne, the Victoria Institute for the Advancement of Science (the BAAS of 1831 was the intended model) and the Philosophical Society of Victoria. (They amalgamated in 1855, becoming the Philosophical Institute, with Blandowski as a founder member.) The university was established in 1855 and a public library opened in

1856 (the foundation stones of both were laid by La Trobe's successor, Sir Charles Hotham), following the grant of colonial self-government in 1855.[64] The creation of a colonial museum lay at the heart of all these developments, associated with the appearance of the new scientific societies.[65] Clearly, it was thought that practical, economic benefits would flow from such scientific endeavour, but there were soon other motives. The gold rush, and its associated social turmoil, had stimulated the conviction that moral regeneration could only be secured through educational, scientific and cultural institutions. Indeed, the Melbourne *Argus* suggested that museums, libraries and gardens were superior to press, pulpit and police in elevating the public.[66] This was a striking expression of what was generally an empire-wide phenomenon: such institutions offered moral uplift, a civilising process that matched their role as evidence of colonial modernity and progress.

These were exactly the sentiments expressed by the President of the Victoria Institute for the Advancement of Science, Mr Justice Barry, at its inaugural conversazione in September 1854.[67] The Institute would offer opportunities for 'mutual improvement', for much 'agreeable mental recreation' enabling the members to collect specimens to be identified and theorised about by more capable scientists. Thus, problems that had stumped the ancients would be 'subjected to the ever-strengthening arm of Science'. Through the printing press and education this fertilisation of the intellect and the assumption of 'vigorous and self-relying habit' would arouse the listless, percolating down to the public at large. As Barry proposed, every scientist needs the mechanic to support him, for 'Science claims Art as its handmaiden'. Here the university and libraries would be vital. He made two classic statements of the role of a colony and of the fate of its indigenous people. He saw 'gifted men' of 'cultivated mind, fervid imagination, and intrepid temperament' who had found themselves 'curbed and confined elsewhere by the pressure of surrounding competition', as having found in the colony 'a field in which their talents may be allowed to expatiate'. And on this 'field' and its inhabitants, he announced that:[68]

> One of the humblest races in the gradation of the human family has yielded to us the possession of the vast territory over which our people are now dispersed, and, by an inscrutable regulation of Providence, is waning before the access of civilization. By exertions unassisted from without, cities and towns have sprung up of a class and with a rapidity which challenge a parallel in former or contemporary history. The events crowded into the last three years have wrought a change, not merely in the actual condition, but in the immediate prospects of our community, which, as regards our social and political state and the opening dawn of accelerated progression, must inspire consolation, confidence, and hope.

The two scientific societies do indeed give an impression of extraordinary energy. Government scientific appointments, originally initiated by La Trobe, provided a core of professionals. The early Institute transactions provide a remarkable compendium of surveys and studies. Subcommittees were formed, such as the Observatory Committee and the Exploration Committee,[69] with manifold observations compiled and published. By the end of the decade, the united societies had already been renamed the Royal Society of Victoria (RSV),[70] complete with a building and a hall.[71] The latter was inaugurated in January 1860 with an address by the President, Ferdinand Mueller.[72] Remarkable sums of money had been raised; and seven reports had been produced on the resources of the colony.[73] Instructions were produced to guide 'scientific observers attached to the Victoria Exploring Expedition' on surveying, astronomy, meteorology, geology, mineralogy, zoology and botany and it was proposed that if 'we have inter-colonial cricket matches' and 'champion races for horses', 'we should also have annual gatherings for the exchange of intellectual ideas, akin to the British Association for the Advancement of Science at its recent meeting in Aberdeen presided over by Prince Albert'. In fact the equivalent Australasian association was not inaugurated until 1888. But in the opening years of the Institute, the notion of a museum was not neglected, and a museum committee was formed.

Yet the relationship between the Institute and the museum was always unclear. In effect, the former claimed ownership of the latter in intellectual if not in legal terms (except for some items),[74] but it would soon see the museum collection slipping out of its grasp, finding itself at loggerheads with one of its own members. After the piscatorial row with Blandowski, mentioned above, it faced a piratical action on the part of the man destined to be the second curator. If Blandowski was a classic figure of the early colonial frontier – European rather than British in origins, an eager 'amateur' scientist with a wide diversity of interests – he was replaced by rather different figures, reflecting the next stage of colonial development. The museum in Melbourne was now to be influenced by two commanding individuals: a curator/director who served for more than forty years and a chairman of trustees who dominated all cultural developments. The first was Frederick (later Sir Frederick) McCoy and the second the judge and first president of the Victoria Institute Sir Redmond Barry.

McCoy in some ways fits the model of the early museum buccaneering maverick, a more highly trained figure than Blandowski, but still a law unto himself and lacking any real scientific specialism.[75] Barry was also a classic middle-class migrant seeking advancement unavailable at home: a lawyer and judge, he swiftly became the leading figure

of a rapidly growing colonial city.[76] He had given his first lecture to the Mechanics' Institute in 1840 and remained indefatigable in all educational activities thereafter. He is credited with founding the university and was its first Chancellor. His interests were perhaps more particularly in the development of the fine arts, with the establishment of an art gallery and a significant library, but he was also involved with the museum. Both were Irish, though very different in personality. McCoy was fiery, blunt, cantankerous and polemical; Barry was suave and courtly with an inclination to be quietly Machiavellian in his dealings.[77]

When the University of Melbourne was founded in 1855, four academics were enticed to Victoria to take up professorships with the inducement of salaries of £1,000 per annum. Of these, three – like Redmond Barry – were associated with Trinity College, Dublin. Frederick McCoy (1817–99), was not, however, a graduate. The son of a professor of Materia Medica, he had given up medical studies in Dublin to concentrate on palaeontology and natural history. He began to catalogue museum collections, first in Dublin, then in Cambridge and Belfast, and from 1838 to publish prolifically in the field of palaeontology. Adam Sedgwick employed him as his collaborator in the Woodwardian Museum in Cambridge in 1846 and he joined Sedgwick on geological field trips.[78] Appointed professor of Geology and Mineralogy, as well as museum curator, at Queen's College, Belfast in 1849, this provided the required experience for his appointment as professor of natural science in Melbourne. Never a specialist, he lectured in chemistry, mineralogy, botany, comparative anatomy and physiology of animals, systematic zoology, geology and 'some palaeontology'.[79] He was also instructed to supervise a botanic garden at the university. Students in these disciplines were mercifully few and McCoy had plenty of time for other activities.

At this point, the embryonic Museum of Natural History (it swiftly became the Colonial and then the National Museum) was lacking its own building (it was housed in the Government Assay Office) and had barely begun its public mission. Blandowski had done little as putative curator. Now the energetic McCoy proposed that the contents of the museum should be exhibited at the university and he successfully secured rooms in the new buildings for this purpose. In 1856, ignoring public protests, the irritation of the scientific and cultural elite (including Barry) and the rage of the nominal curator, McCoy transferred the collection from storage in the Assay Office to the university.[80] The papers of the Institute insist that this was merely a temporary measure and that the museum would be returned – but that would not happen for nearly half a century.[81] Later the RSV claimed to have its own

museum with an honorary curator.[82] This contained several thousand specimens, some exhibited in 'four large showcases' at the society's rooms. The society insisted that this would grow as its connections with learned societies around the world bore fruit.

The Melbourne *Punch* carried an amusing cartoon of McCoy's piracy together with some doggerel entitled 'The Raid on the Museum':

> There was a little man,
> And he had a little plan,
> The public of their specimens to rob, rob, rob,
> So he got a horse and dray,
> And he carried them away,
> And chuckled with enjoyment of the job, job, job.
>
> Blandowski's pickled possums
> And Mueller's leaves and blossoms,
> Bugs, butterflies, and beetles stuck on pins, pins, pins,
> Light and heavy, great and small,
> He abstracted one and all –
> May we never have to answer for such sins, sins, sins.
>
> There were six foot kangaroos,
> Native bears and cockatoos
> That would make a taxidermist jump for joy, joy, joy;
> And if you want to know
> Who took them you should go
> And should seek information from McCoy, Coy, Coy.

McCoy thus had physical, but – at least theoretically – no administrative control of the museum. Continuing to seize the initiative, he laid down his prospectus for museums in Victoria at a meeting of the Philosophical Institute in 1856.[83] This was published in *The Argus* in May 1857 and also appeared as a pamphlet.[84] McCoy's views were severely practical. The museum was a place 'in which the eye of the unlearned could be familiarised with natural objects, with the principles of classification applied to them by scientific men to place their peculiar characters and mutual relations in striking light; and with specimens and models of machinery illustrative of the arts and manufactures'. Museums were not 'just places for the amusement of schoolboys and idlers'. Victoria should consider having museums of natural and applied sciences, of botany, zoology, geology, medicine and agriculture; as well as of economic geology in a School of Mines. As an afterthought, he added a Museum of Fine Arts and Antiquities (containing casts of classical statuary, architectural decoration, coins and a good library). Thus, public instruction through entertainment was not McCoy's thing. The absence of any mention of ethnology or archaeology – in which McCoy had no interest – is also notable. Once

5 The Victoria National Museum when located at the University of Melbourne. The gorilla display, arranged by Frederick McCoy from specimens acquired from explorer Paul du Chaillu, in an effort to disprove Darwin, can be seen on the rear wall.

Blandowski fell from favour, McCoy's position was regularised as Director of the museum in 1857. By then he had also been appointed government palaeontologist, at an additional salary, and his star was in the ascendant. He dominated the museum until the 1890s. As a man of pronounced and unshakeable views, this was to have as much negative as positive effects.

While McCoy published prodigiously, he was entirely an armchair natural scientist. He never conducted field trips; and was strikingly obtuse when a new colony offered, in effect, a fresh and extensive laboratory. He remained fiercely anti-Darwinian, insisting on the immutability of species and denying (as he put it) 'authority, either in scripture or science, for belief in the gradual transmutation of one species into another'.[85] He organised a major exhibition of stuffed gorillas in the museum in another attempt to refute Darwin,[86] and even claimed to find geological confirmation of biblical creationism. However, he seemed very out of date in all his scientific views by the end of his life. He made serious errors, clashing with rival geologist W.B. Clarke on the geological contexts and potential value of coal deposits,[87] and drew down the contempt of practical miners when he insisted, entirely erroneously as it soon turned out, that no gold was to be found at deep levels. He was also dismissive of writing reports and impatient about keeping careful financial records.[88] These characteristics ensured that both university and government – particularly the Chief Secretary's department, which controlled the museum – sought to crush him, but somehow he succeeded in fighting his way out of every sticky situation. The museum's failure to collect ethnology placed it well behind its colonial comparators both in Australia and elsewhere, and this despite the fact that La Trobe and others had expressed an early interest in Aboriginal artefacts. In fact the National Gallery collected some 'curiosities' (though not necessarily Aboriginal) and inherited some from Redmond Barry after his death. Aboriginal artefacts were also displayed in the library. In addition, the gallery contained a collection of coins and medals.

To compound his errors in modern eyes, McCoy was active in the Acclimatisation Society (founded in Victoria in 1861) and approved of the introduction of exotic mammals and fish, plants and birds, even destructive sparrows and rabbits. Yet despite all this, he was showered with scientific honours and titles, often rewards for service on government boards and as a commissioner to a number of exhibitions, those rites of passage for the maturing colony. These included the 1861 Victorian, the 1866 Intercolonial and the 1880 International exhibitions.[89] At the 1861 exhibition, he displayed birds and insects from the museum collection and wrote chapters on zoology and geology in the catalogue. In his defence, he was an indefatigable scientific correspondent and secured large numbers of specimens from around the world through exchanges, classifying these arrivals himself.[90] Tom Griffiths has described him as 'pre-eminent in manipulating long-distance relationships'.[91] He also succeeded in unlocking the government's coffers for the construction, in 1863, of a dedicated museum building at the university, Gothic in style with a central hall 150 feet (48 m) long

and 60 feet (18 m) wide, costing £4,500 and a further £1,200 to fit out. Significantly, he secured the funding for this building while Barry was overseas at the London Exhibition of 1862.

Despite a sense that the museum was remote from the public both physically (a mile out of town on the campus) and philosophically (concentrating on serious academic and scientific, not leisure and entertainment, objectives), it attracted reasonably large numbers of visitors (though, as always, counting systems are unclear and may leave us sceptical about their accuracy), supposedly averaging 53,000 per annum in the 1860s,[92] 95,000 in the 1870s and 110,000 in the 1890s, with a peak of over 130,000 in 1888 (no doubt associated with the exhibition of that year).[93] He managed to keep the museum open from Mondays to Saturdays and was assiduous in publishing news of fresh acquisitions and of visitor figures in *The Argus*.[94] But given the fact that Melbourne outranked Chicago in population in the 1860s (falling back later), this attendance may seem poor.[95] He displayed remarkable models of mining equipment (constructed by a Swedish miner, Carl Nordstrom, between 1857 and 1891), which he saw as an important practical purpose of a museum. He fought every inch for his funding, but in 1863 the total staff of the museum stood at seven, while by 1868 there were twelve. He also secured government financial help in publishing his *Prodromus of the Zoology of Victoria* and *Prodromus of the Palaeontology of Victoria*.[96] He became FRS in 1880. Between 1869 and 1890 he was a member of a technological commission, which encouraged both technical education in Victoria and also the establishment of an Industry and Technology Museum (ITM), planned in the late 1860s and opened in 1870.

There was an explicit London parallel here. The new museum arose out of Melbourne's Intercolonial Exhibition in 1866–67 and was seen as necessary if 'mechanics and artisans here are to compete with those in England'.[97] But whereas London's V&A was planned essentially as a means of bringing aesthetic values to bear upon industrial products,[98] the Melbourne version had much more utilitarian ambitions with, inevitably, a particular specialism in mining and mineralogy. It was even housed in the building constructed for the 1866–67 exhibition, at the back of the library and gallery. To McCoy's great fury, the mining and agricultural collections (with associated staff) were removed from his care at the university to the new museum. The trustees failed to consult him on this, but magnanimously he did give the lecture inaugurating the ITM. McCoy, who was demoted from Director to Curator, now had a rival, James Cosmo Newbery, a chemist and assayer, who was appointed scientific superintendent of the ITM.[99] Newbery was

supervisor of juries at the 1880 Exhibition and had a considerable influence upon the mining industry in the colony.

But whereas the V&A developed into one of the world's greatest museums, this supposed equivalent was to have a very chequered existence. Initially, like the V&A, its arrangements reflected middle-class ambitions for 'mechanics and artisans', but it failed to make practical arrangements for such instruction. The ITM was open from 10 until 4 – impossible hours for working people. Moreover, the strength of sabbatarianism in Victoria ensured that efforts by the trustees to open the museum and gallery on Sundays in 1883 were frustrated for another twenty years (in Britain Sunday opening had become a reality in the late 1880s and secured parliamentary approval in 1896).[100] A Sunday Liberation Society was successfully checked by the Sunday Observance League, which had parliamentary support. The main achievement of the ITM was the organisation of major lecture series, though these were badly attended and were scheduled for the late afternoon when, once more, 'mechanics and artisans' were unlikely to be free. Lectures on economic botany were given by Thomas Macmillan and his daughter appears to have been the first woman employed in a museum in Victoria when she took over the work of cataloguing the phytological section in 1882.[101] She worked alongside another woman, Miss Hodgkinson.

From 1870, the Melbourne Library, Art Gallery and Technology Museum on Swanston Street had an imposing classical frontage, in grandest civic style, which is retained to this day. McCoy seemed all the more isolated. His museum languished at the university, lacking both the architectural statement and the convenience of the downtown complex. Indeed, McCoy's last years represented a sad decline: his ambitions for extensions to the museum were not realised, particularly once recession set in during the mid-1890s (the almost inevitable dip in the economic cycle after the 1880s – Victoria's prosperous decade); there was a fire in 1888; and there were thefts in 1895. He noted with angry dissatisfaction that new buildings were being constructed for museums in Adelaide and Sydney in the 1890s. Although he disliked what he saw as pettifogging bureaucracy, he repeatedly stressed the number of specimens and their supposed value: towards the end he insisted that these figures were 510,000 and £40,000 respectively.

Trustees and government were clearly waiting for him to die. When that occurred in 1899, the museum was almost immediately transferred from the university to the city centre's cultural complex. This represented a new philosophy of bringing the museum to the people. McCoy had been fierce in maintaining that museums should be out of town, set in parkland to avoid pollution (as curators also suggested elsewhere, for example in Auckland). This was a convenient justification

for retaining it at the university, where the grounds were extensive and well-planted. But, ironically enough, the city-centre museum was to be housed in a large brick extension (replacing the wooden former exhibition space) named McCoy Hall. This also spelled the temporary end of the ITM: some of its collections were amalgamated with the National Museum; some were sold off or put into storage. The museum's historian described this as 'calamitous', a 'black day' in its history, stimulating controversy including letters from a former government geologist.[102] The ITM was reopened in 1915 in the Queen's Hall, formerly part of the library. The museums remained in this complex until the new one was opened in 2000 behind the great exhibition building of 1880.[103] The fortunes of the ITM continued to be highly variable (with name changes), but it fully amalgamated with the NMV in 1983.[104]

The architect of these changes was Walter Baldwin Spencer (1860–1929), a very different figure from McCoy. From a well-to-do Lancashire family, he was educated at Owens College in Manchester (forerunner of the university) and at Oxford. He intended to study medicine (something shared with McCoy), but under the influence of key mentors he became a passionate evolutionary biologist, even abandoning formal religious belief in the process. His father, Reuben, donated a numismatic collection to the Manchester Museum in 1894, and Baldwin was to keep in touch with its first keeper, William Evans Hoyle, who had been a school friend. At Oxford, he made a number of important contacts, including the biologist H.N. Moseley, the anthropologist E.B. Tylor and the geographer Halford Mackinder. Moseley, who had an interest in ethnology (and had visited Australia on the scientific voyage of the *Challenger* in the 1880s), and Tylor changed the course of Spencer's career by persuading him to cooperate in transferring the great Pitt-Rivers ethnographic collection from Bethnal Green to its new building in Oxford.[105] This experience brought him into contact with concepts of typological classification of artefacts leading to an evolutionary approach to human societies.[106]

Spencer successfully applied for the chair of biology in Melbourne when he was only 26. Arriving in early 1887, he was soon revolutionising biology teaching and research through new laboratories, field trips and a museum. He became actively involved with the revived (after a period in the doldrums) Royal Society of Victoria, the local Field Naturalists' Club (founded 1880), and the Australasian Association for the Advancement of Science.[107] In 1894, he joined a major scientific exploring expedition to central Australia for which he edited the reports in four volumes. It also stimulated him to create a biogeographical analysis of the distribution of Australian fauna. This expedition drove him further into a major interest in ethnography. He met a number of

men who worked in the far interior of the continent, all of them with a considerable interest in the Aboriginal people among whom they lived. These included a bush policeman called Ernest Cowle and a postal officer, Paddy Byrne.[108] The most productive of these contacts was Francis J. Gillen, the postmaster at Alice Springs, and Spencer set about collaborating with him in publishing on Aboriginal anthropology.[109]

In 1896 they teamed up to conduct notable fieldwork at a time when the great majority of 'anthropologists' were still in their armchairs. Their research was published as *The Native Tribes of Central Australia* in 1899.[110] Distinguished anthropologists, such as Sir James Frazer, were impressed, particularly by their analyses of Aboriginal art and ceremonial artefacts in the context of notions of social evolution. The great success of this work brought them further opportunities to enter the field in northern Australia in 1901 and 1902, and they proved themselves genuine pioneers when they inaugurated both sound recording on wax cylinders and the shooting of moving film. More books resulted and Spencer's reputation as an anthropologist was fully established.[111] He became a government adviser on the indigenous peoples of the Northern Territory and conducted more expeditions before and after the First World War. Gillen died in 1912 ending the publishing partnership.

This is the essential background to the transformation of Spencer from academic evolutionary biologist to notable museum director. McCoy's severely practical museum had contained geological specimens, shells, mineral collections, examples of colonial timbers, as well as lizards, snakes, insects and fish. What almost certainly attracted the public was the large collection of stuffed fauna, some local, and many international. His acquisition of three gorilla specimens of the African explorer, Du Chaillu, was a major coup. The mining collection and the models were probably also appealing. Even Spencer, whose relations with McCoy in his declining years were strained, referred to the latter's 'wonderful acquisitive faculty . . . which not even the protests of the Trustees could curb'.[112] Nevertheless when McCoy's death galvanised the museum, Spencer was already a trustee and chairman of the Museum Committee. Within a matter of weeks, Spencer was honorary director (unpaid because of his university salary). The colonial treasurer was persuaded to grant £13,000 for a new building adjacent to the rest of the museum, gallery and library complex. This was completed in 1905 and the museum reopened in the following year. Spencer rearranged the museum's natural history collections, converting McCoy's geographical organisation into one based on species. He embarked on the creation of faunal habitat groups and secured the scattered ethnographic collection, adding to it immeasurably.

6 National Museum, Melbourne, Victoria, after its return from the university to the centre of town behind the state library. This building was completed in 1905

Although McCoy had no interest in ethnography at all,[113] Victoria had built up a considerable collection of Pacific and exotic materials as well as some Aboriginal specimens. Barry had promoted the display of photographs, casts and artefacts of Aborigines at the Melbourne Intercolonial Exhibition of 1866.[114] Among exotica, the assemblage created by Andrew Goldie in New Guinea between 1876 and 1891 came to the museum. In 1891, the trustees purchased the extensive Zulu and Sotho collections of the Cape Governor Sir Henry Loch. In the last years of the century, C.G.W. Officer was collecting assiduously in the Solomon Islands. The museum trustees employed him to conduct fieldwork collecting during 1900. Until the arrival of Spencer, all this material was housed in the art gallery, the library or the ITM.[115] Spencer himself began to donate Aboriginal material in 1899, and eventually, during the First World War, he handed over his entire private collection as well as persuading other collectors to donate or sell theirs.[116]

R.H. Walcott, who had been Newbery's successor in the ITM, became the curator of ethnography and set about a complete cataloguing of the collections. Spencer himself published a *Guide to the Ethnographic Collection of the National Museum of Victoria* in 1901 and lamented that the opportunity had been missed to make a collection of artefacts

in the early years when they were still in use, as well as the lack of provenance or description for many of the specimens.[117] Two thousand copies were quickly sold and the guide was reprinted in 1915 and 1922. Other staff changes gave the museum a much more professional tone. J.A. Kershaw, employed by McCoy as a taxidermist, became curator of zoology and effectively Spencer's deputy director. Frederick Chapman, a well-trained geologist, was added to the team as curator of palaeontology. In 1906 Spencer inaugurated the publication of that vital attribute of the self-respecting museum, a scientific journal – *Memoirs of the National Museum, Melbourne*.

While Spencer built up collections of bark paintings, stone tools and ornithological specimens, he also became intrigued by human remains, joining the passion for collecting skeletal and cranial material sweeping the world. In 1905, the report of the trustees acknowledged the help of the police department in securing Aboriginal skeletons.[118] This move into physical anthropology coincided with Spencer's not very expert excursion into prehistoric archaeology (his analysis of stone tools and notions of Aboriginal history have largely been discounted). In 1904, he emphasised the disjuncture between ancient 'civilisation' and 'primitive cultures' by insisting that a donation from the Egypt Exploration Fund should go to the gallery rather than to the museum. He also decided to use ethnographic items as exchange materials, sending consignments to the BM, the Manchester Museum, the Pitt-Rivers, and others in the USA and Europe in the early years of the twentieth century. Another accumulation of 160 items was sent to Russia. As late as 1910–11, he sent Aboriginal artefacts to the Field Museum in Chicago in exchange for a 40 ft-long totem pole from the Queen Charlotte Islands, collected by C.F. Newcombe. The trustees' report laconically announced that 'we still await the particulars concerning its history'.[119] (This pole is still prominently displayed in the foyer of the new museum.) Yet by 1912 he had recanted, for in that year he urged the government to introduce controls over the export of Aboriginal ethnographic and skeletal specimens. The New Zealand Maori Antiquities Act (see Chapter Eight) was used as a model and a proclamation was issued in late 1913. Additionally, he had become a pioneer of faunal and environmental conservation, playing a leading role in campaigns to establish a Fisheries and Game Branch, as well as urging the gazetting of national parks.

Thus Spencer, as honorary director, chairman of the museum committee, influential trustee (and eventually member of all of the board's subcommittees) had unprecedented power. Given the fact that he was unpaid throughout, his achievements were remarkable and the budget of the museum remained at strikingly low levels (well under £3,000 in

1914). He had given up biological research: he had become a full-time museum worker and, among his manifold activities,[120] was interested in education and the pioneering notion of a gallery for children. As the Edwardian years passed, Spencer's reports to the trustees significantly became longer and more detailed. Moreover, as a water-colourist himself, he also had a considerable interest in art and helped to develop the National Gallery, advising it on purchases and bequests (though his influence here may have been mixed).[121] He made a personal collection of Australian paintings, notably by Arthur Streeton and Norman Lindsay, which were sold on his retirement in 1919. While his last years in the 1920s were blighted by alcoholism, marital difficulties and declining health, his prodigious energies had ensured that the museum could genuinely be described as 'national'.

Almost inevitably, there was something of a trough after Spencer's dynamism was removed from the scene. The museum's distinction in ethnographic collecting was probably overhauled by the AM in Sydney and the South Australian in Adelaide. It was not until after the Second World War that the NMV recovered its rightful place as one of the more notable museums of the southern hemisphere.[122] But its history had been curious: two dominant figures, spanning a period of seventy years, had struck out in different directions. Effort had gone into the founding of a wholly new museum that led, ultimately, nowhere. The national museum was fortunate to survive and prosper as well as it did.

Notes

1 In 1798, Governor Hunter sent a platypus preserved in spirit to the new Literary and Philosophical Society of Newcastle upon Tyne. Ann Moyal, *Platypus, the Extraordinary Story of how a Curious Creature Baffled the World* (Washington 2001), pp. 4–5.
2 This is a clever play on the earlier concept of an antipodean 'cultural cringe'. There is a small display on 'biological cringe' in the National Museum of Australia in Canberra. See also Libby Robin, *How a Continent Created a Nation* (Sydney 2007), prologue, pp. 1–10.
3 Field subsequently, in 1825, published his *Geographical Memoirs*, which examined the progress of scientific activity in the colony. He considered it to have been slight because of the export of specimens to the UK.
4 The 1821–22 Minute Book survives. Michael Van Leeuwen, 'The Origin and Growth of New South Wales Museums 1821–1880', MA thesis, Macquarie University, 1995, p. 30.
5 Society members were to contribute £5 towards the cost of the museum.
6 The seven original members included, as well as Judge Field, the Colonial Secretary Henry Goulburn, who was interested in meteorology, Dr Henry Grattan Douglas, who arrived from Ireland to take charge of the General Hospital at Parramatta, John Oxley, explorer and surveyor, Edward Wolstonecraft, businessman and banker, Captain John Irvine, and a leading landowner, John Bowman.
7 An agricultural society was re-established in 1822 with the support of Governor Brisbane.

8 Its rules about members giving papers with fines for lateness and non-compliance seem so strict that its demise is not surprising. See the document in Ann Mozley Moyal (ed.), *Scientists in Nineteenth-Century Australia: a Documentary History* (Stanmore, NSW 1976), pp. 110–12.
9 For the early history of the AM, see Ronald Strahan (ed.), *Rare and Curious Specimens: an Illustrated History of the Australian Museum 1827–1879* (Sydney 1979) and van Leeuwen's thesis. There is an unpublished typescript history by Gilbert Whitley, commissioned in 1956. Whitley, an ichthyologist, was not up to the job and produced a collection of extracts from documents. Unsurprisingly, the trustees failed to publish it. This sadly diverted Whitley from finishing his publications on fish. A useful administrative timeline prefaces the *Guide to the Australian Museum Archives*, third edition.
10 Ronald Strahan, 'The Dog that did not Bark: Alexander Macleay and the Australian Museum', *Journal of the Royal Australian Historical Society*, 75, 3 (December 1989), pp. 224–9.
11 Moyal, *Platypus* offers a full account of the platypus saga.
12 There are conflicting accounts of these contacts. Van Leeuwen (pp. 53–4) gives a clear exposition of these documents, but Strahan, 'The Dog that did not Bark', insists that no such documents exist. Julian Holland in Peter Stanbury and Julian Holland, *Mr. Macleay's Celebrated Cabinet* (Sydney 1988), baldly states (p. 26) that 'the origins of the museum are unclear, but it is very likely that Alexander Macleay was the instigator of the plans'.
13 It should be remembered that NSW included all of eastern Australia. While Tasmania had become a separate colony in 1825, Victoria and Queensland had to wait until 1851 and 1859, respectively. Tasmania had a Society of Natural History as early as 1838 and its first museum in 1842, founded by Sir John and Lady Franklin. The Natural History Society became the Royal Society of Tasmania in 1843 and published early scientific papers from Victoria when the latter had no scientific outlets of its own (three volumes of the *Tasmanian Journal of Natural Science* were issued between 1842 and 1848). This society set about founding the Franklin Museum with a building opened in 1863 and extended in 1886 and 1901. The Queensland and the Western Australia museums date their origins to 1855 and 1860, respectively, with the Queensland Philosophical Society originating from 1859 and the Royal Society of Western Australia from 1914.
14 The controversial Mitchell (1792–1855), a military surveyor who became assistant to Oxley in 1827 and surveyor general in 1828, was noted for using convicts as associates on his expeditions. He was also keen on retaining Aboriginal names.
15 Strahan, 'The Dog that did not Bark', p. 226.
16 George Bennett, *Wanderings in New South Wales, Batavia, Pedir Coast, Singapore, and China: being the Journal of a Naturalist during 1832, 1833 and 1834* (London 1834). Suji Sivasundaram, *Nature and the Godly Empire: Science and Evangelical Mission in the Pacific, 1795–1850* (Cambridge 1950) offers background as well as an expert interleaving of science and the evangelical thrust.
17 The museum acquired death masks from the victims of these executions.
18 By then there was a subscription library in Sydney, jointly administered with the museum, 1836–41.
19 Clarke (1798–1878) arrived in NSW in 1838 as chaplain for the Society for the Propagation of the Gospel and quickly developed a consuming interest in its geology (also working in Tasmania), conducting a sequence of expeditions and mapping the geology of NSW with a focus on gold and coal deposits. A pugnacious figure, he was involved in many bitter disputes. He published some 80 scientific papers and was an ardent publicist for scientific ideas in the colonial press. A founder member of the Royal Society of NSW in 1867, he was elected FRS in 1876. The Clarke medal, Australia's first for scientific achievement, was founded in his name in 1878.
20 Angas had travelled in Europe, New Zealand and South Australia, and had

published extensively on the ethnology and natural history of the regions that he had visited.
21 Many paintings of early cabinets of curiosities give prominence to coins and shells. See, for example, Frans Francken the Younger's 'Cabinet of a Collector' (1617) – in the collection of Queen Elizabeth II – which reveals some of the obsessions of colonial museums more than two centuries later.
22 This was by the colonial architect, James Barnet. It was described as an inconvenient building with many hazards likely to cause damage to specimens.
23 For Krefft's career, see G.P. Whitley, 'the Life and Work of Gerard Krefft, 1830–1881', *Proceedings of the Royal Zoological Society of Australia* (1958–9), pp. 21–34.
24 Part of Krefft's report is published in Moyal (ed.), *Scientists in Nineteenth-Century*, pp. 206–7.
25 The colonial treasurer, attorney general and chief justice were all trustees of the museum.
26 Private communication, Dr Philip Jones of the South Australian Museum, October 2007.
27 Quoted in Jim Specht, 'Lasting Memorials: the Early Years of the Australian Museum', *Kalori*, 58 (August 1980), pp. 7–11 and 31, this quotation on p. 7 and R.J. Lampert, 'The Development of the Aboriginal Gallery at the Australian Museum', typescript, library of the Australian Museum, later published in Conference of Museum Anthropologists *Bulletin*, 18 (1986), pp. 10–18.
28 Peter Proudfoot, Roslyn Maguire and Robert Freestone (eds), *Colonial City: Global City. Sydney's International Exhibition 1879* (Darlinghurst, NSW, 2000) offers a general survey.
29 Ibid., p. 10.
30 George became a member of the colonial legislature and managed the family's country estate. He returned to England, suitably re-gentrified, in 1859 and was knighted in 1869.
31 Stanbury and Holland, *Mr. Macleay's Celebrated Cabinet*, passim.
32 The Elizabeth Bay House was restored and opened to the public as a house museum in 1977. The guidebook is very informative about the Macleay family and their period of residence there.
33 W.S. Macleay, *Annulosa Javanica* (London 1825) and 'Illustrations of the Annulosa of South Africa' in Smith, A., *Illustrations of the Zoology of South Africa* (London 1849). The British Library catalogue lists other publications by Macleay Jr.
34 This was the taxonomic belief, influential in some quarters in Britain at the time, that 'groups could be linked by a sequence of affinities into a circle of five elements, and that the elements of one circle could be linked by analogy to the five elements of another circle'. Stanbury and Holland, *Mr. Macleay's Celebrated Cabinet*, p. 20; Harriet Ritvo, *The Platypus and the Mermaid and other Fragments of the Classifying Imagination* (Cambridge, Mass. 1997), pp. 31–5.
35 William John called this, on the analogy of the Ashmolean and the Hunterian, the Macleayan Museum. The main building housed his own collections, including ethnography and geology. A smaller building for the entomological collections was built nearby in 1880. He also built the Linnean Hall in 1885 as headquarters of the Linnean Society of NSW.
36 See the chapter by Lydia Bushell in Stanbury and Holland, *Mr. Macleay's Celebrated Cabinet*, pp. 134–8. The historic photograph collection is described by Leigh McCawley in ibid., pp. 139–45.
37 Ibid., p. 56.
38 Strahan, 'The Dog that did not Bark', pp. 228–9.
39 Today, it is very difficult to find; most people on campus seem to have no idea where it is; and it is apparent that the Nicholson collection of historical and archaeological artefacts, housed in the main quadrangle, is much more highly valued. This was donated to the university in 1860.
40 F.A. Bather, 'Some Colonial Museums', in E. Howarth and H.M. Platnauer (eds),

MUSEUMS IN SYDNEY AND MELBOURNE

Museums Association, Report of Proceedings with the Papers read at the Fifth Annual General Meeting held in Dublin, June 1894 (Sheffield and York 1895), p. 212. Bather's report of his visits covers pp. 193–239.

41 Ramsay's family had been anthropological collectors and had donated items to the Perth Museum, Scotland.
42 Strahan (ed.), *Rare and Curious Specimens*, p. 39.
43 R.J. Lampert, 'The Development of the Aboriginal Gallery'. See also Jim Specht and Carolyn McLulich, 'Changes and Challenges: the Australian Museum and Indigenous Communities', in Paulette M. McManus (ed.), *Archaeological Displays and the Public, Museology and Interpretation* (London 1996), pp. 27–49. In modern times, the museum possesses some 30,000 Aboriginal artefacts.
44 Jim Specht and Lynne Hosking, 'Pacific Island Collections in the Australian Museum', *South Pacific Bulletin*, second quarter (1974), pp. 11–16. See also Susan Thomsett, 'A History of the Pacific Collections in the Australian Museum, Sydney', in *Pacific Arts, The Journal of the Pacific Arts Association*, 7 (January 1993), pp. 12–19. Thomsett recounts in some detail the identities and activities of collectors – traders, plantation owners, captains and others – in the Pacific. The Museum has 60,000 Pacific artefacts, the majority from Melanesia, with smaller collections from Polynesia and Micronesia.
45 A chapter in Strahan (ed.), *Rare and Curious Specimens* is entitled 'Drifting 1921–1954'.
46 The title Curator was changed to Director and Curator in 1917 and to Director only in 1921.
47 This mining museum was founded in Sydney in 1875–76 and received the collections of C.S. Wilkinson, Geological Surveyor of NSW, and the Rev. W.B. Clarke, geologist. The initial collection was lost in the fire of 1882, but it was reconstituted. It offered services to prospectors by examining and identifying specimens of rocks and ores.
48 While the word 'sanitary' seems odd, this would have covered health issues, water supplies, and sewage disposal.
49 Graeme Davison and Kimberley Webber (eds), *Yesterday's Tomorrows: the Powerhouse Museum and its Precursors, 1880–2005* (Haymarket, NSW 2006). The Powerhouse describes itself as the largest museum in Australia. It has been aided by the fact that the tourist centre of gravity has shifted towards Darling Harbour, where it is located.
50 The new Museum of Sydney, which opened its doors in 1995, presents modern displays on Sydney's past, enjoying the cachet of being situated on the site of the original Government House, built for Captain Phillip.
51 La Trobe (1801–75) was of Huguenot extraction and Moravian in Christian affiliation. Both his grandfather and father were Moravian ministers, his father having connections with the slavery abolition movement, considerable interests in music and a friendship with Haydn. La Trobe himself was intended for the same ministry and was educated in Switzerland. However, he became tutor to an aristocratic family in Neuchâtel and then a teacher at a Moravian school in Manchester.
52 A plaque commemorating the centennial of these celebrations is in the Melbourne Botanic Gardens.
53 A. Wesson, 'Mechanics' Institutes in Victoria', *Victoria History Magazine*, 42, 3 (August 1971), pp. 607–17. The two earliest clubs in Melbourne, the Cricket Club and the Melbourne Club were founded a year before in 1838. R.R. McNicoll, 'Melbourne's Two Oldest Clubs', *Victorian Historical Journal*, 46, 2 (1975), pp. 409–17.
54 Quoted in Jill Eastwood, 'La Trobe, Charles Joseph (1801–1875)', *Australian Dictionary of Biography (ADB)*, vol. 2 (Melbourne 1967), pp. 89–93.
55 Quoted in Carolyn Rasmussen (ed.), *A Museum for the People: a History of Museum Victoria and its Predecessors, 1854–2000 (Melbourne 2001)*, p. 15.
56 *The Argus*, 24 September, 1853, p. 4, col. 3.

57 R.T.M. Prescott, *Collections of a Century: the History of the First Hundred Years of the National Museum of Victoria* (Melbourne 1954), pp. 3–6.
58 Ibid., p. 13. It was also considered that the payment of one shilling a skin, secured by these Aboriginal helpers, was exorbitant. Krefft and Blandowski collected ethnographic materials in an area well populated by Aborigines, but these were probably sent to Berlin. Philip G. Jones, '"A Box of Native Things": Ethnographic Collectors and the South Australian Museums, 1830s to 1930s', PhD, University of Adelaide, 1996, p. 77.
59 Quoted in Rasmussen (ed.), *A Museum for the People*, p. 11.
60 L.K. Paszkowski, 'Blandowski, William (1822–1878)', *ADB*, vol. 3 (Melbourne 1969), p. 183.
61 Quoted in Rasmussen (ed.), *A Museum for the People*, p. 41.
62 Quoted in Paszowski, 'Blandowski', p. 183.
63 Prescott, *Collections*, pp. 16–18.
64 Anon., *The Public Library of Victoria 1856–1956* (Melbourne 1956). The government provided £2,500 for the purchase of books in London. La Trobe himself donated 84 volumes.
65 Ann Galbally and Alison Inglis, *The First Collections* (Melbourne 1992); Susan Sheets-Pyenson, *Cathedrals of Science: The Development of Colonial Natural History Museums during the Late Nineteenth Century* (Kingston 1988).
66 Quoted in Rasmussen (ed.), *Museum for the People*, p. 21.
67 *Transactions and Proceedings of the Victoria Institute for the Advancement of Science for the Sessions, 1854–55* (Melbourne 1855), pp. 1–15. After the union, these publications became *Transactions of the Philosophical Institute of Victoria* and then *Transactions of the Royal Society of Victoria*.
68 Ibid., p. 4. Barry was sympathetic towards Aboriginal legal problems and often appeared in court on their behalf. Ann Galbally, *Redmond Barry, An Anglo-Irish Australian* (Melbourne 1995), p. 2.
69 The Exploration Committee organised and helped fund the ill-starred expedition of Robert O'Hara Burke and William John Wills, a poorly conceived and costly venture, its scale of incompetence matched only by the grandeur of the myth built out of their deaths at Cooper's Creek. Derek Parker, *Outback: the Discovery of Australia's Interior* (Thrupp 2007), chapter ten and Tim Flannery (ed.), *Explorers: Epic First-Hand Accounts of Exploration in Australia* (London 1999), pp. 258–74.
70 Duke of Newcastle to Governor Sir Henry Barkly 8 November 1859 announced Victoria's approval of the 'royal' status.
71 *Annual Report of the Philosophical Institute of Victoria for 1859* indicated that the Institute had 208 members (though some had been suspended for non-payment of dues); £3,000 had been spent on the building and £300 on the production of the *Transactions*.
72 *Transactions of the Philosophical Institute of Victoria*, 1854–1887, vol. 4, pp. 1–8.
73 *Annual Report for 1859*. Ferdinand Mueller compiled the report on Agriculture and Horticulture; Frederick McCoy on mineral resources and animal products. In 1859 the funds of the Exploration Committee stood at £3,184.
74 Though, according to Prescott, *Collections*, pp. 7–8, it did consider itself as owning some of the collection, including specimens that had come to it from private donors.
75 Thomas A Darragh, 'Frederick McCoy' in *The Fossil Collector*, January 1992, pp. 15–22, offers a useful short account of McCoy's career and publications.
76 Galbally, *Redmond Barry* depicts Barry as a serial philanderer with a striking sex life for such a prominent public figure. He left the UK after his father's death in 1838: until that time he had educated himself and travelled widely. He left the Irish bar, but failed to gain a toehold in Sydney in 1839, so moved on to the future Melbourne, practised as a lawyer, secured a minor judicial post in 1843, and became a judge of the supreme court in 1852. He was a philanthropist whose home was a significant social centre for the Melbourne elite. He served as commissioner to exhibits from Victoria at major exhibitions in London (1862) and in Europe and

the United States (1877–78). Peter Ryan, 'Barry, Sir Redmond (1813–1880)', *ADB*, volume 3 (Melbourne 1969), pp. 108–11. A complete issue of the *La Trobe Journal*, 73 (Autumn 2004) was devoted to Barry, principally concentrating on his activities in respect of the art gallery, the library and the university.

77 Both were Anglican, McCoy having converted from Catholicism.
78 He briefly joined the Geological Survey of the UK, but was dismissed because Thomas Oldham found his fieldwork inadequate.
79 A professor of botany was appointed in 1882 and of biology in 1887.
80 The dispute between the Philosophical Institute and McCoy rumbled on through June, 1857. See, for example, *The Argus*, 4 and 5 June for letters.
81 *Transactions of the Philosophical Institute*, 1855–56, pp. i–iii insisted that the move was not permanent.
82 RSV, *Transactions and Proceedings*, VIII (1867), pp. 341–7. The honorary curator, Thomas Harrison subsequently gave a lecture on the various theories as to the origin of species, which brought calumny down on his head for his efforts to reconcile religion with science. *Transactions and Proceedings*, IX (1868), pp. XXIV–XXV. The *Transactions* ceased for a number of years because of the withdrawal of a government grant.
83 *Transactions of the Philosophical Institute*, August 1855 to December 1856, pp. 127–34.
84 *The Argus*, 29 May, 1857, p. 7, cols. 3–5. Goodhugh and Hough published the pamphlet.
85 Quoted in G.C. Fendley, 'McCoy, Sir Frederick (1817–1899)', *ADB*, vol. 5 (Melbourne 1974), pp. 134–6.
86 A letter to the London dealer and taxidermist E. Gerrard, dated 22 February 1862 and relating to this du Chaillu gorilla purchase can be found in Moyal (ed.), *Scientists*, pp. 123–4.
87 As Ann Moyal points out in *A Bright and Savage Land: Scientists in Colonial Australia* (Sydney 1986), p. 106, the difference was that Clarke was a fieldworker and McCoy was not.
88 Nevertheless, the *Report of the Trustees of the Public Library, Museums and National Gallery of Victoria, with the Reports of the Sectional Committees* (1880) contained a register of the natural history contents of the museum, all carefully numbered on pp. 43–69.
89 For the 1861 Exhibition, see *Catalogue of the Victorian Exhibition 1861 with prefatory essays indicating the Progress, Resources and Physical Characteristics of the Colony* by W.H. Archer, Ferdinand Mueller, R. Brough Smyth, Professor Neumayer, Frederick McCoy, A.R.C. Selwyn William Birkmeyer (Melbourne 1861); for 1888, see Dennis Dugan, 'Victoria's Largest Exhibition', *Royal Historical Society of Victoria Journal*, 54, 3 (September 1983), pp. 1–11. Melbourne sealed its status by holding no fewer than seven exhibitions before the 1890s, although these were often designed as 'rehearsals' for the Victorian exhibit at international exhibitions: 1855 for Paris; 1861 (London); 1872 (London and Vienna), 1875 (Philadelphia). Only the 1866 (Intercolonial), 1880 (International) and 1888 (Centennial) were 'freestanding'. For McCoy's activities, see Galbally, *Redmond Barry*, pp. 118–19.
90 The Museum Letter books from May 1856 onwards contain examples of much of this correspondence as well as such concerns as instructions to draughtsmen in the preparation of mining machinery and letters to the Chief Secretary's office re. staffing.
91 Tom Griffiths, *Hunters and Collectors: the Antiquarian Imagination in Australia* (Cambridge 1996), p. 18.
92 In 1861, the year of the exhibition, the museum unusually had over 37,000 visitors, many of them Chinese. Prescott, *Collections*, p. 50. The numbers of Chinese visitors to the museum surprised even McCoy and represents an intriguing aspect of the settlement patterns of the gold rush. Why Chinese people were avid museum visitors opens up many interesting issues.
93 Visitor numbers at the National Gallery, the Library and the ITM exceeded 600,000

94 in the same year reflecting the significance of city-centre location. The population of Victoria exceeded 1.1 million.
94 See, for example, *The Argus*, 8 July 1858 and 23 November 1858. Both these articles offer visitor numbers and lists of additions to the collection.
95 David Dunstan, 'Plutocracy at Play: Social Activities of Melbourne City Council', *Victoria Historical Journal*, 63, 2 and 3, pp. 17–36, particularly p. 17.
96 Frederick McCoy, *Prodromus of the Zoology of Victoria or Figures and Descriptions of the Living Species of All Classes of the Victorian Indigenous Animals*, 2 volumes, lavishly illustrated (London and Melbourne 1885 and 1890). In his preface, McCoy wrote of the practical value of his research. *The Prodromus of the Palaeontology of Victoria or the Figures and Descriptions of Victoria Organic Remains* commenced publication in 1874.
97 Warren Perry, *The Science Museum of Victoria: a History of its First Hundred Years* (Melbourne 1972), p. 3.
98 Anthony Burton, *Vision and Accident: the Story of the Victoria and Albert Museum* (London 1999).
99 R.H. Fowler, 'Newbery, James Cosmo (1843–1895)', *ADB*, vol. 5 (Melbourne 1974), p. 391. Newbery had been trained at the Royal School of Mines in London and at Harvard. In 1865 he arrived in Melbourne as analyst for the Geological Survey. His laboratories at the Museum of Science and Industry were important in analysis for the mining industry and for issues such as food contamination. He deserves a great deal more credit than historians of Victoria have given him. Unaccountably, they have concentrated on the much noisier and less competent McCoy to Newbery's detriment.
100 Perry, *Science Museum*, pp. 20–1; Rasmussen (ed.), *A Museum for the People*, pp. 86–7.
101 *Report of the Trustees* etc. 1882, p. 17. Her father's lectures were mentioned in the *Report* of 1880, p. 32. Other lecture courses were in chemistry, metallurgy, geology, physiology, astronomy, pharmacy and telegraphy (in which women interestingly constituted the main part of the student body).
102 Perry, *Science Museum*, pp. 46–7.
103 Since 2004, a world heritage site.
104 It was the Museum of Applied Science from 1944–1960 and later the Science Museum of Victoria.
105 For the manner in which this move involved a shift in focus from visitors to researchers, see Asa Briggs, *Victorian Things* (London 1988), p. 16.
106 For Spencer's life, see D.J. Mulvaney and J.H. Calaby, *'So Much that is New': Baldwin Spencer, 1860–1929* (Melbourne 1985). This title is explained in the epigraph to the book: Spencer was originally homesick, but in 1898 he wrote in a letter that 'England is not the only country in the world' and that he was reconciled to working in Australia 'where there is so much that is new'.
107 This body, designed to bring together all the scientific associations in Australia and New Zealand, and based upon the BAAS model, was proposed by Professor Arthur Liversidge, the Professor of Geology at Sydney, in 1886. After preliminary meetings the first full conference was convened in Sydney in 1888. See Roy MacLeod, *Commonwealth of Science: ANZAAS and the Scientific Enterprise in Australasia, 1888–1988* (Melbourne 1988) and also Roy MacLeod, 'Colonial Science under the Southern Cross: Arthur Liversidge, FRS, and the shaping of Anglo-Australian Science' in Benedikt Stuchtey, *Science Across the European Empires 1800–1950* (Oxford 2005), pp. 175–213.
108 John Mulvaney with Alison Petch and Howard Morphy (eds), *From the Frontier: Outback Letters to Baldwin Spencer* (St Leonards, NSW, 2000) covers this correspondence. The letters reveal the manner in which Spencer's ideas in the museum were influenced by men on the frontier.
109 John Mulvaney, Howard Morphy and Alison Petch (eds), *'My Dear Spencer': the Letters of F.J. Gillen to Baldwin Spencer* (Melbourne 1997).
110 W. Baldwin Spencer and F.J. Gillen, *The Native Tribes of Central Australia* (London

1899; reprinted 1938 with a preface by Sir James Frazer, and reprinted again in 1968).
111 Among the impressive corpus of anthropological works see Baldwin Spencer and F.J. Gillen, *Across Australia* (London 1912); Spencer and Gillen, *Arunta, a study of a Stone Age People* (London 1927), this a more popular version, published well after Gillen's death; Spencer, *Introduction to the Study of Certain Native Tribes of the Northern Territory* (Melbourne 1912); Spencer, *Tribes of the Northern Territory of Australia* (London 1914).
112 Quoted in Mulvaney and Calaby, *'So much that is New'*, p. 245.
113 This was consistent with his anti-evolutionist stance. Those who believed in a dynamic evolutionism were more likely to see a seamless development from natural to human history.
114 Barry first considered such a collection in 1861, perhaps in connection with the 1862 London Exhibition, but at this time the idea was not executed. See Des Cowley, 'Redeeming an Obligation: Aboriginal Culture at the 1866 Exhibition' in *La Trobe Journal*, 73 (Autumn 2004), pp. 113–20.
115 *The Reports of the Committee of the Public Library to the Trustees, proceedings of the institution from the year 1853 to the year 1869 and for the year 1870–71* record donations by a number of Protectors of Aborigines as well as Aboriginal artefacts presented by the Commissioners for Western Australia at the Intercolonial Exhibition of 1866. Ethnographic materials also came from Tasmania, New Zealand, Fiji, New Hebrides, New Caledonia, Samoa, Tahiti, Andaman Islands, India, Russia and elsewhere. *Reports of the Trustees of the Public Library, Museums and National Gallery of Victoria, 1871–1880* are less forthcoming with regard to anthropological materials, but these contain a good deal on the museums' educational functions, natural history, the inadequacy of buildings and their crowded character. The *Reports* of 1881–99 also contain an annual litany of complaint from McCoy about the inadequacy of museum accommodation: in 1889, he was still listing exchanges with other Australian museums; in 1891, he insisted that overcrowding meant that educational functions were limited; and in 1893 he considered that all further acquisitions should be discontinued.
116 These included, as well as Gillen's collection, an accumulation of 500 items put together by J. Field of the Northern Territory. *Report of the Trustees* etc., 1907, p. 28.
117 Spencer, *Guide* (1922 edition), p. 7. There is also a valuable photograph of the ethnological gallery revealing the manner in which many items were packed together in cases. See also, Gaye Sculthorpe, *Guide to Victorian Aboriginal Collections in the Museum of Victoria* (Melbourne 1990).
118 *Report of the Trustees* etc., 1905, p. 30.
119 *Report of the Trustees* etc., 1911, p. 29.
120 Spencer was President at different times of the Royal Society of Victoria, the Field Naturalists' Club of Victoria and the Victorian Football League.
121 See Edmund La Touche Armstrong and Robert Douglass Boys, *The Book of the Public Library, Museums, and National Gallery of Victoria, 1906–1931* (Melbourne 1932) for some of the developments of the Edwardian and inter-war years.
122 For the remarkable riches of the museum, see *Treasures of the Museum, Victoria, Australia* (Melbourne 2004), a multi-authored work illustrating the full range of the museum's collection.

CHAPTER SEVEN

Australia: the South Australian Museum, Adelaide

Museums deal in history of one sort or another – or at least contemporary perceptions of such histories. It is perhaps not surprising that they attempt to push their own pasts back as far as possible. In the case of the South Australian Museum (SAuM – the 'u' to distinguish it from that other SAM, the South African Museum), it has been customary to identify its origins as far back as 1834. The colony of South Australia (SA) was in the process of being conceived as a planned, idealistic and free settlement, an offshoot of the United Kingdom rather than an Australian territory tainted by transportation like its predecessors. In some respects it shared characteristics with New Zealand settlements, including a common 'godfather' in the inventor of 'systematic colonisation', Edward Gibbon Wakefield. Since a new colony was seen to require intellectual institutions, the South Australian Literary Association was founded in London in August of 1834, designed for the 'cultivation and diffusion of useful knowledge throughout the colony by all means in its power'.[1] To this end it was to promote intellectual pursuits such as literature, arts, history and natural science.[2] The inaugural address was given by a lawyer, Richard (later Sir Richard) Davies Hanson, who was to become a highly influential figure in the colony.[3] His speech revealed some of the ideals of the new settlement: he considered that in England minds were restricted by privilege, but that it should be possible to create a community made up of people judged by their knowledge and instruction rather than their social position.[4]

If this offered a radical social panacea (and Hanson was fiercely nonconformist in both religious and political ways),[5] it is clear that the founders considered that the plantation of 'civilisation' in such a colony was dependent on the acquisition and dissemination of such knowledge. The Baconian principle that 'knowledge is power' is clearly hovering in the wings.[6] Not long after this, the society was significantly renamed the South Australian Literary and Scientific Association.

The members, almost all intending to settle in the new colony, were clearly keen to educate themselves about their new environment: lectures were given on geology, on Aboriginal phrenology, and on natural history.[7] Once they had emigrated to the other side of the world, some of them became leading members of the SA elite.[8] Hanson was to be influential in the founding of the SA Institute and Museum in the later 1850s. London plans were translated into colonial action, facilitated by developing knowledge of the region.

Although there had been some earlier landings, the coast of what was to become SA was only fully charted by Matthew Flinders in 1802. Sealing parties landed in the first two decades of the century and the extensive Aboriginal population, settled in some numbers along the Murray River and less densely elsewhere, began to feel the effects of imported disease such as smallpox well before the settlement was founded. The first official colonists arrived in late 1836 at Glenelg and Kangaroo Island and a capital was soon established some miles away at Adelaide. There Colonel William Light laid out a city plan that combined elegance with efforts to keep the wilder aspects of Australia at bay by planting a ring of parkland around the central urban core. The future museum would be heavily influenced by a number of factors, including the strongly bourgeois nature of the settlement and the creation of the important North Terrace overlooking the Torrens River. This was eventually to accommodate the principal railway station, the Parliament, Government House, a building housing the Institute, the library, the museum itself, the university, the hospital, the botanic garden, with the zoological garden nearby. No other city had so many key establishments located so close to each other. The development of the museum was also to be conditioned by the presence (and later rapid disappearance) of Aborigines in the region, by the fact that the colony was not traversed until John McDouall Stuart's expedition in 1862 as well as by the relatively late exploration of the entire interior in the 1890s, after the establishment of the first transcontinental telegraph line in 1872. The creation and maintenance of this line provided unrivalled opportunities for collecting ethnographic material.

But initial scientific interests in Adelaide were more concerned with putting the territory on the taxonomic map of the globe. Although some early settlers formed private museums, a circular despatch from the Secretary of State for the Colonies in London, Lord Glenelg (Charles Grant), to all colonial governors indicated that natural history specimens should be sent to London at the request of the trustees of the BM, and copies of a code of directions for collectors, drawn up by the BM's staff, were also enclosed.[9] An economic recession in the early 1840s brought a new Governor, the youthful George Grey, into the colony. Grey had

7 North Terrace, Adelaide, South Australia, with the original Institute building on the left, the state library (west wing) beyond, and the east wing extension beyond that, eventually wholly occupied by the museum

a considerable interest in natural history: we have already encountered him active (later) at the Cape and he will reappear in New Zealand. He was initially keen on sending specimens to the BM, sometimes of rare animals later difficult to replace (for example, he sent a specimen of the duck-billed platypus in 1867). But he also encouraged intercolonial contacts and always supported museum foundations. In 1843, an enterprising ornithologist and taxidermist advertised his services in Adelaide, mainly in the context of sending materials to England. As late as 1853, an Adelaide entomologist, Charles Wilson, sent a collection of 6,000 insect specimens to Britain.[10] When the Natural History Society of SA had been founded in 1838, it promised to concentrate on the local fauna, advocating a more colony-centred approach.

But the most significant foundation of the period was the Adelaide Philosophical Society of 1853 (later the Royal Society of SA).[11] This society pressed for the formation of an institute and a museum with legislative and financial support. The tentative early stages in such developments had been symbolised by the demise of the first mechanics' institute of 1838, which, together with the subscription library had disappeared by 1844. Another mechanics' institute was formed in 1847 and it united with a revived library in 1848, but that too faded. The drafting of a new Bill in 1856 represented considerably greater ambitions for an institute with, crucially, financial support. This Bill referred to the

'satisfaction of ranking among our national institutions one expressly devoted to the interests of literature and science', providing 'an omen of promise for our future standing as a nation'.[12] The institute was to be nation-building in promoting scientific endeavour as well as in sponsoring the creation of a public library and museum, 'to be open without any payment to all respectable persons'. But respectability was not necessarily class-defined. The Bill suggested that the foundation should be similar in kind to the BM and consequently 'cannot fail to be of very great benefit to all classes of colonial society'.

The library and museum symbolised both state-forming and notions of respectability for the state's citizens. The sum of £500 was placed in the estimates annually to fund this body.[13] The Bill, which was duly passed, was drafted by Hanson and another nonconformist, the Unitarian John Howard Clark, an assayer, accountant and proprietor of the *South Australian Register* (who was highly influential in the founding and development of the Philosophical Society). Clark had a pronounced interest in public welfare and social reform and his work for the Institute is seen as his greatest contribution to early Adelaide.[14] Thus the Act perfectly expressed the ideals of the representatives of the bourgeois elite who had met in London two decades earlier to plan this new sort of colony. The key development was of course the government subsidy. All previous attempts at the creation of a library or a mechanics' institute had foundered on the tension between the ambitions of the middle class, their elitist desire for such institutions, and their failure to discover subscription rates that would render them viable while bringing in the 'respectable' working class.[15]

The problem now was to turn vision into reality. The members of the Philosophical Society had long discussed the possibility of founding a museum. Since premises were the principal problem they resolved to apply to the administration for rooms in government offices, but apparently the mechanics' institute was trying the same ploy. They also pressed for money to be made available for an expedition to the North-West interior of the colony and £3,000 was voted in 1854. Such expeditions were invariably important in the formation of museum collections, but this money was not initially used. Expeditions into the region were only mounted in 1857 and 1858. The Philosophical Society was also active in pressing for the erection of a building to house the Institute and associated societies, of which it would be one. In its memorial on the subject, it repeated the notion that 'one of the principal objects of our Society is the formation of a Museum illustrative of the Natural History of the Province' and this would involve the provision of rooms.

After some controversy it was agreed that the new Institute building

would be constructed on a prominent site on the corner of North Terrace and Kintore Avenue (as it later became). The governing board of the Institute took up the calls for a museum, clearly seeing it as primarily economic in form, with donations from mining companies (copper had become a significant resource in the colony) while Sir George Grey indicated from Cape Town that many donations would come from abroad, that the 'miniature museums' of private collectors would be donated, and that he himself would send in specimens.[16] The government received requests for sums of £3,000 or £4,000 for the Institute building and construction began in 1859.

Although it was in use (without adequate furniture) from late 1860, these premises were at last opened in January 1861 with an 'inaugural soiree', which was supposed to reflect the Institute's ambitions for the colony.[17] A band played popular musical numbers while the different rooms in the building housed a variety of displays and lectures, including 'dissolving views', electric light, microscopes, stereoscopes and stereographs, and other subjects.[18] There were also various art objects, paintings and models, sewing machines, a collection of stuffed birds, English and colonial, shells, weapons with ethnographic items from New Caledonia. The small west room contained a collection of Fijian, Chinese and other 'curiosities'.[19] Thus ethnographic materials featured strongly, though none was Aboriginal. But the opening was more or less chaotic. The address was given by Sir Charles Cooper, a judge who was administering the government in the absence of the Governor, but his speech was rendered inaudible by the noisy conversations of guests tramping from room to room, while the band struck up before he had finished![20] One room was described as looking just like a gallery in the BM, clearly the really important comparator.[21]

The incipient museum was thus accommodated within the building, in three rooms. The Institute had planned a display of mineralogical specimens as its centrepiece, typically illustrating initial economic objectives. But a public appeal was issued for donations and diverse collections came flooding in.[22] The first curator, Frederick George Waterhouse (1815–98), was appointed and the museum opened to the public in January 1862. Waterhouse was typical of his age: a nongraduate, he was a keen naturalist, who had helped his elder brother, a leading light of the Entomological Society of London, later curator of the Zoological Society's collections, in examining the BM collections. Waterhouse sailed for SA in 1852. Like so many others, he was lured to the Victoria goldfields, but his skills lay elsewhere. He put himself forward for the post of curator in 1859 and the Board of the Institute were impressed with his supposed connections with the BM. He was initially given an unpaid position, his salary starting from October

1860. In 1861 he was employed by the government to collect insects and plants on Kangaroo Island while later in the year he joined the transcontinental expedition of John McDouall Stuart as naturalist and zoologist, pursuing his objectives with such zeal that he fell out with Stuart whose main preoccupation was a successful crossing of the continent. Although some of Waterhouse's specimens were destroyed, he returned to Adelaide in early 1863 with a considerable collection of the skins of birds and mammals as well as many examples of insects and plants. He devoted himself to the museum, with very little remuneration (never more than £220 per annum) until his resignation in 1882.[23]

During this period, Waterhouse built up the collections considerably. A great deal of fossil material, for example of Diprotodon and Nototherium, came in, as did many natural history specimens and other material. In 1864 alone the museum received money or items from 142 donors. Taxidermists were employed as collectors, contributing greatly to the zoological collections. But Waterhouse laboured under severe difficulties. The money available was always minimal; the building was wholly inadequate; and the only extension to the museum he ever received was the reallocation of a room. One of his prime concerns, as with all early curators, was to establish international connections, which would put SA on the map and help to build up deposits of exotica, seen as important in the education of a younger colonial generation who might never visit the great museums of Europe or North America.[24] But these objectives were achieved at considerable cost. Waterhouse seemed eager to send duplicates abroad, and sometimes the material so disposed of was not even in the duplicate category. As specimens came in from all over the colony and from the Northern Territory (administered by South Australia from 1863 to 1910), he eased his exhibition and storage congestion by sending items to museums in Germany, England, Belgium, India, Japan, South Africa, the USA, as well as elsewhere in Australia and New Zealand. One exchange relationship was with Julius Haast in Canterbury (Chapter Nine), and he inevitably received moa bones for his offerings. He also made contact with the Indian Museum in Calcutta through a nephew who was assistant surveyor in Bengal and sent large quantities of SA crustacea.

A major means of putting a colony on the world map was the opportunity to exhibit at international exhibitions. It may be that this stimulated the collection of ethnographic items, but the arrangement could also have drawbacks. Collections were put together for the Philadelphia Centennial Exhibition of 1876 and for the Paris Universal Exhibition of 1878. The former assemblage (including zoological,

ornithological and ethnographic materials) went to the Smithsonian and the latter to the Natural History Museum in the Jardin des Plantes in Paris. Some exchanges came in the other direction, but there was a strong suspicion that such reciprocal arrangements were not always balanced or fair and, worse, some of the material lost to Adelaide was unique. Waterhouse was also rather slapdash in his approach to record-keeping and identification while specimens were not well maintained. As the centennial historian of the museum put it, 'The fact that much of the collection was sent abroad and the remainder not properly cared for was most unfortunate for posterity.'[25] Waterhouse's ambition to give the museum a global sweep (mainly in natural history) was thus achieved at some cost. Moreover, his displays had little organisational sense: he merely piled up specimens in display cases, storing as much as he could by placing it on view.

Expeditions continued to be fruitful sources of material, as in the case of an attempted 1862 'rescue' of Burke and Wills and the Survey Party into the Northern Territory in 1868–69. A taxidermist associated with the museum, Frederick (or Friedrich) Schultze, joined this expedition and collected large numbers of natural history specimens, which were shipped south from Darwin in twenty-one boxes. During 1874–75, another taxidermist, Frederick Andrews, associated with the museum over two decades, accompanied the Lake Eyre Exploration Expedition and also collected for the museum. All nineteenth-century colonial museums experienced a tsunami of specimens and few were blessed with adequate space, but the SAuM was poorer than most. Various efforts at extending the Institute building failed and parliamentary grants were not used. Julius Haast's descriptions of the expenditure on the Canterbury Museum filled Waterhouse with envy, as did the reported lavishness in neighbouring Victoria.

But things were about to change, although the new dispensation would come with almost glacial slowness. After the period of economic difficulties, the board continued to press for a new wing to the Institute building or some other means of accommodating both library and museum. They organised a petition to government on the subject and the administration responded by appointing a Royal Commission. This sat during 1873–74, chaired by Hanson, still pursuing his vision from the inaugural meeting of the Literary Association forty years earlier. He sat with two members of the legislative council, an architect and a doctor. Evidence was provided by, among others, Waterhouse, Charles Todd, the founder of the Adelaide Observatory, Richard Schomburgk,[26] the director of the Botanic Garden, John Howard Clark, and a number of others. The issues included whether the museum and library should be separated in their governing arrangements and what sort of a building

or buildings should be provided for them (as well as for the art gallery). The recommendation was that these institutions should remain joined at the hip and that a new building should be built. A brief was issued; drawings and specifications drawn up; and a plan for a Gothic building with three wings – ultimately for museum, library and art gallery – was accepted. The west wing, the first part of this conception, was not completed until 1882, so the new building was ready just as Waterhouse retired. But it would soon be shown to be inadequate, since library, art gallery and museum were once more all positioned within the same structure without separate entrances. This was described as 'inconvenient and objectionable', not least because 'the museum, surely, should be a place in which visitors might freely discuss the nature of the various objects of interest, or children give expression to their childish exclamations of wonder or delight at what they see'. But 'nothing above a whisper' could be permitted because of the adjacent library![27]

The original parent body of the museum, the Philosophical Society, had also failed to prosper in the depressed years of the 1860s.[28] Incorporation with the Institute provided little benefit and it was short of money. Nevertheless, significant papers were read at its meetings on many of the economic, environmental and scientific issues of the day. (Intriguingly, Hanson delivered four lectures to the society in 1864 in which he analysed Darwinian theory, an indication of the relative speed with which evolutionary concepts were being considered even in an environment which was generally hostile to them.) The impecunious society was forced to sell museum cases and a set of the *Transactions of the Royal Society* (London) to the Institute. It is apparent that, after the initial burst of energy, the society and museum languished for many years. Cultural institutions have always been highly vulnerable in times of recession: this had been true in the early 1840s in South Australia, and parlous conditions reappeared in the 1860s and early 1870s. But help was at hand: the formation of the University of Adelaide in 1874, and the arrival of the influential Professor Ralph Tate,[29] revived the society, which was reconstituted as the Royal Society of South Australia in 1880.[30]

Tate also founded its *Transactions and Proceedings* in 1877.[31] The importance of doing so is reflected in the fact that the society exchanged its journal with similar bodies in 231 other countries, including British colonies, the USA and South America as well as Europe. At this stage, the list of members included, in addition to Waterhouse, Schomburgk, Joseph Verco,[32] S.J. Way, the Chief Justice, Sir Thomas Elder,[33] the Commissioner of Police, the Secretary of the Board of Health, the Postmaster General, the Locomotive Engineer of the South Australian Railways, and various professors of the University of Adelaide.[34]

Tate was also to be highly influential in the transformation of the museum. As a botanist and a geologist (with interests in palaeontology, mineralogy, and conchology), he had some museum experience in Britain. As the first incumbent of the Elder chair of natural science at the university, he instituted lecture courses, published extensively, and commenced research on the geology of South Australia. He also published on the mollusca and the flora of the colony. He persuaded the government to appoint its first permanent geologist in 1882. Moreover, he set about assessing the state of the museum after twenty years, pointed to the urgent need for its reorganisation – not least to make it a resource for scholars as well as for the visiting public – and urged the creation of study collections. As in other colonies, the arrival of a university would galvanise ambitions for the museum, its role in scholarship, and its capacity to mediate academic ideas to a general public.

The curatorial administration of the museum was transformed by two appointments. In 1881 George Beazley, recommended by William Flower of the RCS Museum in London, became assistant curator and taxidermist. Then, when Waterhouse was on extended leave before retirement, Dr Wilhelm Haacke from Jena was appointed acting curator. By 1883, he had succeeded to the substantive post with the new title of Director, a status he insisted he required in order to communicate with museum directors in Europe and America. Whereas Waterhouse had been virtually a one-man band, the museum was now provided with a scientific staff. F.W. Andrews and J.G.O. Tepper were appointed 'collectors', also in 1883, the latter with a special concern for entomology. In the following year, A.H.C. Zietz, from Schleswig-Holstein who had experience in the Zoological Institute of Kiel, joined as 'preparator', with a particular specialism in marine biology. (From 1888, Zietz became assistant director and a key member of the museum staff.) C.G.A. Rau was engaged as preparator in 1883, later taxidermist and 'articulator'. A major proportion of the scientific staff now came from Germany or northern Europe. But Haacke's era was to be transitional and was just as destructive of the collections as his predecessor.

When the museum was being transferred into the new building, Haacke decided that the zoological specimens displayed in the Institute had been subject to decay and he threw them all out. He then set about rebuilding the collection, using the services of the newly appointed collectors. He also spent a great deal of time sending material to other institutions, sometimes in disadvantageous exchanges, though he did acquire some exotic materials of note.[35] He despatched no fewer than a thousand zoological specimens to Basle. He also sent away some of the Owen collection of Fijian items to Germany (though many remained in the museum). It seemed as though he was more eager to

impress directors in Europe with his liberality than preserve the SA collection. Moreover, for Haacke and his predecessor, the museum's prime purpose was the promotion of natural history. Ethnographic material was merely useful in offering valuable 'currency' for scientific exchanges.[36] Similarly, he was not interested in coins, so he handed over the considerable numismatic collection to the art gallery.

If he had little concern for Australian ethnography, he was at least clear-sighted about the future. He requested a necessary change of name because 'South Australian Institute Museum' was too long, 'neither very practicable nor particularly handsome'.[37] He urged the founding of a journal (not done until 1918) and regarded the building as 'small and disadvantageous', pointing to the new General Post Office as a superior example.[38] Haacke was soon criticised in the press for his generosity in exchanges, which may have signified that 'for the first time ethnographic artefacts were being regarded by the wider population as elements in the construction of a distinctly local heritage' (and therefore, it might be said, of an identity based on the culture of indigenous peoples).[39] To compound everything, staff relations within the museum reached a low ebb. Haacke's manner created tension with Beazley, Tepper and Zietz. He departed in late 1884 and few tears were shed. After a period in New Zealand he later became Director of the Zoological Gardens in Frankfurt: perhaps his attention to European connections had paid off.

Haacke was not replaced. A new Public Museum, Library and Art Gallery Act came into force in 1884, with a board representative of the government, the university, the Institutes Association, the Royal Society of SA, the Society of Arts, the Royal Geographical Society of Australasia (SA branch) – after 1905 – and the Adelaide circulating library.[40] A crucial appointment was then made to the chairmanship of the Museum Subcommittee. This was Dr Edward C. Stirling who would dominate the affairs of the museum until after the First World War. Of Scottish and West Indian descent,[41] he was born in South Australia in 1848 and educated in natural science at Cambridge and medicine in London. Returning to the colony in 1881 he immediately played a leading role in the university, later founding its medical school. He sat in the Legislative Council from 1884 to 1887 as the member for North Adelaide.[42] After the departure of Haacke, the museum jogged along under the supervision of Stirling's committee, with Zietz providing the museological expertise and Robert Kay, 'General Director and Administrator' of the three institutions, conducting its administration. Stirling became honorary director in 1889 and paid director in 1895 (he was elected FRS in 1893). He returned to his status as honorary director in 1913–14 and was honorary curator of Ethnology from 1914 until

his death in 1919.[43] It was to be the crucial period in the history of the museum.

Stirling recorded the development of the museum in a series of impressive reports.[44] Like all directors, he repeatedly complained of inadequate accommodation, of overcrowding, and of insufficient finance to build the collection adequately. Accommodation did expand in this period, but budgets grew very sluggishly. In 1885, the budget was £1,640, subsequently actually went down, and remained static at just over £1,500 for many years. It only just reached £2,000 by the outbreak of the First World War, but grew to £3,177 in 1916–17. Visitor numbers also grew slowly, from roughly 63,000 in 1884–85 to over 80,000 in 1911–12 and subsequent years (the museum tended to have fewer visitors than the library or art gallery). What attracted these visitors? The 'stuffed zoo' of natural history specimens has always been a draw in imperial museums. This is confirmed by a sudden jump in numbers after a popular elephant at the zoo, 'Miss Siam', died and reappeared stuffed and mounted in the museum around 1904.[45] 'Tasmanian tigers' similarly reappeared in the museum after 1899, while an unusual Oriental rhinoceros was added to the collection in 1907.[46] Another popular display was the coin and medal collection, which had been returned to the museum from the art gallery. This was extensive and was reorganised, identified and partly displayed after a numismatist was appointed to the staff in 1912.[47]

Other efforts to attract the public included the reorganisation of the geological collection into a more 'user-friendly', less scholarly sequence,[48] as well as through the creation of early dioramas. Nevertheless, ethnological objects continued to appear in serried ranks with little social, economic or aesthetic contextualisation. An unwanted interest was revealed when specimen gold ores were stolen in 1895, a common fate in museums in several imperial territories. There had also been an attempt to steal a Maori *mere*, a greenstone hand axe of high status, originally donated by Sir George Grey. Security was increased with barred windows and the employment of a night watchman. During this period, institutes were founded throughout the colony (there were 155 by 1900). These were particularly significant for their libraries, but in a few centres there were also local museums, as at Gawler and Port Adelaide.[49]

Stirling's entry into the affairs of the museum coincided with significant advances in museum displays, possibly related to new techniques associated with international exhibitions. The first diorama was installed in the mid-1880s, featuring Aboriginal figures within a landscape of the lower Murray River, complete with a canoe.[50] A similar diorama, together with other exhibits, was featured in the SA Court

of the London Colonial and Indian Exhibition of 1886. Museum staff helped to organise this exhibit, which set out to give an impression of the physical surroundings, economic, mineralogical, and faunal resources of the continent. Representations of Aborigines appeared in these displays, demonstrating that colonies viewed indigenous peoples as essential to their international 'profile', indicators of both an exotic location and the onward advance of civilisation. Despite the contemporary efforts of Europeans to marginalise Aborigines, they were placed centre stage in summoning up the landscape of the colony.

Meanwhile in Adelaide, Stirling was finding the museum's accommodation in one-third of the west wing hopelessly cramped. But help was at hand. The projected north wing of the planned threefold structure was approved in 1890–1 and was opened at the beginning of 1895. For the first time, the museum had a building to itself.[51] It was much needed, for natural history collections were expanding considerably and even the new building was congested.[52] The Philosophical Society had issued directions for collectors, amateurs and others, back in 1880 (just before becoming the Royal Society of SA). These had been widely distributed and there were many donations. Moreover, Stirling and others were anxious about the danger of various extinctions and the consequent rarity of specimens of such creatures. There were serious gaps in the museum's collection even of local fauna. As elsewhere, scientific expertise was expanded by appointing honorary curators with considerable specialist knowledge.[53]

But the really significant development was that Stirling, like Baldwin Spencer in Melbourne, developed a prime interest in Australian ethnographical collecting. Stirling had also encountered anthropologists, in his case A.C. Haddon and E.B. Tylor, while studying at Cambridge. He too had some knowledge of Pitt-Rivers's classificatory arrangements and he was to build up what has been described as 'the best ethnographic collection in Australia'.[54] This had never been at the forefront of the museum's concerns, although 'curiosities' had been in the collection from the start. Opportunities were missed to collect from the Aboriginal population around Adelaide in the early days of the settlement (though some weapons and tools had been supposedly acquired in 1839)[55] and once the numbers of Aborigines had tragically declined it was too late. Indeed, it has been suggested that there were greater sympathies towards and interest in the Aborigines in the early days of the settlement, represented by the concerns of early government Protectors of Aborigines, artists and enthusiasts.[56] This interest declined in the decades of the 1850s, 1860s and 1870s, only reviving from the 1880s onwards. This was helped by the fact that the Northern Territory became a fertile source of artefacts. It should, however, be remembered

that such collecting took place at a time of widespread land appropriation, Aboriginal resistance, and white reprisals – much as had happened in South Australia itself. Veils are invariably drawn over the methods of collecting, though normally it seems to have been a matter of 'trade', probably by barter rather than the medium of money.

In the 1870s a police inspector called Paul Foelsche had collected large quantities of Aboriginal material in the Northern Territory, which were purchased by the museum in 1879.[57] A major collection of Queensland Aboriginal material was purchased from Clement Wragge in 1899.[58] R.T. Maurice, a wealthy independent explorer, also donated both ethnographic and zoological specimens acquired on his travels (and in 1906 presented two mounted skeletons of New Zealand moas purchased in Japan, revealing the extraordinary international character of trade in such specimens, which are described in greater detail in Chapter Nine).[59] By the last decades of the nineteenth century there were unrivalled opportunities for collecting, enabling the museum to become a storehouse and showcase for the hinterland.[60] The telegraph line, surveyed and constructed across the continent from Adelaide to Palmerston (later Darwin), created a route along which police and posts and telegraph stations were established. Stirling issued a circular to police officers and telegraph station managers in 1890: 'In view of the rapid disappearance of the Aborigines of Australia', it was 'desired to obtain' as many artefacts as possible to create an extensive a collection of Australian ethnography.[61] Some of the recipients became outstanding in the field and the circle of collectors also embraced railway employees, customs inspectors, government bore sinkers, pastoralists, pearlers and traders.

From 1890 to 1891, the Governor, the Earl of Kintore, set off on a transcontinental journey to visit the Northern Territory. Stirling was able to accompany him and returned with collections of some 800 zoological specimens and 500 ethnological items. Another significant stream of ethnographic materials came from the anthropological interests of Lutheran missionaries settled to the west of Alice Springs. The 1,000-item collection of the Rev. J.G. Reuther of the mission at Killalpaninna was purchased in 1907. The museum also invested in the collections of the Rev. Carl Strehlow of Hermannsburg and the Rev. O. Liebler. Yet a catalogue of the museum's ethnographic collection was never prepared. Waterhouse was asked to compile one in 1863, but it never happened. Stirling planned one in 1898, but was clearly too busy with other things. Moreover, the collection was expanding at such a rate that it would soon have been out of date. In 1911, Stirling ambitiously proposed to state premiers that a comprehensive work of Australian ethnology should be prepared (with himself as editor), yet

that did not happen either. Moreover, the museum continued to acquire natural history material. In 1911 Walter P. Dodd, a young Queensland collector, was employed to go to Western Australia and work his way round to Darwin to collect mammals, reptiles and insects.[62] Aborigines mainly did the collecting for him.

The museum also joined the practice of actively collecting human remains, as elsewhere in the Empire. In 1897, Professor Krause from Berlin visited the colony and studied 82 Aboriginal skulls in the museum's collection.[63] The number of crania had reached 100 by 1904, considered by Stirling to be vital for studies by future scholars. Indeed, the search for remains became so keen that South Australia's coroner, William Ramsay Smith, was arrested for body snatching in 1903. An apparently more respectable route was found when an Aboriginal burial ground (dating from before European settlement and therefore representing what Stirling called 'a pure strain of aboriginals') was unearthed at Swanport on the River Murray in 1911. It was excavated by Zietz (not very expertly), but only after workers clearing swamp land had disposed of many of the bones into a pit. Stirling described in some detail the geological characteristics of the site as well as the burial practices of Aborigines, and many of the remains were removed to the museum.[64] Orders were issued that all Aboriginal remains found on Crown lands were to go to the museum and the police actively participated in this collecting (sometimes even questioning prisoners on ethnographic matters). In his report for 1911-12, Stirling recorded various donations of human remains, including 'Tasmanian aboriginal skulls' of an 'extinct race', proudly announcing that 79 of the 123 of such skulls known to exist were in the SAuM.[65] By the First World War, the museum displayed many crania in a large case on the ground floor, no doubt appealing to the macabre interests of visitors, but surely impossible today.[66] The museum director's boast, in 1956, that the museum's collection of skulls 'numbers over one thousand' reads alarmingly a mere half-century later, given today's more appropriate respect for Aboriginal peoples and sensitivity about human remains.[67] By then, most experts recognised that such remains were of limited value from an anthropological point of view, even if they could yield some interesting medical information.[68]

Other acquisitions of the period included the skeletons of a number of whales of different species; large numbers of fossilised Diprotodon (a giant marsupial creature with the appearance of a hippopotamus) from Lake Callabonna (which it was thought might become the South Australian equivalent of the moa to Canterbury, New Zealand); a hitherto unknown marsupial mole (Notoryctes which first arrived in 1888); and from 1892 some material from the Egypt Exploration

Fund.[69] Diprotodon specimens were inevitably sent to the BM (Natural History): Stirling was in touch with the director Ray Lankester and other experts. Indeed, Lake Callabonna was such an important source of Diprotodon that it was declared a fossil reserve in 1901, an early example of Australian conservation. In the case of Notoryctes, Stirling continued the tradition of his predecessors by widely distributing examples to the BM, the RCS, Cambridge and museums in Paris, Berlin, Florence, Utrecht and Stockholm, 'in the interests of science, and without stipulating for exchanges'.[70] Further explorations added to the collections, including the Elder Expedition of 1891–93 and the Horn of 1893–94.[71] Stirling joined this important expedition into Central Australia as anthropologist and doctor: its scientific staff also included Ralph Tate, Baldwin Spencer of Melbourne (as shown in Chapter Six) and other significant figures. Stirling wrote the anthropological parts of the resulting four-volume report and returned with some 2,000 ethnographical objects, some of them bartered at Port Essington on the north coast. It was at this time that scholarly contact was made with Francis Gillen of Alice Springs and some of his notebooks and slides were to be acquired by the museum. W.A. Horn (a wealthy mining magnate) also handed over ornithological specimens from the expedition.

Stirling was a fairly frequent visitor to Europe and the USA, so he was able to think internationally in considering museum development. He was in England in 1891[72] and during 1896–97, while in 1901 he paid study visits to museums in European countries and North America. In the USA he found 'immense public and private liberality' towards museums, in which people took a great deal of pride and interest.[73] This contrasted with the relative poverty of Australian institutions together with underfunding for scientific expeditions and the provision of new displays.[74] He noted that the Americans' approach to the ethnology of their continent was outstanding, but considered that Canada was lagging far behind. These were common enough incantations, but wealthy patrons were even then emerging in South Australia: the gallery received the Elder bequest of £25,000 in 1900 while the museum, gallery and library were to benefit from a considerable legacy from a wealthy doctor in 1903.[75]

More interestingly he pointed out how little Australia was known in most of the museums he had visited. What he meant by this was the lack of ethnographic materials: by the beginning of the twentieth century these had become the major national markers of territories such as Canada and New Zealand. He wrote that 'there is literally scarcely a thing from our country in any of the American Museums'.[76] In fact the Smithsonian had some items from the Philadelphia Exhibition, but the clear implication was that Stirling felt that more Aboriginal artefacts

should be distributed in the world. Within a decade, however, he had changed his mind: he supported the Australian Federal Government in passing legislation to restrict exports. Stirling also argued that the SAuM should be as significant in ethnology and palaeontology as the Canterbury Museum in New Zealand.

Stirling was enlightened and well informed, but he subscribed to the contemporary view that Aborigines' days were numbered.[77] In 1890, he wrote: 'Many native articles are even now no longer to be obtained, and in a few years this national collection will stand as almost the only tangible evidence in the colony of an extinct race.'[78] In 1898, he averred that since 'the aborigines' (indigenous people were never given the respect of an upper-case 'A' at that time) 'of South Australia are rapidly disappearing, it is desirable that in the interests of science and of our successors that a comprehensive and enduring record' should be made 'before it is too late'.[79] Later he regretted that 'we have already allowed whole tribes of natives to disappear without our having become possessed of a single authentic relic'. Stirling's concerns with 'rescue' collecting would help to create a collection that would illuminate cultures that were indeed disappearing, ultimately providing important insights to modern Aborigines, although he could not have anticipated that.

Whether or not the same consideration applied to Pacific Island peoples, the museum had continued to be an avid collector of their artefacts to such an extent that they were more prominently displayed than Aboriginal material.[80] In addition, the worldwide distribution of Benin bronzes after the British 'punitive' campaign resulted in a gift of such loot arriving in Adelaide in 1899.[81] Africa was represented in zoological ways too: big-game hunters began to donate specimens shot on that continent.[82] Imperial attitudes regarding racial extinction, the legitimacy of plunder, and the exploitation of animals for sport were very much alive in SA.

Stirling, like Baldwin Spencer in Melbourne, contributed to the professionalisation of the museum by applying academic expertise derived from the natural sciences or medicine. But from 1914, the museum acquired a more specialised director.[83] This was Edgar Waite (1866–1928), who had studied biology in Manchester and had become first (1888) sub-curator at the Museum of the Leeds Philosophical and Literary Society (later the Leeds City Museum) and, still in his 20s, curator (1891).[84] With some knowledge of museum development in Europe, he arrived in Australia in 1893 to take up a post in zoology at the Australian Museum. From 1906 to 1914 he was in charge of the Canterbury Museum in Christchurch. He was Director in Adelaide until 1928 and supervised the further expansion of the museum buildings and staff.

When he arrived, the U-shaped architectural triptych of west, north and east wings of the library, gallery, and museum buildings had been completed. At that point, the library occupied the west wing; the museum the north; while the gallery had moved into a building built for the Jubilee Exhibition of 1887. The museum was now to take over part of the new east wing, construction of which had begun in 1908. Waite remarked in his first annual report that the 'requirements of the Museum have been made subservient to the architectural features, the new building having to conform in general design to that of the Public Library'.[85] In other words, these cultural structures were still locked into the Gothic style of an earlier period and although Gothic, following prototype designs in Oxford and elsewhere, had become the architectural language of museums in many places, it was never particularly satisfactory for museum displays. Moreover, as exhibition cases had already been purchased, Waite had to put up with what he found. With only relatively minor additions, the SAuM has continued to occupy these old north and east wings, while the state library – with a modern extension – occupies the west wing on a site which is now relatively congested.[86]

8 South Australian Museum, Adelaide, the extension built 1910–12 and opened in 1914, originally partly occupied by the museum, now wholly so.

Australia had been put more firmly on the international scientific circuit by the visit of the BAAS (which had already held meetings in both Canada and South Africa) in 1914 and a number of distinguished scientists visited the museum. They showed a particular interest in the natural history collection and help was solicited in making some identifications.[87] Waite further set about placing the museum on the global scholarly map by founding the journal, *Records of the South Australian Museum* in 1918.[88] He himself became a prolific ichthyologist and herpetologist, participating in a number of expeditions,[89] and publishing in 1923 *Fishes of South Australia* and, posthumously, in 1929 *Reptiles and Amphibians of South Australia*.

In many ways, Waite was unlucky in the timing of his appointment. Everything came to a halt during the First World War when money was very tight. There were also financial difficulties in the 1920s. But by the time of his death, the SAuM had emerged as an institution with major collections of both Australian and exotic material. Nevertheless, the visiting team of Markham and Richards on the Carnegie survey of museums of the British Empire agreed with Waite that the buildings were unsatisfactory, still lacking electric light in the inter-war years. Fieldwork expanded further after Waite's death; African ethnological material arrived from the Congo in 1933; interests in human remains and in Aboriginal rock shelters and caves increased; and life casts of Aborigines appeared in the museum (after 1928) on the suggestion and example of the Smithsonian. Thus the museum continued to pursue worldwide interests at a time when some were beginning to concentrate on their regional specialisms. The SA Government had been wary of rival museums, although the Museum of Economic Botany was founded in the Botanic Gardens in 1880, a Museum of Applied Science became a feature of the School of Mines, and geology and anatomy museums were established at the university.[90] But none of these rivalled the SAuM and, as a result, the museum continues to offer a diverse and varied experience to visitors, while its resources for scholars are by and large 'user-friendly'. In some respects, its original founders would still recognise some aspects of the museum and would probably consider that their vision had been fulfilled.

Conclusion: Australian museums

It would be wrong to make too severe a dichotomy between the followers of Charles Darwin and the protagonists of Richard Owen (1804–92). However fierce Owen's venom may have been respecting the *Origin of Species*, some were capable of working with both. Darwin himself used Owen's researches in building up his grand theory. T.H. Huxley owed

significant patronage to Owen while becoming Darwin's strongest supporter (although he went off Owen once he discovered how vindictive he could be).[91] In Australia, Krefft in Sydney worked with Owen on fossil marsupials while being a devotee of Darwin. Others, like W.S. Macleay, corresponded with Darwin while failing to travel with him down the evolutionary path.

Yet it is the case that Owen secured a greater following in the Australian colonies than elsewhere. The reason is that his fascination with Australian fossil remains started at an early point in his long career and continued for many decades. Originally trained in medicine at Edinburgh, Owen's influential tenure of posts at the Hunterian Museum of the RCS (from 1826), as superintendent of the Natural History Department of the British Museum during its greatest era of expansion (1856 to 1884), and Professor of Comparative Anatomy and Physiology at the Royal Institution coincided with the growth of Australian studies in palaeontology.[92] His interest in the natural history of the Pacific and Australia began in the early 1830s, stimulated by the work of George Bennett, whom we encountered in Sydney in Chapter Six.[93] Owen was also the recipient of fossilised remains from Thomas Mitchell's exploration of the Wellington Caves of NSW in 1831. He identified the two massive extinct marsupials, Diprotodon and Nototherium (among other vanished fauna) and recognised that these had been similar in appearance to the pachyderms of Africa and Asia. In 1859, he published a major paper on the fossil mammals of Australia and researchers there continued to send him large quantities of specimens. His *Researches on the Fossil Remains of the Extinct Mammals of Australia* appeared in 1877. Thus he was a palaeontological guru in Australia and since he strenuously claimed that nothing he had seen indicated evolutionary processes, adhering instead to a form of successive creationism, his Australian associates invariably followed him. Although Owen became an increasingly controversial figure in Britain, his reputation in Australia remained high until at least the 1880s.

While there were notable exceptions, like Krefft and the clerical geologist W.B. Clarke, most of the scientists associated with museums adopted conservative positions. Clarke was relatively ineffectual in reaching a wider public, while Krefft was removed. Krefft, like Mueller at the Melbourne Botanic Gardens (though the latter was no Darwinian), became impatient with the notion that Australian scientists should kowtow to British mentors and wrote to Sir Henry Parkes, the premier of New South Wales, that 'a thorough history of our Animals can only be written in this country and in this Colony'.[94] Nevertheless, the towering reputation of Owen created something of

a barrier for independent Australian research and to an acceptance of Darwinian evolution. The position adopted by powerful families like the Macleays, strong colonial religious susceptibilities, and the influence of maverick figures like Frederick McCoy in Melbourne all contributed to this conservatism.

Thus Australian museums remained behindhand in their presentation of natural historical and fossil materials, although museums elsewhere were also slow to adopt evolutionary display techniques. It was not until a new generation of academic scientists, men like Baldwin Spencer and Edward Stirling, arrived that movement began. Interestingly, both virtually changed professions since they turned themselves into anthropologists and ethnographical collectors on a major scale. The museums in Sydney, Melbourne and Adelaide had all been more interested in Pacific materials than Aboriginal right up to the last decades of the nineteenth century. But despite this slow start, the local anthropological collections became central to their concerns, representing a shift from the Pacific and exotic in favour of the Aboriginal. If the latter were collected against the alleged inexorable determinism of decline and extinction (symbolised by the word 'relic'), still they became important in the development of a distinctive Australian identity, ultimately expressed in a hybrid, often abstract, pictorial art in the twentieth century and in a modern obsession with revived Aboriginal art and crafts displayed in commercial galleries everywhere.[95] In the early days of Australian colonies, artists like George French Angas collected Aboriginal materials in order to render their paintings more authentic. In modern times, however dubious earlier collecting techniques may have been, they have also served to reconnect modern Aboriginal peoples with their pasts. Thus, they made the transition from 'curiosities' informing artistic representations of the Australian environment through allegedly objective symbols of the inevitable disappearance of peoples – ironically through a major social distortion of Darwinian ideas – into materials redolent of multiple meanings, of white desires to situate themselves within natural and human environments and of Aboriginal hopes of a renaissance in the face of the tragic destructiveness of the past. This cultural reinvigoration cannot fully exorcise the haunting of Australian culture by the violence and dispossession of the past, but it can offer up some form of modern cultural redress.[96]

The anthropologist of the SAuM, Philip Jones, has written penetratingly about artefact collection and culture contact.[97] He has argued in what may be called a post-post-colonial reconciliatory vein, that the collecting of Aboriginal artefacts represents accommodation and mutual acculturation rather than simplistic hegemonic relationships,

and that the frontier of contact represents a zone which unified rather than separated. While it cannot be gainsaid that aspects of collecting reflected clear imbalances in power or that the acquisition of artefacts constituted part of the natural history project (creating human typologies in parallel with zoological and other equivalents), still such collecting represented interactions rather than power-laden transactions.[98] And they would ultimately lead to a new sense of interdependence. Artefacts are now imbued with the frontier's double patina (the 'ochre and rust' of the title of his book). They have become 'luminous debris', freighted with the 'skilful game of exchange' through which they were acquired as well as the 'improvisional nature of the encounter'.[99]

In any case, Aboriginal collectors (of both natural history specimens and ethnographic items) were invariably employed by white explorers and police, telegraph station managers and missionaries, to bring in materials and they thereby, in a sense, controlled the supply (Aboriginals were also used as guides, interpreters and advisers). There is evidence that from the 1890s demand stimulated renewed supply as artefacts began to be manufactured for the white market. Moreover, missionaries had been highly active collectors for many decades, their concerns often complementing those of others. They were much more interested in women's materials – as representing symbolic routes into an understanding of social and spiritual relations – and sacred items known as tjurunga.[100] Missionaries and their Aboriginal spiritual followers became entrepreneurs, selling artefacts, sometimes into the international trade that had developed by the 1890s, when dealers in such materials sprang up in Europe, America and Australia itself. By the late nineteenth century, the international exchange of natural history specimens of all sorts had been replaced (at least in terms of sheer volume) by a prolific trade in ethnographic materials. This shift reflected the change in emphases of museums throughout the British Empire, apparent in Australia no less than elsewhere.

Notes

1 Sir Charles Napier of Sind was elected President.
2 This version of the history of the SAuM can be found on the museum's website, 'A Brief History', in a 'Potted History' of the museum compiled in 2004, and in the standard centennial history, Herbert M. Hale, *The First Hundred Years of the Museum – 1856–1956, Records of the South Australian Museum*, vol. XII (Adelaide 1956), p. 1. It also became customary to trace the origins of the Royal Society of SA, to this 1834 meeting. See the Centenary Address of the President, Dr C.T. Madigan, to the Royal Society of SA in May 1936, printed in *Transactions of the Royal Society of South Australia*, vol. LX (1936), p. i.
3 Hanson (1805–76) had trained as a lawyer in London, but his career stalled because of his nonconformist and utopian ideals. He was involved in the SA plans from the start, drafting proposals for the South Australian Land Company, and attended

the South Australian Association's first meeting at Exeter Hall in June 1834. He was sent to Canada in 1837 to assist Lord Durham in investigating land claims and then drafted legal documents for the New Zealand Company. He sailed for NZ in 1839, apparently with the hope of making a quick fortune and then returning home, but failed. He moved to SA in 1846, where he helped revive the League for the Preservation of Religious Freedom. Public lectures delivered in the South Australian Library and Mechanics' Institute in 1849 shocked his audience by their apparent religious radicalism – he was attracted by some of the ideas of Bishop Colenso, the controversial Bishop of Natal, who reciprocated his admiration – and later accepted Darwin's theories. He was active as a lawyer and a member of the first partly elective legislative council, for which he drafted bills. Later Attorney-General, he formed a ministry, which held power between 1857 and 1860. He was appointed Chief Justice in 1861. He became first Chancellor of the University of Adelaide in 1874 and wrote a number of books on religious themes.

4 Rev. John Blackett, *A History of South Australia: a Romantic and Successful Experiment in Colonisation* (Adelaide 1911), described the colony as attracting 'a superior class of men and women'; social and cultural institutions like the museum were a key part of 'the process of nation building' and 'an index to national character' (pp. 121–2).

5 Hanson succeeded in preventing the Anglican Church from building its cathedral in Victoria Square, a central location in Adelaide, arguing that the English established church should have no privileges in SA. The cathedral was built in the posh suburb of North Adelaide.

6 *Nam et ipsa scientia potestas est*. Francis Bacon's notion was appropriated by Edward Said and the postcolonialists, attributed variously to Michel Foucault or themselves.

7 Edward Wright, apothecary and surgeon, delivered a lecture 'on the phrenology and the natural character of the Aborigines of South Australia'.

8 Fourteen or fifteen of those present became members of the colonial elite. See 'Early Organisation and Precursors of the Adelaide Philosophical Society', part of the address by Dr R.S. Rogers, 'A History of the Society, particularly in its Relation to other Institutions in the State', *Transactions and Proceedings of the Royal Society of South Australia*, Vol. XLVI (Adelaide 1922), p. 616. The minute book of these early meetings is in the Library of SA in Adelaide.

9 Glenelg's despatch, dated at Downing Street on 14 October 1838 (should this be 1837 or a different month in 1838?), was printed in the *South Australian Gazette and Colonial Register* of 18 August 1838. The 1838 date for the *Gazette* is correct since the Glenelg despatch is enclosed with a letter from the Colonial Secretary's office of 22 June 1838. The 'Directions for Collecting Zoological Specimens' were printed in the same issue of the *Gazette* offering advice on skinning, preparation and preservation with instructions on recording place and season when caught and notes on habits, habitat and local names.

10 In 1864 the celebrated evolutionist Alfred Russel Wallace donated an insect collection to the SAuM.

11 For early history and personalities, see 'Early Organisation and Precursors', pp. 620–3.

12 Draft Bill published in the *South Australian Register*, 13 May 1856.

13 The Bill also proposed that 'the efficiency and usefulness of such associations would be greatly increased and the means and opportunities of mental and social cultivation and improvement would be extended to a greater number of persons if such societies were enabled to unite to form one Society or Institute'. The debate on the Bill, published in the *Register* of 10 May 1856, revealed that members made allusions to the Royal Societies of Europe as models. There were to be six governors, three representing the Governor and three proposed by the constituent associations of the Institute. The *South Australian Register*, 19 May 1856, suggested that the Mechanics' Institute and Library, the Philosophical Society and the Water Colour Society were all too weak to flourish by themselves.

14 W.G. Buick, 'Clark, John Howard (1830–1878)', *Australian Dictionary of Biography* (*ADB*), vol. 3 (Melbourne 1969), pp. 404–6. Clark chaired the opening meeting of the Philosophical Society and was involved with the Institute and museum until the 1870s. After his death, the Adelaide public subscribed £500 to found scholarships in his name in English literature at the University of Adelaide.
15 A typescript article by Carl Bridge, 'South Australia's Public Libraries, 1834–56' in the Library/Archive of the SAuM debunks the alleged idealism of the framers of SA settlement. They were 'not so much aspiring young radicals as aspiring colonial gentry' who actually sought to keep the 'rabble' out of their enterprises. This was originally true, but genuine cross-class enterprises soon developed. The elite had to broaden its base to secure its cultural objectives.
16 'Early Organisation and Precursors', pp. 628–9.
17 The programme for this soiree along with the estimate and accounts for the catering are in the SAuM Archives. Other Institute social events included a farewell lunch for Governor W.F.D. Jervois and a banquet for the officers of the Overland Telegraph Construction party in November 1872.
18 The Philosophical Institute was eager to get quality scientific instruments into the colony.
19 The collection from Fiji was the gift (1860) of William Owen, a trader (and legislative council member for East Adelaide) who had operated from Port Adelaide to the Pacific Islands.
20 Cooper (1795–1887) was a hesitant and quiet figure, so it is not surprising that he failed to hold his audience. Refreshments were laid on for a thousand people, a throng difficult to control.
21 *South Australian Advertiser*, 30 January 1861.
22 An excellent impression of the workings of the museum, of donations, exchanges, relations with other museums, and so on, can be derived from the SA Institute and Museum letter books, which start in 1861 and were followed through until 1915.
23 For Waterhouse's period as curator, see Hale and John K. Ling, '1856 and All That: Recent History of the South Australian Museum', *Friends of the South Australian Museum* (*FOSAM*), 17, 1 (March 1986). There is a brief entry in the *ADB* by Darrell Kraehenbuehl, vol. 6 (Melbourne 1976), pp. 357–8. Waterhouse published very little and delivered only two papers to the Philosophical Society. He contributed a piece on 'The Fauna of South Australia' to a larger work on the colony, published in 1876.
24 The exchanges books reveal just how extensive Waterhouse's correspondence was, mainly with other Australian colonies, New Zealand, India, Britain, occasionally Germany and the USA.
25 Hale, *First Hundred Years*, p. 24.
26 Moritz Richard Schomburgk (1811–91) was born in Saxony and was the brother of the celebrated Robert Schomburgk, whom he had accompanied to British Guiana in 1840–44 as botanist and historian. He arrived in SA in 1849 and soon planted a vineyard. He became curator of the Adelaide Botanic Gardens in 1865 and continued in this post until 1891 (refusing the same post in Melbourne when it was offered in 1872). He was involved in laying out many other gardens (e.g. of Government House), in afforestation, and in advising commercial growers. He delivered many papers to Adelaide societies and conducted an international correspondence.
27 Report of Stirling to Board of Governors of the Public Library, Museum and Art Gallery of South Australia for 1887–88, p. 12.
28 There was invariably a trough in the fortunes of such societies, whether for economic or social reasons. It is also possible that this parallels the decline in the fashion of middle-class discussion of scientific issues identified in James A. Secord's article 'How Scientific Conversation became Shop Talk', *Transaction of the Royal Historical Society*, 17 (2007), pp. 129–56. It may be that increasing professionalisation helped to narrow the social base for the deployment of such scientific discourse.

29 Trained at the Royal School of Mines in London, Ralph Tate (1840–1901) taught at the London Polytechnic, in Bristol and Belfast, where he founded the Belfast Naturalists' Field Club. In 1864, he was appointed assistant curator of the Museum of the Geological Society of London. He published in geology, palaeontology and botany. After travels in Central and South America, Tate arrived in Adelaide as the first professor of natural science at the new university. He energised scientific studies in SA, published extensively, and was a key figure in the Horn expedition of 1893–94.
30 Centenary Address of Dr C.T. Madigan, p. iii.
31 The first issue of the *Transactions* contained a recherché article by Schomburgk on plant fragments found in ancient Egyptian tombs and other monumental buildings. Many of the articles were by Tate and others associated with the museum.
32 Sir Joseph Verco (1851–1933), born in SA, was a distinguished physician trained in London. With Edward Stirling he was a founder of the University of Adelaide medical school. Founder and president of the SA branch of the British Medical Association, he also presided over the first Intercolonial Medical Congress in Australasia in 1887. He became an enthusiastic dredger for crustaceans and molluscs (sometimes accompanied by Stirling). The Royal Society of SA later founded the Verco medal for distinguished scientific investigations.
33 Elder (1818–97) was one of several brothers who emigrated to SA from Kirkcaldy, Fife. Thomas was the partner of Edward Stirling senior and became phenomenally rich as a businessman (notably in copper mines) and as a pastoralist (owning with a partner land more extensive than the area of Scotland). He financed a number of exploring expeditions and was largely responsible for the introduction of camels together with their Afghan handlers. He put a lot of money into the University of Adelaide, endowing chairs in mathematics and general science, later the medical school and the School of Music. He left ecumenical bequests to Presbyterians, Anglicans and Methodists.
34 Honorary members included Mueller in Melbourne, Macleay in Sydney, G.F. Angas, by then in London, and the Governor.
35 Natural history specimens, ethnological material and casts of New Zealand Maori implements came from the Australian Museum in exchange for the collection exhibited at the Sydney Exhibition of 1880 (and lost in the fire).
36 Private communication, 19 September 2007, from Dr Philip Jones.
37 Haacke to the Board, 17 January 1883, SAuM Archives. This archive contains registers of correspondence, diaries and memoranda, as well as small notebooks and miscellaneous books listing donations, exchanges and purchases. There is very little relating to the years before 1864 and the volume of material inevitably builds up in the 1870s and 1880s.
38 Haacke to the Board, 31 October 1883 and 18 December 1883. SAuM Archives.
39 Philip G. Jones, '"A Box of Native Things": Ethnographic Collectors and the South Australian Museum, 1830s to 1930s', PhD, University of Adelaide, 1996, p. 86.
40 The three institutions, library, museum and art gallery, were not separated until 1940.
41 One of his grandmothers may well have been black.
42 In 1886, Stirling introduced a bill to enfranchise women. He served on the Council of the University, was Dean of the Faculty of Medicine 1908–19 and was knighted in 1917. He created a celebrated garden, including exotica as well as native plants, at St Vigeans, Mount Lofty, named after the village in Scotland where the Stirlings had originated. He left a considerable fortune.
43 Stirling operated as an ethnographer with little institutional background. The Anthropological Society of SA was not founded until 1926 at a time when universities were taking a greater interest in the subject – Sydney appointed a professor of anthropology in that year. But the first professional anthropologist to be appointed to the museum staff was Norman B. Tindale appointed in the late 1930s. Originally the museum's assistant entomologist, he was encouraged by Waite, the Director, to move into anthropology; he took part in an expedition to Princess Charlotte Bay

in 1926-27, collecting ethnographic material, documenting the material carefully; and he travelled in America and Europe during 1936-37, studying Australian collections in overseas museums. While serving as an officer in the RAAF in the Pacific during the Second World War he indulged in some collecting in that region.

44 They became so long that they were not printed 1892-97 as an economy measure.
45 Hale, *First Hundred Years*, p. 75.
46 From personal observation, dioramas of stuffed animals are still popular with visitors. The collection of Tasmanian 'tigers' helped to further their extinction.
47 The Report of the Board, 1916-17, p. 8 suggested that coins and medals were popular with visitors.
48 As reported by T.C. Cloud in the Report of the Board, 1884-85.
49 The Gawler Museum was founded in the 1860s and its two initial curators were German. The first was Richard Schomburgk, later director of the botanic gardens. Schomburgk sent many ethnographic items to Germany. Jones, '"A Box of Native Things", pp. 76-7. Two Germans were active collectors in this area, Otto Wehrstedt from Gawler and Dr J. Richter in the Barossa Valley. Ibid., p. 78.
50 Stirling extolled the virtues of 'natural settings' for faunal displays of the sort he had seen in London and the USA in 1901. 'Extract from Professor Stirling's Report on his visits to museums in America and Europe in 1901', in Report of the Board, 1901-2, pp. 23-4.
51 The *Adelaide Observer*, 19 January 1895 described the main hall as 'the finest of its kind in the Australasian colonies'. Such competitive comparisons seem to have been significant spurs to action. The same issue described the 'brilliant assemblage' for the opening by the Earl of Kintore, attended by the mayors of every town in the colony.
52 Stirling detailed the arrangements for the new building, including the transfer of all technical services from the unsatisfactory crypt of the west wing, in Report of the Board, 1911-12, p. 9.
53 Honorary curators included T.C. Cloud for mineralogy (1882); W.T. Bednall for conchology (1886); Joseph C. Verco for marine material (later conchology); Rev. Thomas Blackburn for entomology (1891); and Rev. W.R. Fletcher for Archaeology in 1893-94 (when he died). Later, Professor Edward von Blomberg Bensly became honorary curator of archaeology in 1897 and identified the Egyptian materials, writing descriptive labels for them. Later, in 1904, a collection of Egyptian pottery arrived in the museum from the Beni Hasan Excavation Committee. In 1908, Douglas Mawson, later celebrated for his Antarctic exploits, became honorary curator of mineralogy, continuing his association with the museum until the 1950s, writing the foreword to Hale's centennial history.
54 Jones, '"Box of Native Things"', p. 88. By modern times, the collection numbered 74,000 registered anthropological items and some two million archaeological objects.
55 'The Deputy Storekeeper for the Colonization Commissioners, Mr Williams, received a "collection of weapons and instruments used by the Natives in the neighbourhood"'. But the records of the Public Stores of that period are no longer extant, and these materials do not seem to be registered with the SAuM today. Government of South Australia, Operational Records Disposal Schedule, dated 14 October 2003. This document gives the legislative history of the museum from 1856 to the present.
56 Jones, '"A Box of Native Things"', p. 75.
57 Police were often interested – not least for professional reasons – in Aboriginal weapons, the onset of 'peace' having caused a decline in their manufacture.
58 Report of the Board, 1899-1900, p. 9.
59 For the Maurice ethnological collections, see the Report of the Board, 1903-4. The moas from Japan were announced in the report of 1905-6.
60 This phrase follows Paul Fox, quoted in Tom Griffiths, *Hunters and Collectors: the Antiquarian Imagination in Australia* (Cambridge 1996), p. 18.

61 Stirling in Report of the Board, 1889–90, p. 14.
62 Report of the Board, 1911–12, p. 8.
63 Krause also visited Victoria and published the results of his examination of 200 Australian skulls in the *Transactions of the Berlin Anthropological Society*. Report of the Board, 1897–98, p. 8.
64 'Abstract of Preliminary Report on the Discovery of Native Remains at Swanport, River Murray; with an enquiry into the alleged occurrence of a pandemic among the Australian Aboriginals' in Report of the Board, 1910–11, pp. 20–4. As a medical man, Stirling was intrigued that this large assemblage of remains related to an unusual event, such as a pandemic, and speculated (accurately) that smallpox probably broke out ahead of the arrival of Europeans to settle.
65 Stirling) in Report of the Board, 1911–12, p. 9.
66 Report of the Board, 1915–16, p. 14.
67 Hale, *First Hundred Years*, p. 83.
68 There have been some 200 scientific papers published on these collections, yielding valuable information in respect of past populations, disease and diet. Information from Philip Jones who is more positive about the value of such collections while recognising the sensitivities.
69 The connection had been made by the Rev. W.R. Fletcher who visited Egypt and made influential contacts, such as with Sir Flinders Petrie, while on leave. Some were described as donations from the Khedive of Egypt, though these may have been handed over reluctantly. Report of the Board, 1890–91, p. 11. Given to the art gallery, this material was subsequently returned to the museum. Some of it, arranged by the museum ethnologist Tindale in 1939–40, is still displayed in its intriguingly old-fashioned form and in 2007 seemed popular with visitors. Redisplay and reinterpretation seem to be inhibited by its status under a National Trust classification. For a fuller account, see Robert S. Merrillees, *Living with Egypt's Past in Australia* (Melbourne 1990), pp. 24–8.
70 Stirling in Report of the Board, 1891–92, p. 13.
71 Other expeditions included the Calvert of 1896–97, the Spencer and Gillen of 1901–2, and the Barclay and McPherson of 1911–12.
72 Stirling listed many donations from England after his 1891 visit.
73 'Extract from Professor Stirling's Report' of 1901, pp. 23–4.
74 Later the Carnegie/Museums Association survey complained that less money was spent in the whole of Australia on museums and art galleries than in Scotland, while the budget of a single major museum in London could be five to six times more than total expenditure in Australia. S.F. Markham and H.C. Richards, *Report on the Museums and Art Galleries of Australia* (London 1933), p. 11.
75 The Elder legacy was announced in the Report of the Board, 1900, p. 14. The Dr Morgan Thomas bequest of 1903 amounted to £65,679. The income of half of this was to be devoted to library purchasing with a quarter each going to the gallery and the museum. By 1916, the overall budget was receiving £2,540 as interest on investments, mainly from bequests.
76 Quoted in Hale, *First Hundred Years*, p. 75.
77 However, he did write museum captions about Aborigines in the present tense. Jones, '"A Box of Native Things"', p. 388. His diorama of a 'native encampment' also implied a living culture.
78 Stirling in Report of the Board, 1889–90, p. 14.
79 Quoted in ibid., p. 83.
80 Pacific Island artefacts are still very prominently displayed in the museum, if in an old-fashioned form. By contrast, there is an excellent modern gallery of Aboriginal materials, which are contextualised in striking ways and with the use of sound and visual media. On my visit, a number of Aboriginal visitors seemed thoroughly fascinated by what they saw.
81 Presented by David Murray who was a member of the Board and bequeathed £3,000 to the gallery in 1907. Report of the Board, 1898–99, p. 9. For a full account of the arrival of Benin material in Britain, see Annie E. Coombes, *Reinventing Africa:*

Museums, Material Culture and Popular Imagination (London 1994), chapter one and passim.
82 The Board reported the acquisition of large mammalia from East Africa in 1902. The Governor of British East Africa sent a specimen in 1908 and more arrived from Nairobi.
83 For the first time there was a strong field with several local candidates.
84 C.J.M. Glover, 'Waite, Edgar Ravenswood (1866–1928)', *ADB*, vol. 12 (Melbourne 1990), pp. 348–9.
85 Report of the Board, 1913–14, p. 9; also quoted in Hale, *First Hundred Years*, pp. 98–9.
86 The museum has taken over a few adjacent buildings, such as the old armoury. Expansion into the Destitute Asylum at its rear was considered, but this is now the SA immigration museum.
87 Report of the Board, 1914–15, p. 6.
88 The *Records* contained material on social and physical anthropology from the start, including cranial measurements and information about the arrival of the Reuther collection. There were also papers by Waite on an Aboriginal girdle and another on widows' mourning caps. But the majority of articles related to natural history. Volume II commenced a catalogue of the fishes of South Australia, presumably a preliminary outing for Waite's subsequently published book.
89 Report of the Board, 1916–17 announced that Waite had led a collecting expedition to Central Australia.
90 I am obliged to Philip Jones for this information. See also A. Auckens, 'The People's University': the South Australian School of Mines and the South Australian Institute of Technology, 1889–1989 (Adelaide 1989) for some account of the Museum of Applied Science.
91 Huxley summed up Owen as 'an able man, but to my mind not as great as he thinks himself. He can only work in the concrete from bone to bone, in abstract reasoning he becomes lost.' Huxley to W.S. Macleay, 9 November 1851, quoted in Leonard Huxley (ed.), *Life and Letters of Thomas Henry Huxley* (London 1900, 2 volumes), p. 102. While Owen's achievements in identification were prodigious (though not always accurate), he became increasingly cantankerous and some thought he mixed up specimens and bent some of the 'facts' to his theories.
92 Ann Mozley Moyal, 'Sir Richard Owen and his influence on Australian Zoological and Palaeontological Science', *Records of the Australian Academy of Science*, 3, 2 (1975), pp. 41–56.
93 Throughout his career, Owen published some ninety papers on Australia's extinct and living fauna. For the Pacific, see Roy MacLeod and Philip F. Rehbock (eds), *Darwin's Laboratory: Evolutionary Theory and Natural History in the Pacific* (Honolulu c.1994) and Roy MacLeod and Philip F. Rehbock (eds), *Nature in its Greatest Extent: Western Science and the Pacific* (Honolulu c.1988).
94 Quoted in Moyal, 'Sir Richard Owen', p. 53.
95 In the 1930s, Aboriginal motifs were included in the painted friezes of the waiting room of Sydney Central Station, a notable example of the union of modernist technology with artistic ideas derived from indigenous people. For a general survey of these progressions in colonial art, see John M. MacKenzie, 'Art and the Empire', in P.J. Marshall (ed.), *Cambridge Illustrated History of the British Empire* (Cambridge 1996), pp. 296–315. There is a moving evocation of the revival of Aboriginal crafts in Griffiths, *Hunters and Collectors*, pp. 281–2.
96 For this haunting, see Griffiths, ibid., pp. 3–4.
97 Jones, '"A Box of Native Things"', pp. 1–2.
98 We should never forget, however, that this collecting took place at a time of massive Aboriginal demographic collapse. Pre-colonial figures of the Aboriginal population are obviously imprecise and anything from 300,000 to a million have been offered as estimates. In 1900, it was possibly reduced to 60,000 and remained very low until the 1930s. Social deprivation and a disturbing complex of economic, cultural and psychological problems have remained the lot of Aborigines until modern times.

99 Philip Jones, *Ochre and Rust: Artefacts and Encounters on Australian Frontiers* (Adelaide 2007), pp. 7, 42, 45. See also Philip Jones, 'Perceptions of Aboriginal Art: a History', in Peter Sutton (ed.), *Dreamings: the Art of Aboriginal Australia* (Ringwood, Victoria 1988 and London 1989).
100 For a discussion of missionary collecting and disposal, see Jones, *Ochre and Rust*, chapter six.

CHAPTER EIGHT

New Zealand/Aotearoa: War Memorial Museum, Auckland

Most of the imperial territories in this book were first engrossed into the British Empire in the eighteenth century, usually acquired in stages. But New Zealand/Aotearoa has discrete origins as a colony in the nineteenth. While the mythic voyages of Cook and others placed the archipelago on the map, literally and metaphorically, and while missionaries, whalers and traders were active in the early nineteenth century, British rule dates from the Treaty of Waitangi with the Maoris in 1840. Institutional science and related cultural forms therefore have a definite starting point; and this formal imperial beginning represents a process of almost instantaneous diffusion. Ideas and methodologies spread around the British Empire very rapidly.[1] In the case of New Zealand, the cultural institutions of the bourgeois sphere arrived with the first organised settlements. These seemed to spring into sudden life, instant communities requiring the immediate formation of the characteristics of rational, 'liberal' civilisation. The wilderness was to be tamed by something more than just settlers hacking their practical way into the environment: intellectual tools were perceived to be as necessary as the agricultural, geological or military.

A fascinating case of this occurs in Nelson, a town in the north of the South Island, which was intended to be much more significant than it subsequently became. Two of the earliest emigrant ships arriving there, the *Whitby* and the *Will Watch*, left London in early 1841, and carried passengers who planned the beginnings of cultural institutions while on board.[2] Under the leadership of Captain Arthur Wakefield (brother of Edward Gibbon) they plotted the intellectual and press adornments of a town that barely existed. There was to be a library (and they collected books when they stopped en route), a museum of history and ethnology, a philosophical society, and newspapers. The first issue of the *Nelson Advertiser* was actually published in London and the second in Nelson itself. The *Nelson Examiner* appeared on 12 March

1842. The first meeting of the Nelson Institute took place on 27 May of that year: the New Zealand Company donated £100 to this fledgling association and, with subscriptions, its opening funds came to £180. Astonishingly, the library and reading room opened on 27 September and collections of specimens for the museum were already being put together. A mechanics' institute followed in 1846, publishing a list of lectures almost immediately. In 1848, a librarian had already been appointed and the library was taking the principal British newspapers and periodical reviews, obviously arriving many months after publication date.

From 1855, the Institute received an annual grant of £100 from the provincial administration and a librarian was appointed with a salary of £60 per annum. The objects of the Institute were declared to be 'the diffusion of useful knowledge by means of a library, reading room, museum, lectures and classes of instruction'. The librarian also became curator of the museum. A new building was planned in 1858 and completed in 1861. The German Ferdinand von Hochstetter (who was working for the Austrians) donated a mineral collection.[3] Hochstetter spent more than a year in New Zealand between late 1858 and early 1860, conducting extensive geological surveys at the request of the New Zealand government, and figuring prominently in the museum histories of Auckland, Nelson and Christchurch.[4] By 1871, the Institute, the philosophical society and the mechanics' institute had become central to the bourgeois life of a relatively primitive town with a population of just over 5,000. Initially, these were members' exclusive clubs and the general public only secured access to the library and museum in 1901. There were financial problems from time to time, with a debt of £800 in 1898.[5] The bank threatened to send in bailiffs, but greater prosperity was enjoyed after 1900. Following a major fire in 1906, the Institute was incorporated by an Act of Parliament of 1907; a new building was started in 1911 and completed in 1912 (Andrew Carnegie refused to contribute because he was convinced the fire had been started deliberately).[6]

The Nelson Institute, library and museum are actually peripheral to the main concerns of this chapter, but its almost instantaneous growth, provincial support, architectural expression and role within a 'pioneer' community are indicative of developments elsewhere. It is clear that migrants, at least those who were middle class or self-improving, wished to replicate home institutions immediately. The provincial administration encouraged this (albeit in parsimonious ways) to stimulate information gathering about the environment, spread educational opportunities, forge links (e.g. through the press) with 'home' and international communities, and lubricate the cohesion of the bourgeois

sphere. This was only marginally about social control since the institutes and their associations were often relatively exclusive. Even the mechanics' institute in Nelson, as elsewhere, satisfied the requirements of its bourgeois founders rather than the 'mechanics' for whom it was supposedly designed. Yet while the bourgeois and upwardly mobile wished to spread their rational ideas and recreational forms, they generally also sought to maintain their social distance. Some original institutes have an air of exclusivity about them.

Nelson provides an excellent example of the planting and growth of intellectual institutions in an apparently unpromising soil of a community of wooden huts and muddy lanes. Here was a wild and unkempt place, fragile and vulnerable, only tentatively reclaimed from the wilderness, its buildings slovenly, dirty and ramshackle. This was true of all early New Zealand (and frontier) towns, representing not so much the harbingers of western civilisation as its scattered detritus. It was to be a number of decades before the street systems, usually so carefully laid out upon the topography, were to be paved, cleaned and lined with the appropriate Victorian architecture of commerce, banking, civic, educational and religious institutions; before clean water supplies, sewage and rubbish disposal, as well as arrangements for the decorous burial of the dead in attractive surroundings were to be provided. Yet this frontier was to be intellectually 'civilised' from the start. Libraries, reading rooms, museums, places for the gathering of 'improvers' were to be among the first structures to appear. For the founders it was a matter of civic and colonial pride, linking a population at the edge to developments taking place seemingly everywhere. These were to contribute to the sense of mission, the intimations of a worldwide purpose, the notion of planting a rational history in apparently hostile ground. This was about the maintenance of class, racial and ethnic pride as well as the construction of new identities. For these institutions were also to be adaptable: they were to pass through a process of peripheral transformation, a morphology that would make them distinctively of New Zealand. The role of these institutions in the interaction of the local and imperial, colonial and international, dominion and nationalist forms of identity was central.

Auckland

While the settlers of nascent Nelson were supplying themselves with institutions offering self-respect and self-improvement, a sense of being truly a part of the British world, Auckland was yet another community clinging to the edge. It was a place on a military frontier, with British and Irish troops forming a significant portion of its population and

occupying land of Maori peoples, sometimes welcoming and helpful, often, not surprisingly, hostile. But Auckland was destined to become the largest city of the dominion with one of the most impressive museums anywhere in the southern hemisphere. Founded in 1840 on an isthmus surrounded by magnificent natural harbours, it was selected to be the capital and remained the seat of government until 1865, when it was supplanted by the more centrally positioned Wellington. Auckland was a much more rumbustious place than Nelson, a muddy settlement of huts and sheds, soldiers, bars and billiard rooms with open sewers flowing down to the harbour. The government building was so mean that it was known as the 'shedifice'. Supplies were limited while its makeshift economic development was frequently hit by recession, the first one as early as 1842–45. A decade later the population was largely made up of migrants from NSW and people of Irish origin (some of them demobbed Fencibles whose role was to protect the town from Maori attack).

On the face of it, this was not a friendly environment for the development of intellectual associations. But the self-improving urge was unstoppable, supplied by the churches and by associations like the mechanics' institute of 1841.[7] Initially peripatetic around the town's huts, it had its own building from 1844, where it sheltered other organisations such as the Total Abstinence Society, the Association for the Suppression of Intemperates, and a pressure group demanding the founding of a 'lunatic asylum'. These give a graphic impression of the nature of the settlement, a place apparently spawning drunks and the psychologically disturbed – or at least fears that this was the case. Like most other such institutes, the founding of a library and a museum were among its ambitions.[8] The Auckland Book Society, an early self-improving association, was duly transformed into a library but the museum did not materialise. The subsequent history of the institute is chequered. While it occasionally hosted successful lectures (such as one given by the visiting Hochstetter in 1859), its educational programme was largely unsuccessful heavily based as it was on bourgeois tastes – subjects such as classical architecture and phrenology. Working men duly voted with their feet and the Institute was wound up in 1879, in common with many across the British Empire in that decade.

The creation of a museum was to have a greater public impact. Within twelve years of its founding, the primitive town boasted a proto-museum.[9] This was yet another case of almost instant imperial interaction. The Great Exhibition at the Crystal Palace in London pulled in exhibits from around the empire, including New Zealand.[10] The Auckland submission was put together by John Alexander Smith, a liquor merchant, trader, soap and candle maker.[11] He was proud that

this was the largest submission from New Zealand, described in the official catalogue as a 'valuable and tolerably extensive collection of native and other products' embracing geological and vegetable specimens 'with a few simple manufactures'.[12] Flushed with success, he resolved to found a museum in Auckland, which opened in the following year.[13] This preceded the creation of any institutional parent. Records are slight, but presumably a committee had been formed to fulfil a conscious need and specimens had been gathered together.

In October 1852 the newspaper *The New Zealander* announced that a museum had been formed with Smith as the first honorary secretary. It had apparently been opened on the 24th of that month with a visit from its patron, the Lieutenant Governor (later Provincial Superintendent and Acting Governor), Colonel Robert Wynyard. The paper suggested that while 'there is not yet a great deal to be seen, yet there are many specimens of New Zealand minerals, some handsome stuffed birds, shells, insects and various other things amongst which an hour may be very agreeably and instructively spent'. A room had been found in the 'old Government farm house' a little beyond the Scotch Church, opposite the barracks.[14] It was to be open on Wednesdays and Saturdays from 10 a.m. to 4 p.m., and all its exhibits and fitments had been given free of charge. The same article published Smith's call for donations:

> The object of this Museum is to collect Specimens illustrative of the Natural History of New Zealand – particularly its Geology, Mineralogy, Entomology, and Ornithology.
> Also, Weapons, Clothing, Implements &c &c, of New Zealand, and of the Islands of the Pacific.
> Any Memento of Captain Cook, or his Voyages will be thankfully accepted.
> Also, Coins and Medals (Ancient and Modern).
> In connection with the above, there is an *Industrial Museum* to exhibit –
> Specimens of building & ornamental Stone,
> " Timber for various purposes,
> " Clays, Sands, &c &c,
> " Dyes – Tanning substances, &c,
> " Gums, Resins &c,
> " Flax, Hemp, Hair, &c, &c.
>
> As it is desirable that samples of New Zealand Wool should be exhibited – contributors are requested to send samples in duplicate, as soon as convenient, stating – the Sheep, where bred – of what breed – also the age – who contributed by.[15]

Donors were requested to send their specimens in on days when the museum was not open, leaving their names and any special remarks.[16]

This is indeed an ambitious prospectus, with natural history and economic resources at the head of the list. The need for an ethnographic collection was also recognised, including Pacific Islands material, no doubt to help explain the origins of the Maori. The significance of the Cook voyages clearly chimed with this. But the museum was also planned to fulfil the needs of a newly founded agricultural economy, together with the requirements of town building. Economic considerations started and finished the list. The museum also had official blessing. The patronage of the Superintendent offered hope that the provincial administration would offer funds at a time when budgets must have been tiny. Such an application met with early, if minimal, success. The sum of £20 was granted in 1853; this was renewed in 1854, raised to £100 from 1855–57; and reduced to £50 for 1858. A committee of twelve Auckland worthies was appointed and a further appeal for donations issued, the object of the museum being to alleviate 'the annoyance often felt by Strangers arriving Auckland who complained of the dearth of information relative to the products of the colony' (there were 708 visitors in the first year).[17] The indefatigable Smith secured the administration's support to send materials to the Paris Exhibition of 1855.[18] He also began to plan a library of scientific works.[19] But he failed to secure the support of the colonial (as distinct from the provincial) government and his appeals for a better building fell on deaf ears. In 1859 Hochstetter used the museum as his base for his geological research and issued a fresh appeal for specimens. The 'Maori wars' had broken out in 1860 and the administration was preoccupied.

Smith moved to Hawkes Bay (Napier), where he became a notable citizen, and a succession of shadowy figures fulfilled the role of honorary curator (including B. Dickson from 1861 and E. Watkins from 1864), but in 1867 Captain F.W. Hutton, who was to be one of the leaders of New Zealand scientific endeavour, took over.[20] His remarkable career embraced a key role in three museums: Auckland, Otago and Christchurch. In 1861, Dickson suggested to the superintendent that the museum was 'too valuable a collection' to be reduced to the 'state of torpor to which the neglect of the public has lately consigned it'.[21] A report of 1864 complained that the museum was 'over-crowded, dirty and neglected' and that, 'Judging by the few visitors of the higher class, the Museum seems sadly to have degenerated since its early days'. The museum required disinfecting to subdue the 'unsavoury odours', with cataloguing and identification inadequate, many of the labels having been eaten by moths.[22] Even Hochstetter's geological donation was virtually useless.

Despite the insecurity of the museum at this time there is some evidence that it was playing a slight role in the early applied science of the

settlement. In 1864, Dickson was asked to supply all possible information on the economic botany of the province to William Colenso[23] who was compiling an essay on the botany, geography and economics of the North Island for the catalogue of the Royal Exhibition in Dunedin.[24] Yet there is little evidence to suggest that Smith's grandiose list of objectives was ever fulfilled or that it played a notably instrumental role in the early economy of the settlement. However, a new era was about to begin. Thomas Kirk, whose background as a nurseryman and sawmill worker in England turned him into a keen botanist, first visited the museum in 1863, and was no doubt disappointed by what he saw.[25] He was later appointed curator.[26] He put together collections (of raw materials and other botanical items) for the Auckland exhibit at the 1865 Dunedin Industrial Exhibition and he started compiling botanical lists of acclimatised and indigenous plants.

The museum was moved to new accommodation – a building which had been an officers' mess, government offices, and later the Northern Club – shortly before the next phase of its history begins. But in November 1867, an umbrella organisation was founded that would shelter and revive it. This was the Auckland Philosophical Society, inaugurated in the rooms of the Acclimatisation Society (with which there was an inevitable overlap in membership, including Kirk).[27] In March 1868, the name was changed to the Auckland Institute and its activities commenced in May of that year. It affiliated to the newly formed New Zealand Institute established in Wellington by Act of Parliament in 1867 under the direction of a key figure in the early history of New Zealand science, Dr James Hector FRS.[28] Hector was convinced of the need to connect scientific departments to a museum and had virtually written his own job description when invited to be director of the Colonial Geological Survey in 1865.[29] The survey, he believed, should have a related scientific institution and museum, the latter arranged for the development of the country, not 'organised for the popular diffusion of knowledge', avoiding the common lapse into 'unmeaning collections of curiosities'.[30] Despite this rather severe prospectus, the museum soon had a large Maori house from Turanga, which filled up with indigenous artefacts.[31]

Hector's ambitions marked the origins of the new capital's Colonial Museum and then of the Institute.[32] Each of the local institutes would be affiliated and papers were to be published in its *Transactions*. This was an excellent system for ensuring that New Zealand scientists and museum workers communicated their research to each other on a colony-wide basis. The first paper heard in Auckland was 'On the botany of the northern part of the North Island', read by Kirk. The fact that he had already been appointed 'assistant secretary and curator' of the local

Institute indicates that it was confident it could take over the original museum. In fact, the provincial council agreed to transfer the museum in 1869 (after Kirk had negotiated with the superintendent) and it was moved to the old post office (a small wooden building), Kirk pledging himself to open it on three days a week. In 1870, he was invited to visit the Colonial Museum in Wellington to select duplicates from its specimens.

After this move Kirk set about the rearrangement and cataloguing of the collections, for which he received a small fee. He also saw the membership of the Institute expand dramatically. The first volume of the *Transactions of the New Zealand Institute* was issued in 1870, running to no fewer than 500 pages, and was distributed free to the Auckland members.[33] It was said that this greatly encouraged others to join and the membership rose from 68 in 1868 to 225 in 1874.[34] By 1870 Kirk was receiving a salary of £80 per annum. In 1873. classes in natural science were mounted associated with the Auckland College and Grammar School, where Kirk became part-time teacher in botany. Given his predilections, Kirk no doubt used these educational connections to teach practical knowledge for future agriculturalists and foresters.

The members of the Institute had already conceived greater ambitions. After a period in which the Institute lamented the inadequacies of the 'dilapidated and unprepossessing' old post office building and complained that they were receiving less support from the provincial government than museums in other provinces, a building fund was opened and grants were applied for with a view to constructing a new and ambitious building.[35] This was to include, as well as the museum, a lecture theatre, classroom, library, laboratories and rooms for the curator. It was also suggested that the mechanics' institute should be incorporated within it, but that idea fell through.[36] After some hesitation over government funding and inevitable delays, the building duly went up (in a somewhat more modest form), completed in 1876, faced in stone, with an adjacent caretaker's cottage in wood. After a period of less than forty years after its founding, Auckland had a relatively impressive museum building which preceded the construction of the city's public and commercial structures. It soon acquired some additional land for extensions. The museum was indeed an early example of civic pride. It had cost more than £4,000, leaving a shortfall of £2,200 over the private subscriptions, eventually covered by a grant from the government.[37]

The private donations (£2,026 had been subscribed towards its cost, with £500 each from James Williamson and Judge Gillies),[38] began a tradition of liberality, which was to be very important to the future development of the museum in Auckland. They also reflected the economic

and population growth of the town. The latter stood at over 12,000 in the early 1870s and passed 50,000 in the early twentieth century (after the setback of a depression in the 1880s). Gas lighting was introduced in 1865 and reached the museum a few years later. The first railway line (to Onehunga) was opened in 1873, and harbour works were developed. Auckland was emerging as a major imperial port.

The Auckland Institute reflected this civic growth. Its members were soon involved in field trips to Little Barrier Island, Arid Island, Manukau Heads and other areas accessed from Auckland's harbours. A list of potential lectures was promulgated (compiled by Hutton and Kirk, 200 copies printed), almost entirely on aspects of agriculture, forestry, the manufacture of raw materials, and environmental and botanical concerns. The members also took a keen interest in the development of gold mining at Thames on the Coromandel Peninsula, seeking specimens for the museum, and claiming that people from Thames came to the museum to have samples identified.[39] But accommodating gold specimens turned out to be a dangerous plan since they stimulated a number of burglaries in 1871 (as elsewhere). Concerns with agricultural chemistry led the museum to appeal to the Geological Survey for soil samples for analysis.

The Institute also attempted to take over the Government Garden on the Auckland Domain, where the museum would eventually be situated, proposing that Kirk should become its superintendent. But, to its regret, the Domain land became a market rather than a scientific garden. Economic practicality won over botanical study. It was decided that conversaziones should be held in order to involve the wives of members; and further field trips were organised (though whether women participated in these is unclear).[40] A medical subsection was proposed in 1869 and Kirk was instructed to recruit for it, but this partly misfired. At least one doctor resigned on the grounds that 'certain notorious quacks' were joining! The membership typically seemed to include professionals, businessmen, officials (including the Provincial Superintendent), military officers and clergy.

The 'prosopography' of the early days of the Institute and museum reveals a remarkable collection of the leading citizens of Auckland. If there was a single driving force it was Thomas Bannatyne Gillies (1828–89), a Scottish lawyer and settler in Otago in 1852. He moved to Auckland in 1865 and was active in the founding of the Institute. He was Superintendent of the Province in 1869, was twice a Member of Parliament, a minister in the 1872 government and, from 1875, a judge of the Supreme Court. As well as his major donation, he secured the Princes Street site for the museum. He had interests in conchology, forestry and new economic crops and combined roles as farmer, barrister,

politician and judge as a typical pioneering polymath.[41] Together with some of his elite confreres, he was highly competitive, particularly in respect of Wellington. Annoyed at the removal of its capital status, they were determined to see that Auckland's societies – including the Institute and the museum – were second to none.

Another dominant figure was John Logan Campbell (1817–1912), often described as a father figure of Auckland.[42] After medical study at Edinburgh, he arrived on the Coromandel peninsula in 1840 and, after a period of living with local Maori, he indulged in land speculation in the area, which would become Auckland (helped by £1,000 from his father). By December 1840 he had founded a merchant firm, but he was a reluctant colonist, missing (by his own admission) the advantages of civilisation. After a restless period, he settled in Auckland again in 1850, indulging in a wide range of commercial activities. Though he made a considerable fortune, Campbell never left as he had intended. He became Provincial Superintendent in 1855–56, a member of the House of Representatives and a minister. Still dissatisfied, he travelled and married in India, but returned to the Auckland business in 1871, joining the Institute in 1872. He became a member of Auckland's financial, business and cultural elite and moved into banking, insurance, timber, brewing and cattle ranching. A major benefactor of intellectual and charitable causes, he left a great deal of land to the city. The Logan Campbell Trust continued to be generous to the museum long after his death.

One of the founders of the museum was a remarkable figure, a medical man with extensive interests in botany and other natural sciences. Andrew Sinclair (1794–1861) had studied medicine in Glasgow, Paris and Edinburgh and became a naval surgeon in 1822. In this capacity he travelled extensively in the Mediterranean, southern Africa, the Pacific coasts of North and South America, collecting botanical specimens and other materials for the BM and Kew. Moving from naval to convict ships be began to sail to Australia and New Zealand, arriving in the Bay of Islands in 1841 where he went on a botanical expedition with William Colenso and Joseph Hooker. In 1843 he met Robert Fitzroy (Darwin's captain, now appointed Governor of New Zealand) and was persuaded to become Colonial Secretary in Auckland, a post he held from 1844 to 1856. He therefore brought to the museum extensive scientific interests acquired around the world, literary and artistic concerns, administrative influence and business acumen.[43]

Another leading figure was Sir Frederick Whitaker (1812–91), a lawyer who had arrived in New Zealand ahead of the Treaty of Waitangi, was Superintendent of the Auckland Province 1865–67, and also served as Colonial Attorney General and premier. He secured a

parliamentary grant towards the cost of the 1876 museum building. Yet another was Arthur Guyon Purchas (1821–1906), a doctor trained in London who was also ordained under the influence of Bishop Selwyn, the first incumbent of the Auckland see. He worked in the parish of Onehunga for twenty-eight years as both doctor and priest. An example of pioneering renaissance man he had interests in flax (a major fascination of the early settlers) as well as coal, and numbered science, architecture, music and social welfare among his concerns. To this group we may add Theophilus Heale (1816–85), a surveyor with experience of copper mining on Kawau and Great Barrier Island, whose expertise in Maori language and customs led to his appointment as Judge of the Native Land Court; Sir George Arney (1810–83), a lawyer who professed a considerable interest in the Maoris and served as Chief Justice of New Zealand from 1857 to 1875; and Josiah Clifton Firth (1826–97) who owned a mill and acquired a 55,000-acre estate on the Waikato lands, transforming fernland into pasture, and making contributions to both the funding and collections of the museum.

Others who became presidents of the Institute in the 1870s and 1880s included Robert Clapham Barstow, the resident magistrate of Auckland, who read papers on Maori migrations and settlement and donated a considerable Maori collection to the museum; Thomas Peacock, an optician and instrument-maker; Edmund Augustus MacKechnie, yet another solicitor who served on the city council, funded the foundation of an art gallery and later made major bequests to the museum; and William Garden Cowie, Selwyn's successor as Bishop. In short, the Auckland museum had a striking galaxy of pioneering supporters. Two significant military figures, active in the Maori wars, were Major Thomas Broun and Captain Gilbert Mair.

After Kirk's departure, Thomas Cheeseman (1845–1923) was appointed curator and secretary of the Institute.[44] Born in Yorkshire, he arrived in New Zealand at the age of eight. Largely self-educated, his fascination with natural history, particularly botany, led him to work in the museum before being appointed curator in 1874, remaining until his death fifty years later. He oversaw the movement of the collections into the new building, which was opened with due pomp by the Governor, the Marquis of Normanby. This grand inauguration was something more than ceremony: it incorporated an art and industries exhibition, symbolising the combination of the arts and practical economic purposes that would justify the museum and attract the public.[45]

From 1878 they were attracted by something else. The fashion for plaster casts, which swept the empire, now reached Auckland. Casts of more than thirty classical statues and other sculptures were donated

by Thomas Russell in 1878 and immediately raised visitor figures.[46] In 1882, the Auckland Museum Endowment Act gave the museum lands at Waikane near Coromandel, supposedly to the tune of £10,000, though this arrangement never operated satisfactorily.[47] Nevertheless, the endowment paid for the new Maori ethnography extension in 1892 and another hall to accommodate the plaster casts in 1897.

As well as repeatedly rearranging the more permanent displays, first in the new building and later in the extensions, Cheeseman embarked on an active period of collecting and research.[48] He built up the zoological, geological and botanical collections and developed the ethnographic materials. He assiduously conducted botanical fieldwork and published a *Manual of the Flora of New Zealand* in 1906. He also created a major herbarium, which was later named after him.[49] Indeed, exchanging and dealing in botanical specimens was a major activity. He corresponded with institutions and private collectors in Australia, Britain, the USA, Switzerland, Italy, Austria and Hungary from the 1870s onwards.[50] These networks helped to put New Zealand on the international scientific map through the distribution of its botanical specimens (at a time when, ironically, they were being almost overwhelmed by exotics). But the museum itself remained an example of classic Victorian clutter, with stuffed animals interspersed with natural historical and ethnographic items, at least until extensions helped to sort things out. Moreover, as the accessions of stuffed mammals indicated, the museum was still attempting to cover all continents to offer its visitors a global experience. Nevertheless, some indication of the growth of the museum can be derived from the fact that its budget was £218 in 1871, £932 in 1903–4, while by 1913–14 its significant investments stood at £22,876, made up of various bequests and endowments.[51]

The Maori collections

The museum's initial thrust was certainly economic, but the ethnographic collections began at an early stage, possibly earlier than elsewhere. The reasons for this are complex. Auckland was in an area of relatively populous Maori settlement. For its first few decades it was a frontier garrison town, heavily involved in endemic warfare. But the Maoris were not united and some peoples allied with the British against their former enemies. Moreover, while the central myth of New Zealand pakeha history – that they had a greater respect for their indigenous neighbours than in many other imperial territories – has been revised in modern times, there was undoubtedly an early fascination with Maori origins and culture. They were placed higher in the scale of the imperial racial hierarchy, but despite miscegenation

and intermarriage from an early stage, and Maori aspirations to some influence by the end of the century, their lot was similar to indigenous peoples everywhere: warfare, land appropriation, disease, and grave social and economic difficulties.

Although British propaganda suggested that the Treaty of Waitangi was necessary to protect the Maori from the military, commercial and biological violence of the whites before 1840, the reality is that the provisions of the treaty were effectively ignored and the imperial state was equally active in the dispossession of indigenous land rights.[52] Still, settlers and travellers soon collected Maori – and also Pacific Island – artefacts, and these assemblages quickly came to the museum. Yet we can now appreciate the fact that, to a certain extent, Maoris themselves controlled these transfers. Those who 'collaborated' with the British were willing to transfer *taonga* (sacred objects) to their new 'allies', a tradition that ran through earlier intra-Maori relations. Such *taonga* had been handed over as a ceremonial act of reciprocity to cement agreements and relationships. Through this mechanism they also ensured that their considerable craft and artistic skills, their spiritual beliefs, relationships with the environment, and aspects of their social systems would be exhibited to the pakeha.

R.C. Barstow, the Resident Magistrate and President of the Institute in 1877, gave his Maori collection to the museum in 1876 soon after the opening of the new building. It was rich in carvings, cloaks and greenstone ornaments. C.O. Davis handed over his collection in 1887. Larger items, maritime and architectural, soon came to the museum. A magnificent war canoe, *Te Toki a Tapiri*, constructed in 1836, had been confiscated during the war and beached at Tamaki. Donated to the museum, it was moved there in 1885 in an epic transportation by wagon, at a cost of £100. In that year and again in 1894, the museum acquired *pataka* (storehouses), significant Maori structures, known as *Te Oha* and *Te Puawai o Te Arawa*. The museum also received important sculptures from the gateways of the Te Pukeroa pa (fortified village). The extensive Mair collection was loaned to the museum in 1891 and purchased for £1,000 in 1901, the whole amount subscribed by the public.[53] The Institute astutely asked the government to match these public donations with another £1,000. This was done and a further extension was built in 1903 as an annexe to the Maori Hall.[54] Further funds were raised in 1906 and 1911 to acquire and re-erect the superb Arawa carved meeting house *Rangitihi*, food stores, and the magnificent *Te Potaka* carved panels found in a sea-cliff cave at Te Kaha.[55]

The moral and cultural complexities of the acquisition of these Maori materials are well represented by the appropriation of the

carving known as *Pukaki*. These have been charted in detail by Paul Tapsell from the standpoint of the Te Arawa or Ngati Whakaue people of the Rotorua area of the North Island.[56] This superb carving represented (and, in Maori terms, virtually personified) a warrior ancestor of the Te Arawa. It originally formed an entrance to the Pukeroa pa of Ohinemutu, which stood near Lake Rotorua. There it was seen and admired by pakeha in the early years of British rule. For the Te Arawa, *Pukaki* symbolised their struggle to establish themselves in the area after their move inland from the Bay of Plenty, for the ancestral *Pukaki* had been involved in much internal strife over land. Later, it was taken down from the gateway and had its long supports and its base removed. In this form, it continued to arouse the interest of visiting whites. In the 1870s the judge of the native land court, Francis Dart Fenton, set about settling land issues in the region, not least in order to free up a block for whites to establish the town of Rotorua. This was already becoming a tourist centre for visitors to the pink and white terraces (destroyed in an earthquake and eruption in 1886)[57] and to enjoy the geothermal activity which would transform Rotorua into a warm spring spa.

The Te Arawa effectively traded the loss of the Rotorua block against confirmation of their rights to adjacent land (although here, as elsewhere in the British Empire, the intention was to create individual rather than traditional communal ownership). Fenton expressed an interest in *Pukaki* and the people's leaders agreed to hand the *taonga* over as evidence of their good faith (together with various other carvings). They thought that they were giving *Pukaki* to the Crown, but Fenton transported it to Auckland (where he lived for most of his life), and delivered it to Gillies who passed it on to Cheeseman. It was displayed in the museum amidst the other ethnographic clutter; it was reduced to the status of a 'curiosity' shorn of its context, with its provenance confused, and glorifying the reputation of Judge Gillies who was constantly cited on its label as the donor. By the time it came to be displayed in a major touring exhibition of Maori culture in the 1980s,[58] its reputation had been gradually transformed from carved curiosity into amazing artefact and a piece of notable art. It was, in other words, revalued aesthetically, but not yet culturally. The exhibition and Tapsell's research ensured that the Te Arawa people rediscovered it, realising its great importance in the spiritual recreation of their past. Aware of the sleight of hand by which a gift to the Crown had been appropriated by private individuals, they demanded its return and in 1997 the museum agreed to send it back for display in Rotorua, close to its place of origins.[59] This was done with great ceremony, with the Governor General accepting *Pukaki* on behalf of the Crown 120 years late.[60]

Another intriguing case involves Maori carved burial chests in which Cheeseman became interested when some were discovered in 1902. He had heard of two that had passed through the hands of an Auckland dealer, one ending up in the Melbourne Museum, the other bought by a private collector and later given to the Colonial Museum in Wellington. The story behind the new finds is highly instructive from the point of view of ethnographic collecting within pakeha/Maori relations. Two Europeans out pig-hunting in the Waimamaku valley stumbled on two caves containing such chests. Various artefacts were associated with these, including a spear, a comb and fragments of flax cloaks. They reported their discovery to the Commissioner of Crown Lands and resolved to persuade the local Maori that they should be in the Auckland museum. Not surprisingly, the proposal caused 'great excitement' among them and they strenuously objected to the removal of the chests. 'They were unable to understand why these sacred articles should be taken from them, especially as they were actually the receptacles of the bones of their ancestors. They regarded the matter as an attempt to trample on their most sacred rites and traditions . . .' But pakeha heavyweights were brought to bear upon them. The Resident Magistrate, Blomfield, insisted that the chests would crumble and disappear, that moving them to a museum would preserve them 'for ages to come', forming 'a permanent memorial to their ancestors'. After much heated debate, the Maoris finally agreed and Blomfield was careful enough to collect oral evidence respecting the graves. Eight were moved to the museum, the burials dating from the years before the Treaty of Waitangi, with the human figure carvings (*tikis*) on the boards of six of the boxes dating from up to two centuries earlier.[61] Other burial chests found later in the sandhills near Raglan were purchased for a private collection.

What happened to the bones which the boxes presumably contained is not mentioned in Cheeseman's account, although there is a hint that they had conveniently fallen out of the boxes into the cave. What is clear is that the whole incident represents the dilemmas of such ethnographic collecting. Maori greatly revere their ancestors, seeing themselves as having a continuing and instrumental relationship with them that should not be broken. Thus the notion that these repositories could be so cavalierly desecrated by emptying and removal must have been deeply shocking. Whether their preservation and the placing of important carvings in the public domain assuaged these anxieties can only be guessed at.

While Cheeseman's account comes from the pakeha side, it seems to indicate a slightly more honourable approach than that suggested by other evidence of collecting. There had developed, as elsewhere, an

insatiable demand for human remains. Cheeseman apparently showed some respect for grave sites, while recognising the museum 'trading' value of such remains, but no respect at all was shown by other collectors such as the Austrian, Andreas Reischek.[62] He was in New Zealand from 1877 until 1889, attempting to model himself on the success of Hochstetter. Essentially a taxidermist, he financed expeditions from his work in this craft, notably for museums in Christchurch and Auckland.[63] He travelled in both the South and North Islands, collecting natural history specimens (often placing rare birds at risk of extinction by excessive shooting)[64] and ethnographic materials. His most notorious exploit was the removal of human remains from Kawhia in the 'King country', where the sacred burial caves had been described by Hochstetter. In 1881, Reischek secured the trust of the Maori King Tawhiao after the war, claimed to have permission to mount an expedition and removed bodies under cover of darkness. These ended up in the museum in Vienna.[65] 'Ambitious and ruthlessly deceitful',[66] he published a highly embroidered and boastful account of his activities, published in English as *Yesterdays in Maoriland*.

Reischek may have been an extreme case, but the whole of the Maori/pakeha relationship was fraught with difficulties at a time when whites only dimly understood the value systems and spiritual significance of remains coveted by European and other museums, allegedly for scientific purposes, not to mention artefacts which were viewed as merely striking pieces of art. While some carvings were freely handed over, many were unquestionably seen by Maori as occupying a reverential position between past and present, between the seen and the unseen, the tangible and intangible. They were undoubtedly felt to be parts of themselves: their removal had the effect of diminishing and degrading their cultural integrity. The museum as site of preservation was initially alien, and in respect of some pieces remained so. But as with so much else, Maoris quickly adapted and frequently sought to bend the museum to their own ends. The museum became a sort of Trojan horse through which they could intrude their own culture into that of the westernising white world. Moreover, by the beginning of the twentieth century, it was recognised that Maori artefacts had a role in encouraging tourism to New Zealand. In 1901, a Maori Antiquities Act was passed to restrict the export of ethnographic artefacts and, significantly, a department of Tourist and Health Resorts was founded in the following year.[67]

Indeed, the Maori collections built up so quickly – and involved whole structures like the meeting house – that extensions had to be built to the 1876 building. The new 1892 southern gallery was constructed at right angles to the main building (two later halls led off it).

This allowed the Maori collection to be displayed in its own coherent space, freeing up the main building for stuffed mammals and innovative habitat dioramas.[68] But in addition to the Maori material, the museum became the repository for Pacific ethnographic items. Several Pacific collections were given or sold to the museum in the late nineteenth and twentieth centuries. In 1948, the New Zealand Government purchased a large private assemblage from Polynesia – the W.O. Oldman collection – and distributed it among various museums in the dominion.[69] Other ethnographic and archaeological materials included a collection from West Africa, while European prehistoric objects had earlier been donated by J.T. Mackelvie.[70]

An inspired idea

By the time of the First World War, so important in the developing national identities of both Australia and New Zealand, Cheeseman and his Institute associates were beginning to be dissatisfied with the 1876 building and its extensions. In a 1917 pamphlet commemorating the fiftieth anniversary of its founding, Cheeseman offered a brief history, describing the museum building as 'not remarkable for its beauty or dignity, and of no imposing size; but large enough to shelter Museum collections of considerable importance'.[71] But he soon got to his real purpose: proposals for future development.[72] These were extraordinarily prescient. Cheeseman argued that it was no longer necessary for museums to be in town centres because of modern transport provision, and that they should be located further out, preferably in public parks free of the pollution of the city. Moreover, adjacent buildings presented a serious fire hazard. Since the functions and objectives of parks and museums were similar, he suggested that the Domain would be an ideal equivalent to Glasgow's Kelvingrove Park and Belfast's Botanic Gardens.[73]

He noted the considerable munificence of Auckland's citizens over the years and argued that the size and importance of the city, with a growing population decidedly larger than that of any other in New Zealand, necessitated the building of a truly ambitious museum to vie with those in Wellington or Christchurch as well as the major museums of Australia. He further proposed that the Auckland museum could become a war museum, assembling 'a collection of military weapons and instruments of war from the earliest times to the present day'. He took this idea an important step further: the museum could become a war memorial, 'commemorative of the services of the many thousands of young men who have willingly left this country and undergone countless sacrifices in order to assist in crushing the German peril', keeping 'fresh and green the memory of deeds of devotion and bravery'.

This idea, which may well have been circulating among the influential members of the Institute of the day, was to prove inspirational.

This was, in short, the museological equivalent of motherhood and apple pie. Instead of spending money on a single purpose memorial, as happened in most other places, the commemoration of the sacrifices of the First World War could be incorporated into the architecture of the museum. This would unlock funds from Auckland companies, from wealthy individuals, from the public at large, as well as from the government in Wellington.[74] The Dominion Museum in the capital quickly awoke to the drumbeat of a stolen march and offered severe objections, but to no avail. As the introduction to Cheeseman's pamphlet indicated, the museum still had the support of the Auckland elite. J.H. Gunson,[75] the mayor of the city and president of the Institute in its fiftieth year, suggested that science and art were part of the functions of the modern state, that the museum was 'cognate to the University', and therefore 'essential to the complete equipment of the men and women who are to lead in the work of progressive civilisation'. The museum was central to civic pride and by extension an important part of a newly forged sense of national identity.[76]

When Cheeseman wrote, the Auckland Institute boasted 400 members, one third of the total membership of the New Zealand Institute and twice that of any other branch. Its revenue was £1,700 p.a. and it had invested capital of some £23,000. The record of public generosity had been remarkable. In 1884 the Institute received the Costley bequest of £12,150, while in 1901 a public appeal had raised £1,000 to purchase the Mair Maori collection, on loan from 1891. The MacKechnie bequest of 1902 had amounted to £2,500: £500 for the purchase of groups of larger mammals and the balance as an endowment for purchasing books for the library, by then a considerable collection of some 6,000 volumes. In 1906, as mentioned, money had been raised to purchase carvings and to re-erect the celebrated Runanga House, *Rangitihi*. Work on the latter was carried out by skilled Maori craftsmen, another way in which the Maori established their stake in the museum. *Rangitihi* was placed in the 1903 extension, surrounded by ethnographic collections. Among his many bequests, J.L. Campbell left £1,000 to the Institute and museum. Significant collections of books had been donated by Messrs Edmonstone and Mackelvie and there had been many gifts of Maori and Polynesian items, as well as of Japanese ceramics and objets d'art. During the previous twenty-five years, annual attendance had risen from 30,000 to 100,000. This was a museum which had genuine public support.[77]

This was amply proved by the raising of funds for the new building. By 1920, £52,000 had accumulated; a public appeal had produced

almost £160,000 for the war memorial; the government contributed £37,000 and interest amounted to over £35,000. A firm of Auckland architects produced an impressive neoclassical design, complete with a Hall of Memory (with a cenotaph based on that in London's Whitehall in front of the building, funded by a separate public appeal).[78] Pioneer legislation of 1928, regarded as path-finding in the Commonwealth, placed the museum finances on a sounder basis through the organisation of local authority contributions throughout the province.[79] By 1929, the building was complete and the collections were moved in time for the grand opening by the Governor General. Symbolically (and perhaps contrasting with the relationship with indigenous peoples in other colonies), he knocked on the door with a Maori carved *mere* (a hand-held chiefly weapon) in the presence of representatives of many Maori peoples.[80]

Moreover, through the Hall of Memory, a museum inauguration had also become a consecration, enshrining the names of both pakeha and Maori fallen.[81] The Wellington press was discontented and jealous, seeing Auckland as a 'pushful, albeit parochial' city,[82] but an institution long seen as central to Auckland's identity and sense of self-importance now had a grand building on a dominant site overlooking the city. The museum symbolised civic and national pride in a unique way. It had become central to the identity formation of pakeha and to

9 The War Memorial Museum, Auckland, New Zealand, completed in 1929.

a certain extent of Maori too.[83] The latter sentiment was represented by the gift in 1925 of another meeting house, *Hotonui* from the chief of the Ngati Awa people of Whakatane, installed in the Maori Court of the new building in 1929.[84]

The 1920s was also the decade in which Cheeseman's successor Gilbert Archey professionalised the museum: it was divided into departments; numbers of staff grew strikingly; and its scientific credentials were enhanced by fieldwork, major expeditions, laboratory research and publications. A scientific establishment was created with a zoologist, conchologist and palaeontologist, botanist, ethnologist, ornithologist and geologist. From 1930, the museum published the *Records of the Auckland Institute and Museum*.[85] The museum survived the difficult economic conditions of the pre-war decade, and in the aftermath of the Second World War, raised almost half a million pounds from public and private sources to build a second Hall of Memory and at the same time greatly increase the display space.[86] In 1944 and 1946, the museum became the beneficiary of 'massive endowments of commercial property in central Auckland' from E.E. Vaile, who also had a considerable interest in Polynesian ethnology.[87] The advantage of linking the museum to the national and provincial spiritual identities of these commemorative objectives again paid off.

Notes

1 This point is made by C.A. Bayly in his *The Birth of the Modern World 1780–1914* (Oxford 2004) with reference to medical knowledge (p. 321) and liberal and other ideas (chapter 8).
2 Lt Col. G.B. Brereton, *History of the Nelson Institute* (Wellington 1948).
3 The influence of Germans on New Zealand scientific history is notable. The first surgeon and naturalist to the New Zealand Company, was Ernst Dieffenbach. See S.H. Jenkinson, *New Zealanders and Science* (Wellington 1940).
4 Ferdinand von Hochstetter (1829–84) was born in Württemberg, the son of a Lutheran clergyman who had scientific interests. A graduate of Tübingen, where he completed both theological studies and a PhD in mineralogy, Hochstetter joined the Austrian geological survey in 1853 and sailed on the *Novara* expedition, designed to fly an Austrian scientific flag around the world, in 1857. At Cape Town the leader of the expedition was urged by George Grey to visit Auckland and the North Island of New Zealand. On arrival there, Hochstetter met Julius Haast (see below) and together they went on major geological expeditions in both North and South Islands, creating geological maps and reporting on natural resources. He took major collections back to Austria, continued to correspond with New Zealand contacts, and remained a propagandist for the colony.
5 Government subsidy ceased in 1888. In 1884, Marion Clark was appointed librarian at a salary of £60 per annum, later raised to £80. Libraries provided early opportunities for female employment. Brereton, *Nelson Institute*, pp. 44–55.
6 This building cost £3,726 and received a grant of £150 per annum for twenty-five years from the city council. At this point the Institute had 280 members and there were 10,854 books in its library. Brereton, *Nelson Institute*, pp. 61–3.
7 Sarah Macready and James Robertson, 'Slums and Self-improvement: the History

and Archaeology of the Mechanics' Institute, Auckland and its Chancery Street neighbours', typescript, Auckland War Memorial Museum (WMM) library.

8 Oliver Stead (ed.), *150 Treasures, Auckland War Memorial Museum* (Auckland 2001), p. 8. Stead's introduction to this volume provides an excellent short history of the museum. Other valuable sources for the early period are G.S. Park, 'John Alexander Smith and the early history of Auckland Museum, 1852–1867', *Records of the Auckland Museum*, 35 (1998), pp. 13–43 and G.S. Park, *An Introduction to Auckland Museum* (Auckland 1988).

9 A.W.B. Powell (ed.), *The Centennial History of the Auckland Institute and Museum* (Auckland 1967). The early history is contained in an article 'The First Century' by Gilbert Archey.

10 Jeffrey A. Auerbach, *The Great Exhibition of 1851: a Nation on Display* (New Haven and London 1999).

11 Smith (c.1814–89) was a merchant seaman who settled in Auckland, displaying a strong entrepreneurial streak. He was also a customs agent, which would have brought him into contact with officialdom in the tiny middle-class community.

12 Quoted in Park, 'John Alexander Smith', p. 19.

13 It was later pointed out that this was an auspicious year for the founding of a museum, coinciding with the creation of the Victoria and Albert in London and the Hermitage in St Petersburg! Richard Wolfe, 'Mr. Cheeseman's Legacy: the Auckland Museum at Prince Street', *Records of the Auckland Museum*, 38 (2001), pp. 1–32, on p. 1.

14 The building might have been a dairy or a servant's cottage. Presumably the word 'old' meant former rather than historic!

15 Smith's draft of this advertisement, dated 22 October 1852, can be found in the archive of the WMM, MA 2003/15, Auckland Museum Correspondence 1852–59.

16 The first annual report, also in MA 2003/15, indicated that 1,954 articles had been contributed by 108 donors. The trustees of the museum were W.F. Porter, J. Williamson and I. Boylan.

17 Memorial for the Annual Report of the Auckland Museum, 24 October 1853, ibid.

18 Provincial Superintendent to Smith, 18 October 1854, ibid.

19 Second Annual Report of Auckland Museum, 27 October 1854. By then 2,413 items had arrived and there had been 1,238 visitors. In 1857 Smith was keen to buy up examples of Maori mats since they were going out of use.

20 Frederick Wollaston Hutton (1836–1905) had a versatile career. He served for three years in the Indian marine, but later transferred to the army, seeing action in the Crimea and the Indian revolt, 1857–58. He emigrated to New Zealand in 1866, having already established a reputation as a geologist. A convinced evolutionist, he received compliments from Darwin himself. He joined the New Zealand Geological Survey and later became provincial geologist of Otago. He became curator of the Otago Museum and a professor at the college in Dunedin, though his pro-evolution views caused controversy with the local Presbyterian church. In 1880, he became professor at Canterbury College and we shall encounter him again as curator of the museum in Christchurch. Active in the branches of the NZ Institute in Auckland, Dunedin and Christchurch, he published extensively on the biology and zoology of the colony as well as on Darwin and his theories. He became influential in the AAAS and was President of the New Zealand Institute.

21 Dickson to Superintendent, 21 December 1861. Auckland Museum Reports, Correspondence, 1861–65, MA 2003/15.

22 Curator to Superintendent, 14 November 1864, ibid.

23 William Colenso (1811–99) arrived in New Zealand in 1834 to run a printing press for the Church Missionary Society at Paihia in the Bay of Islands. He printed biblical translations in Maori and a translation of the Treaty of Waitangi. He met Darwin on his visit to the Bay of Islands and became a botanist and natural history collector, receiving some training from the NSW Government Botanist, Allan Cunningham. He opposed Maori land sales and incurred the enmity of settlers. Always controversial, he had a turbulent private and political life, making many enemies. He was influential in the Hawkes Bay Philosophical Institute and gave an anniversary

presidential address in 1888. 'Hawke's Bay Philosophical Institute: Anniversary Address by the President William Colenso, FRS, FLS' (Napier 1888).

24 Superintendent to E.B. Dickson, 23 April 1864, Correspondence 1861–65, MA 2003/15.

25 'Thomas Kirk and the Auckland Museum', typescript, lacking either author or date (possibly 1952?) in the library of the WMM, MS 1398.

26 Thomas Kirk (1828–98) emigrated from Coventry to New Zealand with his wife and children in 1862. He quickly became fascinated by the local botany and started collecting and publishing papers. Between 1869 and 1873 he was secretary and treasurer of the Auckland Acclimatisation Society. In Auckland he worked as a surveyor and as a meteorological observer and visited and collected in many areas of the North Island. Between 1874 and 1880, while serving as Colonial Botanist he lectured at Wellington College and later at a College of Agriculture in Canterbury, which gave him the opportunity to collect in the South Island. In 1885 he was appointed Colonial Conservator of Forests and served until made redundant in 1887. He published *The Forest Flora of New Zealand* in 1889.

27 Acclimatisation societies were founded in many parts of the empire, but were particularly active in New Zealand, their intention being to introduce familiar plants, animals and birds from Europe. This process had indeed started in the eighteenth century and rendered New Zealand one of the most prominent instances of 'biological imperialism'. See Alfred W. Crosby, *Ecological Imperialism: the Biological Expansion of Europe, 900–1900* (Cambridge 1986), particularly chapter 10. Archives NZ contains a number of records relating to acclimatisation dating from this period. See AP2 48 1096/76 and AP2 47 1137/76 for letters referring to acclimatisations dating from 1875 and 1876.

28 The forerunner of the Institute, the New Zealand Society, had been originally founded in 1851, influenced by the ubiquitous Sir George Grey, but it did not prosper.

29 James Hector (1834–1907), medical graduate of Edinburgh University, received some training there in botany, zoology and geology. Sir Roderick Murchison recommended him to John Palliser's expedition to western Canada where he established himself as a field geologist, natural historian and explorer. He emigrated to New Zealand on his appointment as director of the Geological Survey of Otago in 1861. He explored many parts of the South Island and was influential in the Exhibition in Dunedin in 1865. On moving to Wellington in the latter year, many government scientific institutions were placed under his control but from the later 1880s, he lost most of them and was reduced to being director of the Colonial Museum and manager of the New Zealand Institute. For an account of Hector's involvement in scientific controversies, see Amiria Henare, *Museums, Anthropology and Imperial Exchange* (Cambridge 2005), pp. 166–7.

30 *Catalogue of the Colonial Museum, Wellington New Zealand* (Wellington 1870), preface, p. iii.

31 Hector neglected ethnology, and in 1902 a separate Maori museum was proposed. In fact, the ethnographic collections were swiftly built up in the twentieth century. Henare, *Museums*, p. 199.

32 An anonymous account of the origins of the Colonial Museum and its relationship with the NZ Institute can be found in the *Colonial Museum Bulletin*, 1 (1905) (Auckland 1906), pp. 3–70. This Edwardian survey includes many photographs.

33 James Hector (ed.), *Transactions and Proceedings of the New Zealand Institute* (Wellington 1868), containing articles from Auckland, Wellington and Christchurch and material on the founding of the Institute.

34 Annual Reports of the Auckland Institute and Museum, 1872–74.

35 Annual Report, 1872, p. 8.

36 Annual Report, 1870–71, p. 6.

37 Initially a loan was taken out to cover the shortfall. Then it was noticed that the government had made a grant of £2,000 to the museum in Otago, which Auckland had long seen as benefiting more liberally from official support. Representations

secured the grant for Auckland. *Annual Report*, 1877, p. 9. A condition of the government grant was that the museum and library should be opened daily. Sunday soon became the best attendance day, contrasting with controversies about Sunday opening elsewhere (e.g. in Victoria).

38 James Williamson (1814–88), an officer in the merchant marine, arrived in New Zealand in 1840. He became a successful shopkeeper, publican and farmer in Auckland and district, making a lot of money out of government contracts during the Maori wars. He served on the boards of banks and insurance companies and built the grandest Auckland mansion on an estate near Onehunga. The severe crash of the 1880s caused his insolvency.

39 Annual Report, 1873, p. 7.

40 One such function took place on the evenings of 16 and 18 September 1880 and, according to the programme, took the form of demonstrations of apparatus, including photography, electricity and the telephone; also a lathe, gas-making, fretwork and hydraulic machines; a demonstration of taxidermy; and 'scientific instruments' of various sorts. The whole climaxed with oxy-hydrogen lamp slides of scenes in North India (shown by Bishop Cowie), landscapes in North Wales and views of the Rocky Mountains. WMM Library.

41 Gillies, who had accompanied Kirk on some expeditions, endowed scholarships in zoology, botany, chemistry and physics at the Auckland University College.

42 Campbell was the grandson of an Ayrshire baronet, illustrating the manner in which scions of elite Scottish families were attracted to migration. He sailed from Greenock in 1839 as surgeon on an emigrant ship with the intention of sheep farming in Australia. After an expedition in NSW he moved on to NZ in 1840. R.C.J. Stone, *Young Logan Campbell* (Auckland and Oxford 1982).

43 Henare, *Museums*, pp. 153–4. For more detail, see Brian Molloy's entry in the *Dictionary of New Zealand Biography (DNZB)*, updated 22 June 2007. Sinclair was an active correspondent of Charles Darwin and became associated with Julius Haast in the South Island from 1861 (after a lengthy visit to Europe, as well as research for Joseph Hooker's *Handbook of the New Zealand Flora*). He was drowned in the Rangitata River while on an expedition with Haast.

44 Wolfe, 'Mr. Cheeseman's Legacy' provides some detail.

45 There was also a series of popular scientific lectures, a display of scientific equipment including microscopes and spectroscopes, as well as oxy-hydrogen lantern slides. Annual Report, 1877, pp. 7–8.

46 Roger Blackley, 'The Greek Sculptures in the Auckland Museum', *Art New Zealand*, 48 (1988), pp. 96–99. Russell was a wealthy expatriate Aucklander living on an English estate and purchased the casts from a dealer in Covent Garden. They prompted John Logan Campbell (who had paid for the pedestals and erection of the casts) to establish an art school attached to the museum in 1881. The Auckland Society of Arts' annual exhibition prompted the founding of an Art Gallery. Unusually, and effectively, some of these casts are still displayed in the WMM in striking architectural positions. See C.D. Whitcombe, 'Descriptive and Historical Handbook to the Auckland Art Gallery and Mackelvie collection' (Auckland 1888) for the suggestion that this was the first permanent such gallery in the colony. See also R. Tizard, 'The Auckland Society of Arts, 1870–1970: a centennial history' (Auckland 1970), which also claims that Auckland led the way.

47 It was hard to realise income from these endowments because of the difficulties of selling land in the area. Annual Report, 1891–92, and subsequent reports. The provincial system of government was abolished in 1876, centralising administration in Wellington.

48 In 1895 the Institute took over the management of Little Barrier Island, purchased by the government to preserve its avifauna. This became a major interest of the Institute. *Annual Report*, 1895–96, p. 9.

49 Cheeseman corresponded with both Charles Darwin and Sir Joseph Hooker. Stead (ed.), *150 Treasures*, pp. 11–12.

50 Jeanne H. Goulding, 'Notes on the Cheeseman Herbarium', *Records of the Auckland*

Institute and Museum, 11 (1974), pp. 105–17 (Part 1), 12 (1975), pp. 95–120 (Part 2), 13 (1976), pp. 101–8 (Part 3). Turnbull Library, Wellington.

51 Annual Reports, 1871, 1903–4, and 1913–14.

52 Ann Parsonson, 'The fate of Maori land rights in early colonial New Zealand: the limits of the Treaty of Waitangi and the doctrine of Aboriginal title' and John C. Weaver, 'The construction of property rights on imperial frontiers: the case of the New Zealand Native Land Purchase Ordinance of 1846', both in Diane Kirkby and Catharine Coleborne (eds), *Law, History, Colonialism: the Reach of Empire* (Manchester 2001), pp. 173–89 and pp. 221–39, respectively.

53 Gilbert Mair (1843–1923) was born at Whangarei on a farm called Deveron after the Scottish home of his father. He formed a connection with the Te Arawa Maoris because some had migrated north to work on the Kauri gumfields and he learned to speak their language. He became a government surveyor and Resident Magistrate's Court interpreter. He served in the Maori war in the Rotorua area fighting with the Arawa in 1867 and became known as Ko Tawa. Promoted Captain in 1870 he had already established a reputation as a guerrilla commander among the pakeha and as a traditional warrior among the Te Arawa. After the war he held a number of civil appointments and was caught up in the war against Parihaka in 1881. He collected extensively among the Te Arawa and acted as an agent for other collectors such as Alexander Turnbull, Sir Walter Buller and the Dominion Museum. His collecting methods may not have been particularly ethical, but he remained close to the Te Arawa people and was buried in their cemetery at Ohinemutu. See Paul Tapsell, *Maori Treasures of New Zealand: Ko Tawa* (Auckland 2006). Almost 250 items of the Mair collection are to be found in the WMM.

54 Annual Report, 1903–4, p. 7.

55 The amounts were, respectively, £662 and £684. *Te Potaka* were panels from a large storehouse which had been built at Maraenui on the Bay of Plenty. Warned of a raiding war party, the people dismantled the storehouse and stored it in a sea cave at Te Kaha. The existence of these carvings in their hiding place became known to pakeha around 1889. An Auckland dealer chartered a small vessel and bought the carvings for £75 from the local Maori; the museum bought them by public subscription in 1912. Stead (ed.), *150 Treasures*, pp. 190–1.

56 Paul Tapsell, *Pukaki: a Comet Returns* (Auckland 2000). Tapsell is himself a member of the Te Arawa people.

57 One of the best descriptions of this event is to be found in Ken Hall, *George D. Valentine: a 19th Century Photographer in New Zealand* (Nelson 2004), pp. 58–81.

58 This exhibition, known as Te Maori, was put together by a committee which, for the first time included consultation between pakeha and Maori people. It was shown in New York, St Louis, Chicago and San Francisco, as well as in Wellington and Auckland on its return to New Zealand. S.M. Mead (ed.), *Te Maori: Maori Art from New Zealand Collections* (New York 1984).

59 In one of Tapsell's oral interviews, a Te Arawa elder (Kuru O Te Marama Waaka) acknowledged that *Pukaki* had probably been saved for posterity through its period in Auckland. He saw tourism and museums as important in preservation, although 'taonga' were 'of much greater significance to the people who produced them than to an outsider' while context, environment, and history were more important than classification or artistic portrayal. Tapsell, *Pukaki*, pp. 132–4.

60 There was one despairing attempt by a member of the Maori people around Auckland to keep it in the WMM. *Pukaki* had been seen as under their care while 'in exile' away from Rotorua.

61 The whole story, with descriptions of the boxes and carvings, is in T.F. Cheeseman, 'Notes on certain Maori carved Burial -chests in the Auckland Museum', *Transactions of the New Zealand Institute*, new series, XXXIX (1906), pp. 451–6. These Waimamaku waka koiwi remain in the WMM collection. I am grateful to Paul Tapsell for this information. See also Aileen Fox, 'Carved Maori Burial Chests: a Commentary and a Catalogue', *Bulletin of the Auckland Institute and Museum*, 13 (1983), pp. 1–6. This article, based on studies of burial chests in the BM, Vienna,

Melbourne, and other NZ museums, is purely a catalogue with some functional and aesthetic judgments, with nothing on controversies surrounding acquisition.
62 Reischek (1845–1902) was born in Linz. After a period as gamekeeper and hunting guide, he set up as a taxidermist in Vienna. After his visit to NZ, he returned to the museum at Linz. Michael King, *The Collector: a Biography of Andreas Reischek* (Auckland 1981).
63 Reischek worked as a taxidermist in Auckland in 1880–81. Correspondence between Reischek and Cheeseman (1879–89) on botanical, ornithological and ethnological matters, is in the WMM library, MS 1511.
64 For example, he shot 150 specimens of the nearly extinct stitchbird.
65 The putative remains of the chief Tupahau were returned to New Zealand for re-burial in 1985.
66 King, *Collector*, p. 10.
67 Henare, *Museums*, pp. 198–9.
68 These included notable displays of birds. See B.J. Gill, 'Tales: Brian Gill finds Bird Specimens in Museums tell Stories of Pioneer Discoveries', *Forest and Bird*, 306 (November 2002), pp. 32–5 and 'C.F. Adams – an American Taxidermist at Auckland Museum, 1885–6', *Records of the Auckland Museum* 41 (2004), pp. 13–26. See also B.J. Gill, 'History of the Auckland Vertebrates Collection at Auckland Museum, New Zealand, 1852–1996', *Records of the Auckland Museum*, 36 (1999), pp. 59–93 and B.J. Gill, 'Arctic anniversary: Centenary of the "Arctic Group" at Auckland Museum', *Te Ara*, 31, 1 (2006), pp. 25–6. I am grateful to Dr. Gill for copies of these articles.
69 On the movement of Pacific art into the mainstream, see Richard Wolfe, '"primitive perceptions": Changing Attitudes towards Pacific Art', *Art New Zealand*, 69 (1993), pp. 76–81.
70 Annual Report, 1881, p. 10.
71 Thomas Cheeseman, 'The First Fifty Years of the Auckland Institute and Museum and its Future Aims: a Jubilee Sketch' (Auckland 1917), p. 2.
72 'Present outlook' and 'future aims' took up pp. 3–21 of the pamphlet.
73 Negotiations for the lease of a site on the Domain opened in 1913 and were concluded in 1920.
74 The Auckland Harbour Board wished to donate £5,000 and sought government permission to do so. Archives New Zealand, M (series), 1 (record) 3/13/226 relating to the WMM Fund, 1921.
75 James, later Sir James, Gunson (1877–1963) was President of the Institute 1917–25. He was chairman of the Citizens' Committee planning the new war memorial and raising the funds. He was influential in many aspects of Auckland's civic development in the period.
76 A tribute to Cheeseman (by 'APWT') in the same pamphlet described him as 'the foremost living authority on the Flora of New Zealand' and the museum as having 'served as a centre for the diffusion of information on all matters relating to the natural history of the Dominion'.
77 The membership of the Institute had fallen off badly in the last two decades of the nineteenth century, only to revive in the twentieth.
78 The Hall of Memory was inscribed with the names of more than 7,000 men and women who had died in the First World War.
79 Auckland War Memorial Museum Maintenance Act (1928).
80 Richard Wolfe, *A Noble Prospect: 75 Years of the Auckland War Memorial Museum Building* (Auckland 2004); also 'Auckland War Memorial Museum: an Architectural History' (Auckland 1997).
81 The government had lost the names of the Maori dead, but the list was reconstructed from the evidence of Maori elders throughout the province.
82 *The Star*, 8 April 1920 used this phrase, complained of favouritism, and dilated on the better claim of the under-funded Dominion Museum with its 'irreplaceable national collections'. This and various other articles in a similar vein from *The Dominion* and *The New Zealand Times* are to be found in the WMM Library,

Special Collections, folder 1. Auckland newspapers charted with some satisfaction the remarkable progress of the public appeals.
83 Issues of identity are dealt with in B. Dibley, 'Museum, Native, Nation; Museological Narrative and post-colonial Nation Identity Formation', unpublished MA thesis, Department of Sociology, University of Auckland (1996) and Paul Tapsell, 'A tribal response to museums', DPhil, University of Oxford (1998).
84 Gerry Barton and David Reynolds, 'Hotonui: the restoration of a meeting house' (Auckland 1985).This meeting house had been carved between 1874 and 1878 and opened at Parawai near Thames. It was gifted by Apanui Hamaiwaho.
85 The connection between the Institute and the Museum was only broken with the Auckland War Memorial Museum Act of 1996.
86 This time some 4,700 names were inscribed and the space of the museum was increased by some two-thirds.
87 Stead (ed.), *150 Treasures*, p. 18.

CHAPTER NINE

New Zealand/Aotearoa: the Canterbury Museum, Christchurch

If Auckland has been called an extension of the Australian frontier, Canterbury was conceived as 'a transplanted model English community',[1] planned and executed by the Canterbury Association in 1850. Its four first ships of migrants (carrying 780 colonists) were supposed to spread the Anglican, aristocratic and class-conscious ambitions of its founders. This was to be a 'civilised' frontier from the start, its capital Christchurch, a sort of Oxford of the South, its pastoralism, wheat-growing, trade and other forms of money-making elevated by its cathedral, college, fine Gothic architecture, and intellectual associations including a museum. The reality was rather different. The site chosen was essentially a swamp, a productive swamp for Maori hunting, but a strange environment in which to found an idyllic city of trees and gardens.[2] In the 1860s it was still a frontier town, a group of shacks with the usual drainage and health problems, standing on the bleak, treeless plains over the Port Hills from Lyttelton. One early resident described it as dreary and ugly. Until it was cleared and had its fringes planted with willows, the Avon was choked with flax. Moreover, its genteel planners were confounded by the drunkenness and vice that characterised the early years.[3] But a printing press had arrived with the first ships and a provincial government building had risen like 'a palace amidst a scattering of cottages'. It, and the cathedral, represented the considerable ambitions for the place: this garden city was to represent the highest Victorian municipal ideals, a centre of education and intellectual endeavour for the whole of New Zealand. Its classical grid layout, with the cathedral at its core, the Avon snaking through bordered by parkland, exotic trees, and (later) statuary would reflect this.[4] By 1861, the population exceeded 3,000 pakeha; twenty years later this had risen to over 15,000 with more than 30,000 in city and suburbs.[5]

Improving bodies, societies and newspapers were founded almost immediately. Christ's College was established promptly in 1850 and

a Colonists' Society in Lyttelton followed in 1852. The freemasons were active from 1851; the Christchurch Club was founded in 1856; and a mechanics' institute dated from 1859.[6] There was a musical society from 1856, an agricultural and pastoral association from 1863, young men's literary and acclimatisation societies both from 1864. Church organisations proliferated: soon Methodist, Congregational, Presbyterian and Anglican churches were erected. And the press preceded all of it: the first issue of the weekly *Lyttelton Times* appeared in January 1851 (it was twice weekly from 1854); The Christchurch *Press* was established in 1861 and was followed by the *Canterbury Times*, the *Weekly Press* in 1865 and an evening paper, the *Star*, in 1868. Others followed. Canterbury people were avid readers, not least because of the large numbers of clergymen and schoolteachers among them.

While the literate Canterbury 'Pilgrims' claimed cultural and social leadership, in fact there had been pioneers (some of them Scots) prior to 1850 and this settlement was soon diluted by many other migrants, particularly once immigration schemes got going in the 1870s. Even the River Avon, set to become such a civic symbol, was named not after the English precursor, but after one in Ayrshire. And its museum was founded not by an English aristocrat, but by a German scientist. This was the remarkable Julius Haast (1822–87), who was probably born in Bonn and receiving instruction in geology there. Something of a romancer, he greatly upgraded his father's social status and claimed to have been a student at the Friedrich Wilhelm University.[7] After extensive travels in Europe and a period living in Frankfurt, he left Germany perhaps because of the suppression of liberalism and the prospect of compulsory military service. Arriving in Auckland in 1858 to report on prospects for German migration to an English shipowner, he famously encountered Hochstetter. They soon planned geological expeditions together and became close friends. After Hochstetter's departure, Haast worked for the Nelson provincial government examining the economic geology of the north-west of the South Island. He successfully persuaded the Canterbury administration to extend his geological survey into their province and started by surveying the route of a tunnel between the port of Lyttelton and Christchurch. He was appointed provincial geologist in 1861.

He became a British subject in the same year and married Mary, the daughter of the Canterbury Provincial Engineer Edward Dobson in 1863.[8] His explorations led him up the main river systems of Canterbury, into the Mount Cook area, and the Westland region.[9] He named the Franz Josef glacier, intruding the name of the Austrian emperor into this Maori and Anglophone territory. He began to publish copiously, his reports illustrated by maps and drawings.[10] He worked

on glaciation, although his estimation of himself was higher than that of others, including James Hector. He also developed a significant public profile. In October 1861 he gave lectures on his explorations in the Southern Alps to the Christchurch Mechanics' Institute (an audience of 300 in the town hall) and to the Lyttelton Colonists' Society. This body had been calling for the establishment of a natural history museum for two years.[11] His research and publications brought a succession of honours: a PhD from Tübingen in 1862; FRS in 1867 (fixed for him by Hooker); papers read at the geological and zoological societies of London (a gold medal from the latter in 1884); a knighthood from the Austrian emperor in 1875 (after which he added 'von' to his name), CMG 1883; DSc from Cambridge 1886 as well as a KCMG and a variety of other orders.[12] A number of geographical features and geological formations were named after him. Haast had joined the elite of imperial scientists, albeit in an adopted empire.

He was determined to crown all this work with a museum where specimens could be deposited and studied. A museum, he declared, was 'a department of indispensable necessity in every country – ten times more necessary in a new country'. Such a museum would be the work of generations and, together with a library, was the 'keystone of all educational systems'. A geological survey was worthless unless the resulting specimens were 'arranged, tabulated, and catalogued in a museum'.[13] He had brought seven cases of specimens to Christchurch and stored them in the geological survey department in the tower rooms of the new provincial building. These collections were soon incorporating zoological and other materials. In 1862 he recognised the need for a scientific association, which would act as a propagandist body, help promulgate ideas and become the intellectual supporter of such a museum. The Philosophical Institute of Canterbury was founded in July of that year with Haast as its first President and leading light.[14] Inevitably, his first address constituted a prospectus for a museum. Its objects were to be the advancement of science, literature and the arts as well as the development of the resources of the province. Haast was still largely in economic mode, but he now had his supportive cadre. In his report for 1870, he announced that, 'I intend to devote ... considerable attention to economic science'.[15]

This was good public relations and the press seems to have been more prepared to uphold his ambitions than some of the provincial legislators. He assiduously cultivated the editors whose Canterbury chauvinism convinced them that Haast had the capacity to put the province on the scientific map, not least through his connections with Darwin, Hooker, Murchison, Hochstetter, Mueller and others.[16] He was an assiduous correspondent with all these scientific luminaries and

flattered many of them by naming significant geographical features.[17] During the 1860s he even persuaded the *Lyttelton Times* to publish, in full, addresses to the BAAS by Charles Lyell and Joseph Hooker, and to review significant scientific publications of the day.

By 1863, his museum (not yet open to the public) contained 742 geological specimens, 520 fossils and 182 shells.[18] In 1862 the provincial council had voted £100 for a large collection obtained from Heidelberg, while Hochstetter contributed German fossils, ores and minerals. Haast also secured a cast of the bones of a moa, the extinct and flightless bird that was to feature very prominently in the museum's history. A herbarium, bird skins and invertebrates were also acquired. Attempts to secure finances for a museum building failed, but collecting was now in take-off mode. A Nottinghamshire clergyman sent over 1,000 preserved European and North American plants in exchange for a New Zealand herbarium; Hooker sent specimens from Kew, while Mueller sent Australian examples. Ornithological materials came from Gerard Krefft of the Australian Museum in Sydney and Hector in Wellington also contributed. Haast's list of correspondents spread out to embrace Louis Agassiz in Cambridge, Massachusetts, Georg von Frauenfeld, Director of the Imperial Zoological Museum in Vienna, Dr Jaeger also of Vienna, and others in the British Empire. By 1870 he was busily exchanging with museums in Bremen, Darmstadt, Munich, Stockholm, Calcutta, London and many other places.[19] Major international networks were brought to bear on a region where concepts of western scientific observation were replacing, as Te Maire Tau has argued, a very different approach to the environment by the local Ngai Tahu people, for whom the natural world was deeply embedded in their sense of history, their awareness of webs of kinship and genealogies.[20] Now western notions of command and control (symbolised by the transformation of the swamp) would be expressed through the museum.

The administration continued to resist expenditure on a museum building, but rooms were provided in the provincial headquarters; a cottage was also made available, as well as a workshop above a space known as 'the coffee room'. In 1865, the museum exhibited specimens at the exhibition in Dunedin, a taxidermist was appointed, and the administration resolved to hold a competition for the design of a museum building, even although the funding was not yet available.[21] The joint winner was a local architect, B.W. Mountfort, with a Gothic design in keeping with the ethos of city and province, and the intention was that it should be located in Victoria Square (as it became) near the cathedral.[22] An influential judge was James Edward Fitzgerald who had worked at the BM from 1844 to 1848, and considered Dean

and Woodward's Gothic Oxford Museum to be the ideal.[23] Meanwhile, the museum rooms were opened to the public in late 1867 (Tuesdays, Thursdays and Saturdays from 11 a.m. to 3 p.m.), but visitors often got lost in the provincial offices searching for them.[24]

No fewer than 7,887 specimens (4,312 collected by Haast) were on display. In 1868, Haast's appointment as provincial geologist was terminated and he seriously considered leaving the colony.[25] The system of provincial government was about to come to an end and no one could be sure of central government funding. But the administration at last set aside £1,200 for the museum, now to be located in the Domain (later Hagley Park and the Botanic Gardens) at the other end of Worcester Street from the cathedral in an area zoned (in Edward Jollie's original plan of 1850) for intellectual and cultural institutions. It was to be in stone and brick instead of wood and would be the neighbour of Christ's College.[26] The buildings of Canterbury College, first mooted in 1873 and opened in 1877, would be erected in educational Gothic nearby, and the college and museum were to form a harmonious assemblage. However, the grant for the museum building was inadequate, so Haast threw himself into a public appeal, raising £483 11s.[27] The members of the Institute were among the most supportive of these exploits. After a period as honorary curator, Haast was appointed director and completed his transition, as his son put it, 'from explorer to museum builder'.[28] He also wrote that his father was to develop a museum superior to that in Wellington: this was something more than filial piety – it was the truth.

Mountfort's building was completed in late 1869 and the grand opening by the Provincial Superintendent William Rolleston took place in February 1870. The theme was the marriage of science and art: Rolleston quoted Ruskin as seeing Art as the servant and interpreter of Nature, presenting the museum as 'but one stage of progress in our study of Science'.[29] The opening took the form of an art exhibition, funded by subscription and the provincial authorities, which was to include both the illustrative arts and archaeological and ethnological materials, together with a few models of inventions and discoveries. There were also examples of lace, Indian silks, monumental brass rubbings, ceramics, photographs, rare books, architectural designs, coins and medals as well as prints, lithographs, and sculptures, with a few original paintings. An organising committee was made up of the elite of the province and the level of admission fees implies that this was going to be very much a middle-class interest.[30] Nevertheless, 300 people surveyed 3,000 exhibits on the first day. Art and artefacts were always going to be more popular than economic products.

The original building, consisting of a 'lofty and spacious room' with

10 Canterbury Museum, Christ Church, New Zealand. A modern recreation of Julius Haast's museum display.

a gallery supported by columns in indigenous kauri wood, still exists in the heart of the present museum, a striking survival. The building was in grey basalt with quartz rhyolite dressings to the lancet windows, the ceiling divided into octagonal panels glazed in 'Chance's diamond rolled glass'. After the end of the exhibition, Haast set about laying out his displays and the museum was opened yet again by Rolleston in September. The centre of the gallery was reserved for moa and other skeletons; ethnology, ornithology, geology and mineralogy were around the walls and in the gallery. On the end wall was a copy of a portrait of Edward Gibbon Wakefield, regarded as the founder of the territory, a picture that hangs there to this day. Haast proudly reported that the museum possessed 25,353 specimens, of which 16,055 were exhibited.[31] Since this was in a room 70 feet long by 35 feet broad, it was another example of clutter. Not surprisingly, there was no room for the herbarium, the entomology collection, or many of the coins. The governing arrangements were settled by legislation establishing a board of trustees, with six official and six elected members.

The trustees included the Provincial Superintendent, the Judge

of the Supreme Court, the Provincial Secretary, the Speaker of the Provincial Council and the Chief Surveyor as well as six elected members of the Christchurch elite (one of them Haast himself). Among these, Rolleston (1831–1903) was by far the most important. He had arrived in Canterbury in 1858 and moved to a sheep station. Having served on a commission on education he became Provincial Secretary, then Superintendent from 1868 to the abolition of the provincial system (which he fiercely opposed) in 1876.[32] These were good years for Canterbury when the economy did well on wool and wheat. It was regarded as a successful province with a model superintendent and a revenue superior to any other province. His brother George was Professor of Physiology at Oxford and proved to be a useful contact for the museum.[33]

Among the elected trustees were J.D. Enys (1837–1912), a settler of 1861.[34] He owned a sheep station, but was more interested in natural history, pursuing ferns and mosses, moa bones, marine fossils, birds, moths and butterflies. He accompanied Haast on expeditions, supported the museum on the provincial council and donated many specimens to the collection. Another was T.H. Potts (1824–88) whose remarkable story is one of riches to rags. He sold an interest in a gun manufacturing business in Birmingham for £50,000 and travelled to Canterbury in 1854 to join members of his wife's family. He soon owned 81,000 acres for sheep as well as an estate near Christchurch where he built a neoclassical mansion. He was involved in all the intellectual developments of the province, travelled with Hector and Grey, and was a close friend of Haast. A notable ornithologist, he was an early conservationist. He argued that Resolution Island should be a reserve, '*tapu* to dog and gun' (this was done), but he lost all his fortune in the depression of the 1880s.

Two other Haast supporters were Alfred Charles Barker (1819–73), the first Christchurch doctor, who was a skilled photographer and an ardent Darwinist, corresponding with T.H. Huxley and Richard Owen; and Charles Fraser (1823?–86), a Presbyterian minister from Aberdeen with a keen interest in natural history, who arrived in Canterbury after a request to the Free Church of Scotland by 300 Scots settled there.[35] He founded St Andrew's Church (and several others in the province), but his relationship with his congregation was stormy, not least because as a theocratic Darwinist his views were too advanced for them. He was active in the philosophical institute (founder member and later secretary) and other organisations such as the Society of Arts, the mechanics' institute and the YMCA. He founded schools, passionately believed that education should be secular to avoid sectarian strife, and later became a member of the senate of the University of New Zealand.

Representing an intriguing link between Calvinism and liberalism, he nevertheless resigned as a trustee over Sunday opening in 1874 (see p. 219). If this was the influential group of Haast associates and supporters, still the relationship between the museum and the philosophical institute was purely informal.

The munificent moa

Moa skeletons appropriately occupied pride of place in the centre of the new museum's main hall. The moa had become the museum's fortune, the 'currency' by which exchanges could be made with other museums.[36] The earliest moa bones discovered in New Zealand had been immediately sent to Europe. It was as early as 1839 that Owen in London had concluded that the fragments he had received were from a giant flightless bird. Haast's first moa came from a cave in the Aorere valley in the Nelson province during his geological survey. A near-perfect skeleton, it went to the Nelson museum, which presented it to the Imperial Geological Museum in Vienna, which cannily made money from preparing plaster casts. This was, no doubt, a lesson to Haast. In 1863, goldminers in Central Otago found a moa and presented it to the York Museum. Moa bones soon supplemented (but did not replace) bird skins as his exchange 'currency', particularly when a remarkable graveyard of moa bones was found in a swamp at Glenmark fifty miles north of Christchurch in 1866 (ultimately it was estimated that some 1,000 moas had perished there, perhaps sheltering from a major bush fire). G.H. Moore, New Zealand partner of the owners of the estate, presented a number of these to the museum. In 1868 Haast was back at Glenmark, excavating more skeletons, and discovered the bones of a giant extinct eagle. The following year, a moa-hunter encampment was found near the mouth of the Rakaia River. In 1872, Haast employed the geologist and fossil hunter, Alexander McKay to excavate the Moa-bone Point Cave at Sumner near Christchurch.

This led to a fierce controversy. McKay, a self-trained and now legendary geologist, refused to accept Haast's theory that the moa was very ancient and that its hunters were a pre-Maori Palaeolithic people.[37] Haast sought to find parallels across the globe and the idea would have acted as a form of legitimation for the European arrival since the Maori could themselves be seen as settlers on the land of others. McKay, and also Hutton, correctly surmised that the moa was recent and had been exterminated by the Maori. McKay and Haast indulged in a race to publication and the whole incident revealed that Haast was both stubborn and vindictive (as well as wrong). McKay's sense of humour led him to publish in 1880 a poem called 'the Canterbury Gilpin' (clearly a play on

Pilgrim – gilpin in Scots is a very large fat person)[38] in which a live moa struts the streets of Christchurch with Haast on its back. The moa bolts and both disappear into the countryside never to be seen again. The rather humourless and unbending Haast cannot have been pleased!

Nevertheless, when Mountfort's building was opened, Haast's moas were already arousing the envy of the museum world.[39] Haast was busily despatching moa bones around the globe to satisfy the universal desire for complete (or near-complete) skeletons. Sensibly, he was not going to sell his museum short, the 'merchant of moas' determining to secure the best possible price. Owen at the BM (Natural History) was keen to secure a moa and offered Haast some casts in exchange. Haast was not amused: he thought a good moa was worth between £20 and £40 and casts were unacceptable. Thus he combined hard-headedness with a lack of sentimentality about British imperial relations. He repeatedly created bad blood over the value of his moas, but W.H. Flower, curator of the museum of the Royal College of Surgeons and Owen's successor in South Kensington, was more sympathetic.[40]

Haast's relations with private natural history dealers in Europe and North America were also strained. Haast, however, discovered that the market was tricky and his 'currency' was soon heavily devalued as moa bones flooded the world. Nevertheless, a Canterbury guide book of 1907 was quite clear that Christchurch possessed the 'finest Museum south of the line', and that it was the moas that had put it 'far ahead of other colonial museums'.[41] Haast had certainly augmented the collections to a remarkable degree, the extent of his 'trade' revealed in his Exchange Book (1869–83), which demonstrates that he started by tapping his German and Austrian connections but later moved into more imperial mode, establishing connections with Roland Trimen in Cape Town and with the curators of Australian museums. He was much taken up with other matters between 1883 and his death in 1887, but the next volume of the Exchange Book (1888–1913) continues the tradition of close associations with South Africa and Australia.[42] Moreover, he secured the benefit of free carriage on New Zealand shipping companies, as museums elsewhere did with other shipping lines.[43] The moa theme continued: after Haast's death, further moa bones were found at Waimate and the museum was commissioned to excavate them.

The moa was to become a symbol of New Zealand: they had become, in the words of James Belich, the 'glamour birds of New Zealand prehistory'.[44] Moas and stuffed kiwis were exhibited at the International Industrial Exhibition at Vienna in 1875 (Hochstetter was an imperial commissioner)[45] and three were on view at the Colonial and Indian Exhibition in London in 1886. The McKay and Hutton theory of extermination by Maoris became more generally accepted and eventually

the relationship between Maori and moa grew in significance: there were eleven or twelve species with high concentrations in some areas of the North and particularly South Islands, possibly providing a 'protein boom' facilitating population growth.[46]

Extensions and developments

Within a year of its opening, the inexorable curatorial law was operating. The museum was crammed to overflowing and an extension was called for. The Provincial Council voted £2,000 for this and a school for technical science, the extension again designed by Mountfort.[47] The new building, with display areas on two floors, offices and a workshop, was opened at right angles to the original later in 1872. The cost had been reduced by using hard labour gangs from the prison and by shortening it by seven feet. Haast fought to secure strong and airtight cases to protect his specimens. A new moa room was soon opened, and, after the customary complaints about the unpleasant odours emanating from the taxidermy laboratory, he secured permission to build a detached workshop. Late in 1872 the cast fashion reached Christchurch. Haast's friend George Gould arranged for eighteen casts of classical statues and eleven busts to be sent from Europe.[48] These were said to illustrate Grecian, Roman, Renaissance and modern art, and were displayed in the upper room of the new extension. By the end of the same year both museum and Christ's College were affiliated to the University of New Zealand: Haast started to deliver a course of lectures in geology and became Professor of Geology at Canterbury College (1876–87) and a member of the senate of the university (1880–87). He now had all the academic status he desired. The pay-off was that the new board of governors of Canterbury College brought the museum under its control.

Haast continued to press for more extensions, but antagonised some provincial legislators, who roundly attacked the museum as a 'toy shop'.[49] Haast's continued fight even involved lawsuits against the government for broken promises.[50] But public support, particularly among the elite, continued. After what was described as a 'sabbatarian storm' the museum was opened on Sunday afternoons from June 1874, a remarkably early date for such a development. And the planning of extensions resumed: the Maori house was rebuilt to the east of the museum in 1874 (see pp. 220–1); Mountfort prepared plans for a major extension in 1875 and this was finished in the following year with a new and much photographed entrance portico featuring animal sculptures and a biblical text (Haast suggested one from Darwin but that was rejected).[51] This building was adorned with a flèche to emphasise the link with the cathedral at the other end of Worcester Street.[52] The

new building facilitated the opening of a mammal room in the 'great hall' with mounted specimens of animals from throughout the world, including an elephant, grizzly bears, and a number of large cats. In 1882 the space between the original building and the 1876 addition was roofed over providing considerable additional gallery space. This was the last major extension until the 1950s, apart from separate structures outside, protection for the Maori house and a shelter to accommodate a whale specimen.

The Maori house represented an early shift from the economic and natural history collections in the direction of ethnography. Haast himself had made the (not uncommon) transition from geologist to palaeontologist to osteological excavator to an interest in ethnography. His erroneous belief in a pre-Maori Palaeolithic people in New Zealand distorted his image of the past, but he certainly subscribed to the view that the Maori (whose population suffered a severe drop, perhaps up to 50 per cent in this period as a result of the combined ravages of measles, influenza, tuberculosis, syphilis and warfare) were doomed to disappear and that museums had an obligation to rescue as many of their artefacts as possible. He also developed an interest in rock paintings and published on them.[53] Among his many exchanges were Maori skulls, sent to the Ashmolean Museum in Oxford and the Anatomical Museum in Berlin.[54] But to secure a tattooed Maori head, in which there had been a trade during the wars, he had to import one from Britain. Maori soon objected to the display of heads and Haast covered them with a black cloth, but the board of trustees ordered their removal. They were later returned to the Maori. He had also been acquiring large numbers of Maori artefacts and he needed a suitable structure in which to display them. The resulting house, *Hau-Te-Ana-Nui-o-Tangaroa*, however, had nothing at all to do with the people of the Canterbury area or even of the South Island.[55] It was purchased for £220 from J. Locke of Napier, the native commissioner of the region who had been active in both land transactions and in acquiring (often in dubious circumstances) Maori artefacts. He had, in short, used his public office to enrich himself. This house, designed by Hone Tuahu, had been intended as a residence for the Chief Henare Potae of Tokomaru between Poverty Bay and the East Cape.[56] Another casualty of the Te Kooti war of 1866–69 (some of its carvings were burned), it was dismantled and re-erected by visiting Maori craftsmen (the original designer and Tamati Ngakako) from the region.[57]

By its completion it was far from being a traditional Maori structure: it was severely adapted for European use, confirming the impression that such 'meeting houses' were an invented tradition.[58] It was given a concrete foundation and a pakeha frame; kauri was incorporated for strength; it was covered with corrugated iron; and windows and doors

appeared with different dimensions. But it was decorated by many carvings (some new), some painted in dyes. Maori artefacts were hung from the walls and rows of desk cases were filled with objects. Wax figures of Maoris were placed on the veranda. Skulls and skeletons of Maoris were shown in the 'Ethnological Room'. These displays reflected pakeha perceptions and expectations. They also had little to do with Canterbury, but were supposedly illustrative of Maori people throughout New Zealand. At first apparently unproblematic (and moved from one side of the building to the other to accommodate extensions), it became controversial by the 1950s. By then, local Maori were alert to the fact that an alien house was standing on their spiritual land. At the time of the centennial extensions, it was dismantled and put into store, where it remains. There has even been a proposal that to overcome Maori sensibilities it might be rebuilt on the roof.[59]

In 1886–87 Haast achieved a new apex to his career when he was appointed the New Zealand Commissioner at the Colonial and Indian Exhibition in London. At this time he picked up a large number of honours and his son Heinrich, still in his 20s, acted as curator during his absence. While in London he sent a New Zealand charm (which he called a *tiki*) to the Prince of Wales and received a handwritten letter from Albert Edward thanking him for the souvenir.[60] He also continued his collecting exploits (he had a grant of £100 for this, together with a private donation of £50), now thinking in global terms, illustrated by his acquisition of two Egyptian mummies, one from an English collector and another through contacts in Egypt.[61] This was his last hurrah, for he died three weeks after his return to New Zealand with his new acquisitions largely uncatalogued.

The Canterbury Museum clearly owed a great deal to Haast's energies, his international contacts, his wheeling and dealing in exchanges, and his vigorous building of its collections. He persuaded the provincial council and the colonial government to extend the museum repeatedly and also succeeded in raising public subscriptions. In his will, he left a bequest for the foundation of a department of New Zealand geology and palaeontology. But there was a darker side to him. He was excessively self-important, obstinate, bad-tempered and constantly eager to advance himself. He indulged in competitive publishing, always anxious that no march should be stolen on him, falling out with James Hector, Alexander McKay and others in the process. Some of his theories, pursued with great pertinacity, were wrong.

He also became estranged from one of his sons (George Augustus) who changed his name to Young and failed to pass on any family history to his own descendants.[62] Moreover, the older son's hagiography perpetuates many legends and obscures Haast's destructiveness.

Heinrich described him as a 'bird protector', but the truth is very different: he helped to drive some New Zealand birds to extinction. He was utterly profligate with bird skins and eggs, using them for barter throughout his period as director. He employed hunters in the 1870s and 1880s urging them to acquire (which of course meant kill) as many birds as possible. As he wrote to one supplier, 'I have many hungry mouths to feed in all parts of the world who want bird skins in exchange for other specimens'.[63] In 1878 a bird lover on the museum committee tumbled to what Haast was up to (he had asked for more money to pay suppliers) and the committee told him to desist and use fossils instead. Typically, he reacted with an outraged letter, which was returned to him as too discourteous and personal to be considered. After his death, very few birds were used in exchanges. Yet Haast, himself an avid hunter, had offered respectability to a practice pursued by many private dealers and collectors like Walter Buller.[64] Nevertheless, the modern Canterbury Museum is intensely proud of Haast. In an intriguing and unique display, it has a mock-up of his office with an effigy of the great man at his desk.

The post-Haast era

F.W. Hutton was acting curator for more than a year after Haast's death, but was succeeded by H.O. Forbes in December 1889. Forbes was an osteologist, clearly regarded as an appropriate profession for a museum so rich in moa and other skeletons. His appointment was also short-lived. He soon fell out with the board and departed in May 1892. Hutton was now appointed permanent curator of a museum which, at this stage, comprised galleries devoted to statuary, antiquity, ethnology, foreign natural history, mineralogy, geology, Maori ethnography and a New Zealand room. This layout reflected the fact that Haast's ambitions, forwarded by his international connections and exchange activities, were to develop a worldwide collection. Interestingly, at the time of the 1870 legislation, the objectives of the museum were stated as being to make as complete a collection as possible of specimens illustrating the natural history and ethnology of New Zealand; typical collections illustrating the natural history of the world and 'the rise and progress of the human race'; and 'a collection of relics which, though of no intrinsic value, have an interest from association with persons or localities' (presumably the latter referred to settler 'relics').

During the two decades before the First World War, the museum developed in a number of new ways. Hutton published an impressive guide to the collections in 1895 with further editions in 1900 and 1906.[65] Ethnography was augmented when the museum joined many

others in participating in the dubious Benin bonanza after the 1897 campaign against the West African kingdom.[66] Further material arrived from Africa, Oceania, Asia and elsewhere. Meanwhile, the transformation of Haast into a founding hero was furthered by the donation of a bust by his widow in 1900 (which is still displayed in the entrance hall). Hutton also tried to maintain international contacts. In 1905 he set out for Britain carrying many duplicates for exchange, but died at sea on the way home. The association of the museum with government expeditions and with sub-Antarctic and Antarctic research was developed in this era.[67]

In 1901, Hutton accompanied the Governor on a voyage on the government steamer around the southern islands, collecting for both the BM and for Canterbury. His successor, Edgar Waite, joined Governor Lord Plunkett on a similar voyage in 1907 and then travelled up the East Coast from Stewart Island to Auckland collecting marine and invertebrate specimens. Further sub-Antarctic collecting expeditions took place later in 1907 and in 1912 (the latter to the Macquarie Islands). Christchurch famously became a port of call for Captain Scott's ill-fated expedition and the Canterbury Museum became closely associated with Antarctic exploration and research: it was, for example, involved with the British, Australian and New Zealand Antarctic Research Expedition of 1929–31. Today it boasts major modern displays in this field.

The museum also developed into a site of settler memory, picking up on one of the 1870 objectives. The collecting of colonial period artefacts started around 1908 and led to the establishment of an early colonists' section in 1916. This reflects the dominion nationalism promoted by the First World War, although it occurred well after the founding of the Otago Early Settlers' Association in 1898 and the start of its collecting activities, which culminated in the opening of a Settlers' Hall and Museum in 1908.[68] At the end of the war, there was a move to make the Canterbury Museum the repository of 'war trophies', including an aircraft, which was displayed in an outside shelter above the blue whale acquired in 1907. This aircraft was removed as part of a propaganda and recruitment drive in the Second World War and was never returned.

But the striking thing about the Canterbury Museum is the extent to which it stayed true to its scientific roots. This is reflected in the disciplines of its directors. Haast was a geologist, as was Hutton (acting 1887–88, director 1892–1905), and Robert Speight (1914–35).[69] H.O. Forbes (1888–92) was an osteologist; Edgar Waite (1906–14)[70] an ichthyologist; R.A. Falla (later Sir Alexander, 1936–47) an ornithologist.[71] The pattern was only broken by Roger S. Duff (1948–78),[72] who had been an assistant at the museum from 1938 and was an ethnologist,

the first appointed in the museum's history.[73] He did a great deal for the Maori and Polynesian collections, organised travelling expeditions, and was instrumental in securing the Oldman Collection (see Chapter 8) for New Zealand. M.M. Trotter (1979–83) was an archaeologist; and Anthony Wright, the director at the time of writing (formerly in a senior position at the Auckland WMM) is a botanist and geologist. Both Haast and Hutton (in 1892) were elected FRS.

The conventional version of the museum's history is that after the heroic age (or ego) of Haast, there was a period of relative stagnation and financial stringency (particularly during the inter-war years) when Canterbury seemed to lose a certain amount of interest in its museum. It was only after the Second World War that the museum began to flourish again and it was at this time that the first extensions since the days of Haast were built; the staff was thoroughly professionalised in a sequence of departments; and its prominent role in the community was resumed. Certainly, the size of the staff tends to confirm this. Between 1867 and 1902 there were only three. This had increased to nine by 1938, twelve in 1959, nineteen in 1965, and twenty in 1975. Growth continued dramatically in the succeeding twenty years from thirty-six in 1985, fifty in 1997, to sixty-six in 2006.[74]

Conclusion: New Zealand museums, the environment and identity

The character of New Zealand museums was moulded by the relatively sudden irruption of whites into the country, and their sense that here was an environment that was unique in its historic landscape forms, flora and fauna. They were also influenced by mineralogical ambitions and the desire to find paying ores, which was sweeping Australasia at the time. The provincial and colonial geological surveys were the original basis on which all the museums were founded, although their interests soon expanded under the influence of related societies and curatorial polymaths. Just as in Nelson, where improving settlers saw a museum and a library as central to their mission, so too did the original attempts to found a New Zealand society in Wellington in 1851 and 1859 lead to the earliest efforts to create a collection.[75] But it was the geological energies of James Hector, first in Otago after 1862[76] and then in Wellington from 1865, that promoted the founding of museums in these places.[77]

The Wellington and Auckland museums were closely connected with their associate societies (and, in Wellington, Hector dominated both), but in Canterbury, the Christchurch educational institutions became more important.[78] All these collections were first geological

and economic, then natural historical. As elsewhere, the rhetoric of early New Zealand museums suggested that they were crucial to productive development, but the realisation soon dawned that their influence was often marginal to the real world of pioneering entrepreneurship and endeavour. Economic and natural science thrusts were swiftly modified by ethnological and archaeological concerns, though Hector in Wellington showed little interest in this shift.[79] To Victorians, of course, the study of peoples was as much scientific as devotion to plants and minerals, with similar passions for the establishment of global parallels and connections.

This shift to ethnological collecting happened early. The stock explanation for this is that Maori were seen as part of the natural world, to be 'collected' and rationalised just like other phenomena. But the reality was more complex. The settlers comprehended their own origins – and museums were part of their cultural and intellectual self-knowledge, a key element in their racial curriculum vitae – and they were consequently keen to understand the provenance of the Maoris. Their connection with Polynesia was understood, but not the history of their migrations and settlement. If the early settlers believed that 'civilisation' could only take root if the landscape were dominated and tamed, that their imported culture could only succeed if they fully controlled the natural world, then its indigenous human inhabitants had to be subjected to the same rigours. Museums offered a symbol of such yearning for dominion by presenting the colony in miniature. They reduced natural, economic and ethnographic phenomena to a comprehensible scale.

Moreover, the influence of Darwin was particularly powerful in the colony, emphasised by the close connections maintained by its scientists and museum curators with Europe, North America and other parts of the British Empire. Some of the members of the various institutes constituting the New Zealand Institute were convinced that the remoteness of the territory's unique flora and fauna, as well as indigenous people, ensured that they were weak and doomed to extinction in the face of stronger imports of plants, animals and people. Museums, therefore, had a role in preserving aspects of the past as well as promoting understanding and development in the present. Their exhibits could ease the observer's passage through extinctions to a new and imported developmental world.

Not all observers, however, thought in such severely Darwinian terms. One of the characteristics of nineteenth-century New Zealand was the number of pakeha who learned the Maori language and became, in their various ways, sympathetic to indigenous society. This was also reflected in museum collections and the capacity of the Maori

to manipulate displays of their own culture. While patronising and arrantly ethnocentric views were often expressed in ways not too different from those of other imperial territories, still an alliance was formed by some pakeha with Maori people to record their traditions, language, cultural and spiritual forms.

We have already encountered Gilbert Mair who was honoured by his Maori associates.[80] A good second generation example was Elsdon Best (1856–1932), New Zealand born, who worked on a station in the Poverty Bay area, served in the armed constabulary in the later Maori disturbances, and then joined the Lands and Survey Department. A fluent Maori speaker, he worked for the Maori Health Service (founded 1900) and as ethnologist in the Dominion Museum, where he produced a stream of publications on all aspects of Maori life. His obituary was written by a Maori friend.[81] What Best's career illustrates is the way in which forms of hybrid identity were beginning to emerge in New Zealand.

Museums have some significance for this identity formation. Initially, they were concerned with whites and wider contexts. Locally, they represented the cohesion and tastes of a colonial elite anxious to secure their authority by maintaining connections with each other. Power lay in united effort.[82] And this local identity was partially formed by demonstrating their adherence to a rational and scientific world through connections with Europe, North America and other imperial territories. In the case of New Zealand, the founding of a central institute, with those of the other main centres affiliated to it, was particularly efficient in both keeping such an elite together and in creating a forum for information and ideas that could be plugged into wider global circuits. Museums also sought to form worldwide collections, not least of cultural materials, for exotica often pulled in the crowds, offering them the shock of the different. This offered the elite opportunities to pursue a downward filtration effect through which their tastes and cultural and scientific norms could reach school and college students as well as, through museum attendance, the general public.

It is well known that New Zealanders in the later twentieth century developed a revulsion against the domination of the landscape by exotic flora and fauna, repudiating the objectives of the acclimatisation societies, and desiring to return to forms of zoological and botanical nativism. Museum practice in a sense preceded this, for a shift had already taken place towards an emphasis on the local and national (including Polynesia). This was bound up with the realisation that New Zealand was as much defined by its indigenous people as by its landscapes and geology, palaeontology and botany. Thus, although they did not fully realise it at the time, the pakeha search for a separate national identity,

starting at least at the turn of the twentieth century, could be fostered by preserving Maori artefacts and architecture, by incorporating aspects of Maori traditions and craftsmanship, and by adopting Maori symbols and artistic forms. Wellington acquired a carved Maori House (*Te Hau-ki-Turanga*) from Poverty Bay as early as 1868 and, intriguingly, the first meeting of the New Zealand Institute took place within it. It may just have been a convenient space, but some of those present must have realised that they were positioning themselves within the ark of Maori architecture.[83] At a later date, this search for hybridity is neatly symbolised by the Governor-General's use of a Maori *mere* in knocking on the door of the new Auckland Museum. A Maori artefact would unlock the portals of a new museum-led identity, a grand war memorial promoting New Zealand nationalism. And this pakeha identity established its unique status through collaboration with Maori carvers, chieftaincies and ceremonies. This may still have been done in patronising and discriminatory ways, but, nevertheless, the foundations were laid for propaganda that proposed a uniquely cooperative relationship between white and indigenous, between New Zealand and Aotearoa. However synthetic this was at times, museums with their newly prominent Maori collections at the very centre of their concerns, played an important role.[84] Exotica have retreated in prominence, and in modern times this has reached its apotheosis in the new Te Papa museum in Wellington.

Notes

1 John Cookson, 'Pilgrims' Progress – Image, Identity and Myth in Christchurch', in John Cookson and Graeme Dunstall (eds), *Southern Capital, Christchurch: Towards a City Biography 1850–2000* (Christchurch 2000), p. 15.
2 Eric Pawson, 'Confronting Nature', in Cookson and Dunstall (eds), *Southern Capital*, pp. 60–84.
3 The early problems of Canterbury are charted in Joan P. Morrison, *The Evolution of a City: the Story of the Growth of the City and Suburbs of Christchurch, the Capital of Canterbury, 1850–1903* (Christchurch 1948) and W.J. Gardner (ed.), *A History of Canterbury* (2 vols, Canterbury 1971).
4 The first map of Christchurch by Edward Jollie is printed on p. 37 of Janet Holm, *Caught Mapping: the Life and Times of New Zealand's Early Surveyors* (Christchurch 2005). The streets of the putative city, like those of Lyttelton and Sumner, were named after English bishoprics.
5 There were 50,000 by the turn of the century and 100,000 by the 1920s.
6 The minutes and annual reports (1859–73) are in the Christchurch public library. A committee had been formed as early as 1852 to found an athenaeum or mechanics' institute, but the latter (which became the Christchurch Literary Institute in 1868) was eventually created by the trade unionist Charles Joseph Rae (1820–94), a member of the Canterbury Trades' Council and the Christchurch branch of the Amalgamated Society of Railway Servants. A Chartist who had served in the Royal Navy, he emigrated to NZ because of the barriers to reform in Britain, so he arrived with specifically radical ambitions. He founded the *Guardian and Canterbury*

Advertiser in 1862 (lasting only a few months) and later bought and edited other newspapers. He remained an active supporter of trade unions and Labour interests until his death. The main achievement of the Institute was to found a library. This was handed over to the Canterbury College in 1873 and in 1948 became the city's public library.

7 H.F. von Haast, *The Life and Times of Sir Julius von Haast: Explorer, Geologist, Museum Builder* (Wellington 1948, by his son) and Colin J. Burrows, *Julius Haast in the Southern Alps* (Christchurch 2005). See also Sally Burrage, 'Sir Julius Ritter von Haast', *Canterbury Museum News*, 16 August 1987 and *The Canterbury Times*, Jubilee number, 16 December 1900, pp. 33–4. Haast claimed that his father was a prosperous merchant who became a burgomeister of Bonn. Haast's birth certificate identifies him as a peddler. Julius probably never went to the university in Bonn. The reality is that his achievement was all the greater because he was self-taught. Another presumably apocryphal story is that when the Duke of Edinburgh visited Christchurch in command of *HMS Galatea*, Haast claimed he had saved his father, Prince Albert, from drowning in the Rhine while they had both been bathing in the river. Haast, *Life and Times*, p. 574.

8 Edward Dobson (1816?–1908) was a London-born engineer, architect and surveyor who had worked on railways in Nottinghamshire. The end of the railway boom drove him to Canterbury in 1850 and he became provincial engineer in 1854. He accompanied Haast in exploring, surveying and labelling geological specimens and worked on the railway and telegraph line from Lyttelton to Christchurch. He wrote papers for the Philosophical Institute and involved himself in educational projects. Arthur's Pass was named after his son who surveyed alpine routes and learned Maori. Twice President of the Philosophical Institute of Canterbury, he was knighted in 1931. Both were close allies of Haast. Suzanne Starky, 'Dobson, Arthur Dudley 1841–1934 and Dobson, Edward (1816/17?–1908)', *Dictionary of New Zealand Biography (DNZB)*, updated 22 June 2007.

9 Burrows, *Julius Haast* offers a detailed examination of Haast's explorations and discoveries.

10 His geological work in the region was described in Julius von Haast, *The Geology of the Provinces of Canterbury and Westland, New Zealand* (Christchurch 1879).

11 Henry F. Wigram, *The Story of Christchurch, New Zealand* (Christchurch 1916), p. 163.

12 These are listed in appendix two of Burrows, *Julius Haast*.

13 Haast, *Life and Times*, pp. 394–5.

14 P.B. Maling, 'The Philosophical Institute of Canterbury: a survey of the first 100 years' (a reprint of three articles published in *The Press* of Christchurch in July and August 1962). The first meeting took place in the Geological Survey Office in the provincial offices, with the bishop in the chair.

15 Annual Report, *Journal of Proceedings*, Session XXXIV, the collections to include timber, wool, flax, grain, building limestones and cements, coal and raw or partially manufactured material. He also wished to display models and inventions, but these were later handed over to the College of Mining.

16 Haast, who had abandoned his Catholicism, considered that *The Origin of Species* was the greatest work of the age (he had a signed copy) and arranged honorary membership of the Canterbury Institute for his hero Darwin. Haast, *Life and Times*, pp. 227 and 449.

17 Haast named well over 100 geographical features and declared (in a letter to Sir William Hooker) that he wished to 'create a kind of Pantheon or Walhalla for my illustrious contemporaries amongst these never-trodden peaks and glaciers'. Names included the geologists Murchison, Lyall, Buckland, Jukes and Elie de Beaumont; physicists Davy, Faraday, Tyndall and Liebig; botanists Mueller and Hooker; zoologists Darwin and Dana; geographers Petermann, Johnston, Humboldt, Malte-Brun and Ritter; explorers Franklin, Ross, D'Urville; historian Macaulay; pioneers Godley and Moorhouse; Indian revolt heroes Havelock, Clyde and Lawrence. See 'Julius von Haast, Giver of Place Names', *The Press*, 21 March 1870. Naming has long been

NZ/AOTEAROA: CANTERBURY MUSEUM, CHRISTCHURCH

seen as a crucial component of taming. Here Haast summoned up the scientific and imperial worlds into the NZ landscape.

18 Julius von Haast, 'Origin and Early History of the Canterbury Museum, being the Annual Address by Professor Julius von Haast', *Transactions and Proceedings of the New Zealand Institute*, 1881 (Wellington 1882), pp. 503-15, particularly 503.

19 Haast later (in his 1871 report, footnote 31) added Paris, Dublin, Brussels, Frankfurt, Berlin, Tiflis, Montevideo, New York, Washington, Cape Town, Shanghai, Hong Kong, St Petersburg, Christiana, and Perth (WA) to his list of contacts. These exchanges could be hazardous. Haast lamented that a number of valuable items were lost on the ship *Matoaka* in February 1869.

20 Te Maire Tau, 'Ngai Tahu and the Canterbury Landscape – a Broad Context', in Cookson and Dunstall (eds), *Southern Capital*, pp. 41-59.

21 I am indebted to Sally Burrage, veteran curator and historian of the museum, for a detailed chronology of this period, derived from the *Proceedings of the Provincial Council*, official correspondence, and other sources. She also provided a most illuminating tour of the present museum, pointing out the historic parts of the building.

22 Benjamin Woolfield Mountfort (1825-98) from Birmingham had been articled in 1844 to Richard Carpenter, a Gothic revival church architect in London. A high churchman, he sailed to Canterbury on one of the four ships in 1850. After an initial setback (he became a drawing teacher and portrait photographer for a period) he emerged as a significant Gothic revival architect. He was the designer of the provincial council buildings, supervising architect of George Gilbert Scott's cathedral, and rose to prominence designing churches throughout the country. His designs for the museum and Canterbury College reveal his understanding of developments in the Gothic in England as well as his originality in turning these into a local idiom.

23 Ian Lochhead, *A Dream of Spires: Benjamin Mountfort and the Gothic Revival* (Christchurch 1999), p. 263. Mountfort knew of Gilbert Scott's design for the cathedral and may have been influenced by it.

24 Handwritten report of the Geological Survey Department for 1868, p. 3, Christchurch Museum Library and Archives.

25 He attempted to secure an appointment in Western Australia, manipulating his connection with the Governor Sir Frederick Weld (who had earlier been the premier of New Zealand). Haast, *Life and Times*, pp. 564-5.

26 An earlier grant of £800 had been for a wooden building.

27 Haast, 'Origin and Early History', p. 513

28 Haast. *Life and Times*, chapter XLV.

29 Ibid., p. 599.

30 12s 6d would buy a ticket for the whole run for gentlemen, 7s 6d for ladies, both later reduced. A single entrance was 1s, 2s 6d the price of admission to evening conversaziones.

31 'Report on the Arrangement of the Collections in the Canterbury Museum' by Dr Julius Haast, FRS, Director, accompanied by a list of donations, deposits and general contents, *Proceedings of the Provincial Council*, Session XXXIV (1871), p. 3. There are no 'free-standing' annual reports for the Canterbury Museum. Initially Haast reported to the Provincial Council on the geological survey and the collections, later on the museum, and these were published in the session papers. Later reports – well into the twentieth century – went to the board of governors of Canterbury College.

32 Rolleston moved on into national politics and held ministerial office. A fierce opponent of George Grey and Julius Vogel, he was not as successful as he was in provincial administration.

33 George Rolleston worked competently in anatomy, physiology and anthropology. Interestingly, he sided with Huxley's contention that Richard Owen's insistence on a unique structural feature in the human brain – the hippocampus minor – was incorrect. (I am grateful to John Brooke for this information.) The 1875 Report listed Rolleston among donors to the museum. Another family connection with a member of the Christchurch elite was John Samuel Enys of Cornwall who sent out a large

series of scientific journals. Report for 1873, Session XL, no. 27. All the reports of this period are full of lists of donors, including much ethnographic material. Haast also established a connection with Professor Thomas Oldham, FRS, Superintendent of the Geological Survey of India. Report 1871, *Journal of Proceedings*, Session XXXV.
34 June Starke, 'Enys, John Davies (1837–1902)', *DNZB*, updated 22 June 2007.
35 Ian Breward, 'Fraser, Charles (1823?–1886)', *DNZB*, updated 22 June 2007.
36 Haast himself recounted this in his 'Origin and Early History' address. See also Richard Wolfe, *Moa: the Dramatic Story of the Discovery of a Giant Bird* (Auckland 2003).
37 Alexander McKay (1841–1917) was born in Scotland and started learning his geology as a summer cowherd. Emigrating to NZ at the age of 22, he became an independent prospector and goldminer in Otago and NSW. While prospecting the Mackenzie country of the South Island he encountered Haast who employed him as an assistant. He was a particularly able fossil-hunter and this brought him to the attention of Hector. The rest of his career was spent in the Geological Survey and the Mines Department, and he developed new theories about the antiquity of NZ and about tectonics, both substantiated after his death. He was a fierce admirer of Charles Lyell. He has been described as 'that venerable and romantic figure of geological history'. S.H. Jenkinson, *New Zealanders and Science* (Wellington 1940), p. 33.
38 An alternative meaning is 'sprightly young fellow', but these Scots nuances could well have been lost in translation.
39 Darwin was astonished and Agassiz wrote to Haast about the jealousy of the museum world. Susan Sheets-Pyenson, *Cathedrals of Science: the Development of Colonial Natural History Museums during the Late Nineteenth Century* (Kingston 1988), p. 81,
40 These relationships have been charted by Sheets-Pyenson using the Haast correspondence deposited in the Turnbull Library, Wellington. *Cathedrals of Science*, pp. 81–3. The deposit of the Haast papers in Wellington created something of a correspondence storm between Haast's son and Roger Duff, the Canterbury Museum Director in 1950. Museum library and archive, file compiled by Sally Burrage.
41 *Christchurch on Avon* (Christchurch 1907), pp. 35–6.
42 Canterbury Museum Exchange Book, 1869–83 and Exchange Book, 1888–1913, Canterbury Museum library and archive, transcribed by Sally Burrage to protect the originals. The *Report of the Trustees of the Public Library, Museums, and National Gallery of Victoria*, 1874–5, p. 4 reported the arrival of an 'almost perfect skeleton' of a moa from Haast.
43 Haast, *Life and Times*, p. 625.
44 James Belich, *Making Peoples: a History of the New Zealanders, from Polynesian Settlement to the End of the Nineteenth Century* (Auckland and London 1996), p. 34.
45 Correspondence (between J.E. Featherstone, the Agent General in London and the Superintendent, Auckland) on the shipping of New Zealand specimens to this exhibition can be found in Archives NZ, AP2 18 1352/74. For representations of New Zealand and the Pacific at the international exhibitions of this period, see Ewan Johnston, 'Representing the Pacific at International Exhibitions 1851–1940', PhD, University of Auckland, 1999, particularly chapters 6 and 7.
46 Belich, *Making Peoples*, discusses the options on pp. 34–5, 44–5, 47 and 50–54.
47 This school and other educational developments associated with the museum were endowed with a block of land 103,000 acres in extent situated at the junction of the Rangitata and Potter Rivers.
48 Gould (1823–89) arrived in New Zealand in 1850 and lived in Auckland, Wellington and Christchurch. Starting out as an outfitter, he became a squatters' agent and a shipper of wool. Through land and building and insurance societies he built up considerable wealth. He was a benefactor of working men's clubs and the YMCA, as well as of the museum. As a director of the New Zealand Shipping Company, he may well have been influential in securing free transport for Haast's exchanges.

Haast regularly drew on his generosity when money was needed. G.H. Scholefield, *Dictionary of New Zealand Biography* (Wellington 1940); also a compilation of biographies of people of significance in the history of the museum, Canterbury Museum archives. Gould does not merit an entry in the *DNZB*, although his son, also George (1865–1941) does.

49 Provincial councillors also suspected Haast of putting more energy into building up a European reputation for himself. Wigram, *Story of Christchurch*, p. 166.
50 Sheets-Pyenson, *Cathedrals of Science*, p. 51.
51 The text proposed by William Rolleston was from Job 26 verse 14: 'Lo, these are parts of his ways but how little a portion is heard of him'.
52 This attractive feature was later discovered to be unsafe and removed at the time of the centennial extensions in the 1950s.
53 His descriptions of these paintings appeared in the *Transactions of the New Zealand Institute*, X (1878), p. 44 and also in the *Journal of the Anthropological Institute* in the same year. The paintings were found in a rock shelter in the Weka Pass and reproductions duly appeared in the museum.
54 Haast, *Life and Times*, p. 627.
55 An account of the rebuilding of the Maori house and of the Maori collections can be found in the *Guide to the Collections of the Canterbury Museum*, third edition, 1906, pp. 202–7. Earlier editions, printed lavishly by the *Lyttelton Times* for the board of governors, were issued in 1895 and 1900.
56 The Museum Report of 1875 recounted the activities of the Maori craftsmen and described the house as coming from the Ngati Porori people.
57 The carvers were paid five shillings a day plus food working from January to December 1874. Canterbury College asked the government for a grant of £500 to cover these costs, but was turned down (the government had paid the cost of purchase and transportation). The money seems to have been raised by public subscription. Notes compiled by Sally Burrage.
58 Amiria Henare, *Museums, Anthropology and Imperial Exchange* (Cambridge 2005), p. 237. Their appearance at so many museums and exhibitions represented exchanges in craft techniques between Maori and pakeha.
59 Interview with the museum's anthropologist, Roger Fyfe, July 2006.
60 This letter, from Abergeldie Castle, Ballater, dated 13 October 1886, is in the Haast family papers, reproduced on microfilm, MS 0037, folder 26, in the Canterbury Museum library.
61 One of these mummies was sent to the Auckland WMM in 1957 in exchange for three Oceania ethnographic items. The obscurities in the provenance of the mummies are explained in a document by Roger Fyfe, a copy of which he kindly gave me on my visit to Christchurch.
62 R.C. Young (Haast's grandson) to Mrs A.M. Harris, 2 January 2006, Burrage file, Canterbury Museum library, describes this family dispute.
63 Haast to A. Barnes, 12 June 1874, Canterbury Museum correspondence: quoted in Sally Burrage, 'Exchange of native bird skins, skeletons and eggs by the Canterbury Museum from 1869–1913', *Records of Canterbury Museum*, 15 (2001), pp. 1–7. Letters extracted on p. 1. In this article Mrs Burrage usefully lists the numbers of bird skins exchanged and the museums to which they were sent. Over 3,000 skins were sent out by Haast, as well as 96 skeletons and a smaller number of eggs. There must, in addition, have been a considerable wastage in selecting good specimens.
64 Sir Walter Lawry Buller (1838–1906) was born and brought up on a farm in NZ becoming a proficient Maori speaker. He received a legal education in England and had a significant career in law and politics in NZ. He was passionate about natural history and became FRS in 1879. An avid collector of birds, he believed that both the Maori and NZ flora and fauna were doomed to extinction (saying that the duty of 'good compassionate colonists' was to 'smooth down' the Maoris' 'dying pillow'). He sent large collections of birds to the Colonial Museum in Wellington, Lord Rothschild at Tring, the Carnegie Institute and Museum, Pittsburgh, the Oxford University Museum (via a private collector) and the Canterbury Museum. He did

not keep proper records and there were frequent disputes about rareties. He traded in Maori artefacts, donating some to Sir George Grey and European museums, and displaying others at the London Colonial and Indian Exhibition in 1886, of which he was NZ commissioner. Ross A. Galbreath, *Walter Buller: the Reluctant Conservationist* (Wellington 1989), pp. 322–5; Ross Galbreath, 'Buller, Walter Lawry 1838–1906', *DNZB*, updated 22 June 2007.

65 footnote 55 above.

66 Roger Fyfe and Sally Burrage supplied information about the Benin materials (acquired in 1898, 1899 and 1904), which featured in an exhibition 'The Royal Art of Benin in the Antipodes' in 1995. Other items were acquired from the Mediterranean, the Middle East, North, East and Central Africa. There is even a piece of wood, certified as authentic by the African explorer and administrator Harry Johnston, taken from the tree at Chitambo, Lake Bangweolo, under which David Livingstone's heart was buried.

67 The Philosophical Institute had voted down a motion for an Antarctic expedition in 1881, but the arrival of the *Discovery* and Captain Scott in Christchurch in 1901 (and its return in 1904) stimulated much interest and led to the sub-Antarctic expedition of 1907. Maling, 'Philosophical Institute', pp. 4–5. Both Scott and Shackleton donated items to the museum. Wigram, *Story of Christchurch*, p. 166.

68 Seán G. Brosnahan, *To Fame Undying: the Otago Settlers' Association and its Museum, 1898–1998* (Dunedin 1998). This museum became a notable expression of early settler social history. Grossly underfunded and understaffed until the 1980s, its collection greatly expanded in the twentieth century. Now transformed, a name change from Otago Early Settlers' to Otago Settlers' Museum enabled it to deal with all settlers, including Maori, Chinese and other ethnic groups. The author visited it in 1998 and in 2003 and is grateful to Seán Brosnahan for supplying a copy of its history.

69 Robert Speight (1867–1949) arrived in Canterbury in 1879 and was educated there, studying at Canterbury College under Hutton. After some years teaching geology, he became assistant curator at the museum in 1908 and curator in 1914. His interests lay in the sub-Antarctic islands, in volcanic activity, alpine landscapes and glaciers, historic global climate changes, and geomorphology. His period at the museum was characterised by lack of money and staff, and declining public support.

70 Born in Leeds, Waite was a curator in the Leeds museum, 1888–92. He was active in the Leeds' Naturalist Club and the Geological Association, visited the principal museums of Europe and was appointed zoologist at the Australian Museum, Sydney in 1892. He joined marine research expeditions, publishing on Australian fauna and fish.

71 Sir Robert Alexander Falla was assistant zoologist on the Antarctic Research Expedition, 1929–31; ornithologist at the Auckland WMM 1931–36 and its assistant director, 1936–37. He was influential in developing museum educational services, established the Association of Friends of Canterbury Museum, and started the process of separating governance of the museum from Canterbury College.

72 Duff, born in Invercargill in 1912, spent some time in Britain, 1947–48, studying British museums. During this period he heard of the W. Oldman collection and alerted the NZ government to its sale. His doctoral thesis was on the moa-hunting period of Maori history. He organised the Cook Bicentenary Polynesian Exhibition in 1969–70 and in 1975–76 a travelling exhibition of the Art of Oceania, for UNESCO. During his time, the museum secured an independent board of trustees. It almost trebled in size, while its staff numbers doubled.

73 Other first specialist appointments (as opposed to earlier 'multi-skilled' curators) were zoologist (1948), librarian and archivist (1950), geologist, entomologist (both 1964), archaeologist (1965), osteologist, marine zoologist (both 1966), pictorial history curator (1972), colonial collection (1974), Antarctic (1975), conservator (1995).

74 In this year there were also twenty casual staff members, two emeritus curators, five research fellows and forty-six volunteers.

75 C.A. Fleming, *Science, Settlers and Scholars: the Centennial History of the Royal Society of New Zealand* (RSNZ Bulletin 25, Wellington 1987), pp. 7–10.
76 Like Canterbury, the Otago museum in Dunedin was infused with an educational impulse. The mechanics' institute there was founded in 1851 and promoted the idea of a museum. This languished, but was resuscitated by the foundation of the Athenaeum in 1859. These early efforts were galvanised by Hector and Buchanan after 1862. Alan David McRobie, 'An Administrative History of the Otago Museum', MA thesis, University of Otago, 1966, pp. 3–5 and 6–8, The Hocken Library, Dunedin, where other useful theses include those by Susannah Jane Risk and Robyn Notman. The mechanics' institute also prompted the founding of the museum in New Plymouth. McRobie suggests that a lecture given at the YMCA in Dunedin in 1862 by the eminent Scottish botanist, W. Lauder Lindsay, on 'the Place and Power of Natural History in Colonisation' (later published in the *Edinburgh New Philosophical Journal*, April–July 1863, pp. 20–28) was highly influential. Lindsay argued that natural history was a central means of promoting colonisation, and was the cheapest way of making natural sciences available to the public. This crystallised opinion in Otago. McRobie, 'Administrative History', pp. 4–5. Lindsay was also involved in exchanges between NZ and Scotland, including Maori artefacts. Henare, *Museums*, p. 168.
77 R.K. Dell, *Dominion Museum, 1865–1965* (Wellington 1965).
78 Other local museums included the Wanganui Museum, founded in 1892 by S.H. Drew. See C.W. Cimino, 'Guide to the Exhibits of the Wanganui Museum' (Wanganui 1984).
79 Henare, *Museums*, p. 199.
80 Another notable collector of Maori and Polynesian cultural items was Alexander Horsburgh Turnbull (1868–1918), the founder of the Turnbull Library in Wellington.
81 Te Rangi Hiroa, 'Obituary – Elsdon Best FNZInst', *Transactions of the New Zealand Institute*, 62 (1932, parts 3 and 4), pp. 179–82.
82 For a survey of this elite, see Jim McAloon, 'The Christchurch Elite', in Cookson and Dunstall (eds), *Southern Capital*, pp. 193–221.
83 For 'biographies' of meeting houses, see Eilean Hooper-Greenhill, 'Perspectives on Hinemini: a Maori meeting house' and Ngapine Allen, 'Maori vision and the imperialist gaze', in Tim Barringer and Tom Flynn (eds), *Colonialism and the Object: Empire, Material Culture and the Museum* (London and New York 1998), pp. 129–43 and 144–52. Another version of the Hinemini story, with additional material from NZ can be found in Eilean Hooper-Greenhill, *Museums and the Interpretation of Visual Culture* (London 2000), chapters 3 and 4.
84 In modern times, museums have been given Maori names. See, for example, the 'Guide to the Auckland War Memorial Museum, Te Papa Whakahiku' (Auckland 2002).

CHAPTER TEN

Museums in Asia

Imperial museums in Asia were unquestionably distinctive compared with those of the territories of white settlement. Despite similarities in foundation, cultural and historical, social and economic differences produced contrasting characteristics. In the first place, western-style Asian museums developed out of the foundation of the Asiatic(k) Society of Bengal in Calcutta in 1784. Similar Asiatic societies later appeared in Bombay (Mumbai) in 1827, Ceylon (Sri Lanka) in 1845 and Singapore in 1877.[1] Interestingly, the Royal Asiatic Society in London founded in 1823 by T.H. Colebrooke (who had been highly influential in Calcutta) postdates the original Bengal society by some forty years.[2] Metropole followed where scholars had led the way in the East India Company's (EIC) territory. These societies had ambitions to study the literary, religious, philological and historical manifestations of Asian civilisations. These were perceived to be fascinating both in their great antiquity, and through their links to the ancient worlds of Europe and the East. This was an intellectual exploration often positioned within a contemporary concept of decline from past glories, illustrating cultural decay and dilapidation and thereby justifying modern European imperialism.

Nonetheless, the approach to such societies was very different from that relating to indigenous peoples in North America, Africa and Australasia. Still there were, additionally, peoples in Asia (indigenous 'tribes') who could be placed within this wider ethnographical mindset. This chapter examines the origins of museums in the British Empire in Asia with particular attention to the motivations for their founding and the justifications offered for expenditure on them. In the second half of the chapter, the history of the Singapore Museum is analysed in greater detail.

The resulting ambitions for museums lay in the 'literary' and cultural, historical and archaeological rather than economic fields, with

the aesthetics of civilisations often more to the fore than natural history or exploitable resources. If these were essentially eighteenth-century concerns, the economic motivation was added later as the nineteenth century progressed. Significantly, in Singapore this impulse was explicitly mentioned in the 1870s when the museum was taken over by government. Thus, the original foundations were essentially in the hands of private societies with their membership of professionals, administrators and others who performed the role of local savants interested in pursuing the history and cultures of the peoples among whom they lived. That is not to say that these were not deeply practical concerns, designed to inform and thereby facilitate their rule. But economic exploitation was left to merchants and planters, miners and manufacturers. The economic motivation for museums was projected later as a justification for official expenditure: with such funding, they had to be more specifically developmental. Nevertheless, the period in which the stress was on the economic was relatively brief. Ethnographic collecting became as important as it was in museums throughout the British world (and other imperial worlds). By the time of the First World War, when museums were attuning themselves much more to their visitor audience, it was zoological and ethnographic collections that had become prominent.

The original 'intellectual' museum foundations were about the identities and self-regard of their 'scientific' founders. They were, in effect, 'collective cabinets' illustrating the content of libraries and the apparatus of meetings, the delivery and publication of papers. But the museum's role in identity formation soon spread out from this middle-class intellectual base. As we have seen, in the four former white 'dominions' the museums became important in the construction of white identities, related to the land and the peoples where they had settled. Museums in Asia, though originally significant in the construction of a cultured self among their founding fathers, played a less important role in the identity formation of white imperial rulers. While it was accepted that they were positive attributes of the appropriately developed colony, as status formers, and effectively markers of the newly imposed 'civilisation', administrations were seldom interested in funding them generously, if they were funded at all. This was partly because the question 'what is the museum for?' never received a precise answer. Scientific and cultural research? Economic development? Entertainment and instruction? The imparting of civilised notions to indigenous peoples? The economic rhetoric ought to have been the most potent, but since the practical purposes of museums were never fully worked out and their developmental efficiency proved, they remained vulnerable. In times of recession, they tended to be

soft targets for 'cuts'. But, unexpectedly, they quickly came to assume importance for the developing identity of local Asian peoples. Instead of whites, Asians became the principal audience and, to the surprise of European curators, it was soon apparent that people who found themselves in the melting pot of colonial cities found museums to be important places of resort in holidays and free time, in fact places where they could rediscover multiple cultural identities.

The museums of Calcutta and Bombay (Kolkata and Mumbai) reflected the distinctive characteristics of the two cities: Calcutta the imperial capital of administrators, lawyers, scholars (though with an important commercial sector too); Bombay primarily the city of commerce and money. The Calcutta museum would be imperial; the first Bombay one (the V&A) specifically local. In Calcutta, the celebrated Asiatic Society announced at an early stage that a museum would be part of its purposes. In 1796, a meeting, presided over by Governor General Sir John Shore, resolved that the society should 'establish a Museum and Library and that donations of books, manuscripts and curiosities will be thankfully received and acknowledged'.[3] Although some 'curiosities' were soon arriving in its rooms, the society initially concentrated on the building up of its library and its Orientalist studies before developing its museum. In 1805, the government of Bengal granted the society a plot of land on Park Street and this was expanded by a further grant in 1849. The associated museum was founded in February 1814 and today proudly describes itself as the ninth oldest in the world.[4] Its first curator was the celebrated Danish botanist Nathaniel Wallich, who had proposed its foundation.[5] He subsequently became more famous for his association with the Calcutta Botanic Gardens. An intriguing list of sixteen areas of collecting was issued at the outset and a number of early donors were recorded in 1816, including six women (but as yet no Indians).[6] The list is striking compared with the interests of museums in settler territories at a later date. First, almost all the categories are entirely concerned with India. Second, the list is headed by cultural materials, including ancient sculptures and indigenous crafts. Third, geological concerns are included only at the end of the list.

Nevertheless, the museum was doomed to struggle for a number of decades.[7] A sequence of poorly paid curators came and went and the collections remained in a chaotic state, presumably accessed mainly by society members. The accommodation was far from adequate, and attempts to secure a government grant were initially unsuccessful. In 1836, the society encountered a major budget crisis and Sir Edward Ryan, a leading member, appealed to the EIC government to save society and museum from ruin.[8] In typically bureaucratic fashion, the court of

directors was anxious about the precedent such support would create in respect of societies in other presidencies. Moreover, the company was more interested in its own museum in its headquarters in Leadenhall Street in London and was wary of a competitor in India.[9] The court decreed that any museum in Calcutta should be subordinate to and an accessory of the London one, and only duplicate material should stay in India. As shown in earlier chapters, the notion that the appropriate location of a museum devoted to imperial collections was still London persisted for a number of decades in the early nineteenth century. But it was the discovery of coal at Raniganj that helped the administration to realise that a geological survey and an associated museum might have some practical significance. The local administration resolved to offer a grant of 300 rupees a month to pay the salary of a qualified curator.[10] From 1841, the funding of a Geological Survey and of a Museum of Economic Geology was very much on the agenda.

From the appointment of Edward Blyth as curator in 1841, a tradition was established whereby the museum was controlled by a zoologist and this discipline came to be regarded as its principal area of research. (Blyth was not qualified in geology and another appointment was made to cover that field.) The museum prospered and by the 1850s the government was beginning to accept the virtue of establishing an imperial museum in the capital. Negotiations were instituted for the handing over of the society's collections. After a hold-up caused by the revolt of 1857, the discussions were reinstituted in 1858 and by 1865 agreement had been reached that the society would transfer its zoological, geological and archaeological collections to a public museum to be maintained by the government under a board of trustees. The original idea was that the society would be accommodated in the new building, but it abandoned that arrangement, received substantial compensation and remained in its Park Street premises. Blyth's successor, Dr John Anderson, was a medically trained Scot who steered the museum towards its emergence as a fully fledged imperial institution in a new and dedicated building. An impressive structure around a central quadrangle was completed in 1875, located on Chowringhee Road, one of the principal thoroughfares and close to Park Street.[11] It was opened in 1878 after Anderson, now described as superintendent, had arranged the collection.

The first galleries were devoted to zoology, geology, fossils, as well as Hindu and Buddhist sculptures. The Calcutta Exhibition of 1883–84 had a galvanising effect upon the museum, in common with exhibitions in other colonies. Economic products and examples of industrial arts were handed over and a new extension to house them (together with ethnography) was completed in 1888. With the building of a further extension

11 Indian Museum, Calcutta (Kolkata). The building on Chowringhee Road, completed 1875 and opened in 1878.

in 1910–11 to accommodate archaeology and applied arts, the museum was reorganised into five sections: art, archaeology, geology, industrial arts, anthropology and zoology (a curious but suggestive combination). One of Anderson's interests was craniology and he made a large collection of human skulls, but these were never exhibited to the public.[12] Anderson's successor, James Wood-Mason, had been his assistant and developed the museum's interest in marine biology, using the research facilities of the Indian Marine's ship *Investigator* from the 1880s, a tradition continued by Surgeon-Captain A.W. Alcock of the Indian Marine Service (Superintendent 1893–1903). The museum was also active in publishing the results of its research, first in *Indian Museum Notes* (the first volume published in 1889–91), then in *Memoirs of the Indian Museum* and *Records of the Indian Museum* (both started in 1907).

The original arrangements for the admission of the public in the 1850s seem to indicate that Indians were not expected to be among their number.[13] But within fifty years, the situation had changed dramatically, with the Asiatic Society leading the way. From 1829, it had begun to admit Indian members and by the 1830s the membership lists included some of the most celebrated Bengalis of the day. In 1885 it had its first Indian president and the Indianisation of this body had begun, albeit still in an imperial context. An Indian became chairman

of the trustees and Indian staff appeared in the museum from the same decade.[14] Thus both the society and the museum were rapidly being absorbed into Bengali and Indian identities. By the early years of the twentieth century, Indian visitors (predominantly male) had taken over the museum. In 1904–5, well over half a million Indians visited it compared with fewer than 10,000 Europeans.[15] By that time, the museum was no longer a protected place where Europeans could feel cocooned in their own bourgeois racial environment. The Indian Museum was indeed just that, a place for Indians.

Bombay was somewhat more behindhand in the founding of museums, although Dr George Buist (1805–60, editor of the *Bombay Times* from 1839 to 1857 and inspector of observatories) was keen on creating a collection in the 1840s. He wrote on scientific subjects and on antiquities for the Bombay Asiatic Society's journal, and was put in charge of gathering specimens to be sent from the presidency to the 1851 Exhibition in London. In 1853, Dr Erskine, the director of public instruction, considered that the collection being put together for the Paris Universal Exposition should eventually form a museum in Bombay. A museum committee was constituted and Lord Elphinstone, the Governor, appointed Buist as curator and secretary of the Central Museum of Natural History, Economy, Geology, Industry and Arts. Thus it owed its origins to the exhibitions movement and represented more specialised economic interests than its Calcutta predecessor. Buist duly assembled natural history specimens, mineral samples, economic products and implements, keen to maintain craft values and the aesthetics of workmanship. It opened in 1857 and generated considerable public interest. But soon after its opening, the collection was vandalised and many specimens were lost during the 1857 revolt. In 1858, a public meeting was held in the town hall to seek public subscriptions for the reopening of the museum and gardens in honour of Queen Victoria. This meeting was chaired by Jugonnath Sunkarsett, one of the merchant princes of Bombay, and several other prominent Indians.[16] The joint secretaries of the museum committee were Bhau Daji Lad and George Birdwood. The former raised 116,141 rupees from the public, to which the government added a further 100,000.

The committee selected the present site in Byculla, some distance from the current city centre. At that time Byculla was an important area: government house[17] was there (later moved to Malabar Point) as was the first railway station, and the residences of members of the elite. It is now a well-populated district, thereby providing a significant constituency for the museum. Governor Sir Bartle Frere laid the foundation stone in 1862, but another decade passed before the museum was opened, in 1872. It was in a strikingly handsome Palladian building

with magnificent high Victorian interiors, set in gardens (now Jijamata Udyan) designed by Birdwood. From 1862, it had been called the Victoria and Albert Museum (and was renamed Bhau Daji Lad in 1975).

Birdwood (1832–1917, later Sir George), who was destined to become a celebrated figure in London, had been the curator for ten years after 1858. Trained as a doctor he had been a member of the Bombay medical service, but he became more influential through his commitment to the maintenance of the craft traditions of India.[18] He considered Indian craftsmanship to be a model for the world, set in a holistic social and economic context and inspired by centuries of tradition. It would be the perfect antidote to the debasement produced by the Industrial Revolution. He was an avid collector, supported by a number of wealthy Indians, such as the Parsi Sir Jamsetjee Jeejeebhoy. Thus, having started out as a strictly natural history and economic museum, it had broadened its remit and, among other things, made collections relating to the history and archaeology of Bombay and its region. Indeed, it has always sold itself as a local rather than an imperial museum and represented in some respects a significant new development for India.[19] Today its grounds have become an extraordinary Valhalla for statues from the British imperial period, transferred from other sites in the city, and now standing as mute symbols of a lost empire. In the past few years, the museum has been completely renovated by the Indian National Trust for Art and Cultural Heritage and reopened in early 2008. While its transfer into a wholly Indian identity is complete, it has impressively maintained its connection with a British past, offering a degree of balance through its superb and concise displays, which act as models of museum restoration and refocusing.[20]

This Asiatic V&A received greater scholarly legitimacy from the founding, in 1883, of the Bombay Natural History Society.[21] This body arose from a meeting attended by eight residents of the city, six Europeans and two Indians. It actively collected for the museum and only severed its connection with it some ten years after Indian independence. Apart from donating to the museum, it maintained impressive collections of its own, which the government of Maharashtra recognised as of national standing by providing a grant for the building of Hornbill House, its current home. In modern times, this society has been recognised as important both in documenting and conserving India's biodiversity and in nature conservation.

In the early twentieth century it was proposed that there should be a new museum commemorating the visit of the Prince of Wales (later George V) to India in 1905. Once again a meeting in the town hall, attended by wealthy Indians and other dignitaries, resolved to erect such a memorial museum. It was decreed that the 'building should

12 The restored V&A Museum (now Bhau Daji Lad), Bombay (Mumbai), originally opened in 1872.

have a handsome and noble structure befitting the site selected and in keeping with the best style of local architecture'. Almost immediately, the government of Bombay started to collect antiquities and stored them in the Asiatic Society rooms in the town hall. This was partly a response to the demands of the archaeologist Henry Cousens, who had been pressing for a museum to house the antiquities he was excavating in western and north-western India.[22] There was no doubt that this was to be a prestigious project. The administration handed over a centrally located plot of land known as the Crescent and, after an open competition, George Wittet was commissioned to design the building in 1909. He chose the Indo-Saracenic style producing a pastiche of Islamic and Hindu elements, including a nod to regional Maratha forms. This building, itself a form of museological statement, was completed in 1915, but its opening was postponed because of the First World War, when it acted as a military hospital.[23] It was finally inaugurated in 1922, designed to display the arts, culture and heritage of India. Known in the British period as the Prince of Wales Museum it is now the Chhatrapati Shivaji Maharaj Vastu, its name incorporating the greatest of Mahratta heroes. George V's statue is still preserved in its gardens. Its displays span natural history, Indian antiquities, Far Eastern ceramics, Tibetan

THE LADY HARDINGE WAR HOSPITAL, BOMBAY.

13 Prince of Wales Museum (now Chhatrapati Shivaji Maharaj Vastu), Bombay (Mumbai). Completed in 1915, it was used as the Lady Hardinge War Hospital during the First World War. It was opened as the museum in 1922.

and Nepalese art, metal work and crafts, with European paintings from the Tata collections.

Elsewhere in India, museums were important in the preservation and development of Indian crafts and in the efforts of princes to establish themselves as forward-looking, modern rulers in a supposedly European style.[24] The celebrated Lahore Museum, where Rudyard Kipling's father Lockwood was highly influential, was opened in 1894 (it is now in Pakistan).[25] It was designed to exhibit the arts and crafts of the Punjab, but also collected antiquities, ethnographic materials and Tibetan art.[26] Museums appeared in many other cities of British India. But what is interesting about some princely museums is that whereas the foundations in the British-ruled presidency and provincial cities were devoted largely to the display of Indian natural history, economic resources, archaeological artefacts and other cultural materials, the princely museums seem sometimes to have been concerned with the revelation of the European arts to India. Thus, paradoxically, the institutions of imperial territories focused on India (perhaps there were good practical reasons for this) while some princes were eager to emulate European museums and demonstrate how 'modern' they were.

After the Gaekwad of Baroda, Maharaja Sayajirao, resolved to found

a museum in his state in 1886 events moved fast. The foundation stone was laid in 1887 and a grand Saracenic building, designed by two British architects, was completed in 1894. The Gaekwad later added a smaller picture gallery, completed in 1914, but only opened after the First World War. The museum received cultural materials from Europe, reflecting the ruler's own tastes, and eventually had rooms devoted to Michelangelo, the Graeco-Roman period, the European Middle Ages and early modern pre-industrial times and the eighteenth to twentieth centuries (industrial era). Even today, its collection on the civilisations and arts of Asia remain in store, although they are displayed in temporary exhibitions. The paintings for the art gallery were also in the European tradition. On the other hand, the Albert Hall Museum in Jaipur (now the Maharaja Sawai Madha Singh Museum) was intended to have a predominantly Indian collection, encouraging the reinvigoration of local crafts and industries.[27] It arose from the Jaipur Exhibition of 1883 and was associated with a recently founded art school in the city.[28] Its foundation stone was laid by the Prince of Wales (Edward VII) in 1876; it was designed by the high priest of hybrid styles, Sir Swinton Jacob, and opened in 1887. Meanwhile, the Lalgarh Palace Museum in Bikaner (again by Jacob in a fusion of Rajput, Mughal and European styles, opened in 1902) reflects both eastern and western tastes.[29] In both these cases Jacob's buildings were intended to convey a powerful ideological charge, embracing East and West, and demonstrating sculptural craftsmanship as much as the contents within.

The foundation of a museum in Colombo, Ceylon, was very much a gubernatorial venture.[30] Here was a museum-loving governor, who had used his political career as an MP in London to involve himself closely with matters relating to the BM and the National Gallery. Sir William Gregory (an Irishman from Galway) administered Ceylon from 1872 to 1877 and seems to have spent much of this time scheming and planning the creation of his museum. His ambition was to create an institution in Colombo to match the great Botanical Gardens at Peradeniya, which he much admired. His motivation was largely cultural in the best traditions of the Asiatic societies: the museum should obtain reproductions of inscriptions (some by photography) from throughout the island, to display examples of Ceylonese ancient art and sculpture (which he regarded as under threat if left in their original locations) as well as more recent arts and crafts. It should also be concerned with the natural history and productions of the island. Thus, this was a museum of Ceylon and for Ceylon. He managed to secure the agreement of the executive and legislative councils, but failed to seek the permission of the Colonial Office. He was urged on by the local Asiatic society, which wanted accommodation for its activities and a location

for its already considerable library. But when London found out what he was up to, the construction of the building was temporarily stopped. Nevertheless, Lord Kimberley, Colonial Secretary, declared that 'the Museum is evidently a hobby of Mr Gregory's and as he does his work zealously and well, I am afraid I must indulge his fancy, tho' I am doubtful of its utility, especially since I have seen it so much puffed'.[31]

Gregory got his fancy and the first building, a grand affair designed after he had consulted various experts, was completed in 1876. Gregory was said to have supervised the works himself and he set about arranging its filling with copies of epigraphic records, dismembered architectural remains, reproductions of ancient manuscripts and old literary works. Natural history and ethnography soon followed. It is clear that his objectives were a highly improving blend of cultural edification and education rather than recreation, though the visitors no doubt turned its opportunities to their own ends. He had been greatly helped by the fact that the 1870s constituted a decade of comparative prosperity in the colony before the coffee industry collapsed in the following decade. Gregory kept up his interest in the museum long after he had left Ceylon (making frequent return visits).[32] It weathered the financial storms of the years following his departure and extensions were opened in 1909, 1930, 1962 and 1973 before the modern era of museum creation and construction arrived. A new Natural History Museum and a Museum of Science and Technology were built more recently.[33]

By this time, museums were proliferating through South-East Asia. Officials, rulers and local white residents felt an inexorable need to join the international movement. For example, Raja Charles Brooke, the second 'white raja', first considered founding a museum in Sarawak in the 1860s, probably influenced by the great traveller and evolutionist Alfred Russel Wallace. It duly opened on Market Place, Kuching, in 1886, moving to a new building in 1891. It was designed as a museum of natural history and ethnography and is now regarded (together with six others) as a symbol of 'indigenous pride, identity and traditions of our people'.[34] As early as 1911 it was publishing the *Sarawak Museum Journal*. Museums were opened in Perak (in Taiping) and Selangor (in Kuala Lumpur) in the Malay peninsula in 1886 and 1898.

Sir Hugh Low, third British Resident in Perak, by then rich in tin, was the founder of the first. His curator was Leonard Wray, a botanist and geologist, who designed an ambitious building and collected avidly to fill its first location in two large rooms in the state building. The museum was built between 1883 and 1886, with four galleries divided into zoology, archaeology, ethnology and a herbarium, with a library. Between 1901 and 1931 it was administered by the museums department of the Federated Malay States (FMS) with Wray as the first

14 Colombo Museum, Ceylon (Sri Lanka), opened in 1886.

overall director, appointed in 1904. Donations were received from both the BM (Natural History) and many private donors.[35] Enlarged in 1903 to accommodate the ethnographic exhibits, its curator still lamented lack of space in 1906. Although it is apparent that economic motivations were significant from the start (all forms of rubbers, guttas and gums were displayed together with information on tin-bearing areas, open-cast mining, and specimens of gold and sapphires), zoological and ethnographic collections remained important.[36] From 1909, however, its ethnographic collecting concentrated on the Malay Peninsula and exotic materials were passed on to other museums, including Singapore. By then educating the young had become its main 'selling point', providing 'an elementary acquaintance with the fundamental laws that govern nature and the animal kingdom or a rudimentary knowledge of anatomy; and the scope of the economic and geological sections, when in order, will be invaluable in a country such as this'.[37]

The Selangor Museum was founded by a group of Europeans in Kuala Lumpur who were interested in natural history and ethnology. Among these was the first Commissioner of Police of the FMS. It concentrated on the interests of these founders. The first curator (Butler, 1898–1900) embarked on a collection of Malay birds, which later became the finest in the region.[38] He left, significantly, to become the superintendent of game preservation in the Sudan. The renewed fascination with physical anthropology led to the museum acquiring a set of anthropometric

[245]

instruments to measure the various peoples of the peninsula in what became an international project in this period.[39] From the start it was discovered that Europeans made very little use of the museum. The 1903 report offered an intriguing breakdown of visitors over the previous three years, indicating that whereas only minimal numbers of whites visited, Tamils, Malays and Chinese were far keener to do so. This reflected similar experiences in other Asian museums. By 1904, the original building was in a ruinous state and a new one was projected and completed in 1906. Wray, in overall charge, proposed sending ethnological specimens to the BM because Malaya was virtually unrepresented in what he called the British national collection. The Wild Animals and Birds Protection Enactment, 1904, was designed to prevent indiscriminate slaughter by hunters and collectors threatening extermination to the wild fauna and avifauna of the peninsula (this act applied to Perak, Selangor and Negri Sembilan). This reflected a worldwide concern with extinctions prevalent at this time,[40] but it also indicated the extent to which the fauna of the peninsula, notably diverse and distinctive, like the natural environment of the region, was under threat.

Singapore

This question of identity construction through the medium of the museum was important in Singapore. This island, now a booming city state and one of the most aggressively growing, if diminutive, 'tigers' of Asia, was formerly little more than an outpost of Sumatran and Javanese states. By the time Sir Thomas Stamford Raffles decided in 1819 that it would make an excellent trading post for the EIC, it had diminished in importance. It was inhabited by a few Chinese planters, some Aboriginal peoples, and a number of Malays, all under the jurisdiction of the sultanate of Johor. The local ruler, the temenggong, ceded suzerainty to the British company against the authority of both his indigenous overlord and the Dutch. But the EIC turned a blind eye to such local protests and their position was legitimated through an Anglo-Dutch treaty of 1824. In 1826, the British coastal positions in Penang and Malacca (Melaka) were joined to Singapore in the Straits Settlements, operating as a residency under Indian and later Bengali authority. In 1832 Singapore became the capital of the Settlements and was transferred to the control of the Governor-General of India in 1851. They were removed from the administrative orbit of India in 1867 and declared a Crown colony under the Colonial Office in London. Within a few years, Raffles's estimation of Singapore's strategic position was more than justified, greatly helped by steam shipping and the opening of the Suez Canal in 1869. The island was confirmed as the pivot

around which British trading and shipping interests in South Asia and the Far East rotated. It became a notably cosmopolitan centre with Portuguese, German, Armenian, Chinese, Indian and other traders and workers swiftly moving in. It also became a key stopover point for visitors and officials travelling between Europe and the Far East.

Inevitably, as the number of officials, clergymen, professionals and merchants grew, there was a demand for the usual colonial institutions that would provide an education for potential employees, give status to the settlement, and ease their sojourn in this relatively remote and climatically steamy outpost. The Singapore Institution, first founded in 1823, was designed to fulfil these needs. The Institution was proposed by Raffles himself and he chaired the inaugural meeting at his home on what is now Fort Canning Hill. Raffles wished to revive the history and literature of the region by ensuring that it was taught to the 'higher order of natives and others'. This was also part of a policy to establish Singapore as the most significant of the future Straits Settlements since it was proposed that the Institution should embrace a newly established Malay College while the Anglo-Chinese College should be transferred from Malacca to the island entrepôt. This college had been founded in 1818 as a missionary establishment, complete with a small Chinese history museum. Thus, the proposals were clearly designed to educate Chinese and Malay inhabitants in western modes. A scholar of Chinese, the Rev. R. Morrison (who had headed the Anglo-Chinese College) was appointed as the first Librarian along with a Dr Collie, also described as professor of Chinese and librarian. The library would operate by levying subscriptions from both institutional and private users. The Institution was also expected to develop a museum while scientific lectures would be delivered in English. It was charged with collecting 'the scattered literature and traditions of the country, with whatever may illustrate their laws and customs, and to publish and to circulate in a correct form the most important of these'.[41] Here was the standard motivation of the Asiatic societies.

The interests of Raffles himself were clearly represented here, though the absence of any reference to natural history is strange. Raffles had taken a scholarly interest in the region since his administration of Java after the British conquest from the Dutch in the Napoleonic Wars. He had made collections of natural history, books and manuscripts (many lost in a fire on his ship at Bencoolen in 1824, though he promptly set about finding replacements) and had written a history of Java, a descriptive catalogue, and a self-justificatory record of his own service. Interestingly, some of his natural history interests were based on the work of one of his right-hand men, William Farquhar, who has always been lesser known, partly because he never published.[42] Farquhar

(Resident in Singapore 1819–23, after a long period in Malacca) has been rediscovered as a founder of Singapore, partly because of the magnificent collection of natural history illustrations commissioned from local Chinese artists, which are now a treasured possession of the Singapore National Museum.[43] It has been said that he was sympathetic towards, and more eager to work with, native authorities than the more autocratic Raffles.[44]

In their pursuit of natural history, both made extensive use of indigenous helpers. Raffles is said to have employed four collectors, for botanical specimens, for insects, for marine materials, and another for mammals and birds. We know something of Farquhar from the Hikayat Abdullah, the autobiography of Munshi Abdullah, Farquhar's contemporary in Malacca. Farquhar kept a small zoo during his time there and employed *pawangs* (loosely translated as 'medicine men') to capture animals and collect specimens for him. He sent many of these to the Asiatic Society of Bengal or to the Royal Asiatic Society in London. Yet, despite this activity (perhaps mainly designed to inform scientists in India and Britain) the mission of the Singapore Museum was originally seen as cultural and historical.

But the Institution turned out to be tentative and temporary. Raffles left, as did Dr Morrison, moving on to develop his mission in China. Although a building was erected, it stood empty for a number of years. Only in the late 1830s did both school and library become a reality. The colony had become economically more settled; the possibility of its return to the Dutch had receded; and the EIC realised that it might indeed have a future. But although the library is frequently mentioned in school reports in subsequent years, the museum appears to have had a shadowy existence and much of the original collection subsequently disappeared. In 1845, the library was revived on a subscription basis and in 1849 the notion of a museum was back on to the agenda.[45] A list of potential acquisitions was drawn up, including coins, manuscripts, inscriptions on stone or metal, implements, cloth and other articles of native art and manufacture; 'figures of deities used in worship'; 'instruments of War or other weapons', musical instruments, vessels used in religious ceremonies; ores of metals; minerals; fossils; 'and any other object which may be considered suitable for the purposes of Museum'.[46] Despite the final items, the main emphasis seemed to continue to be on 'literary' and historical materials.

The 1840s were a time when Singapore was beginning to combine social and physical attractions with a degree of economic well-being. The Botanic Gardens had been founded as early as 1822, with the advice of Nathaniel Wallich who was visiting Singapore;[47] newspapers had been founded in the same decade; musical events had become relatively

commonplace; a chamber of commerce appeared in 1837, a race meeting in 1843, a masonic lodge in 1845, while churches of various denominations played a significant role in social as well as spiritual life.[48] The Singapore Agricultural and Horticultural Society was formed in 1836 and re-established in 1860.[49] Cricket was played from at least 1837 and a club founded in 1852[50] while amateur dramatics became a significant source of entertainment. Private museum collections, such as those of the wealthy Chinese merchant Hoo Ah Kay (known as Whampoa) and the wife of the American Consul, Mrs Balestier, had become celebrated. A public museum seemed a necessary addition to the adornments of the port.

By 1850, Singapore theoretically had such an institution though it was initially little more than an appendage to the library. Contributions began to arrive, including archaeological and ethnographical materials. But this was again a false start. Singaporeans seemed to be more intent on displaying the colony and its surroundings in London than at home. A collection of 500 items, illustrative of the natural history, the edible products and the handicrafts of the region, were collected for the Great Exhibition of 1851 at the Crystal Palace. They were displayed in the Court House before being sent off to the United Kingdom. But this failed to energise incipient museum formation in the colony. There seems to have been an extraordinarily blank period in the 1860s, a time of recession, when the Singapore newspapers either failed to appear or have been lost. There are no library and museum minute books covering the years 1866–72.[51] The existence of a museum even disappeared from the town's commercial directories, though we know that the two cultural institutions had been moved into rooms in the town hall in 1862.

It seems to have been the acquisition of Crown colony status that reactivated the museological ambitions of the trading settlement. Again, the stimulus seems to have come from London. The Colonial Secretary, Lord Kimberley, sent out a circular despatch in March 1873 calling on colonies 'to establish and maintain, at a very reasonable cost to each Colony, a permanent Exhibition of Colonial Produce in connection with the Exhibition Building at South Kensington'.[52] It was proposed that this should be organised in the summer of 1873, to open in 1874, and it was further suggested that, 'In a permanent Exhibition of the nature now contemplated, it will be desirable that not only commercial products, but objects of interest of whatever kind, illustrating the Ethnology, Antiquities, Natural History and Physical Character of the country, should be included'. Kimberley also sold the idea that such a permanent exhibition would be cheaper than the cost of sending in collections for temporary exhibitions. Singapore duly voted funds

for this (over £400 for the setting up of a display and over £20 for its annual maintenance). In fact the series of South Kensington exhibitions which ran from 1871 to 1874 was something of a failure (Henry Cole had insisted on an unpopular arrangement by category of product rather than by geographic origins) and this notion of creating a comprehensive compendium of colonial products in London did not materialise.[53] It later came to pass in a limited form in the South Kensington Imperial Institute, which was opened a number of years after the much more important Indian and Colonial Exhibition of 1886.[54]

Dr H.L. Randall, Principal Civil Medical Officer of the Straits Settlements proposed to the new Governor, Sir Andrew Clarke, in late 1873 that a Singapore museum should be established to accommodate 'objects of Natural History'. A few months later, the Governor appointed a committee under the chairmanship of the influential medical man (and member of the legislative council), Dr Robert Little, to consider the London Colonial Secretary's request. This committee, which included Hoo Ah Kay, seems to have been highly energetic in its initial meetings. The two projects, in effect, became fused and a newly formed library and museum resulted with some government funding. It was agreed in 1874 that it should be known as the Raffles Library and Museum.[55] A joint librarian and museum curator (James Collins, an economic botanist from India) was appointed and began to receive specimens.[56] A zoological garden was also formed and animals arrived from the Melbourne Acclimatisation Society and the Zoological Gardens in Hamburg.[57]

The museum, however, was very much subservient in status to the library. The space for the former was very limited and became even smaller when one of its rooms was taken over to cope with expansion in the numbers of books. In 1876, the curator provided a list of what such a museum should contain, now heavily economic in its focus. This included food substances; medical plants used by the natives; textiles; dyeing and tanning; gums and gum-resins; gutta-percha and rubbers; woods; animal and mineral products; models of machinery; native productions; and ethnological specimens, which could be obtained in abundance from captains of trading vessels.[58] It was also proposed that the residents in the native states (the residency system having been recently instituted in the Malay peninsula) should be requested to collect for the museum. By this time, however, the job seemed to be getting on top of Collins who was proving to be highly erratic, and he was dismissed in 1877.

Repeated complaints about space constituted the litany of museum curators everywhere, but Singapore had special problems. The climate was highly damaging to all specimens, 'ferruginous dust' penetrated

everywhere as a result of ill-fitting doors and windows; and the depredations of insects both in the displays, given the inadequacy of the cases, and in the fabric of the building were to create havoc. The whole establishment was brought under government control by an ordinance in 1878 and the possibility of a new building was first mooted, though funds were not available. The museum marked time, handicapped by the continued combination of the offices of librarian and curator for several more decades (apart from one brief period), and by its cramped quarters in the town hall. Nevertheless, an impressive collection of krises (ornamental knives) and spears was acquired from Sir Frank Swettenham for $500 in 1882; a catalogue (later described as premature) was issued in 1884; and items arrived from the Sydney Exhibition in the same year.[59] Moreover, the early holders of the post of librarian and curator were not of the highest quality.

The scholarly credentials of the colony were greatly enhanced by the foundation of the Straits branch of the Royal Asiatic Society in 1877. An influential committee under the chairmanship of Archdeacon (later Bishop) G.F. Hose was formed and the objects of the society were declared to be 'the investigation of subjects connected with the Straits of Malacca and the neighbouring countries'. Papers would be published in a journal (the first issue in July 1878 and subsequently published half-yearly).[60] Council members were chosen and the first full meeting took place in early 1878. Hose delivered an inaugural address, which emphasised the need for study of the developments in Islam in the region, of Malay languages and literature, of the character of the native states, and above all of the geography of the peninsula to fill in remaining blank spaces on the map.[61] He extolled an earlier effort to develop such studies inaugurated by J.R. Logan of Penang who published the *Journal of the Indian Archipelago* between 1847 and 1862.[62]

At subsequent meetings papers were read on the Chinese in Singapore and on the dialects of the Melanesian tribes in the Malay peninsula. By July, the society boasted some 133 members, including senior officials, other white residents and several Muslims (but as yet no Chinese, though Seah Liang Seah was elected in 1888). Richard Schomburgk was a member (see Chapter Nine) as was (in an honorary capacity) the Russian associate of the Macleay family, N.N. de Miklouho-Maclay, who is commemorated on a plaque at the University of Sydney.[63] Celebrating the work of the society in an anniversary address in 1917, and placing it in the context of other Asiatic societies, Walter Makepeace intoned that 'The Empire of Knowledge knows no geographical boundaries'.[64] He lamented the fact that the study of Islam had not proceeded as Hose had wanted it to, both because it was national policy not to interfere in religious matters and because the British were diffident

15 Raffles Museum and Library, Singapore, opened in 1887. The library subsequently moved out and this building survives as part of a much larger complex, the National Museum of Singapore.

about discussing religion! (This reveals that Hose's clear interest in the expansion of Christendom was not necessarily matched by government or private action.) Moreover, the popular lectures, which might have disseminated information to a wider public, had never happened. He also advocated the maintenance of a photographic archive and the appointment of a Photographic Records Committee. The connection between the society and the museum was less clear than that with the library, but still its members maintained an interest and some collected for it, while one of its prominent founder members, Dr N.B. Dennys, became its curator for a period after the departure of Collins. The society's commitment to anthropology was reflected in the fact that bound copies of a local 'Notes and Queries' edited by the honorary secretary and based on the 1874 *Notes and Queries* published in London, were issued with the journal. Society and museum were part of the same social and intellectual complex.

It was to be another new governor, Frederick Weld, who recognised the need for a dedicated building and supported the spending of government funds. Weld, who had been premier in New Zealand during 1864–65, was committed to science and had an interest in museums. He had also been Governor of Western Australia (1869–75) and of Tasmania (1875–80) before his appointment to the Straits Settlements. A budget of $80,000 was duly passed for a building designed by the Colonial

Engineer Henry McCallum. Constructed by two Chinese contractors on the present site on Stamford Road, it was ready for opening by Weld in October 1887, his last act before leaving the colony, and yet another imperial homage to Victoria's Golden Jubilee.

Weld revealed his credentials by making a proud claim that he had been responsible for the founding of a scientific and industrial department in New Zealand. His speech was purely economic in tone, contrasting with the ambitions of earlier founders and with the scholarly concerns of the branch of the Asiatic Society. He considered that Singapore was

> a place where a museum on a large scale should be established, where the traveller or student or businessman should have before him every possible product of these countries and specimens, not only in mineralogy or natural history and botany, but also industrial exhibits and all that may tend to make these countries better known and develop their resources.[65]

In the pursuit of these ends, the museum should 'possess a staff competent to render service in science and industrial knowledge', thus devoting itself 'to the development of these settlements and states'. The building he opened accommodated the library on the ground floor with the museum occupying most of the first floor. There was also space for the Asiatic Society as well as living accommodation for the librarian/curator. It remains the front central block of the national museum, and was extended in 1907 and again in 1916.

But even this impressive new building failed to alleviate the problems of maintaining a museum in such a climate. Dampness and mould were endemic; dust still penetrated; insects still conducted their depredations; and termites attacked the structure (causing a collapse in the roof of the entrance hall at one stage). Sparrows also invaded the space – a convenient place to nest. Yet as the prosperity of the colony grew expenditure was fairly generous, although the museum often received only a quarter or less of the sum allocated to the library. Moreover, the problem of curatorial stability was not resolved. Dennys was succeeded briefly by Arthur Knight and in 1887 it seemed as though the appointment of William Davison, an ornithologist who had collected in the Malay peninsula, might provide the solution. He was highly regarded, coming with impressive references, and was a good linguist. But his term of office, despite the opening of the new building, was no more successful than that of his predecessors.[66] Several years of problems culminated in his death 'in tragic circumstances' (suicide?).

Dr G.D. Haviland of the medical service, rather surprisingly, then became curator and librarian. Haviland had private means but, even so,

he found the salary too meagre and his annual reports give the impression of a choleric individual exuding ill temper. He ruminated on the 'comparative failure of the Museum to fulfil the objects for which it was founded'. Although the present building was superior to the old one, still 'the needs of the Museum seem to have been overlooked in building it': rooms and cases were eminently unsuitable. The combination of library and museum remained problematic. Moreover, he considered that reported visitor numbers had always been highly dubious and he found that the European population was simply not interested since all Europeans who come 'seem to be passengers'.[67] But he was impressed by the numbers of 'native visitors', particularly on holidays such as the Chinese New Year. The importance of the museum to the Chinese population (and it will be remembered that they had also been avid visitors in Melbourne) was acknowledged by the appointment of Dr Lim Boon Keng, a medical man, to the committee from 1898.

Haviland's report was certainly the fullest there had been for some time and was divided up into sections on ethnology, zoology, economic botany, geology and mineralogy. He had pronounced ideas about the presentation of an ethnological collection:

> to be of real value [it] should be made systematically, and with an end in view; every object should be carefully and properly labelled, and the label record the date and exact locality from where the object came. Good photographs of the people illustrated in the collection are most important. Mere unlabelled curios are not worth the cost of housing and caring for.

This was clearly a cry from the heart, reflecting the extraordinarily haphazard nature of collecting and presentation in the past. His (temporary) successor in 1894 found the geological and mineralogical collections to be unimpressive and considered that this should be remedied given the economic importance of this section. This, however, flew in the face of the knowledge that Europeans seldom used the museum for such instruction and the interests of Chinese and Malay visitors generally lay elsewhere.

Despite all these difficulties, there were no fewer than sixty applicants for the post when Haviland left. The committee were looking for someone who would do more to put the institution on the international scientific map and thought they had found him in Dr R. Hanitsch, a German-born member of the Zoology Department at the University College in Liverpool. Despite his marriage to an English woman, there was some xenophobic animus against him on the committee. But he retained the post from 1895 to 1919 and the museum had at last found an appropriate incumbent capable of transforming it. During Davison's time, there was a renewed emphasis on natural history collecting, and

this was developed by Hanitsch who was an indefatigable leader of collecting expeditions into the peninsula and adjacent islands.

Inherited employees cooperated and he appointed new ones: there were 'native' collectors, a shikari (or hunter), taxidermists (one Indian, one Goanese later joined by a head taxidermist from Edinburgh, Valentine Knight) and a Ceylonese carpenter to make cases. Hanitsch also embarked on a programme of dredging (often using the government steam yacht, SS *Sea Belle*) to develop the marine collections.[68] He was determined to make the museum a major scientific centre, reflected in the increasing numbers of distinguished visitors from Europe and Asia, and deprecated foreign expeditions that resulted in a vast amount of material being scattered through the museums of Europe and America.[69] He struggled with a small budget (lamenting in 1900 that museums in Selangor and Perak received more) and an inadequate building, exacerbated by years of depression at the beginning of the twentieth century. In 1906 an extension, another building behind the existing one and connected to it in an H formation, was completed. The zoological collection was moved into the new structure and ethnography remained in the old one. The newly arranged museum was reopened for the 1907 Chinese New Year and was immediately thronged with visitors. In 1908, Hanitsch's title was changed to Director and he published a *Guide to the Zoological Collection* (it sold badly, to his chagrin, although in 1911 it was said that the most frequent purchasers were Japanese passengers travelling to or from Europe).

Hanitsch did not neglect ethnography. Collecting and donations continued to enhance the museum's holdings, although for several years after his appointment, there was no room to display any of it.[70] In 1890, one Vaughan Stevens had been contracted to supply (for the sum of $288) 'as complete a collection of specimens as he can procure, illustrative of the ethnology of the native tribes of the Malay Peninsula', though there is no indication whether this arrangement was a success.[71] At the end of the century, the curator moved out of the living accommodation in the building, creating three new galleries for ethnography, which he described as the 'best lit and ventilated rooms in the Museum, and, together with their new furniture, appear much more attractive than the other galleries'.[72] These were fully opened in 1903 when he suggested that a good ethnological collection was 'the most urgent requirement of the museum'. This sense of urgency was heightened by his conviction that efforts to secure such material might already be too late. He gloomily proposed that 'The Museum at present can only give an impression of poverty to the European visiting it, instead of conveying to him some idea of the vast resources of the Malayan region or of the wealth of this Colony'.[73]

Despite the pessimism of Hanitsch, the 1906 Report declared that the ethnographical additions to the collection were 'much more striking' than equivalents in zoology, botany or geology.[74] The space available for ethnography was extended once the new building was completed. In subsequent years, the collection was augmented from Malay sales of silverware (also silver from Brunei), brassware from itinerant traders, coins, Chinese and other examples of porcelain, textiles, batik and indigenous weapons. Agricultural and other shows (including the Malaya/Borneo Exhibition of 1907) held in Singapore and the peninsula brought large amounts of such material to light. The collection of Cecil Wray, the Resident of Pahang was purchased and several others came the museum's way.[75] In 1911 a member of the museum staff volunteered to allow Valentine Knight to make plaster casts (particularly of his head, hands and feet) for the construction of a lifelike model to display clothing, ornaments and weapons. In the same year, Hanitsch increased his knowledge by visiting the Ethnological Museum of the Batavian Society of Arts and Sciences in Java as well as other institutions in the Dutch East Indies (he had already paid visits to Europe to see museums in 1901 and 1906).

Hanitsch joined the government's payroll in 1899, an arrangement resisted in the past. Through these years the government grant fluctuated considerably. Between 1887 and 1889, it stood at $10,000. From 1890 to 1898 it was reduced to $9,000. Without the curator's salary, it became $4,255 in 1899 rising to $7,400 in 1902. From 1910 it returned to $10,000 and reached $12,000 in 1913. Over this period, the value of the Straits dollar declined considerably. As with so many other places, this was indeed a museum running on a shoestring despite its considerable importance to the Chinese, Indian and Malay population.[76] In 1908, over 10,500 visitors were admitted to the museum during the two-day Chinese New Year period; in 1918, the figure reached 17,472, at a time when Singapore's total population (according to the 1911 census) was 185,000. It was said that about a quarter of the entire population of the colony had visited in the course of the year.[77] It seems that these large numbers were attracted – as elsewhere in colonial museums – by the zoological collections, which were augmented with some startling specimens such as an elephant and a tiger.[78] Nevertheless, the developing collection of magnificent ethnographic materials, including precious items sold by the families of distressed rajas,[79] must also have been an attraction. Such items also appealed to thieves: the first silver theft took place in 1894, when part of a replica regalia from Perak was taken. There were two more break-ins in 1910 and 1912 when silver was again targeted, but losses were relatively slight.

Having proved itself a significant source of entertainment and

instruction to Singapore's cosmopolitan population, a move was made in 1919 to make it more attractive to Europeans who had never been among the museum's most eager visitors. The centenary of the founding of the colony, marked in a variety of ways, prompted Hanitsch and others to propose the development of a Singapore history section. Portraits, plans and pictures of old Singapore would be collected, supported by some of the principal trading and engineering companies. This inaugurated a collection that is now one of the central elements in the National Museum of Singapore.[80] Indeed, the museum was to become vital to identity formation in the city state, aided by donations from wealthy Chinese residents as well as representatives of other communities.[81] This was Hanitsch's last legacy to the museum. He had reached retirement age during the First World War, but soldiered on for the next few years, his energies sapped and worn down by the combination of roles of librarian and museum director. By then he found distinguished visitors, formerly a flattering source of delight, irksome and time-consuming.[82] He and his large family retired to England.

There were increasing signs of professionalisation in the museum from the 1920s. Hanitsch's successor, John Moulton, who had been the curator of the Sarawak Museum for over a decade, set about a complete reorganisation to bring the museum up to date. Photographs of the period reveal attractive displays in fine architectural surroundings. He also decided on a closer focus on the region, including the Malay peninsula, Borneo, Sumatra and Java. While the two institutions remained joined, a European head librarian was appointed in 1920 (in the past the library staff, under the Director, had been mainly Chinese). Electric light – at least in the offices – was at last introduced. Moulton was also involved in organising the Malaya/Borneo exhibition in Singapore in 1922 and the displays at this event helped to expand the ethnographic collections. The museum was opened on Sundays between 1921 and 1931 and in the latter year an aquarium was acquired to attract more visitors.

After Moulton's early departure into a senior government position in 1923, his successor, Cecil Boden Kloss instituted the *Bulletin of the Raffles Museum*, first published in 1928 (it continued to appear until the mid-1960s), although the *Journal of the Federated Malay States Museums* had been published since 1905. A series B of the bulletin, specialising in anthropology, was founded in 1936, enabling the first to concentrate on zoology. Boden Kloss was not only the Director of the Raffles Library and Museum, but also (after 1927) Director of Museums in the FMS and the Straits Settlements. During this period, historical and ethnographic collections continued to grow; the structural integrity and decoration of the building were improved; and visitor numbers continued to rise dramatically, allegedly reaching 300,000 in 1930,

though there was a dramatic slump in the following year as the recession bit deeper. The regime of Boden Kloss was also relatively short and his successor was an internal appointment, his assistant F.N. Chasen. After the severe financial restraints of the 1930s, the museum continued to emerge as a scientific institution investing much time in fieldwork. Major donations of historical, archaeological and ethnographic material continued to arrive while Carnegie grants after 1935 helped to fund the creation of a gallery of Asian prehistory, the modernisation of the public displays, the publication of scientific papers and the appearance of new examples of taxidermy.

The first appointment of an Asian to a senior post took place in 1938. But all prospects of further developments were brought to a halt by the Second World War. Uniquely among the museums in this study, that of Singapore was endangered by Japanese conquest and occupation. But influential senior Japanese, Professor Hidezo Tanakadate and the senior official Marquis Toshichika Tokugawa, who established his office there, protected the museum.[83] In 1944 it was handed over to the British with only minor damage to its structure. Some objects could not be accounted for and many records were lost, but there had been no wholesale looting. Gilbert Archey, later the Director of the Auckland War Memorial Museum, was appointed officer-in-charge of monuments, fine arts and archives in the British military administration. Other museums in the region were not so lucky. The Selangor Museum, again protected by the Japanese, was largely demolished by an allied bomb in 1945, while the Perak Museum was looted between the departure of the British and the arrival of the Japanese. Chasen's assistant M.W.F. Tweedie, who had been imprisoned during the war, was appointed to head the museum in 1946. The staff now comprised, in addition to the director, two curatorships, of anthropology and of zoology, representing the twentieth-century emphases of the museum. As happened elsewhere, the late nineteenth-century stress on its economic and developmental value had been abandoned.

In 1955, the library and museum were at last separated and a new dedicated building was constructed – partly with private funding – for the library. The Raffles Museum (the National Museum from 1960) maintained a research mission and was often criticised for its lack of public appeal. The last expatriate director, C.A. Gibson-Hill (1956–63), a significant scholar who led many collecting expeditions, accepted that ethnography and history had overtaken natural history in importance. After independence (and a period of uncertainty) the potentially very significant role of the museum in establishing the identity of the new territory (particularly after its separation from the Malaysian federation) became apparent. In 1972, the zoological collections were transferred to

the National University of Singapore zoology department with some of them displayed at the science centre. More than ten thousand books and journals went from the museum library to the university. In turn, the museum received the university's small collection of art and artefacts. The National Art Gallery was founded in 1976 and in the mid-1980s the museum was closed, and reorganised into galleries devoted to Singapore history, the Straits Chinese, ceramics, and South-East Asian ethnography.[84] The social history collections greatly expanded in this period.

But the twists and turns in the fortunes of the museum had still not been straightened out. Tourism became an important part of the Singaporean economy. The state had become increasingly interested in its role as a great crossroads of Asia as well as a place with a remarkably cosmopolitan population, well positioned to reflect the magnificence of Asian civilisations. The so-called ethnographic collections continued to grow and it became obvious that major loans would also be possible. Conveniently, colonial buildings, such as the extensive British administrative headquarters in Empress Place, beside the river, became available. Moreover, judging by the numbers of plaques and the willingness to maintain and convert historic structures, Singaporeans developed a commitment to 'heritage'.

In the twenty-first century, the National Museum in Stamford Road was again closed. It was now to be dedicated to Singapore's history and aspects of its social and cultural life. All the ethnographic items and magnificent cultural artefacts would be moved to a Museum of Asian Civilisations in the newly converted Empress Place building. The ambition for this collection is perfectly expressed in its insistence that it is 'the first museum in the region to present a broad yet integrated perspective of Pan-Asian cultures and civilisations', a place where 'Asian cultures come alive'. This was opened in 2003. The National Museum followed later, with the two original buildings of the H formation connected by an impressive glass atrium, and equipped with galleries reflecting much technical wizardry. Singapore has become a major centre for museums, its diminutive size compensated not only by its booming economy and growing population, but also by its capacity to represent history and civilisations in a more advanced form than almost any of the museums surveyed in this book.

Notes

1 Branches were founded in China and Japan in 1858 and 1872.
2 Max Müller considered Colebrooke to be the greatest Oriental scholar England had produced. Quoted in O.P. Kejariwal, *The Asiatic Society of Bengal and the Discovery of India's Past, 1784–1838* (Delhi 1988 and 1999), p. 76. Colebrooke was President of the Bengal Society in 1806.

3 *The Indian Museum 1814–1914* (Calcutta, 1914, reprinted with many appendices in 2004). This quotation is on p. 3 of the notes towards the end of the book. The original centennial history, written by various members of the staff and edited by the Superintendent, Dr N. Annandale, was published anonymously. The republished version constitutes an excellent set of sources, includes a chapter on the museum's history 1914–2004 by Shyamalkanti Chakravarti and a useful timeline from 1814 to 2004, but pagination is problematic.
4 This is not strictly accurate: various older public museums such as the Ashmolean in Oxford, the Teylers in Haarlem, the two Hunterian museums, are not included.
5 Wallich (1786–1854), a Dane, was appointed surgeon to the Danish settlement at Serampore in India in 1807. After the British takeover he became assistant surgeon with the EIC. He worked with William Roxburgh, the company's botanist in Calcutta, remaining at the Botanic Garden 1817 to 1846, and conducting expeditions in India and Burma.
6 The museum wished to collect the following: 1) Ancient monuments, Mohammedan or Hindu; 2) Figures of Hindu deities; 3) Ancient coins; 4) Ancient manuscripts; 5) Instruments of war peculiar to the East; 6) Instruments of music; 7) Vessels used in religious ceremonies; 8) Implements of native art and manufacture; 9) Animals peculiar to India dried or preserved; 10) Skeletons or particular bones of animals peculiar to India; 11) Birds peculiar to India, stuffed or preserved; 12) Dried fruits and plants; 13) Mineral or vegetable preparations peculiar to an Eastern pharmacy; 14) Ores of metals; 15) Native alloys of metals; 16) Minerals of every description.
7 The early history of the museum can be reconstructed from Rajendralal Mitra, 'Centenary Review of the Asiatic Society 1784–1884', part 1, 'the History of the Society', pp. 1–81 (Calcutta 1885, reprinted 1986), particularly pp. 31 ff.; 'the Indian Museum and the Asiatic Society of Bengal', *Calcutta Review* 43, 86 (1866), pp. 427–70; Asutosh Mukhopadyay, 'The History of the Indian Museum', *Calcutta Review*, 275 (1915), pp. 1–21; Mukhopadyay, 'The History of the Indian Museum: an inaugural address delivered on Nov. 28 1913 in the Museum Hall' (Calcutta 1914); A.F.M. Abdul Ali, 'The Indian Museum: the Story of its Birth and Development', *Calcutta Municipal Gazette*, 22 November 1930, pp. 108–9; Baini Prasad, 'The Indian Museum', *Bengal Past and Present*, 57 (1939), pp. 54–65; and Prasad, 'The Indian Museum', *Science and Culture*, 5, 12 (1914), pp. 727–34; Shyamalkanti Chakravarti, 'The Indian Museum, Calcutta: a Journey through 175 years' (Calcutta 1989). See also 'Correspondence between the Government of India and the Asiatic Society relative to the establishment of a public museum in Calcutta' (Calcutta 1859). Some of these items are available in the Asiatic Society Library, some in the overflow depository in Metcalfe Hall.
8 Ryan's portrait, by Thomas Lawrence, hangs today (in very poor condition) in the lobby of the Asiatic Society's Library.
9 This museum eventually went to the South Kensington Museum, later the V&A. Anthony Burton, *Vision & Accident: the Story of the Victoria and Albert Museum* (London 1999), pp. 118–19.
10 The administration declined to purchase the zoological collection of Major W.E. Hay from Africa, South America and the Eastern Archipelago for 30,000 rupees thereby maintaining the focus on India.
11 The Geological Survey of India is still next door and the Asiatic Society round the corner.
12 Anderson was also professor of comparative anatomy at the university.
13 '... no great influx of the native population, such as is now to be seen any day in the Imperial Museum, was looked for', *The Indian Museum 1814–1914*, p. 53.
14 T.N. Mukherji was assistant curator from 1887 and several Indians reached curatorial positions and departmental headships by 1914. Babu Rajendralal Mullick, Rai Bahadur was nominated trustee by the Governor General in 1869; Raja Jotendro Mohun Tagore followed in 1871, was Vice-Chairman in 1877, and first Indian chairman in 1880 and again in 1885, by then adorned with a KCSI. Rajendra Lala Mittra

Rai Bahadur became a trustee after he assumed the presidency of the society in 1885.
15 Some 470,321 of these were male and only 95,875 female. Europeans were divided into 7,561 males and 3,454 females. *Indian Museum, 1814–1914*.
16 These included Banarjee Hormusjee Wadia, Byramjee Jeejeebhoy, Cazee Mahomed Yoosoof (sic? Yusuf) Moorgay, Braz Fernandes, and Munguldass Nuthoobhoy.
17 Now the Haffkine Institute.
18 For Birdwood and Indian crafts, see John M. MacKenzie, *Orientalism: History Theory and the Arts* (Manchester 1995), pp. 121–4.
19 Cecil L Burns, *Victoria and Albert Museum, Bombay, Catalogue of the Collection of Maps, Prints and Photographs illustrating the history of the Island and City of Bombay* (Bombay, 1918) lays out this local remit in its introduction. See also Ernest R. Fern, *Victoria and Albert Museum: Catalogue of the Industrial Section* (Bombay 1926).
20 It also contains an important conservation centre.
21 www.bnhs.org. I am grateful to the honorary secretary, J.C. Daniel, for information.
22 Kalpana Desai with B.V. Shetti and Manisha Nene, assisted by Vandana Prapanna, *Jewels on the Crescent* (Ahmedabad 2002), p. xii.
23 In 2008 the museum building was under restoration and stone carvers were working high up on scaffolding illustrating the crafts that this and other Indian museums were intended to preserve.
24 A survey of Indian museums can be found in Shobita Punja, *Museums of India* (Hong Kong 1998).
25 Its foundation stone was laid by the Duke of Clarence on a visit to India in 1890.
26 For an example of a hybrid object produced in Lahore, see Naazish Ata-Ullah, 'Stylistic hybridity and colonial art and design education: a wooden carved screen by Ram Singh', in Tim Barringer and Tom Flynn (eds), *Colonialism and the Object: Empire, Material Culture and the Museum* (London 1998), pp. 68–81.
27 Tim Barringer, 'Victorian Culture and the Museum: Before and After the White Cube', *Journal of Victorian Culture*, 11, 1 (2006), pp. 133–45, particularly pp. 135–6. The galleries are divided up into textiles, arms and art. Punja, *Museums*, pp. 202–7.
28 Giles Tillotson, 'The Jaipur Exhibition of 1883', *Journal of the Royal Asiatic Society*, 14 (2004), pp. 111–26.
29 For a discussion of hybrid architecture, see Deborah Swallow, 'Colonial architecture, international exhibitions, and official patronage of the Indian artisan: the case of a gateway from Gwalior in the Victoria and Albert Museum' in Barringer and Flynn (eds), *Colonialism and the Object*, pp. 52–67.
30 P.H.D.H. de Silva, *Colombo Museum: One Hundred Years, 1877–1977* (Colombo 1977).
31 Quoted in ibid., p. 34.
32 On his return to Britain, Gregory again threw himself into the affairs of museums, as well as of the Royal Irish Academy. A grand statue was later erected in the grounds of the Colombo Museum.
33 www.museums.gov.lk.
34 www.museum.sarawak.my.
35 See the Report on the Perak Museum for 1903 published in the *Journal of the Federated Malay States Museums*, vol 1, 1 (1906), pp. 31–5. The 1904 report is in ibid., 1, 3 (1906), pp. 83–4.
36 See the article on museums by H.C. Robinson in Cuthbert Woodville Harris (ed. Malay Civil Service), *Illustrated Guide to the Federated Malay States* (London 1910–11), pp. 252–5.
37 Report on the Perak Museum for 1904, p. 96.
38 Robinson, 'Museums', p. 273.
39 Report of the Selangor Museum, *Journal of the Federated Malay States Museums*, 1, 1 (1906), pp. 35–7. 1904 Report in ibid., 1, 3 (1906), pp. 83–6. The anthropometric

measurement programme was mainly directed at the Aboriginal peoples of the Peninsula. The *Journal of the FMS Museums*, VI, part II (1915) contained 'Notes on various Aboriginal tribes of Negri Sembilan', by Ivor H.N. Evans, and 'Measurements of some Sungkai and Slim, South Perak, with notes on the same', by C. Boden Kloss with a large series of photographs of these peoples.

40 John M. MacKenzie, *The Empire of Nature: Hunting, Conservation and British Imperialism* (Manchester 1988).
41 An account of these developments can be found in a section on the Raffles Library and Museum, by Dr R. Hanitsch (the curator of the museum) in Walter Makepeace, Gilbert E. Brooke, and Roland St J. Bradell (general editors), *One Hundred Years of Singapore* (two volumes, London 1921, republished in Singapore with an introduction by C.M. Turnbull in 1991), vol. I, pp. 519–66. Dr Morrison at the opening meeting announced that College, European Library and 'extensive Museum' would have the effect of 'diffusing knowledge to Chinese and Malay students'.
42 Farquhar (1770–1839) was in the EIC Madras Engineers from 1790. Serving on the expeditionary force which took Malacca from the Dutch in 1795, he acted as resident there from 1803 becoming Resident and Commandant in 1813 after participating in the invasion of Java in 1811. He spoke Malay and married a Malaccan girl, with whom he had six children. Working with Raffles on the cession of Singapore he was then Resident there from 1819 to 1823. Raffles believed that Farquhar had not followed his instructions and dismissed him, though he was popular with merchants and the native community and is now honoured as a more sympathetic Resident.
43 This collection of some 477 paintings was sold by the London Royal Asiatic Society in London, and was presented to the museum by a wealthy businessman. There was a major exhibition, when all were exhibited together for the first time, in the museum in 2007. The paintings are particularly valuable for their synthesis of Chinese artistic tradition with western expectations.
44 An interpretation featured in the magnificent Singapore history galleries in the National Museum.
45 'Straits Settlements, Annual Report on the Raffles Library and Museum, for the year ending 31st December, 1893', p. 1, when the library was said to be in its fiftieth year, the museum in its twentieth.
46 Hanitsch in Makepeace et al. (eds), *One Hundred Years*, Vol. I, p. 535.
47 Raffles invited Wallich to Singapore in 1822 to advise on the creation of a garden.
48 These dates can be found in Makepeace et al. (eds), *One Hundred Years*, vol. II, p. 587.
49 Charles Burton Buckley, *An Anecdotal History of Old Times in Singapore from the foundation of the settlement under the Hon. East India Company on February 6th 1819 to the transfer to the Colonial Office as part of the colonial possessions of the Crown on April 1st 1867* (Singapore 1902, republished with an introduction by C.M. Turnbull 1984), pp. 304–5 and 683.
50 Ilsa Sharp, *The Singapore Cricket Club, 1852–1985* (Singapore 1985), pp. 13–21.
51 Makepeace et al. (eds), *One Hundred Years*, Vol. I, p. 541.
52 A copy of this despatch is printed in the Report for 1874.
53 John E. Findling (ed.) and Kimberley D. Pelle (assistant ed.), *Historical Dictionary of World's Fairs and Expositions, 1851–1988* (New York 1990), entry by Catherine Dibello, pp. 44–47. John Allwood, *The Great Exhibitions* (London 1977), p. 48, thought they were a 'dull, almost scientific, display of goods'.
54 John M. MacKenzie, *Propaganda and Empire: the Manipulation of British Public Opinion, 1880–1960* (Manchester 1984), chapter 5.
55 The combination may have followed the BM; even the cases were ordered on the BM model.
56 Some came from a Mr Newman in Bangkok; others from Captain Kirk of the steamer, *Royalist*, illustrating yet again the role of ships' captains and other maritime people in the collecting imperative. In 1874, a collection of stone adzes, arrows and other items from New Guinea was purchased from the sailors of HMS *Basilisk*

for the sum of $70. Ethnological specimens were acquired from Borneo and a collection of woods from J. Meldrum of Johor.
57 Initially, two soldiers from the garrison took charge of the animals, but this was a failure, and a European keeper was appointed.
58 Report, 1876.
59 Report, 1885.
60 *Journal of the Straits Branch of the Royal Asiatic Society*, July 1878 (Singapore 1878), pp. i–xi.
61 'Inaugural Address by the President, the Venerable Archdeacon Hose', delivered on 28 February 1878, ibid., pp. 1–12.
62 Hose analysed the identities of writers of papers contributing to this journal and revealed the range of professions and of nationalities represented, including 'as a promise for the future, one Chinaman'. Subjects of papers embraced all the natural sciences, economic products and the arts, together with statistical material on population, trade, weather and temperature.
63 Miklouho or Miklucho-Maclay gave the paper on Malay dialects. For his Sydney connections, Peter Stanbury and Julian Holland, *Mr Macleay's Celebrated Cabinet* (Sydney 1988), pp. 53 and 153.
64 'A review of the Forty Years' Work of the Society', an address at the AGM of 28 February 1917, *Journal of the Straits Branch of the Royal Asiatic Society*, vol. 78, June 1918 (Singapore 1918), p. xi.
65 Quoted in Gretchen Liu, *One Hundred Years of the National Museum, 1887–1987* (Singapore 1987), p. 9. See also Rajamogan (son of Sumiah Chelliah), 'The National Museum in Historical Perspective 1874–1981', BA (Hons) thesis, department of History, National University of Singapore 1987/88 and Teo Moey Marianne, 'Singapore National Museum: History and Future', MA dissertation (Museum Studies) of the University of London, 1987, and the annual reports of museum, library, zoological gardens and botanic gardens available from 1874. Those up to and including 1919 were used for this work. See also *Bibliography (1874–1987)* compiled by Kow-Tan Siew Kwee and Tan Tai Peng (Singapore 1987), with useful listings of curatorial staff and their publications. These indicate that anthropology gradually came to the forefront.
66 Davison's desire to open the museum on Sundays only happened in the 1920s. See Rajamogan, 'National Museum', p. 13.
67 Report, 1893.
68 A five-day voyage from Port Swettenham was reported in 1911, Report, p. 6.
69 Report, 1897, p. 4.
70 Reports by Hanitsch 1897, 1898 and 1899. The 1900 report had a long section on ethnography and he included information about antiquities secured from excavations.
71 Report, 1890, p. 3.
72 Report, 1903, p. 4.
73 Ibid., p. 6.
74 Report, 1907, p. 5.
75 Gretchen Liu (ed.), *Treasures from the National Museum of Singapore* (Singapore 1987), p. 11. For the silver and gold collections, see the chapter by Lee Chor Lin, pp. 36–7. See also Baldev Singh, *Malay Brassware: a Guide to the Collections* (Singapore 1985); Eng-Lee Seok Chee et al., *Kendis: A Guide to the Collections* (Singapore 1984).
76 In 1910, a major Malay festival turned out large numbers, as did the Tamil festival in November, when 'crowds became vociferous sightseers'. Report, 1910, p. 11.
77 This was in 1920. See Rajamogan, 'National Museum', p. 30. In 1894, it was reported that there had been 74,813 visitors, a very high proportion, but maybe reflecting Haviland's anxieties about accuracy.
78 Hanitsch reported in 1897 the interest of Chinese visitors in animals 'appealing to their emotions'. In 1909, a large male elephant was shot by the Sultan of Johor and Hanitsch led the expedition to recover it, accompanied by Valentine Knight, P.M. de

Fontaine, assistant taxidermist, and Ah Wong, the Collector. Some 25 Malay, Tamil and Chinese 'coolies' were employed. Although only a skeleton, it was immensely popular. Hanitsch, *The Singapore Free Press*, 22 November 1909, reprinted in Liu, *One Hundred Years*, pp. 34–5. A full-grown tiger was later purchased from a dealer. Report, 1912, p. 3.
79 The rajas of Rhio and Lingga were in this category.
80 For historical paintings and prints, see Marianne Teo's chapter in Liu (ed.) *Treasures*, pp. 216–17.
81 In 1918 the gates were widened for access by motor traffic, perhaps indicating greater usage by Europeans and prosperous members of the Chinese and Malay communities.
82 Hanitsch had welcomed scientists from Germany and Russia, the Duke and Duchess of Mecklenburg with Dr Münter, Wu Ting Fang, Chinese Minister in Washington, Raja Brooke, Prince Alexander of Teck, Count Nils Gyldenstolpe, and Mr and Mrs Sidney Webb. Reports 1910 and 1911.
83 E.J.H Corner, *The Marquis, a Tale of Syonanto* (Singapore 1981) recounts the history of the library and museum under the occupation. Corner suggested that hospitals, the College of Medicine, Government House, the museum and the botanic gardens all escaped looting. Later, returning British forces posed a danger: Corner and Archey prevented the botanic gardens from being used as a military supply depot and the herbarium as a barracks – the fate of the botanic gardens at Peradeneya, Ceylon. Corner, *The Marquis*, pp. 146–8.
84 This was the arrangement when I first visited the museum in the 1990s.

CHAPTER ELEVEN

Conclusion

> The first function of a Museum is to give an example of perfect order and perfect elegance to the disorderly and rude populace. Everything in its own place; everything looking its best because it is there; nothing crowded, nothing unnecessary, nothing puzzling. (John Ruskin)

This quotation appeared as an epigraph to the guide to the Canterbury Museum, Christchurch, New Zealand, published in 1895. It clearly represented an ideal to which the museum and its curator aspired. Yet the reality was very different. 'Perfect order' and 'perfect elegance' were seldom achieved by the colonial museum. The 'disorderly and rude populace' (making due allowance for Ruskin's typical condescension) were seldom initially influenced by museums because of the nature of class consumption and the racial complexities of the colonial setting. The notion of everything in its own (and presumably unchanging) place assumed another form of unrealistic perfection, namely of arrangement and of aesthetics, while 'nothing unnecessary, nothing crowded, nothing puzzling' made assumptions about the practicalities and the funding, the confidence of contemporary disciplines and the expertise of curators, which were belied in the eternally messy experience of museums. Only the notion that 'things' were reified into objects of significance by their very presence in the museum bears some ring of truth, though repeated transformations of meaning through the generations were outside Ruskin's experience.

Ruskin's idealism, skewed towards his particularly didactic and aesthetic ends, seems all the more unrealistic when applied to the various phases through which museums passed in the nineteenth and early twentieth centuries. These steps in museum development are highly instructive. They can perhaps be divided into five, identified as the proto-foundation, the pioneering, the transitional, the pre-modern and the modern. These may not be strictly applicable to all the museums examined here, but key elements of each can be found

in the dissemination and development of the museum idea throughout the British Empire. Nor are they discrete in a chronological sense. The dates are purely notional: periods shade into each other and are often hard to distinguish. Nevertheless, such an analysis does seem useful.

The proto-foundation phase would cover the time when there were early tentative museums reflecting the initial burst of enthusiasm of private societies and other institutions, including the religious. Canada mirrored European developments more closely because of its longer history of settlement, but everywhere we can identify an initial era of the prototype assemblage, lacking in official support and, generally, interest beyond that of a small elite. At this time (pre-1800 and the early years of the nineteenth century), the museum idea had not yet fully formed, and in consequence it covered many different objectives including the religious and the educational. In the overlapping pioneering phase, however, the museum tends to have strictly pragmatic objectives, concerning itself with the resources of the territory and attempting to establish itself through its allegedly practical and developmental virtues. The rhetoric claims its social and economic significance for the incipient colony, largely to encourage official support. Sometimes, museums were nurtured within geological surveys precisely to combine scientific value with the potential advice to prospectors, miners and dealers. At this time, the museum usually lacked separate professional staff, securing expertise from geological and other establishments. It often lacked a building, but occupied rooms in government offices or parent organisation's headquarters. The museum was viewed as an adjunct to other economic work.

When the museum added, or sometimes originated with, wider natural historical concerns, it often remained the preserve of a small elite club, a bourgeois group that pursued interests inherited from, but also rapidly enhancing, the development of academic disciplines and societies in Britain and elsewhere. Early colonial scientists were more concerned to send specimens to the national institutions in the UK, partly to demonstrate the importance of the colony. Dominant figures in London, such as Richard Owen, wielded considerable influence over colonial curators and their museums, although that power was sometimes challenged and a tradition of exchanges of both ideas and specimens across colonies became well established. However, the focus was localised in a variety of ways, not least when elite groups sought to transform their initial desire to interact with each other (and with savants elsewhere) into an ambition to spread their intellectual 'enlightenment' and their social and moral 'respectability' to other classes, drawing them into the civilised state of studiousness through the museum. Some might well have been readers of Ruskin

CONCLUSION

(in the appropriate period) and were no doubt keen on aspects of his philosophy.

These developments overlap with the 'transitional' phase, perhaps dating to the middle decades of the nineteenth century, though in some colonies the first three phases happen very quickly indeed. The striking feature then was that administrations were seduced into supporting the whole concept. Paradoxically, as this happens, the severe focus on the economic function was often abandoned. It was recognised that private societies were unable to cope with the burgeoning demands of the expansive museum and that geological collections, for example, were too restricted in their focus. Governments were persuaded to endow museums as a recognised arm of the colonial state, an aspect of the prerogatives of 'responsible government' leading to self-rule. Official sanction lent status and offered recognition that the museum might contribute to the standing of the colony. Collections grew, through a variety of methods including exchanges with other territories in the Empire and beyond.

Rhetoric was stepped up in this transitional phase, though the process was contested since some members of legislative councils often lacked conviction in their value. Libraries usually seemed more useful and art galleries attracted a larger audience. Museums remained chronically underfunded, understaffed, and under-supplied with accommodation. In times of recession, they were invariably the first to experience cuts. Thus, although museums interacted with, and were stimulated by, the development of the full range of intellectual institutions, colonial governments seldom danced to the supposedly enlightened tunes of certain sections of their bourgeois elite. The role of the museum in moral improvement and in nation formation was not universally accepted. If it was, it was more by lip service than hard cash.

Nevertheless, ambitions to set up international contacts and plug into global scientific networks can be identified in this period. Elite proponents infiltrated government and advocated that the museum was a cultural institution vital to the colony's yearning to be a nation, an object of value in itself. Along with the exhibitions, which interacted with and influenced museum development, the desire for a display space positioning the colony within a wider international nexus of scientific and commercial endeavour became a key rite of passage. Science at this time was on the way to being an autonomous entity, feeding ideas to the metropolis rather than the other way round. There was a desire to stress the achievements of the particular colony. Nevertheless, internationalism was furthered by the fact that many early curators were Germans (in one case French, in another Silesian), maverick figures, but bringing wider ranges of contacts and expertise

to bear. It is interesting that, after 1859, they were often more open to Darwinian notions of evolution by natural selection than some of their contemporaries.

The satisfying of these colonial aspirations became more significant in the pre-modern period, often helped by economic development. This phase can be seen to run roughly from the 1860s to the inter-war years. Museums were given stronger legislative backing, with boards of trustees or governors. The need for new and better buildings was invariably recognised if these ambitions were to be fulfilled. Museums were generally in the hands of dominant and reasonably well-qualified staff (if small in numbers and not yet fully professionalised). By Edwardian times, the staff base had expanded and there was a move towards the creation of departments, reflecting the greater delineation and progressive subdivision of disciplines. Scientific respectability grew, particularly in league with colonial universities founded in that period (in some cases a little earlier, particularly where a college preceded full university status). These connections with tertiary education initially helped to give many museums credibility in their adherence to some of the great scientific ideas of the age. Some were more dubious than others such as the fascination with the 'science' of race, which led to the extensive collection of human remains. Evolutionary ideas, after a choppy period of controversy in the period from the 1860s to the 1890s, came to be more fully accepted.

Museums also made the almost universal shift towards ethnography (and also archaeology) with the extensive correspondence and exchanges with other institutions throughout the world stepped up. Along with this went a realisation that a visiting public had to be catered for: new and attractive displays (for example, dioramas and stuffed fauna) were created and trustees and writers of annual reports recognised that visitor numbers (however dubiously compiled) were actually important, not least in convincing funders that the museum was popular and had educational value – the latter a newly prominent concern.

At the same time, museums often had to make hard choices. It became obvious that any attempt to replicate the great institutions of Europe and the USA in their global sweep was not possible, either in terms of space or of funding. So there was a tendency to heighten the focus on the local (the Royal Ontario in Toronto was the great exception). The establishment of research publications constituted another step in the march of the museum towards scientific respectability, also enhancing educational roles. Education became yet more significant in the inter-war years, often under the influence of international foundations like the Carnegie. By this time, most importantly, the museum's

CONCLUSION

role in the establishment of identity was beginning to be apparent.[1] By the end of this 'pre-modern' period, visitor numbers seem much healthier (although they often dropped back in times of economic difficulty, as in the early 1930s); budgets were more realistic, if also subject to recessionary pressures; and the whole institution was generally more self-sustaining. It had become a key component of patriotic endeavour, made ready for the appropriation of knowledge as part of a modern nationalist thrust.[2] Interestingly, the staff tended to become more exclusively British and the networks more imperial. The tradition of 'transverse' relationships across colonies (and with other non-British or non-anglophone polities), already established in the nineteenth century, continued to be pronounced.

The modern period (only superficially covered in this book) would be characterised by full professionalisation, by an explicit desire to draw in the public through accessible exhibits designed to achieve this, and by a mature recognition of the educational and recreational value of the museum. The realisation that the museum is also about community identities, that it should be inclusive rather than exclusive (in respect of indigenous peoples, for example) is also typical of the modern. This progressive inclusiveness had to pass through a series of phases, initially embracing the social classes of white (mainly British) settlerdom, then through diverse ethnicities created by wider migration patterns, before reaching out to other categories of 'native' peoples. In the modern (and some might say also the 'post-modern') phases museums become much more self-reflective and major renovations and reorganisations are set in train. As it happens, this coincides with a decline in the relationship between the museum and tertiary education, a time when scientific and anthropological research becomes much more laboratory- and field- rather than specimen-based. Some museums remain important in the international nexus of knowledge, but proportionately less so than they had been in the nineteenth century. The economic thrust of the museum has moved in the direction of tourism. People now circulate more regularly than things.

These phases can be characterised in another way. At first, prototype museums were entirely localised and specific in their aims. When the territory became the focus, the advocates of colonial museums turned towards the economically practical, arguing for the need for local knowledge to stimulate development (and therefore migration). But they soon thought in terms of metropolitan models. In the innocent age of hesitant beginnings, ambitious founders sometimes imagined that they could create great institutions to vie with European and American equivalents. At this point, the belief in progress – and in the positive role of the museum – was so profound that the expectations

of such progress became wildly overblown. Such ambitions survived the transitional phase, but with the pre-modern, the realisation grew that the museum cloth had to be cut to the colonial width. Museums had to become distinctive in terms of their local environments. This coincided with the great shift towards ethnographic collecting, which progressively became more concerned with a local anthropological focus. The museum began the search for a more specific identity. This characteristic became more pronounced in the early twentieth century, when it was dawning on some contemporaries that distinctive identities can best be rooted not only in local environments, but also in the cultures of indigenous peoples. By the modern period, this tendency had been fully worked out.[3] Thus museums throughout their histories were fully involved in discourses of both imperial and national identities, categories that are not necessarily exclusive.[4] Yet identities were more complicated even than this. They can also embrace aspects of provincial and civic power. As too many scholars fail to notice, identity can also adopt significant local forms. Despite the great transformation in scale, there is a sense in which some museums have come full circle, from local to national to local again. The foundation of genuinely 'national' museums in the modern era, specifically focusing on the nation and its peoples (the Australian National Museum in Canberra and the New Zealand Te Papa in Wellington are good examples) has heightened this sense of the civic or provincial pride in others.

These changes should not be seen as representing some kind of 'progressive' continuum. The modern expression of the museum idea is no more immutable than its nineteenth- or twentieth-century predecessor. An excessive adherence to contemporary fads and fancies, for example, can sometimes make reconstructions date rapidly. Thus, museums remain highly malleable. They are capable of reforming, refocusing and re-presenting themselves, using the same collection, in the light of constantly changing ideas. As Eilean Hooper-Greenhill has pointed out: 'the radical potential of material culture, of concrete objects, of real things, of primary sources, is the endless possibility of rereading'.[5] In some respects, in the course of the transformations in the colonial museum, a scientific gaze was transformed into an aesthetic and social one. But this should not be over-emphasised: contemporaries saw the sciences of nature and of people as seamless. Still, they largely failed to notice the shift taking place from an international scientific focus to a more local cultural one. Thus, museums, as well as being re-drawn in scientific and aesthetic, spiritual and ideological ways, can contribute to a sense of the variety of levels of identity demarcated by the imperial, the colonial, the self-governing territory, the civic and modern nationalism. None of these is exclusive.

CONCLUSION

As this progression has worked through, museums have multiplied: they now exist in many different formats and are dedicated to a wide variety of purposes. They can also be found in many stages of reconstruction, part of this process of repeated transformation. Some in the Commonwealth seem to be preserved in aspic – as in some galleries in the Indian Museum, Kolkata, or the Pacific ethnography display in the South Australian Museum, Adelaide. Notable examples of overall reconstruction and reformulation can be found in Victoria, British Columbia and Melbourne or Singapore. Some are redeveloped little by little, often limited by resource constraints. Some, like the Royal Ontario in Toronto, are so large and significant that landmark buildings have been added (by the architect Daniel Liebeskind) and major reconstructions have taken place in individual galleries. Specific displays are today constantly rethought in a dynamic and self-reflecting process, if funding is available.[6] Museum practitioners would of course be deluded if they imagine they have reached a state of Ruskinian perfection, where they can rest in a state of museological nirvana.

Major reconstructions have occurred in museums in Britain in recent years, and these have some resonances for Commonwealth developments. One example would be the notable Kelvingrove Art Gallery and Museum in Glasgow.[7] When this museum opened in 1901 (built on the profits of the city's 1888 exhibition), it presented the world to Glasgow. As an emblematic example of civic pride expressed through the great recreational and educational museum, its object was to display to visitors the geology, zoology, civilisations, peoples, and the great artistic achievements (mainly of Europe) of humankind. As such it was divided into strict departments, art upstairs, the natural world and artefacts (including ethnography) downstairs. After its costly renovation, the focus has shifted to presenting Glasgow and Scotland to the world. The division between upper and lower floors has been abandoned. Glasgow's contributions to art and design are highlighted, prominently displayed on the ground floor. Some of the ethnographic materials are now used to illustrate the multi-ethnic character of the city. Others are shown against European contexts in order to reveal the magnificence of their craft values (e.g. Benin bronzes). Art and artefacts are brought together to demonstrate the ways in which Scotland has been represented in different media. Barriers have been broken down by displaying themes (for example, the human form as depicted in global arts of past and present). Interpretation is more extensive than before, the curators explaining (perhaps over-explaining) contexts and meanings more than in the past. The focus is narrowed by the creation of more specialised museums (such as transport) elsewhere.

Another way of doing all of this is illustrated at the refurbished

Walker Art Gallery and Museum in Liverpool, where the celebrated ethnographic displays remain, but the artefacts are presented as far as possible through the eyes and words of their own cultures as well as through the perceptions of collectors and travellers. In London, the removal of the British Library to its own building enabled the BM to bring all cultures together. The anthropological collections lurking in the separate Museum of Mankind (code for non-western humankind) have now been moved into the main building. This constitutes much more than a geographical repositioning. It speaks of an ideology that insists that all cultures must be given equality of status, at least presented in adjacent space. Meanwhile, at the ROM in Toronto a new First Nations gallery attempts to use different viewpoints, including recordings, to present ethnographic materials. But the central display method is still based upon the activities of individual 'ethnologists', which some might see as uncomfortably close to presenting First Nations peoples through the eyes of those who visited and collected among them in the past.

An additional example lies at the very heart of Afrikaans identity in South Africa and related historical myth. Even the Voortrekker Monument in Pretoria/ Tshwane, a truly monumental Art Deco shrine to white expansion, settlement and defeat of black resisters, has been adjusting itself to the new conditions. Built and opened in 1937 as a celebration of the centennial of the Battle of Blood River between Boers and Zulus, it represented a high point of white authority and dominance. Now the visitor encounters new displays, which attempt to set the Great Trek of the Afrikaans people into worldwide traditions of migration, including Mongol, Arab, North American Indian, and so on. By revising the 'exceptionalism' of the Boer Trek, formerly a key element in its mythic character, this is intended to soften the edges of this most disruptive of historical events for black people in southern Africa. In 2005, new and old displays survived together, identified by linguistic signifiers. The old ones (typically displaying firearms and other artefacts of Afrikaans culture) were captioned only in Afrikaans. The new ones also had captions in English and Sotho, the language of the province of Mpumalanga where Pretoria/Tshwane is situated.[8] While new exhibits offered some response to fresh political realities, nothing could be done about the heroic sculptures around the outside of the Monument or in its great central hall. These could only be reinterpreted as evidence of a white triumphalism at a particular moment in historical time. And that is a reminder that the museum has external as well as internal characteristics. Enquiring visitors should consider their responses to the museum structure before entering it. Indian examples present object lessons here.

CONCLUSION

In all these ways it has been truly said that museums have been transformed in modern times: from temples into forums, mausoleums into talking shops. Formerly, they were places where cultural or natural icons, mediated by priestly curators, could be displayed and receive due deference. Curators saw themselves as objective observers. Now their institutions are theatres of debate, dialogue and interactive exchange, where curators are fully involved in the dialectic: they still have power, but it is a power moderated by public review, press criticism, and sometimes demonstrations on the steps. To prevent such demonstrations, museums have consulted local communities and formed advisory groups, as in the slavery displays at the Maritime Museum in Liverpool. In Canada, Africa and Australasia (less so in Asia, where these developments took place at an earlier stage), museum curators have had to become much more sensitive to the needs of indigenous peoples (in Britain, to immigrant diversity). Indeed, it has become essential in the enlightened museum to broaden the ethnic base of museum professionals, though this has often not proceeded far enough. Thus the interpenetration of so-called scientific with indigenous knowledge has (or should have) become institutionalised. Still, this is not a purely modern phenomenon. As described in this book, colonial information about the natural world was invariably derived from 'native' helpers (who acted as collectors and informants).[9] In these ways, global scientific networks (sometimes regressive as well as radically modern) interacted with the local dynamic exchanges of ideas.

Some museums continue to play a significant role in scientific research. Some still publish the journals founded in the late nineteenth and twentieth centuries, when they seemed to be a significant stage on the route to scholarly respectability. Almost all significant museums continue to maintain libraries and archives as research tools for their own staff and as a public resource (the Royal British Columbia Museum is a notable exception to this pattern). Many larger museums have developed significant conservation functions or make important contributions to environmental issues.[10] It is instructive that when the Bhau Daji Lad Museum in Mumbai (formerly the V&A) reopened in 2008, it contained an important conservation unit of value to a wider museum sector. In these ways, museums enhance their reputation with their peers, the public, and pressure groups concerned with 'heritage' and environmental affairs.

Nevertheless, museums and their staffs need to maintain their vigilance against the danger that their rather grand reputations (and architectural presences) will foster the self-arrogated cultural authority inherent in their histories, transferring it to visitors and observers. New ways of presentation will never be the last word: they are always just

one phase in the repeated representation of the museum. One scholar has written – very pertinently from the point of view of museums – that too often 'archaeologists, trying to define sites and their history, feel they can stand on the debris of their own and others' ancestors with equanimity, colonising the space for themselves'.[11] There have been, perhaps, too many instances of standing on debris and colonising spaces in this book, and hopefully reflective and self-critical approaches will help to avoid this.

We should also remember that museums, however dubious they may or may not be in their cultural origins, are also highly vulnerable places. The breakdown of 'failed states' and the damage wrought by war have placed many museum collections at risk. The extensive looting of the Baghdad Museum of Iraq in April 2003 caused the removal and, in some cases, destruction of priceless relics of the great Mesopotamian civilisations. One professor at an American museum described this as being equivalent to the destruction of the Uffizi, the Louvre and all the museums in Washington DC, while another characterised the events as a form of cultural genocide.[12] Yet American soldiers stood by and some may even have participated. The significance of the whole incident was treated lightly by the American Secretary of Defence, Donald Rumsfeld, who denied that the American army had any role in policing Iraq and dismissed the losses with the notorious phrase 'stuff happens'. It was apparent that he did not consider that these events diminished in any way his inheritance of world cultures. Meanwhile, as the Mugabe regime in Zimbabwe set about redefining in tragic ways the concept of the 'failed state', its museum collections also came under threat. In 2006 serious losses began to be noted from these fine assemblages of African art and artefacts. Some were opportunist thefts, but others may well have been by senior staff (no doubt resentful at not being paid or pressured by terrifying inflation and problems of subsistence and health), with items smuggled out of the country and sold on the world market.[13]

Perhaps the very vulnerability of museums helps to demonstrate that the notion that they do not acknowledge their own history cannot be sustained. Craig Clunas has written that, 'It is very hard to research the history of a museum. The point of a museum is that it has no history.' Hence, 'the museum cannot allow itself to document its own frequently changing display arrangements, since then it will have a history and if it becomes a historical object in its own right then it can [be] investigated, challenged, opposed or contradicted'.[14] If this were true, this book would have been much more difficult to research and write than it has been. It may be that in the early days of colonial museums, their founders really did believe that they were building

CONCLUSION

unchanging shrines where scientific and public observers could be the votaries of their natural and ethnographic mysteries. But it was soon apparent that this would not be the case. The reality is that photographs and trustees' annual reports do indeed chart the historical development of the museum, its changing displays and expanding buildings. They were certainly soon challenged, opposed and contradicted and if curators originally resented such public exposure, they soon came to recognise that they had to live with it and manipulate it to their own ends.

Amy Woodson-Boulton has recently written (in 2008) that 'no work has yet tried to synthesise a study of the great number of museums founded as a general Imperial movement'.[15] This book represents an effort to plug that gap. She has also suggested that 'the museum movement in Britain and its Empire was widespread, but locally driven, without any central administration'.[16] While the preceding chapters have confirmed this view, they have also revealed that the imperial museums movement was something more than a case of spontaneous and independent growth. It was an inseparable part of the throwing of a Victorian cultural net across imperial territories, closely bound up with a habit of mind exhibiting global reactions to studies and concepts of nature, the interactive debate stimulated by scientific controversies, and fresh, if sometimes deterministic, awareness of the relationships among humans and their cultures in their earlier and current manifestations. While museum formation and collecting only occasionally elicited the formality of an imperial despatch from London, nevertheless, they were subject to a striking set of networks, imperial and international, which ensured that no institution developed in isolation.

Perhaps the great unknowable remains the whole question of visitor reaction.[17] There were no visitor surveys in this period and the users of museums (apart perhaps from the elite that spawned them and theorised about their value) remain essentially shadowy. Annual reports offer few clues and it is clear that, as in Europe, visitors would have ranged from those who genuinely sought self-instruction to those who were making the museum, as Ruskin put it, a 'refuge against either rain or ennui'.[18] For Ruskin the museum should be dedicated to 'the manifestation of what is lovely in the life of Nature, and heroic in the life of Men'; it should be for simple persons, by whom he declared that he meant 'children' and 'peasants' (scholars should be elsewhere); it should contain the least things and the greatest (but only if they are good of their sort); above all it should not be a theatre, but a source of 'noble education' where the simple should go 'to learn and the wise to remember'. Ruskin's improving philosophy is perfectly symbolised by his stern assertion that, 'There should be a well-served coffee-room attached to the building; but this part of the establishment without any

luxury in furniture or decoration, and without any cooking apparatus for carnivora'.[19] Displaying fauna and eating meat seemed too incongruous a conjunction.

Some modern museums have become elegant cafes and restaurants, retail emporia and corporate space, with a museum attached.[20] Their new role as tourism and leisure precincts, often catering to an international as well as a local audience, has helped to reorientate them towards visitors rather than to collections, itself a recognition of the fact that in the modern world it is people who move more freely than things. All of this re-emphasises the role of the museum as itself a metaphor for travel, offering cultural staging posts to tourists.[21] In almost all cases, museums have indeed become theatres, stages with a perpetual enactment of identities presented through the intertwining of past, present and future. It is clear that they began to perform this role in the colonies at an early stage, certainly as soon as grander buildings were created for them. We know that visitors found certain 'acts' upon this stage more agreeable than others (the simulacrum of reality through taxidermy was one). They also, regardless of whether they were practitioners of the 'glance' or the 'gaze', began to see this theatre as producing a perpetual (and, as it turned out, constantly changing) performance of different sorts of identities. Indeed, it is apparent that the visitors' use of the museum often ran ahead of the curators' intentions.

When large numbers of Chinese, Indian and Malay visitors began to find museums in South-East Asia a convenient extension of their religious festivals, it is clear that something notable in identity formation was taking place. They were, perhaps, experiencing the thrill of finding themselves.[22] The same effect also occurred in India and later in the territories of white settlement. The museum had been so eclectic in its displays that in one era it could foster the local colonial identity of whites while in another it could reconstitute the cultural yearnings and sense of both dispossession and renewal in its indigenous users. In modern times, these two streams may have found a valuable confluence. In consciously offering insights into identities for a modern travelling (and local) public, they have transformed themselves from imperial into nationalist institutions, even if their origins within empire can never be fully obscured.

Observing other visitors in museums remains as stimulating an activity as examining the collections. Live humans in museums, particularly in multicultural contexts, constitute the most intriguing study of all, something that Ruskin might not have anticipated. Ultimately, museums are nothing without visitors and, as with all media, the audience often takes from the experience quite different

CONCLUSION

cultural sustenance from that which they are being fed. That perhaps is the main lesson presented by the colonial museum. The view from above is well documented; that from below much less so. Yet there are enough clues to help us realise that visitors often went there for reasons other than those presented by their creators. This is not to deny that some went for precisely the ideal mixture of instruction and frisson of discovery that curators hoped for. Museums, as T.H. Huxley once put it, should offer an experience of 'recreation by wonder'.[23] But other visitors, whether sheltering from the rain or not, found intriguing messages about themselves. Both ecological and multicultural museums – or displays in institutions with a wider focus – can now be found in many places. But perhaps visitors were finding messages of environmental and multicultural identities in colonial museums long before they were intended to do so. That is why they were important and are increasingly so in modern times. And this is where they have often creatively diverged from their parent European stock. The colonial museum mutated into the 'national' (sometimes meaning provincial in federations) very quickly. Studies of museums need to pay them much greater attention.

Notes

1 For a wider discussion of this phenomenon, see F.S. Kaplan (ed.), *Museums and the Making of 'Ourselves': the Role of Objects in National Identity* (Leicester 1994).
2 This 'model' of museum development in relation to the colonial state represents a modification of Saul Dubow's fivefold analysis of the inter-relationship of scientific knowledge, power and identity in South Africa. Dubow, *A Commonwealth of Knowledge: Science, Sensibility and White South Africa 1820–2000* (Oxford 2006), pp. 12–13. His phases involve the creation of a white middle-class civic order; the incorporation of scientific societies into the institutions of a self-governing colony; efforts at reconciliation of Afrikaans and English speakers in the 'South Africanisation' of science; emphasis on South African patriotic achievement; and the 'renationalisation' of science in the apartheid era. This study of museums is, however, able to give greater prominence to indigenous peoples, their contribution to knowledge and their changing relationship with the museum.
3 This analysis of phases of response is very close to one I proposed for colonial art in John M. MacKenzie, 'Art and the Empire', in P. J. Marshall, *The Cambridge Illustrated History of the British Empire* (Cambridge 1996), pp. 296–315.
4 For a discussion of the interpenetration of these two forms of identity, based on the work of Carl Berger in respect of Canada and Keith Hancock for Australia, see Dubow, *A Commonwealth of Knowledge*, p. v.
5 Eilean Hooper-Greenhill, *Museums and the Shaping of Knowledge* (London and New York 1992), p. 215.
6 Robert Lumley (ed.), *The Museum Time Machine* (London 1988), particularly Brian Durrans, 'the future of the other: changing cultures on display in ethnographic museums', pp. 144–69. Christina F. Kreps, *Liberating Culture: Cross-cultural Perspectives on Museums, Curation and Heritage Preservation* (London 2003) considers the Eurocentric museum model in the non-European world (museums in this study would all be examples) and indigenous models of museums, though in a contemporary time frame.

7 I spent part of my boyhood in a tenement flat directly opposite this museum: it was the most significant museum influence on my life.
8 Personal observation, 2 April 2005.
9 C.A. Bayly, *Empire and Information: Intelligence Gathering and Social Communication in India, 1780–1870* (Cambridge 1996), p. 7 and William Beinart and Lotte Hughes, *Environment and Empire* (Oxford 2007), p. 208 discuss the interpenetration of knowledge systems.
10 Peter Davis, *Museums and the Natural Environment: The Role of Natural History Museums in Biological Conservation* (Leicester 1996).
11 Paul Lane, 'Breaking the mould? Exhibiting Khoisan in South African Museums' in *Anthropology Today*, 12, 5 (1996), p. 7.
12 *The Guardian*, 10 June 2003. An exhibition on the destruction wrought upon the site of Babylon by the coalition forces opened in the BM in London in November 2008.
13 Details about these thefts are on the website of the Museum Security Network, http://msn-list.te.verweg.com, and other associated websites.
14 Craig Clunas, 'China in Britain, the Imperial Collections', in Tim Barringer and Tom Flynn (eds), *Colonialism and the Object: Empire, Material Culture and the Museum* (London 1998), p. 44.
15 Amy Woodson-Boulton, 'Victorian Museums and Victorian Society', *History Compass*, 6 (1), pp. 109–46 (January 2008). www.blackwell-compass.com/subject/history. This quotation comes from footnote 53, p. 134.
16 Ibid., p. 111.
17 Philip Wright, 'The Quality of Visitors' Experience in Art Museums', in Peter Vergo (ed.), *The New Museology* (London 1991), pp. 119–48 offers a rare analysis of visitor experience.
18 E.T. Cook and Alexander Wedderburn (eds), *The Works of John Ruskin* (39 vols, London, 1903–12), vol. 34, p. 250.
19 All of these quotations can be found in a series of letters on museums written by Ruskin between March and June of 1880. Cook and Wedderburn (eds), *Works*, vol. 34, pp. 247–62.
20 The Singapore National Museum perfectly represents this development, with the whole of the ground floor of the original building given over to these purposes. But it remains a great museum.
21 These ideas are partly based on Andrea Witcomb, *Re-Imagining the Museum: Beyond the Mausoleum* (London 2003), pp. 4, 23, 49.
22 Ibid., p. 154.
23 This was yet another epigraph to the guide to the Canterbury Museum of 1895.

INDEX

Aboriginal artefacts (Australia) 68, 128, 131, 133, 141, 146–7, 165, 167–8, 170–1, 175–6
Aborigines (Australia) 5, 120, 131, 133, 135, 136, 145, 147, 157, 165–76 *passim*
Adelaide Philosophical Society *see* Royal Society of South Australia
Agassiz, Louis 133, 213
Albany Museum, Grahamstown 79, 94, 105–16
Alcock, Surgeon-Captain A.W. 238
American Museum of Natural History 65
American museums 9, 21, 24, 25, 49, 57, 60, 63, 64, 65, 67, 71, 161, 170, 255, 269
 see also USA
Anderson, Benedict 8
Anderson, C. 131
Anderson, Dr John 237–8
Angas, George French 125–7, 128, 175
Annand, Rev. Joseph 37
Antarctic 223
Archey, Gilbert 203, 258
Arney, Sir George 194
art galleries 12, 17, 32, 44, 47–8, 69–70, 80, 138, 143, 148, 160, 163, 165, 166, 194, 214, 238, 242–3, 259, 267, 271–2
Ashmolean Museum, Oxford 2, 220
Asiatic societies 247, 251
 Bombay 234, 239, 241
 Calcutta (Bengal) 87, 234, 236, 238–9, 248
 Ceylon 234, 243
 London 234, 248, 251
 Singapore (Straits branch) 234, 251–2, 253
Atherstone, William Guybon 105–6, 114–15
Auckland Institute 190–6 *passim*, 200–201, 203

Australasian Association for the Advancement of Science (AAAS) 137, 144
Australian Museum (AM), Sydney 85, 120–32, 148, 171, 213

Bain, Andrew Geddes 81, 106, 109
Banks, Sir Joseph 27, 121, 131
Barker, Dr Alfred Charles 216
Barnett's Museum, Kingston 27, 44
Baroda Museum 242–3
Barry, Redmond 136, 137–8, 141, 142, 146
Barstow, Robert Clapham 194, 196
Batavian Society of Arts & Sciences, Java 256
Beazley, George 164, 165
Bell, Charles 85, 91
Benin artefacts 71, 171, 223, 271
Bennett, Dr George 124, 128, 174
Bennett, Tony 16
Berlin 110, 169
Berlin museums 65, 91, 110, 170, 220
Best, Elsdon 226
Bhau Daji Lad Museum *see* V&A Museum, Bombay
Bikaner Museum 243
Birdwood, Sir George 239–40
Birkbeck, Dr George 26
Blandowski, Wilhelm (William) 127, 134–5, 137, 138, 139, 140
Blyth, Edward 237
Boas, Franz 63, 64–5
Bombay Natural History Society 240
botanic gardens 85, 93, 106, 121, 125, 134, 138, 157, 162, 173, 174, 200, 214, 236, 248
Boyle, David 33–40, 44, 45, 62
Brant-Sero, John Ojijatekha 38
British Association for the Advancement of Science (BAAS) 62, 91, 94, 97, 129, 135, 137, 173, 213

[279]

INDEX

British Museum (BM) 2, 13, 46, 83, 84, 90, 109, 121, 124, 147, 157, 158, 159, 160, 170, 174, 193, 213, 218, 223, 243, 245, 246, 272
Brooke, Raja Charles 244
Broom, Dr Robert 93, 112
Buist, Dr George 239
Byrne, Paddy 145

Campbell, John Logan 193, 201
Canadian Institute *see* Royal Canadian Institute
Canadian National Museum, Ottawa 30, 35, 64, 66, 72
Canadiana Museum 56
Canterbury College, Christchurch 214, 219
Canterbury Museum, Christchurch 162, 171, 199, 210–27, 265
Carnegie, Andrew 185
Carnegie foundation 12, 67, 68, 70, 97, 113–14, 173, 258, 268
casts 49, 109, 128, 139, 194–5, 213, 217–18, 219
 see also human casts
Ceylon 84, 108, 234, 243–4
Chapman, Frederick 147
Chasen, F.N. 258
Cheeseman, Thomas 194–5, 197, 198–200, 201, 203
Chhatrapati Shivaji Maharaj Vastu *see* Prince of Wales Museum, Bombay
China/Chinese artefacts 3, 24, 52, 53–5, 57, 64, 98, 108, 113, 160, 247, 248, 256, 257, 259
Chinese New Year 254, 255, 256
Clark, John Howard 159, 162
Clarke, Captain Andrew 134
Clarke, Sir Andrew 250
Clarke, Rev. William Branwhite 124, 141, 174
Colebrooke, T.H. 234
Colenso, William 190, 193
Collins, James 250, 252
Colombo Museum, Ceylon 243–4, 245
Colonial Museum, Wellington 190–1, 198
 see also Dominion Museum

Cook, Captain James 59, 80, 87, 121, 131, 184, 188–9
Corbin, A.F. 70
Cousens, Henry 241
Cowle, Ernest 145
crafts 4, 13, 25, 65, 67, 71, 175, 196, 227, 236, 239–40, 242, 243, 249, 271
Crofts, George 52, 54
Currelly, Charles Trick 45–58, 64, 72

Darwin, Charles/Darwinism 1, 15, 25, 28, 34, 38, 66, 83, 88, 120, 124, 127, 130, 140, 141, 163, 173–5, 193, 212, 216, 219, 225, 268
Davidson, John 70
Davison, William 253
Dawson, Sir William 30, 34, 39
dealers, artefact 25, 46, 50, 52, 53, 64, 65, 79, 129, 176, 198, 218, 222, 255
Dennys, Dr N.B. 252, 253
Dessin, Joachim Nickolaus von 79–80
Dessinian collection 80, 87, 93
Dickson, B. 189–90
dioramas 44–5, 66, 91, 97, 145, 166–7, 200, 268
Diprotodon 161, 169–70, 174
Dobson, Edward 211
Dominion Museum, Wellington 201, 226
 see also Colonial Museum
Dorsey, George 65, 71
Drury, James 91, 92
Duff, Roger S. 223–4
Dutch 79–80, 90, 246–7, 248, 256

East India Company (EIC) 84, 234, 236–7, 246, 248
Egypt/Egyptian artefacts 27, 30, 32, 45, 46–7, 48–9, 50, 51, 52, 53, 55, 70, 71, 85, 92, 113, 114, 147, 169–70, 221
Egypt Exploration Fund 32, 49, 92, 147
Egyptian Halls, London 83
Elder, Sir Thomas 163, 164, 170
Elora 33–7
Elora Museum 33, 34–5

INDEX

Elphinstone, Lord 239
Entomological Society, London 160
Enys, J.D. 216
ethnography 4, 9, 12, 13, 14, 16, 21, 22, 24–5, 26, 30, 35, 37–40, 51, 56, 58–9, 60, 63, 65, 66, 68, 71, 72, 80–1, 83, 87, 90, 92, 98, 108, 112–14, 115, 125–6, 130, 132, 144–8, 157, 160, 161–2, 165, 167–70, 175–6, 189, 195, 197–200, 201, 220, 222–3, 225, 234, 235, 237, 242, 244–5, 249, 255–6, 257–9, 268, 270, 271–2, 275
exhibitions, international and colonial 2, 4, 26, 33, 110, 141, 161, 166, 239, 249–50, 267
 Adelaide, Jubilee (1887–88) 172
 Calcutta (1883–84) 237
 Chicago, World's Columbian (1893) 37, 65
 Cincinnati (1888) 37
 Dunedin (1865) 190, 213
 Glasgow (1888) 271
 Grahamstown (1887) 109, 110
 Grahamstown (1898–99) 111
 Jaipur (1883) 243
 London, Crystal Palace (1851) 2, 4, 33, 187, 239, 249
 London (1862) 33, 142
 London (1871–74) 249–50
 London, Colonial & Indian (1886) 167, 218, 221, 250
 Melbourne, Victorian (1861) 141
 Melbourne, Intercolonial (1866–67) 141, 142, 146
 Melbourne, International (1880–81) 141, 143
 Melbourne, Centennial International (1888–89) 142
 New York (1853–54) 33
 Paris, Universal (1855) 33, 189, 239
 Paris, Universal (1878) 161
 Philadelphia, Centennial (1876) 32, 161, 170
 St Louis World's Fair (1904) 66
 Singapore, Malaya/Borneo (1907) 256
 Singapore, Malaya/Borneo (1922) 257
 Sydney, International (1879–80) 128–9, 132, 251
 Toronto, National 45
 Vienna, International Industrial (1875) 218
exhibitions, public 1, 16, 26, 44, 50, 69, 70, 83, 114, 134, 141, 194, 197, 214–15, 243
expeditions 1, 37, 48, 49, 55, 63, 65, 82–3, 112, 123, 125, 127, 128, 129, 134, 135, 137, 144–5, 157, 159, 161, 162, 170, 173, 193, 199, 203, 211, 216, 223–4, 255, 258

Fairbridge, Charles Aken 84
Falla, (Sir) R. Alexander 223
Fallows, Rev. Fearon 81
Fannin, John (Jack) 61–2, 63, 66
Farquhar, William 247–8
Federated Malay States (FMS) 244, 245, 257, 258
Ferris, Will 70
Field, Barron 121
Field Museum, Chicago 64, 65, 66, 71, 147
First Nations (Canada) 5, 25, 36–7, 38, 44–5, 46, 51–2, 58–72 *passim*, 147, 272
Firth, Josiah Clifton 194
Fitzwilliam Museum, Cambridge 49, 85
Flavelle, Sir Joseph 48, 50
Fleming, Sandford 2–3, 36, 40
Flower, William H. 127, 164, 218
Foelsche, Paul 168
Forbes, H.O. 222–3
Fothergill, Charles 28–9
Fraser, Rev. Charles 216–17
Frere, Sir Bartle 239

geological surveys 26, 29, 30, 31, 33, 35, 39, 63, 90, 132, 185, 190, 192, 211, 212, 217, 224, 237, 266
Germans 79, 81, 92, 95, 110, 122, 125, 185, 211, 213, 218, 247, 254, 267
Germany 12, 31, 65, 71, 84, 87, 111, 127, 161, 164, 200, 211
Gesner's Museum, St John, New Brunswick 26–7
Gibson-Hill, C.A. 258
Gill, Leonard 96, 97

[281]

INDEX

Gillen, Francis J. 145, 170
Gillies, Thomas Bannatyne 191, 192–3, 197
Glanville, B. 107–9, 110
Glanville, Miss 109
Goodwin, A.J.H. 115–16
Gould, George 219
Gregory, Sir William 243–4
Grey, Sir George 83–6, 107, 108, 157–8, 160, 166, 216
Griffiths, Tom 141
Gunson, James H. 201

Haacke, Dr Wilhelm 164–5
Haast, Julius 161, 211–24
Haida 59, 63, 69
Hanitsch, Dr R. 254–7
Hanson, (Sir) Richard Davies 156–7, 159, 162, 163
Harvard Peabody Museum 64
Haviland, Dr G.D. 253–4
Heale, Theophilus 194
Hector, Dr James 190, 212, 213, 216, 221, 224–5
Hedley, C. 132
Hely-Hutchinson, Sir Walter 111, 115
Hewitt, John 113
Hochstetter, Ferdinand von 185, 187, 189, 199, 211, 212–13, 218
Hodgkinson, Miss 143
Holmes, William 123
Hoo Ah Kay 249, 250
Hooker, Joseph 193, 212, 213
Horn, W.A. 170
Hose, Archdeacon (Bishop) G.F. 251–2
Hudson's Bay Company 59, 61, 65
human casts 85, 91–2, 98, 146, 173, 256
human remains, collecting of 9, 10–11, 64, 93–5, 147, 169, 173, 198–9, 220, 238, 268
Hunterian Museum, Glasgow 2
Hunterian Museum, London 2, 174
hunting and game 3–4, 22, 58, 61–2, 68, 79, 81, 109–10, 112, 147, 171, 198, 199, 210, 216, 217, 222, 245, 246, 255
Hutton, Capt. F.W. 189, 192, 217, 218, 222–3, 224

Huxley, T.H. 173–4, 216, 277

Imperial Institute, London 37, 250
Imperial Zoological Museum, Vienna 213
India 5–6, 108, 161, 193, 236–7, 240, 241, 242, 246, 276
Indian Museum, Calcutta (Kolkata) 2, 89, 161, 235–9, 271
Indian National Trust for Art and Cultural Heritage 240
Industry & Technology Museum (ITM), Melbourne 142–4, 146
Iroquois 38

Jacob, Sir Swinton 243
Jaipur Museum 243
Java 129, 246, 247, 256, 257
Jeejeebhoy, Sir Jamsetjee 240
Jones, Philip 175

Kaffrarian Museum 79
Kay, Robert 165
Kelvingrove Art Gallery & Museum, Glasgow 200, 271
Kermode, Francis 66–9
Kershaw, J.A. 147
Kew Gardens, London 65, 121, 193, 213
Khoesan 5, 82, 91, 94–5, 98, 113
Kimberley, Lord 244, 249
Kipling, Lockwood and Rudyard 242
Kirk, Thomas 190–1, 192, 194
Kloss, Cecil Boden 257–8
Knight, Arthur 253
Knight, Valentine 255, 256
Köhler, W.H. 85
Krefft, Johann Ludwig Gerard 127–8, 129, 130, 131, 135, 174, 213
Kwakiutl 59, 63, 65, 66, 69, 71

La Trobe, Charles Joseph 132–4, 137, 141
Lahore Museum 242
Lankester, Ray 170
Layard, Edgar 84–8, 90–1, 108
Lewis, Mortimer 125
Lim Boon Keng, Dr 254
Linnean societies 121, 122, 130, 133
Liverpool 37, 66, 129, 254, 272, 273

INDEX

Logan, J.R. 251
Logan, William 29–30, 33, 36
looting 3, 10–11, 13, 38, 53–5, 56–7, 65, 71, 94–5, 171
Low, Sir Hugh 244
Ludwig, C.F.H., Baron von 81, 83
Luschan, Felix 91
Lyell, Charles 1, 22, 28, 30, 34, 39, 213

McCallum, Henry 252–3
McCoy, Prof. (Sir) Frederick 127, 135, 137–44, 145, 146, 147, 175
McKay, Alexander 217–18, 221
MacKechnie, Edmund Augustus 194
Mackelvie, J.T. 200, 201
Maclear, Sir Thomas 85
Macleay, Alexander 122–3, 124, 129
Macleay, George 124, 129
Macleay Museum 130
Macleay, William John 129–30
Macleay, William Sharp 122, 129–30, 174
Macmillan, Miss 143
McCulloch, Rev. Thomas 25–6
McGregor Museum, Kimberley 79, 95
McOwan, Peter 108, 111
Mair, Capt. Gilbert 194, 196, 201, 226
Makepeace, Walter 251–2
Malacca (Melaka) 246, 247, 248, 251
Malay peninsula 244, 245, 250, 251, 253, 255, 257
Manchester Museum 144, 147
Maori 5, 184, 187, 193, 194, 195–203, 210, 213, 217–21, 225–6, 227
Maori artefacts 45, 147, 166, 188–9, 190, 194, 195–203, 219–21, 222, 224, 227
Maori houses 190, 219–20, 227
marine collecting 59, 63, 223, 238, 248, 255
Markham and Richards empire museum survey 173
Masters, George 130
mechanics' institutes 26–7, 33, 34, 39, 61, 133–4, 138, 158, 159, 166, 185, 186, 187, 191, 211, 212, 216

Mechanics' School of Arts, Sydney 125
Melbourne Museum *see* National Museum of Victoria
Menzies, James Mellon 53, 55
Metropolitan Museum, New York 49
Miers and Markham empire museum survey 12–13, 21, 97
Miklouho-Maclay, N.N. de 251
Mining Museum, Sydney 132
missionaries 3, 9, 13, 32, 37–8, 53, 65, 81, 94, 131, 168, 176, 247, 248
Mitchell, Thomas 123, 127, 128
moa 161, 168, 169, 213, 215, 216, 217–19, 222
Moffat, Robert 81, 82
Mond, Sir Robert 48
Moody, Henry 63
Morrison, Rev. Dr R. 247, 248
Moulton, John 257
Mountfort, B.W. 213, 214, 218, 219
Mueller (Müller), Ferdinand von 134, 137, 174, 212, 213
Murchison, Sir Roderick 124, 212
Musée de l'Instruction Publique, Quebec 37
Musée de Seminaire, Quebec 25
Muséum d'Histoire Naturelle, Paris 83, 162

National Museum of Victoria (NMV) 127, 132–48, 198, 271
Native Sons of BC 70
Natural History Society of BC 62–3, 66
Natural History Society of South Australia 158
Nelson Museum 185, 217, 224
New Zealand Institute 190–1, 225, 227
Newbery, James Cosmo 142–3, 146
Newcombe, Charles Frederick 63, 65–8, 147
Nicholson, Prof. Henry A. 34, 39
Normal School Museum, Toronto 32, 39
Northern Territory, Australia 161, 162, 167–8
Nowell, Charlie 63, 66

[283]

INDEX

Ontario Provincial Museum, Toronto 28, 37–8, 39, 44, 50, 51, 53, 56
Osler, Sir Edmund 48, 50, 52
Otago 189, 192, 217, 223, 224
Owen, Richard 84, 124, 127, 133, 173–5, 216, 217, 218, 266

Pacific Island artefacts 37, 80, 120, 124, 128, 131, 146, 160, 164, 171, 175, 188–9, 196, 200, 201, 223, 224, 226, 271
Pappe, Dr Ludwig 85, 108
Pellatt, Sir Henry 52
Perak Museum, Taiping 244–5, 255, 258
Péringuey, Louis 88, 90, 91, 92–3, 97
Petheridge, Robert 132
Philosophical Institute of Canterbury 212, 214, 216, 217
Philosophical Institute of Victoria 134, 135, 139
Philosophical Society, Sydney 121–2, 123
Piers, H. 108
Pitt-Rivers museum and classification system 38, 66, 144, 147, 167
Pöch, Dr Rudolf 95
Potts, T.H. 216
Prince Albert 137
Prince Alfred 86
Prince of Wales 68, 221, 240, 243
Prince of Wales Museum, Bombay 240–2
princely museums, Indian 6, 242–3
Pukaki 197
Purchas, Arthur Guyon 194

Quebec 21–2, 25, 27, 30, 37, 80

racial attitudes 10, 11, 23, 25, 36, 57, 65, 67, 78, 90–4, 96, 97–8, 171, 186, 195, 225, 268, 272
Raffles, Sir Thomas Stamford 246–8
Raffles Library and Museum *see* Singapore Museum
railways 2–3, 7, 9, 24, 25, 34, 35, 53, 57, 59, 60, 89, 96, 111, 163, 168, 192
Ramsay, Edward Pierson 131
Randall, Dr H.L. 250

'rational recreation' 4, 21, 27, 136
Rawson, Rawson A. 84–5
Reischek, Andreas 199
Rolleston, Prof. George 216
Rolleston, William 214, 215, 216
Roosevelt, Theodore (Teddy) 68
Royal Asiatic Society, London *see* Asiatic societies
Royal British Columbia Museum, Victoria 40, 58–72, 271, 273
Royal Canadian Institute 28, 33, 36–7, 40, 48
Royal College of Surgeons (RCS) 121, 124, 133, 164, 170, 174, 218
Royal Ontario Museum (ROM) 6, 21, 24, 31, 33, 39, 40, 44–58, 71–2, 268, 271, 272
Royal Scottish Museum 49
Royal Society of Canada 30, 36
Royal Society of South Africa (RSSA) 89, 93, 97, 111
Royal Society of South Australia 158–9, 163, 165, 167
Royal Society of Victoria (RSV) 137, 138–9, 144
Ruskin, John 214, 265, 271, 275–6
Russell, Thomas 195
Ryan, Sir Edward 236
Ryerson, Rev. Egerton 32, 35

Salish 59, 65, 69
San *see* Khoesan
Sarawak Museum, Kuching 113, 244, 257
Scholefield, E.O.S. 67–8
Schomburgk, Richard 162, 163, 251
Schonland, Dr Selmar 94, 110–14
Sclater, William 89–91, 94
Scots 26, 27, 29, 31, 33, 35, 39, 46, 60, 80, 91, 131, 165, 192, 211, 216, 218, 237
Scottish museums 31, 49, 271
Sedgwick, Adam 124, 138
Selangor Museum, Kuala Lumpur 245–6, 255, 258
Selwyn, Bishop 194
Sheets-Pyenson, Susan 14, 16
Shore, Sir John 236
Shrubsall, Dr Frank C. 94
Sinclair, Andrew 193
Singapore Institution 247–8

[284]

INDEX

Singapore (National) Museum 234, 245, 246–59, 271
Smith, Dr Andrew 80–3, 85, 90, 129
Smith, John Alexander 187–90
Smithsonian Museum 65, 162, 173
Somerset, Lord Charles 80–1, 82, 84
Sotho 91, 92, 146, 272
South African Association for the Advancement of Science (SAAAS) 89, 93
South African College 83, 84, 85, 89, 90
South African Institution 82, 84
South African Literary & Scientific Association 84–5
South African Museum (SAM) 78–98, 110, 113, 115, 116
South African Philosophical Society see Royal Society of South Africa
South Australian Institute 157–60, 162–3, 164, 165
South Australian Literary & Scientific Association 156–7, 162
South Australian Museum (SAuM), Adelaide 80, 148, 156–76, 271
South Kensington Museum see V&A
Speight, Robert 223
Spencer, Walter Baldwin 144–8, 167, 170, 171, 175
Steedman, Andrew 83, 91
Stevens, Vaughan 255
Stirling, Dr Edward C. 165–71, 175
Strachan, Bishop John 31
Straits Settlements 246, 247, 250, 252, 257, 259
Stuart, John McDouall 157, 161
Sunday opening 90, 143, 217, 219, 257
Swettenham, Sir Frank 251

Tanakadate, Prof. Hidezo 258
Tate, Prof. Ralph 163–4, 170
Technological Museum, Sydney 132
telegraph network 3, 7, 9, 24, 59, 89, 157, 168, 176
thefts, museum 127, 143, 166, 192, 256, 274
Thomson, Edward Deas 123–4
Tokugawa, Marquis Toshichika 258
Transvaal Museum 79, 83, 113
treasure hunting see looting

Trimen, Roland 87–8, 90, 218
Trollope, Anthony 88
Tweedie, M.W.F. 258

Universities
 Aberdeen 70
 Adelaide 157, 163, 164, 165, 173
 British Columbia 62, 70
 Cambridge 167, 170
 Cape Town 93
 Dublin, T. C. 138
 Edinburgh 26, 30, 35, 39, 80
 Glasgow 26
 Laval 30
 McGill 30, 31
 Melbourne 135, 136, 138, 140–1, 143–4
 New Zealand 219
 Oxford 88, 144, 216
 Rhodes (Grahamstown) 111, 113
 Singapore 259
 Sydney 130, 251
 Toronto 31, 35–6, 45, 47, 48, 49–50, 55
 USA 12, 24, 34, 37, 48, 50, 51, 57, 59, 87, 133, 163, 195
 see also American Museums

V&A Museum, Bombay (Mumbai) 235, 239–40, 241, 273
V&A Museum, London 2, 13, 50, 57, 132, 142–3
Vancouver Art, Historical & Scientific Association 69
Vancouver Mountaineering Club 70
Vancouver Museum 69–72
Vancouver Natural History Society 70
Vancouver Naturalists' Field Club 70
Verco, Joseph 163
Victoria Institute for the Advancement of Science 135, 136–7, 138
Vienna 95, 199, 213, 217, 218
Vixseboxse, J.E. 88, 89, 111, 112

Waite, Edgar 171–3, 223
Wakefield, Captain Arthur 184
Wakefield, Edward Gibbon 156, 184, 215

INDEX

Walcott, R.H. 146
Walker, Sir Edmund 46, 47, 49, 50, 54
Wall, William Sheridan 124, 125, 130
Wallace, Alfred Russel 244
Wallich, Nathaniel 236, 248
War Memorial Museum, Auckland (WMM) 184–203
Warren, Sarah Trumbull 48–9, 52
Waterhouse, Frederick George 160–4, 168
Watkins, E. 189
Webb, Sir Aston 50
Weld, Frederick 252–3
Whewell, William 2
Whitaker, Sir Frederick 193–4
White, Bishop William Charles 52–5, 56–7
Williamson, James 191
Wilman, Miss 95
Wilson, (Sir) Daniel 35–7
Wittet, George 241

women 22, 28, 35, 45, 48, 176, 192
women and museums 15, 48, 63, 69, 71, 95, 96, 97, 109–10, 112, 132, 143, 201, 236
Wood-Mason, James 238
Woodwardian Museum, Cambridge 138
Wray, Cecil 256
Wray, Leonard 244–5, 246
Wright, Anthony 224
Wright, Prof. Robert R. 31, 39

Xhosa 91, 94, 98, 105, 114

York (Toronto) Museum 27

Zietz, A.H.C. 164–5, 169
Zimbabwe 79, 90, 92, 274
zoological gardens 29, 157, 165, 250
Zoological Institute, Kiel 164
Zoological Society, London 83, 160, Zulu 146, 272